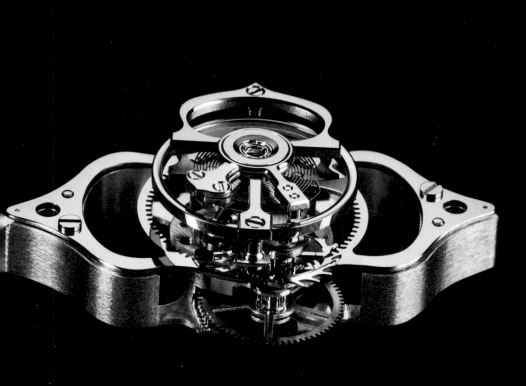

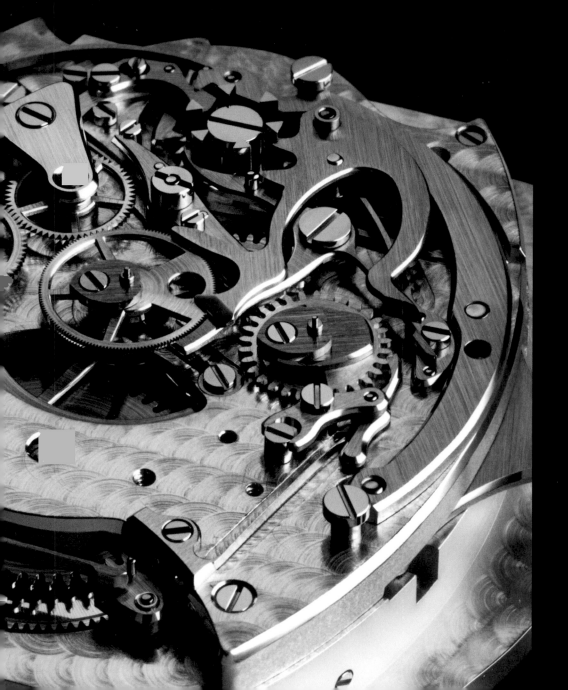
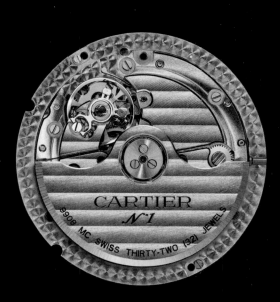
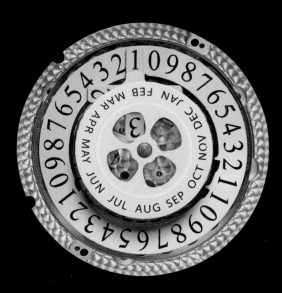

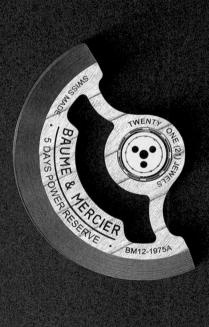

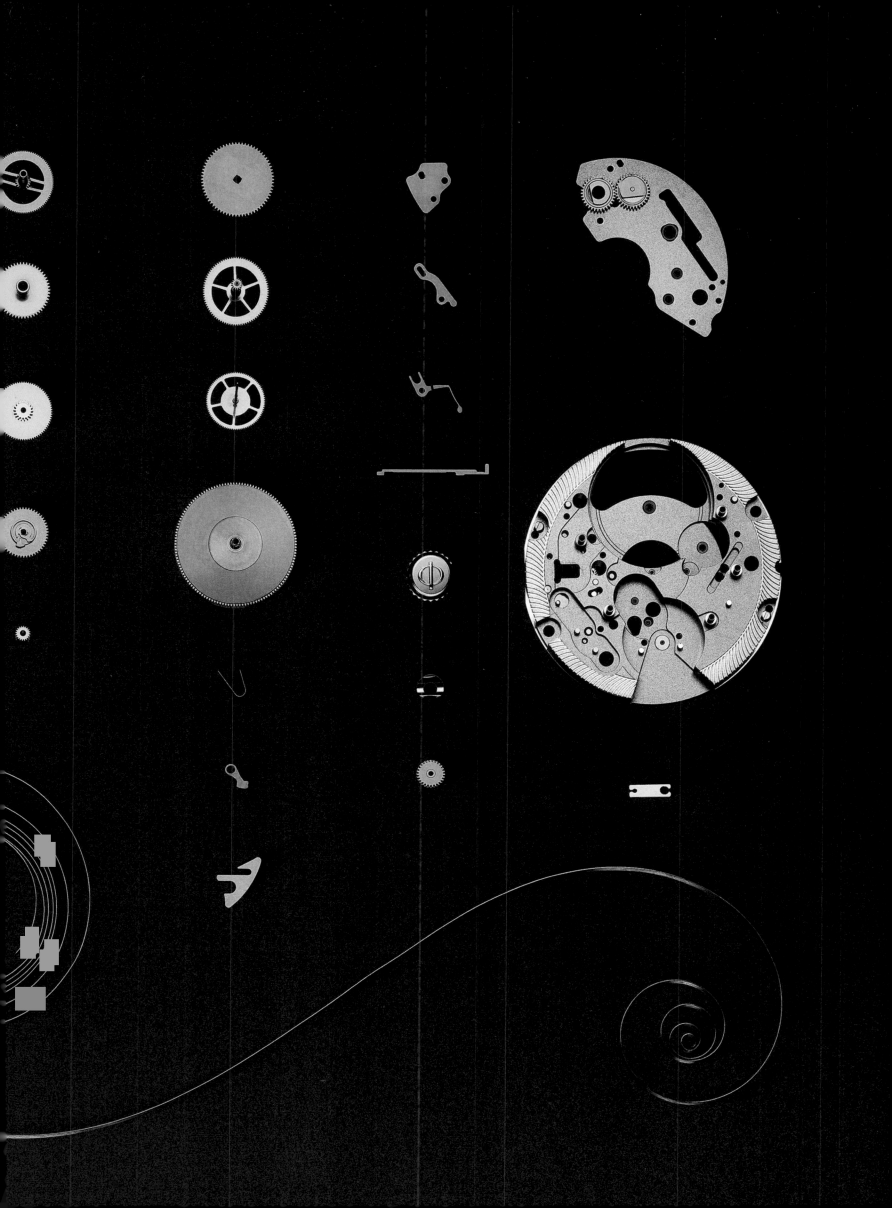

TAG Heuer Carrera, Cal. Heuer 02T, 2016

In the Engine Room of Time

"There are thieves who are not punished by the laws and yet steal people's most precious treasure," Napoleon Bonaparte once declared laconically. And he meant nothing else but time. Anyone who wants to measure its passage in a mechanical way rather than by the course of the sun, the trickling of sand, the dripping of water or the melting of candles has no other option but to cut precious time into larger or smaller pieces. Geared clocks have done precisely that since the late 13th century. For example, stationary clocks rely for this purpose on a pendulum swinging regularly to and fro every second. A pendulum wouldn't be practicable in portable timepieces, so an alternative was needed. The Dutchman Christiaan Huygens unveiled his solution in 1675: it consisted of a balance wheel coupled with a metal hairspring. Propelled by the energy stored in mainspring, Huygens' invention subdivides mankind's most valuable asset by steadily oscillating throughout life's various circumstances. To build portable hand-wound movements with three hands (one each for the hours, minutes and seconds), watchmakers need at least sixty components divided into eight basic assemblies:

1. The drive system with the mainspring as the source of energy
2. The transmission system to convey this energy
3. The distribution system, also known as the escapement
4. The regulating system
5. The motion work
6. The components to display the time
7. The hand-setting system
8. The winding system

Beyond these few essentials, the scale of complexity in the discipline of mechanical timekeeping continues almost infinitely upwards. Further components are required to perform various additional mechanical functions, which include, for example, automatic winding or the practical time zone mechanism. If many of these components are united in a microcosm, aficionados describe the ensemble as a grand complication. Taken to the extreme, such highly complex movements can concatenate upwards of 1,000 components, some of which are veritably Lilliputian. Needless to say, all of them must be carefully coordinated and meticulously adjusted to cooperate accurately.

At the beginning of the 20th century, Carl Ludwig Schleich expressed his enthusiasm for this ingenious mechanical collaboration: "What lofty aesthetic beauty graces the fine movement of a watch, as it similarly indwells electric motors, the sparkling engines of mighty ships and the great halls of ironworks! To achieve the spiritual objective via the simplest means, to follow the straightest path to the desired destination, the draw the most beautiful line as a fitting symbol of the purest idea [...]. A beneficent angel, a guardian of beauty always accompanies the practical needs of technology! In ugliness, matter prevails over idea; but in beauty, idea prevails over matter."

Wristwatches had not yet become widely accepted during the lifetime of the enthusiastic German surgeon and writer, but their history can be traced back to 1571, when the Earl of Leicester presented Queen Elizabeth I of England with a bracelet to which the nobleman's jeweler had attached a small pocket watch. The first wristwatch per se was crafted in 1806, when Empress Joséphine of France commissioned Marie-Étienne Nitot to build a ticking wedding present for Auguste Amalia, daughter of King Maximilian I Joseph of Bavaria.

The first serially manufactured wristwatches, which were destined for the forearms German naval officers, were produced by Girard-Perregaux around 1880. Incidentally, to the best of all knowledge and belief, not a single specimen of these timepieces survives today. The horological discipline of complications, in this instance a minute repeater, first found its way to the wrist in 1892. Louis Cartier importantly contributed to the emancipation of the wristwatch from pocket watch design with his creation of the "Santos" in 1904. With the rare exceptions of Alberto Santos-Dumont, military men, sportsmen and a few unconventional thinkers, the vast majority of men showed little interest in wristwatches until the 1930s. These traditional gents preferred to continue carrying the measurer of all things temporal in their pockets. Their conservative habit was further encouraged by watchmakers and scientists, who rebuked the folly of strapping a vulnerable mechanical watch to the most actively mobile part of the human body. Nevertheless, what the writer Sigismund von Radecki denigrated as "the handcuff of time" began its unstoppable triumphal procession from the 1940s onwards, equipped either with a simple manually wound movement or the increasingly popular automatic winding mechanism, and not infrequently also equipped with other additional functions, which will be discussed below. Chronographs, calendar movements, repeaters or tourbillons help to ensure that sweet time is not a superhighway leading us at high speed from cradle to grave, but a shady byway where unhurried mortals can park and enjoy the sunshine.

Im Maschinenraum der Zeit

„Es gibt Diebe, die von den Gesetzen nicht bestraft werden und dem Menschen doch das Kostbarste stehlen", stellte Napoleon Bonaparte einmal lakonisch fest. Und er meinte damit nichts anderes als die Zeit. Wer sie nicht mit dem Lauf der Sonne, rieselndem Sand, fließendem Wasser oder brennenden Kerzen, sondern auf mechanische Weise messen möchte, muss sie in mehr oder minder kleine Stücke zerteilen. Nichts anderes tun Räderuhren seit dem späten 13. Jahrhundert. Stationäre Exemplare nutzen zu diesem Zweck beispielsweise ein im Sekundentakt schwingendes Pendel. Weil ein solches in tragbaren Zeitmessern nicht funktioniert, brauchte es eine Alternative. Und die präsentierte der Niederländer Christiaan Huygens im Jahr 1675. Gemeint ist die Unruh, gepaart mit einer metallischen Unruhspirale. Angetrieben durch einen Federspeicher teilt sie das kostbarste Gut der Menschheit durch Oszillationen in unterschiedlichsten Lebenslagen. Für tragbare Handaufzugswerke mit drei Zeigern für Stunden, Minuten und Sekunden benötigen Uhrmacher mindestens sechzig, in acht grundlegende Baugruppen aufgeteilte Komponenten:

1. das Antriebssystem mit der Zugfeder als energiespendendes Organ
2. das Übertragungssystem zur Weiterleitung der Energie an
3. das Verteilungssystem, auch Hemmung genannt
4. das Reguliersystem
5. das Zeigerwerk
6. die Organe zur Zeitanzeige
7. das Zeigerstellsystem
8. das Aufzugssystem

Darüber hinaus ist die Mechanikskala quasi nach oben offen. Jede mechanische Zusatzfunktion, angefangen beim automatischen Aufzug bis hin zum praktischen Zeitzonendispositiv, verlangt nach zusätzlichen Bauteilen. Finden viele davon in einem Mikrokosmos zusammen, spricht man von einer großen Komplikation. Auf die Spitze getrieben, können derartige Uhrwerke aus mehr als tausend teilweise winzigen Komponenten bestehen. Logischerweise müssen alle sorgsam aufeinander abgestimmt sein und akkurat kooperieren. Jenes ausgeklügelte mechanische Miteinander ließ Carl Ludwig Schleich Anfang des 20. Jahrhunderts in höchsten Tönen schwärmen: „Im feinen Werk der Uhr – im elektrischen Betriebe, im Gang blitzblanker Schiffsmaschinen, im Eisenwerk – welch hohe ästhetische Schönheit! Der geistige Zweck mit einfachsten Mitteln, der gerade Weg zum Ziel, die schöne Linie als Symbol zur reinsten Idee […]. Den praktischen Bedürfnissen der Technik geht stets ein guter Engel zur Seite: ein Wächter der Schönheit! Im Hässlichen siegt die Materie über die Idee, im Schönen aber die Idee über die Materie."

Armbanduhren hatten sich zu Lebzeiten des deutschen Chirurgen und Schriftstellers noch nicht auf breiter Front durchgesetzt, obwohl deren Geschichte zurückreicht bis ins Jahr 1571, als der Graf von Leicester seiner Königin Elisabeth I. von England einen Armreif mit daran befestigter Uhr schenkte. Die erste originäre Armbanduhr fertigte Marie-Étienne Nitot 1806 im Auftrag der französischen Kaiserin Joséphine als Hochzeitsgeschenk für Auguste Amalia, Tochter von König Maximilian I. Joseph von Bayern.

Etwa 1880 produzierte Girard-Perregaux die ersten Serienarmbanduhren für deutsche Marineoffiziere. Nachweislich überlebt hat übrigens kein einziges Exemplar. Das Thema Komplikation, in diesem Fall eine Minutenrepetition, fand 1892 ans Handgelenk. Einen wichtigen Beitrag zur Emanzipation der Armbanduhr vom Taschenuhrdesign leistete Louis Cartier mit der Kreation des Modells „Santos" im Jahr 1904. Abgesehen von Alberto Santos-Dumont, Militärs, Sportlern und einigen Querdenkern konnten Männer der Armbanduhr bis in die 1930er-Jahre herzlich wenig abgewinnen. Das Maß aller zeitlichen Dinge trugen sie nicht zuletzt deshalb wie gewohnt in der Tasche, weil Uhrmacher und Wissenschaftler gegen die Unsitte schimpften, Uhren an der bewegtesten Körperstelle zu befestigen. Dennoch trat das, was der Schriftsteller Sigismund von Radecki einmal als „Handfessel der Zeit" bezeichnete, ab den 1940er-Jahren seinen unaufhaltsamen Siegeszug an – ausgestattet mit schlichtem Handaufzugswerk oder der immer beliebteren Automatik, dazu auch noch mit weiteren Zusatzfunktionen, von denen im Folgenden die Rede sein wird. Chronographen, Kalenderwerke, Repetitionen oder Tourbillons tragen dazu bei, dass die Zeit keine Schnellstraße zwischen Wiege und Grab ist, sondern ein Platz zum Parken in der Sonne.

Parmigiani Fleurier, components of a mechanical movement ◦ *Parmigiani Fleurier, Komponenten eines mechanischen Uhrwerks*

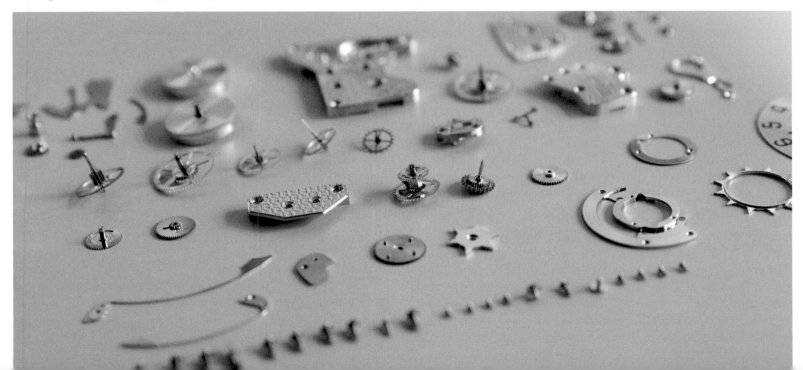

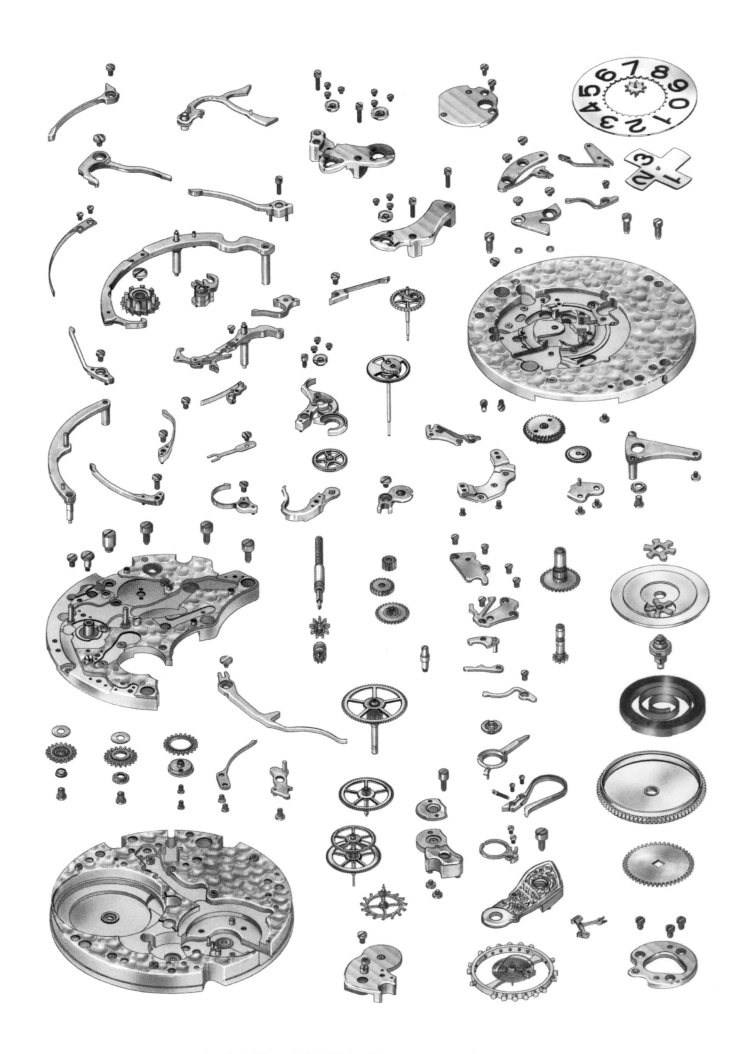

A. Lange & Söhne, Cal. L.951.1—390 components ∘ Komponenten

Page 3, clockwise from top left ◦ Seite 3, von oben links im Uhrzeigersinn: Cartier, Cal. MC9452-b ◦ Bulgari Carillon Tourbillon, 2015 ◦ Cartier annual calendar rotor and under the dial ◦ Cartier Jabreskalender Rotor und unter dem Zifferblatt ◦ Cartier MC9431-a
Pages 4–5 ◦ Seiten 4–5: Baume & Mercier Clifton Baumatic, Cal. BM12-1975A, components ◦ Komponenten, 2018

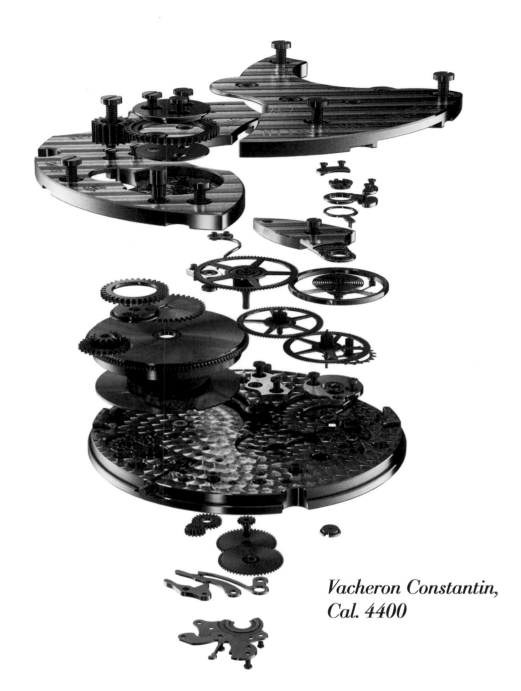

Vacheron Constantin, Cal. 4400

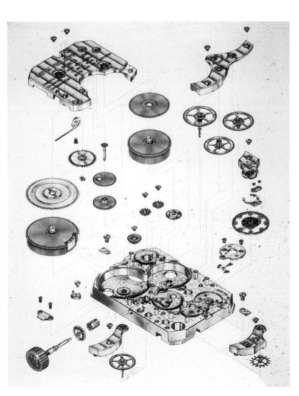

Patek Philippe 10-Day Tourbillon, Ref. 5100

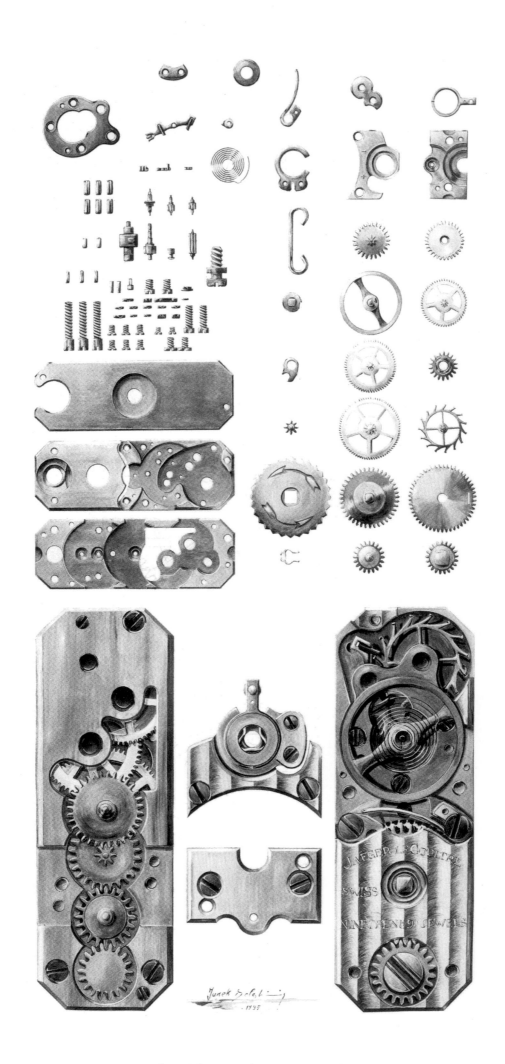

Jaeger-LeCoultre, Cal. 101—98 components ◦ Komponenten

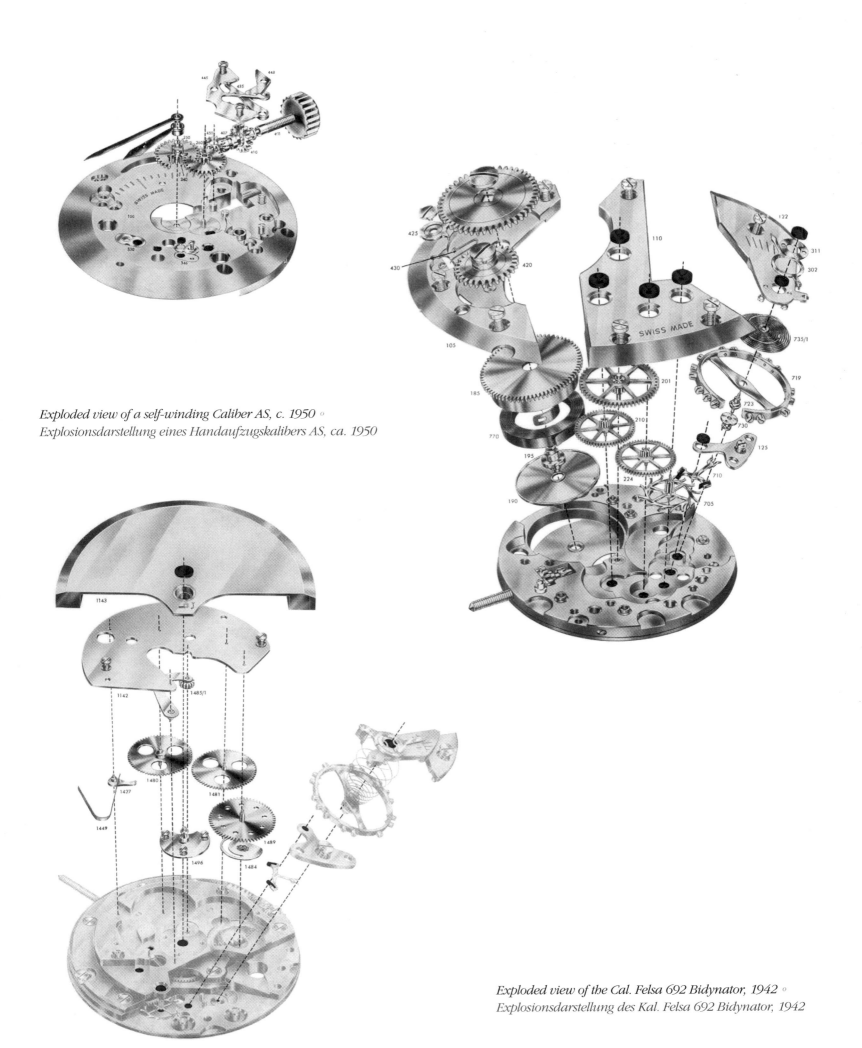

Exploded view of a self-winding Caliber AS, c. 1950
Explosionsdarstellung eines Handaufzugskalibers AS, ca. 1950

Exploded view of the Cal. Felsa 692 Bidynator, 1942
Explosionsdarstellung des Kal. Felsa 692 Bidynator, 1942

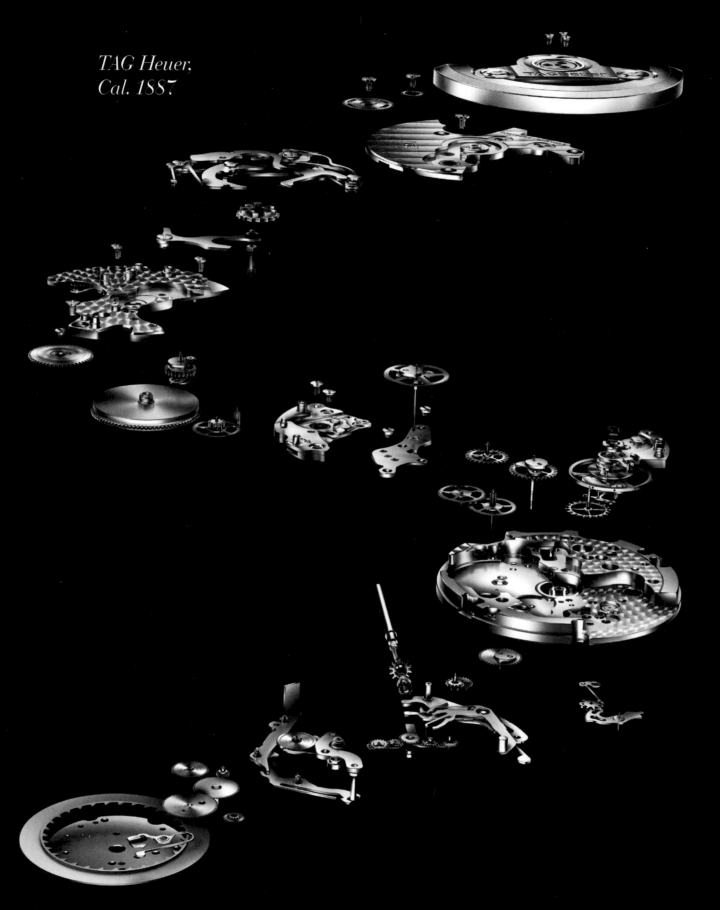

TAG Heuer,
Cal. 1887

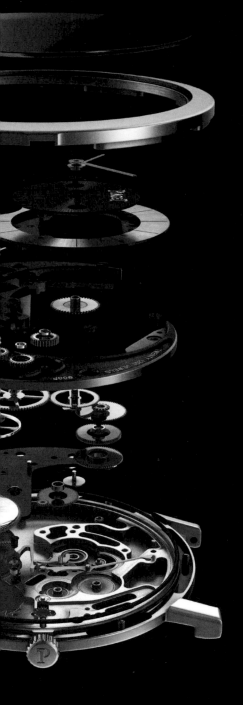

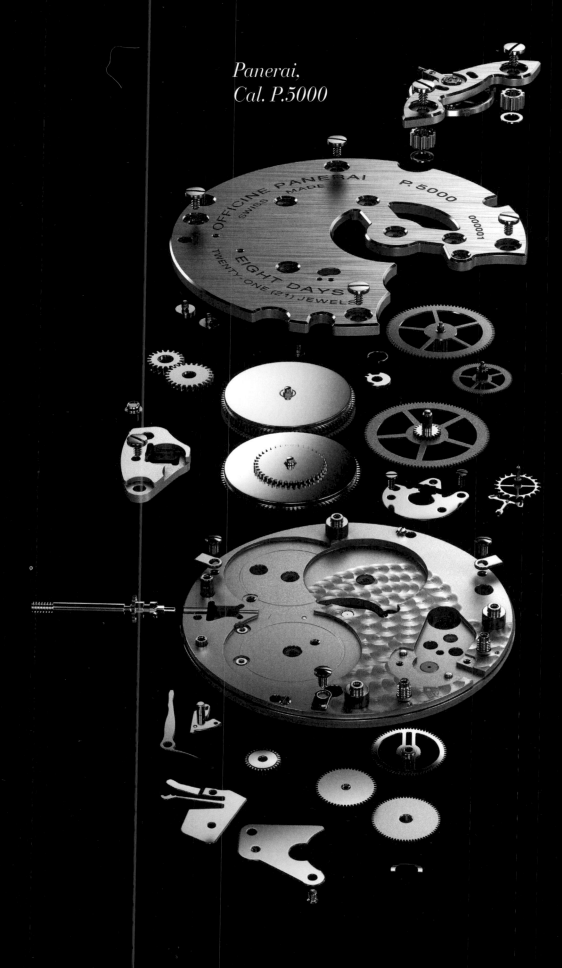

Panerai,
Cal. P.5000

Piaget, Cal. 900P

Equation
Zeitgleichung

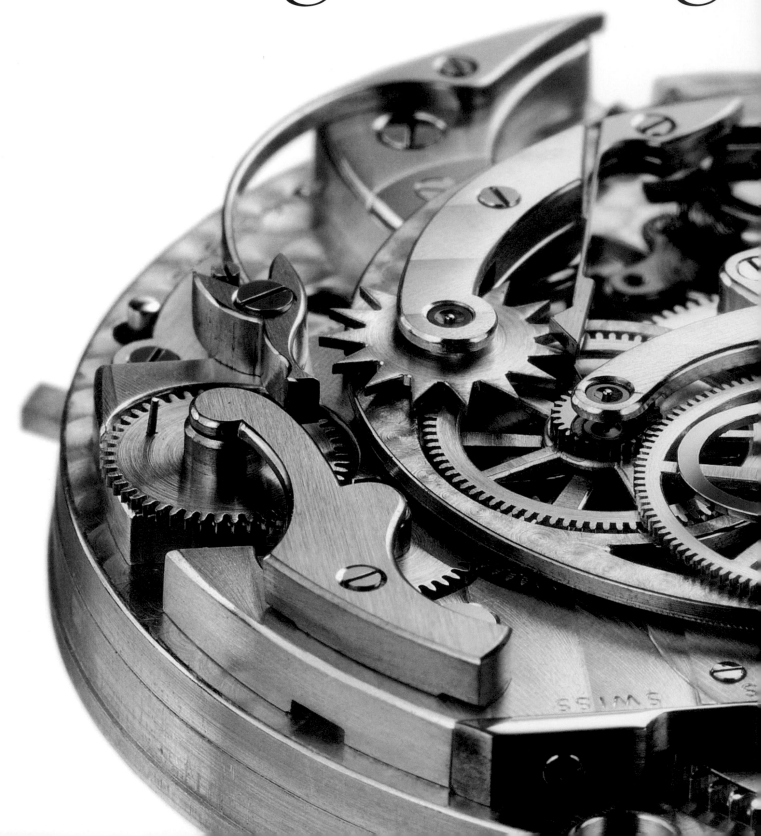

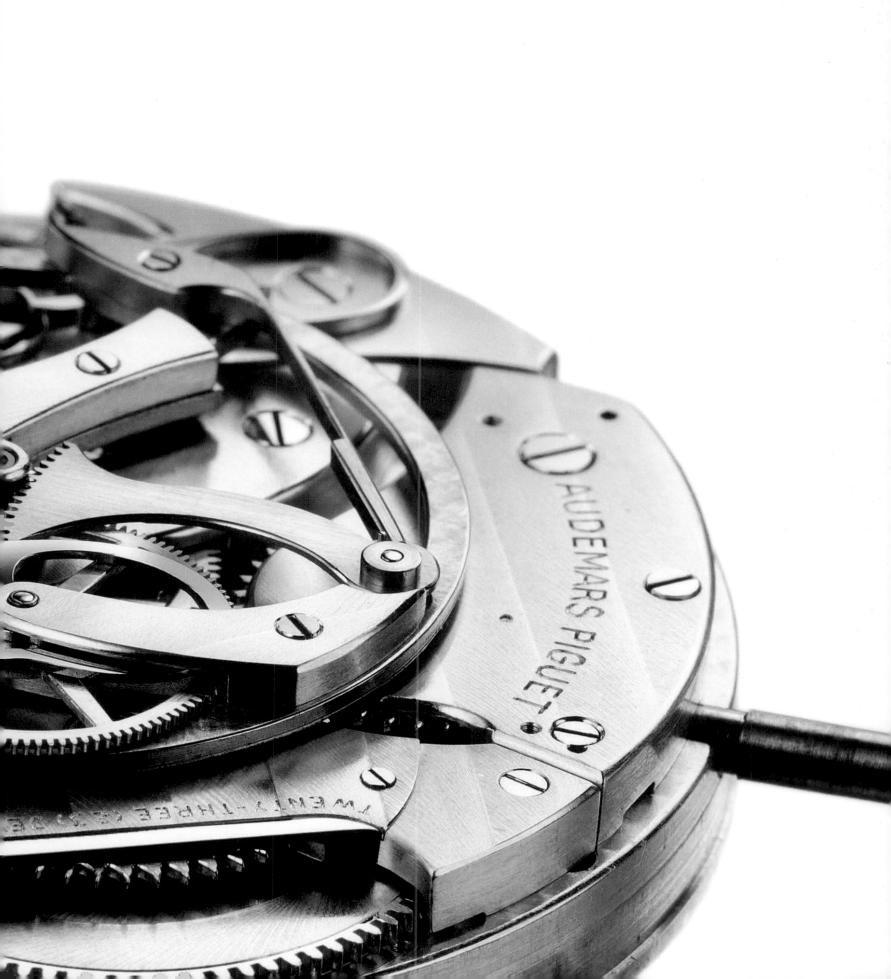

Thoughts on Time

Many of our contemporaries are more or less unaware that that there was once a time when "clock time" played either no role at all or only a very minor one in people's lives. Our ancestors would simply rise when the rooster crowed, do whatever tasks their day's work might require and afterwards, like their chickens, go to sleep when dusk darkened into night. Summer days offer us more hours of sunlight than winter days, so people logically worked longer during the warm season. To compensate for the labors of summer, they treated themselves to a lengthy hibernation each winter. In a nutshell, daily life was oriented according to the rhythms of nature, which are defined by the Earth's rotations around its axis and its revolutions around the sun. Mariners and fishermen also kept a sharp eye on the moon, because it determines the ebb and flow of the tides.

What, then, is time?

Philosophers and scientists have perennially sought to arrive at a fundamental definition of the concept of time. But to this day, they have yet to provide humankind with a comprehensive, plausible and generally valid elucidation.

"What, then, is time?" pondered the great church teacher Augustine in his *Confessiones*. Despite lengthy and erudite ruminations, he finally had to admit: "If no one asks me, I know; if I wish to explain to him who asks, I know not."

Albert Einstein likewise struggled to find an answer at the beginning of the 20th century. He summarized his views in the theory of relativity, which was published in 1905. In it, the genius turned many ideas upside down that common sense and scientific research had previously believed to be true about this admittedly thorny topic. Einstein claimed that time is not an absolute quantity, but a relative one. This, he said, is why time can never be anything but what can be read from the face of a clock. This seemingly trivial statement was born from a fundamental insight: moving clocks tick more slowly than stationary ones! What time it is at any given moment depends on who is asking, who is answering, and how each one moves in relation to the other. Even more fundamental examination of the temporal sequence of events likewise allows different observers to arrive at different answers. To support his assertions, the astute researcher devised extremely sophisticated thought experiments, which for many years baffled even the most learned theoreticians. With a mischievous wink, Einstein offered a simple explanation of the relativity of time: "When you sit with a nice girl for two hours it seems like two minutes. When you sit on a hot stove for two minutes, it seems like two hours."

Clocks for time

After these introductory remarks, our idea of time still probably remains rather vague. Naturally, the philosophers' concepts of time are no less difficult to understand than the physicists' notions of it. For simplicity's sake, the following observations will be based on Einstein's convenient postulate, namely, that "time what can be read from the face of a clock."

What kind of clock? That question is only of secondary importance. Basically, each clock or watch consists of the same subassemblies: a housing or case, a movement, and a time display. In addition to protecting the timepiece's interior mechanisms, the case usually also serves a decorative purpose. Regardless of whether it is mechanical or electronic, the clockwork or movement inside the housing or case subdivides the uniform and noiseless passage of time into clearly defined segments. Hands relieve the movement of its anonymity. But their rotations require smaller units than the natural intervals of year, month and day.

The attempt to divide the time span from sunrise to sunset, and afterwards the interval from sunset to sunrise, into two sets of twelve equally long sections failed to yield a viable solution to the conundrum of time. As is well known, the diurnal periods of light and darkness vary with beautiful regularity over the course of a year. Any child can tell you that a summer day has more hours of sunlight than a winter day. Nonetheless, so-called "temporal hours," which are longer in summer and shorter in winter, were used until the end of the Middle Ages. No fewer than four different ways of tallying the hours were variously used in Europe and the Near East.

In this context, the moment when each day begins is purely a matter of conventional agreement. It essentially makes no difference whether each new day is defined as starting at midnight or at noon. The same applies to the choice of counting each day's hours in two 12-hour periods or one 24-hour interval.

True and mean solar time

In the 14th century, the introduction of equinoctial hours of equal length precipitated a fundamental change in the way we humans apportion our most precious resource. To understand this, one must comprehend the difference between true and mean solar time. True solar time is based on the true solar day and can only be determined for one particular location at a time. The time at that place on

Blancpain Villeret
Équation du Temps Marchante

Gedanken zur Zeit

Dass es einmal eine Zeit gab, in der Zeit keine oder nur eine untergeordnete Rolle spielte, ist vielen Zeitgenossen womöglich kaum bewusst. Früher standen die Menschen beim Krähen des Hahnes auf, verrichteten danach ihr wie auch immer geartetes Tagwerk und gingen bei anbrechender Dunkelheit mit den Hühnern schlafen. Weil es im Sommer länger hell ist als im Winter, arbeitete man in der warmen Jahreszeit logischerweise mehr. Zum Ausgleich gönnte man sich einen ausgiebigen Winterschlaf. Kurzum: Das Alltagsleben orientierte sich am Rhythmus der Natur, definiert durch die Rotationen der Erde um ihre eigene Achse und um die Sonne. Fischer hatten auch den Mond im Blick, denn er bestimmt die Gezeiten, sprich Ebbe und Flut.

Was also ist die Zeit?

Seit jeher versuchen Philosophen und Wissenschaftler, den Begriff der Zeit grundlegend zu definieren. Eine umfassende, plausible und allgemeingültige Auslegung sind sie der Menschheit bis heute schuldig geblieben.

„Was also ist die Zeit?", sinnierte in seinen *Confessiones* bereits der große Kirchenlehrer Augustinus. Trotz ausgiebigen Grübelns musste er letzten Endes eingestehen: „Wenn mich niemand danach fragt, weiß ich es; will ich es jedoch einem Fragenden erklären, weiß ich es nicht mehr."

Um eine treffende Antwort rang zu Beginn des 20. Jahrhunderts auch Albert Einstein. Seine Auffassung findet sich in der 1905 publizierten Relativitätstheorie. Hierin stellte das Genie vieles auf den Kopf, was gesunder Menschenverstand und naturwissenschaftliche Forschung bis dahin zum schwierigen Thema erarbeitet hatten. Keine absolute Größe sei die Zeit, sondern eine relative. Deswegen könne sie immer nur das sein, was man an der Uhr ablese. Die nur scheinbar triviale Aussage resultiert aus einer fundamentalen Erkenntnis: Bewegte Uhren gehen langsamer als stationäre! Wie spät es gerade ist, hängt davon ab, wer fragt, wer antwortet, und wie sich beide in Bezug zueinander bewegen. Die noch grundlegendere Beschäftigung mit der zeitlichen Abfolge von Ereignissen lässt ebenfalls verschiedene Erkenntnisse zu. Beweise lieferte der scharfsinnige Forscher mittels extrem anspruchsvoller Gedankenexperimente, die sogar die hohe Wissenschaft jahrelang nicht nachzuvollziehen vermochte.

Mit dem ihm eigenen Schalk im Nacken lieferte Einstein gleichwohl eine simple Erläuterung zur Relativität der Zeit: „Wenn man zwei Stunden mit einer schönen Frau zusammen ist, vergeht die Zeit relativ schnell. Sitzt man hingegen zwei Minuten auf einer heißen Ofenplatte, verstreicht die Zeit relativ langsam."

Uhren für die Zeit

Nach diesen einleitenden Bemerkungen bleibt das Wissen um die Zeit vermutlich weiterhin nebulös. Naturgemäß ist der philosophische Zeitbegriff genauso schwer verständlich wie der physikalische. Daher soll bei den folgenden Betrachtungen Einsteins griffiges Postulat gelten: „Zeit ist das, was man an der Uhr abliest." Um welche Art von Uhr es sich handelt, spielt dabei eine untergeordnete Rolle. Grundsätzlich besteht jedes Exemplar aus den gleichen Baugruppen: Gehäuse, Werk, Zeitanzeige. Neben der schützenden Funktion kommt der Schale meist auch eine schmückende zu. Das von ihr umfangene Uhrwerk, egal ob mechanisch oder elektronisch, unterteilt die gleichförmig und geräuschlos verstreichende Zeit in wohldefinierte Abschnitte. Zeiger nehmen dem Uhrwerk seine Anonymität. Ihre Rotationen verlangen jedoch nach weiteren Einheiten über die naturgegebenen Abschnitte Jahr, Monat und Tag hinaus.

Keine brauchbare Lösung brachte die Unterteilung der Zeitspannen von Sonnenaufgang bis -untergang und wieder bis Sonnenaufgang in jeweils zwölf gleich lange Abschnitte. Bekanntlich variieren die Hell- und Dunkelzeiten im Laufe eines Jahres mit schöner Regelmäßigkeit. Im Sommer sind die Tagstunden länger als im Winter. Gleichwohl galten die sogenannten Temporalstunden bis zum Ende des Mittelalters. Europa und Vorderasien kannten sogar vier unterschiedliche Stundenzählungen.

Reine Vereinbarungssache ist in diesem Zusammenhang der Beginn des Tages. Somit spielt es prinzipiell keine Rolle, ob man ihn mitternachts oder mittags anfangen lässt. Gleiches gilt für die Unterteilung in zweimal 12 oder einmal 24 Stunden.

Wahre und mittlere Sonnenzeit

Im 14. Jahrhundert brachten gleich lange Äquinoktialstunden einen grundlegenden Wandel im Umgang mit dem kostbarsten Gut der Menschheit. Man muss zwischen wahrer und mittlerer Sonnenzeit unterscheiden: Die wahre Sonnenzeit basiert auf dem wahren Sonnentag und kann jeweils nur für einen bestimmten Ort ermittelt werden. Dort ist High Noon, wenn ein senkrecht in die Erde gesteckter Stab den kürzestmöglichen Schatten wirft.

Schon früh hatten Astronomen herausgefunden, dass sich die Erde nicht auf kreisrunder, sondern elliptischer Bahn um die Sonne bewegt. Im Laufe des Jahres variiert der Abstand zwischen 147 100 000 und 152 100 000 Kilometern. Folglich beträgt die Differenz 5 Millionen Kilometer oder beinahe 3,5 Prozent. Überdies besitzt die Erdachse auch noch eine gewisse Neigung.

Anfang des 17. Jahrhunderts konstatierte der Astronom Johannes Kepler (1571–1630) im zweiten seiner fundamentalen Gesetze, dass die Erde während eines Jahres variierende Winkelgeschwindigkeiten erreicht, was wiederum zu unterschiedlichen Tageslängen führt. Der längste wahre Sonnentag misst etwa 30 Minuten mehr als der kürzeste. Für ein geordnetes Leben nach der Zeit war das schon damals schlichtweg zu viel. Der Ausweg bestand in einem gedanklichen Konstrukt, bei dem eine fiktive Sonne den Himmelsäquator mit konstanter Geschwindigkeit durchwandert. Ihr Stundenwinkel liefert das Maß für die mittlere Sonnen- oder Ortszeit, deren gleich lange „bürgerliche Tage" 24 Stunden, 1440 Minuten oder 86 400 Sekunden dauern.

the globe is high noon when a rod, inserted vertically into the ground, casts its shortest shadow on that particular day.

Astronomers discovered long ago that the Earth does not pursue a circular path around the sun, but follows an elliptical orbit instead. During the course of each year, the distance between Earth and sun varies between 147,100,000 and 152,100,000 kilometers. Consequently, the difference between perihelion and aphelion is five million kilometers, or almost 3.5 percent. Furthermore, the Earth's axis is tilted rather than perpendicular to our planet's orbital plane. At the beginning of the 17th century, the astronomer Johannes Kepler (1571–1630) stated in the second of his fundamental laws of planetary motion that the Earth attains varying angular velocities during the year, which consequently leads to varying lengths of day. The longest true solar day is about 30 minutes longer than its shortest counterpart. Even in those bygone years, this discrepancy was simply too much for living an orderly life in harmony with natural time. The solution was a mental construct in which an imagined sun travels along the celestial equator at unvarying speed all year round. Its hour angle provides the measure for mean solar or local time, which is divided into equally long "civil days," each of which consists of 24 hours or 1,440 minutes or 86,400 seconds.

The equation of time

Ordinary years have 365 days, but the times of true and mean noon differ on all but four of those days. The difference between true and mean solar time nonetheless obeys a cyclical regularity over the course of the year. When the equation of time (also known as "the equation") was meticulously calculated in 2011, maxima were recorded on February 11 (minus 14 minutes and 14 seconds) and on November 3 (plus 16 minutes and 26 seconds); true and mean solar time coincided on April 13, June 13, September 1 and December 25.

This astronomical fact had already challenged creative watchmakers centuries ago. A kidney-shaped cam in the timepiece's movement, rotating once around its own axis during the course of a year, can be shaped to depict the algorithm for the equation of time. The cam collaborates with a sophisticated lever mechanism to display the equation. The lever continuously scans the equation of time as programmed around the circumference of the cam and transfers the current value to a hand. This hand shows, for example, whether the sun will not reach its highest altitude in the midday sky for 11 minutes or whether it had already passed that point 6 minutes earlier.

Although the difference does not play a role in the everyday life of ordinary people, the first large clocks with equation displays were already keeping time in the late 17th century. As the centuries passed, the equation mechanism was miniaturized and built into pocket-watches and sometimes also into wristwatches.

Vive la (petite) différence

Weak demand for such mechanisms did not deter watchmakers from developing two fundamentally different systems to display the equation. In the simpler version, a hand shows the current difference between true and mean solar time on a scale ranging from -17 to +15 minutes, which the wearer mentally subtracts or adds to the time shown by the minute hand. This pesky mental arithmetic is eliminated by the "Équation Marchante" in upscale equation timepieces. An extra gear mechanism propels an additional minute hand around the dial so that its distance from the ordinary minute hand corresponds to the calculated equation of time. The equation hand alternately leads or lags behind its "civil" twin, and both hands coincide four times each year. A quick glance accordingly suffices to know, for example, that the sun crossed the meridian ten minutes ago, although mean solar time is exactly noon. This knowledge isn't particularly useful in everyday life, but aficionados of complicated horological mechanics enjoy this rare complication.

The equation of time for the pocket and the wrist

The legendary Breguet No. 160 "Marie-Antoinette" with equation display has achieved fame among pocket watches. A young nobleman ordered it in 1783 for the French queen, who, as is well known, reluctantly laid her head upon the guillotine on October 16, 1793 due to a revolution. The ultra-complicated timepiece was not completed until 1827, after the death of its creator Abraham-Louis Breguet. This magnificent pocket watch was stolen from a museum in Jerusalem in 1983, but reappeared under mysterious circumstances more than two decades later.

Equation displays also rank among Patek Philippe's most famous grand complications. James Ward Packard and Henry Graves Jr. were two clients for whom the Geneva-based luxury watchmaker built these elite mechanisms.

Vacheron Constantin unveiled a highly complex pocket watch in 2015, i.e. just in time for the company's 260th anniversary. Caliber 57260 inside its case consists of 2,826 components. Its bevy of 57 different functions naturally includes an equation display.

Chopard's opulent L.U.C "All in One" would be an ideal choice for connoisseurs who would like to carry the equation of time on their wrist. Its Caliber L.U.C 05.01-L concatenates 516 individual components and debuted in 2010, which was the same year that Panerai premiered its complex "L'Astronomo Luminor 1950 Equation of Time Tourbillon." This wristwatch also shows the times of sunrise and sunset, so the watchmakers individually modify each timepiece to show Old Sol's rising and setting at its owner's preferred geographical location.

The German watchmaker Martin Braun had already sparked an appreciative furor with his "Boreas" in 2002. In addition to showing the times of sunrise and sunset (individually calibrated for its owner's place of residence), a hand indicates the difference between true and mean sun time.

Two models with "running equation" display debuted in 2004: Blancpain's "Équation Marchante" and Jaeger-LeCoultre's "Gyrotourbillon I." The latter also integrates a perpetual calendar and a three-dimensional tourbillon.

Audemars Piguet launched the Jules Audemars "Équation du

Zeitgleichung

Normale Jahre haben 365 Tage. An 361 weichen die Zeitpunkte des wahren und mittleren Mittags voneinander ab. Übers Jahr hinweg ergibt sich jedoch eine mathematisch nachvollziehbare Gesetzmäßigkeit, was die Differenz zwischen wahrer und mittlerer Ortszeit angeht: Maxima waren im Jahr 2011, als die Zeitgleichung – auch Äquation genannt – optimal berechnet wurde, am 11. Februar mit -14 Minuten und 14 Sekunden sowie am 3. November mit +16 Minuten und 26 Sekunden zu verzeichnen. Am 13. April, 13. Juni, 1. September und 25. Dezember stimmten die Tageslängen überein.

Dieser astronomische Sachverhalt forderte kreative Uhrmacher schon vor Jahrhunderten heraus. Der Zeitgleichungsalgorithmus lässt sich in einem nierenförmigen Gebilde abbilden, welches im Uhrwerk während eines Jahres um seine Achse rotiert. Darüber hinaus braucht es ein durchdachtes Hebelwerk zur Anzeige der Äquation. Kontinuierlich tastet es die programmierte Zeitgleichung am Umfang besagter Niere ab und überträgt den aktuellen Wert auf einen Zeiger. Der wiederum lässt beispielsweise wissen, ob die Sonne ihren höchsten Stand am Himmel erst in 11 Minuten erreichen wird oder ihn schon 6 Minuten zuvor passiert hat.

Obwohl der Unterschied im Alltagsleben normaler Bürger keine Rolle spielt, gab es schon im späten 17. Jahrhundert erste Großuhren mit Äquationsanzeige. Bei Taschen- und vereinzelt auch Armbanduhren folgte sie im Laufe der Jahrhunderte.

Es lebe der kleine Unterschied

Die geringe Nachfrage hielt Uhrmacher nicht davon ab, zwei grundsätzlich verschiedene Indikationssysteme zu entwickeln. Bei der simpleren Version stellt ein Zeiger die jeweils aktuelle Differenz zwischen wahrer und mittlerer Sonnenzeit auf einer Skala von -17 bis +15 Minuten dar. Demnach muss man rechnen. Das lästige Addieren oder Subtrahieren eliminiert die gehobene Variante der Äquationsuhren, „Équation Marchante" genannt. Ihr Zusatzgetriebe lässt einen zweiten Minutenzeiger im Abstand der errechneten Zeitgleichung ums Zifferblatt drehen. Streckenweise wandert er vor dem „bürgerlichen" Minutenzeiger, dann wieder hinterher. Viermal jährlich marschiert das Duo quasi Hand in Hand. Ergo liefert ein einziger Blick die Erkenntnis, dass die Sonne den Meridian tatsächlich schon vor 10 Minuten überschritten hat, während es laut mittlerer Sonnenzeit exakt 12 Uhr Mittag ist. Im täglichen Leben hilft dieses Wissen zwar nicht wirklich weiter, aber Liebhaber diffiziler uhrmacherischer Mechanik erfreuen sich an der raren Komplikation.

Unterwegs mit der Zeitgleichung

Berühmtheit unter den Taschenuhren mit Äquationsanzeige hat die legendäre Breguet No. 160 „Marie-Antoinette" erlangt. Ein junger Adeliger orderte sie 1783 für die französische Königin, die ihr Haupt bekanntlich am 16. Oktober 1793 revolutionsbedingt unter das Fallbeil der Guillotine legen musste. Die Fertigstellung des ultrakomplizierten Zeitmessers erfolgte erst 1827, also nach dem Tod seines Schöpfers Abraham-Louis Breguet. 1983 wurde die Uhr aus einem Jerusalemer Museum gestohlen. Über 20 Jahre später tauchte das Prachtstück unter mysteriösen Umständen wieder auf.

Äquationsanzeigen sind beispielsweise auch den berühmten großen Komplikationen von Patek Philippe zu eigen. Die Genfer Nobelmanufaktur fertigte solche für James Ward Packard oder Henry Graves Jr.

2015, pünktlich zum 260-jährigen Jubiläum des Unternehmens, präsentierte Vacheron Constantin eine hochkomplexe Taschenuhr. Das darin verbaute Kaliber 57260 besteht aus 2826 Komponenten. Zum Spektrum der 57 verschiedenen Funktionen gehört natürlich auch eine Äquationsanzeige.

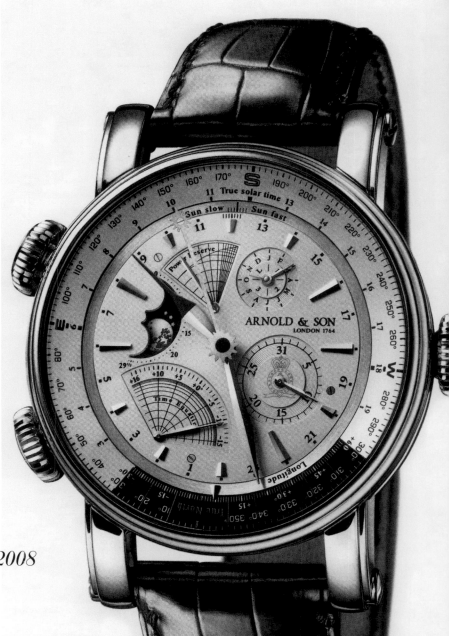

Arnold & Son True North Perpetual, 2008

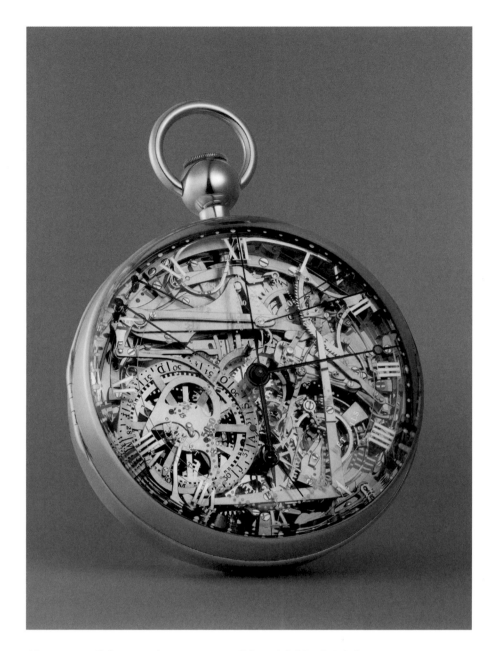

Breguet Marie-Antoinette No. 1160, 2008

Equation display of Breguet, Ref. 3477 ∘
Äquationsanzeige der Breguet, Ref. 3477

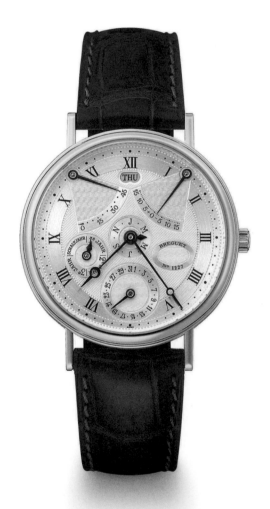

Breguet, Ref. 3477

Temps" in 2005. In addition to the equation, it also shows the times of sunrise and sunset. This extraordinarily complex timepiece is further endowed with a perpetual calendar and an astronomical moon-phase display.

Arnold & Son launched the "True North" in 2006. In addition to displaying a second time zone, perpetual calendar, the age of the moon and the remaining power reserve, the jam-packed dial of this complex timepiece also shows the equation of time.

In 2009, Girard-Perregaux's "1966" family welcomed a model with an annual calendar and a hand between the "4" and the "5" to show the difference between true and mean time on its tidily unostentatious dial. Breguet's watchmakers dedicated themselves to this complication on the "Marine Équation Marchante 5887" in 2017.

This foregoing compilation should be understood only as a selection rather than as an exhaustive list because the watch industry, in its tireless striving to attract purchasers, traditionally exploits the full potential of additional complications, which naturally also include diverse displays of the equation of time.

Pages 14–15: Audemars Piguet, movement with equation display, pocket watch No. 97801, 1925 ∘
Seiten 14–15: Audemars Piguet, Uhrwerk mit Äquationsanzeige, Taschenuhr Nr. 97801, 1925

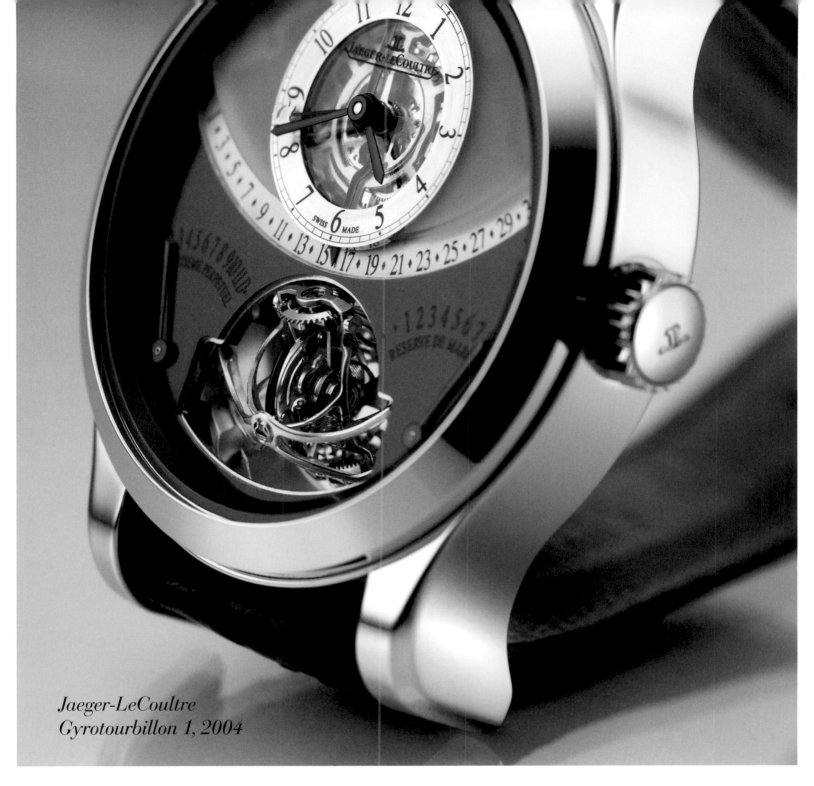

Jaeger-LeCoultre
Gyrotourbillon 1, 2004

Wer die Zeitgleichung am Handgelenk bei sich tragen möchte, kommt unter anderem bei der opulenten L.U.C „All in One" aus dem Hause Chopard zu seinem Recht. Das 2010 lancierte Kaliber L.U.C 05.01-L besteht aus insgesamt 516 Komponenten. Panerai stellte im gleichen Jahr das komplexe „L'Astronomo Luminor 1950 Equation of Time Tourbillon" vor. Weil sich auch die Zeiten des Sonnenauf- und -untergangs ablesen lassen, stimmen die Uhrmacher das Œuvre auf die individuellen Wünsche des Käufers ab. Schon 2002 sorgte der deutsche Uhrmacher Martin Braun mit seiner „Boreas" für Aufsehen. Neben der auf den jeweiligen Wohnort abgestimmten Anzeige des Sonnenauf- und -untergangs stellt ein Zeiger die Differenz zwischen der wahren und mittleren Sonnenzeit dar.

Gleich zwei Modelle mit marschierender Äquationsanzeige brachte das Jahr 2004: „Équation Marchante" von Blancpain und „Gyrotourbillon I" von Jaeger-LeCoultre. Letztere bietet überdies einen ewigen Kalender sowie ein dreidimensionales Tourbillon. 2005 lancierte Audemars Piguet die Jules Audemars „Équation du Temps". Neben der Äquation stellt sie ebenfalls die Zeiten des Sonnenauf- und -untergangs dar. Des Weiteren sind ein ewiges Kalendarium sowie eine astronomische Mondphasenanzeige mit von der Partie.

Als Arnold & Son die „True North" mit prall gefülltem Zifferblatt auf den Markt brachte, zeigten die Kalender das Jahr 2006. Neben zweiter Zonenzeit, ewigem Kalender, Mondalters- und Gangreserveanzeige bietet das uhrmacherisch komplexe Modell auch eine Darstellung der Zeitgleichung.

Seit 2009 gibt es in der „1966"-Familie von Girard-Perregaux ein Modell mit Jahreskalender und Indikation des Unterschieds zwischen wahrer und mittlerer Zeit durch einen Zeiger zwischen „4" und „5" des ansonsten schlicht gehaltenen Zifferblatts. Breguet widmete sich der Thematik 2017 beim Modell „Marine Équation Marchante 5887".

Diese Zusammenstellung versteht sich als Auswahl, denn auf der Suche nach Kaufanreizen nutzt die Uhrenindustrie traditionell das gesamte Potenzial an Zusatzfunktionen – darunter eben auch die Anzeige der Zeitgleichung, egal in welcher Ausprägung.

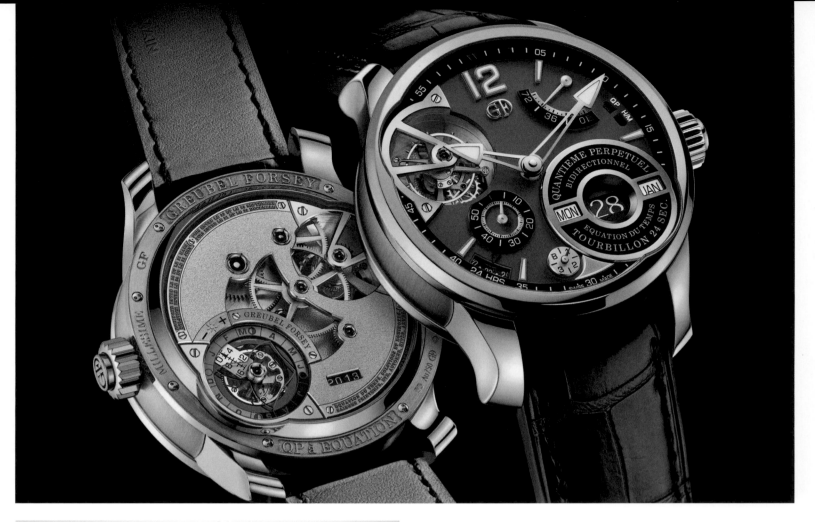

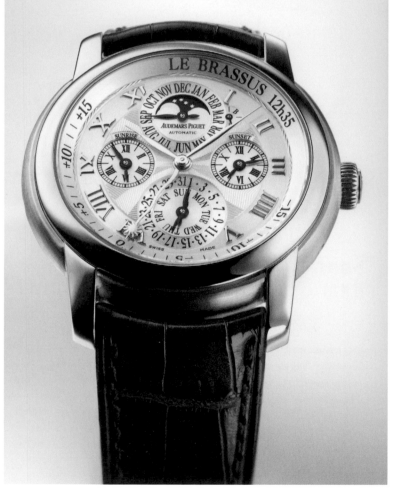

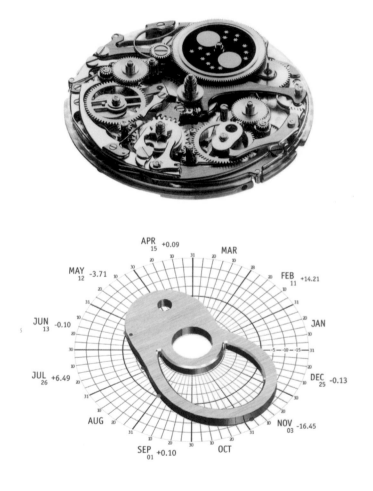

This page, from top: Greubel Forsey QP à Équation, Ref. 3967 ◦ Audemars Piguet Jules Audemars Équation du Temps: watch, under the dial and equation cam disk ◦ Diese Seite, von oben: Greubel Forsey QP à Équation, Ref. 3967 ◦ Audemars Piguet Jules Audemars Équation du Temps: Uhr, unter dem Zifferblatt und Äquationskurvenscheibe ◦ Right page: Girard-Perregaux 1966 Annual Calendar and Equation of Time ◦ Rechte Seite: Girard-Perregaux 1966 Jahreskalender und Zeitgleichung

Panerai Radiomir 1940
Equation of Time 8 Days Acciaio, 2015

Blancpain Équation du Temps Marchante,
Cal. 3863

Vacheron Constantin Les Cabinotiers Celestia
Astronomical Grand Complication 3600,
Ref. 9720C, 2017

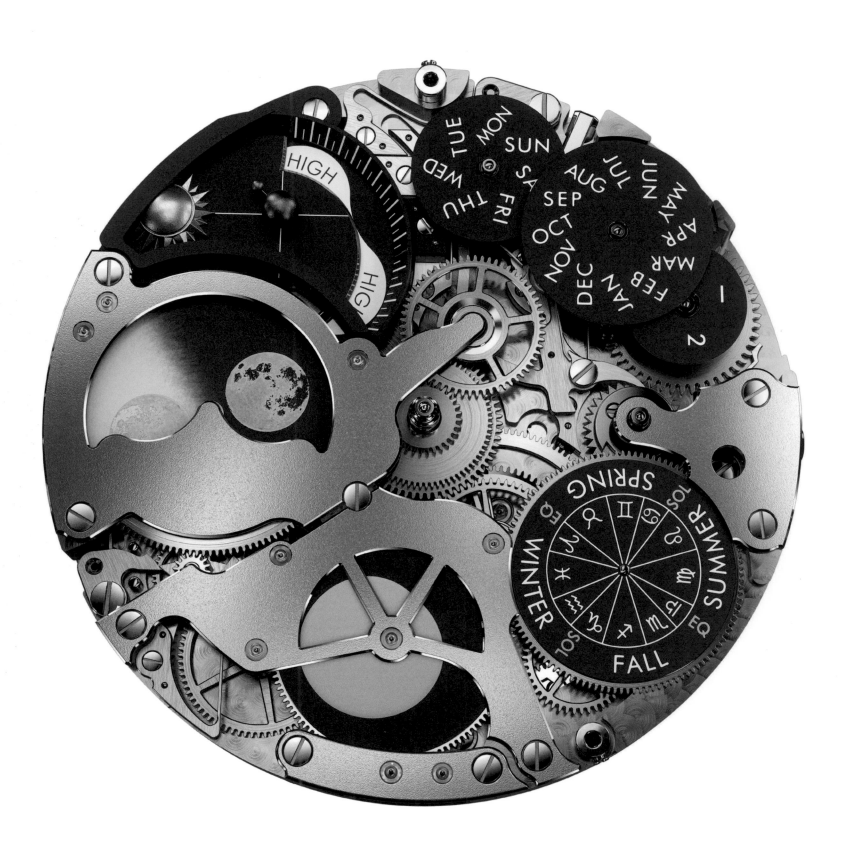

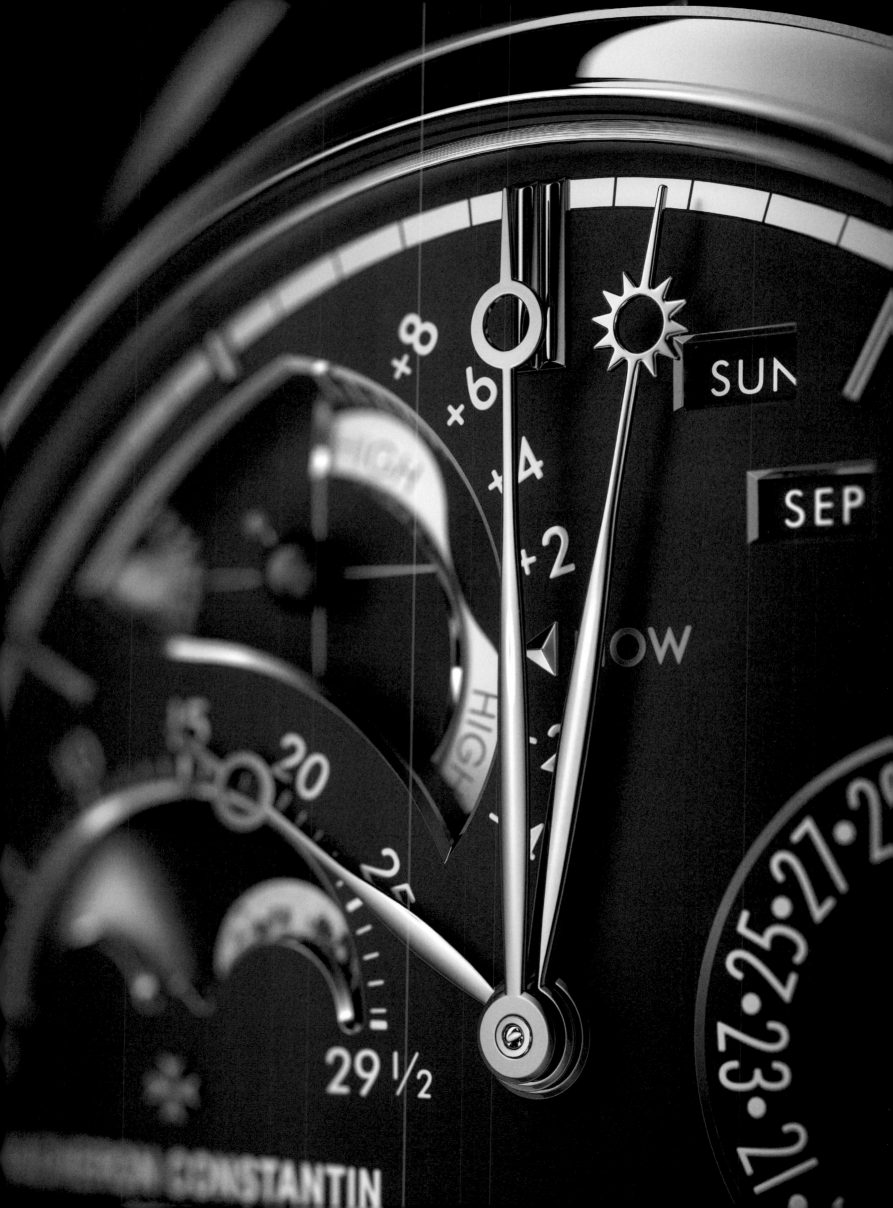

Automatic
Automatik

Previous pages ◦ *Vorherige Seiten: Patek Philippe Nautilus, Ref. 5711*
Top: *First Eterna-Matic, ball bearing, 1948* ◦ *Oben: Erste Eterna-Matic, Kugellager, 1948*
Bottom ◦ *Unten: Abraham-Louis Perrelet, self-winding pocket watch* ◦ *Taschenuhr mit Selbstaufzug, 1770*

Self-winding Watches

"The fashionable foolishness of wearing a watch on the most restless part of the body, i.e. in a bracelet, will hopefully disappear soon", thundered Hamburg Professor Hermann Bock in 1917.

As history teaches us, it did not. Quite the opposite: the dynamic motions of the forearm meant that the self-winding mechanism, which had been invented as early as 1770 for pocket watches, was finally able to begin its triumphant advance. Admittedly, several years would pass before self-winding watches gained widespread acceptance. But rotors and little gears to automatically tension the mainspring ultimately became the most important and longest-lasting additional function of mechanical wristwatches.

Flashback

Contrary to what is often assumed, the convenience of automatic winding was not the reason for its invention in the 18th century. Abraham-Louis Perrelet, born in Neuchâtel in 1729, is widely acknowledged as the mechanism's godfather. This man, who is said to

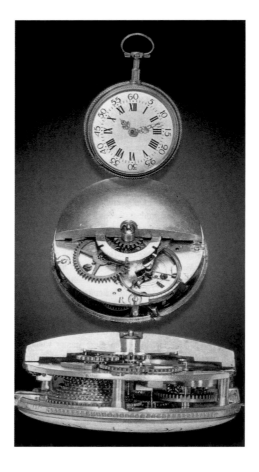

have taught himself the art of watchmaking after only 15 days of apprenticeship under an incompetent master, tackled the winding system of conventional pocket watches with verve and persistence. Previous attempts by others had failed. The problem was not in the inadequate technical functioning of the winding system, where there was basically little to criticize. Nor was it a matter of convenience. Fine gents—the only people who could afford pocket watches in those days—could let their servants wind their watches. The biggest stumbling block was the key. When it was needed, this little tool was all too often not ready at hand. In addition, the indispensable keyhole allowed dust and moisture to penetrate into the case and wreak havoc with the delicate movement. This, of course, decreased the reliability and lifespan of the precious timepieces.

Talented watchmakers set out to develop alternative winding methods that would eliminate the unloved key. The Parisian watchmaker Pierre-Augustin Caron (1732–1799) is credited with having devised the earliest solution. A rotatable annulus tensioned the mainspring of his little watch, which was integrated into

Selbst sei der Aufzug

„Die Modenarrheit, die Uhr an der unruhigsten Körperstelle, im Armbande, zu tragen, verschwindet hoffentlich bald wieder", wetterte der Hamburger Professor Hermann Bock im Jahr 1917. Wie die Geschichte lehrt, tat sie es bekanntlich nicht. Ganz im Gegenteil: Die Dynamik des Unterarms führte dazu, dass der bereits 1770 für Taschenuhren erfundene Selbstaufzug endlich seinen Siegeszug antreten konnte. Zwar zogen bis zur allgemeinen Akzeptanz der Automatik noch einige Jahre ins Land. Letzten Endes aber entwickelten sich Rotoren und kleine Getriebe zum selbsttätigen Spannen der Zugfeder zur bedeutendsten und nachhaltigsten Zusatzfunktion mechanischer Armbanduhren.

Rückblende

Anders als oft angenommen, ist die Bequemlichkeit des automatischen Aufzugs keineswegs der Grund für seine Erfindung im 18. Jahrhundert. Als geistiger Vater gilt der 1729 in Neuchâtel geborene Abraham-Louis Perrelet. Dieser Mann, dem man nachsagt, er habe sich nach nur 15-tägiger, fruchtloser Uhrmacherlehre bei einem schlechten Meister die Uhrmacherkunst selbst beigebracht, rückte mit Verve und Ausdauer dem Aufzugssystem herkömmlicher Taschenuhren zu Leibe. Hierbei handelte es sich nämlich um eine vielfach angeprangerte Schwachstelle. Das Problem lag nicht etwa in einer unzureichenden technischen Funktion des Aufzugs. Hier gab es grundsätzlich wenig auszusetzen. Auch drehte es sich nicht um das Thema Bequemlichkeit. Feine Herrschaften – nur solche konnten sich damals überhaupt eine eigene Taschenuhr leisten – konnten das regelmäßige Aufziehen ja ihren Dienern überlassen. Stein des Anstoßes waren vielmehr die Schlüssel. Wenn man sie brauchte, waren die kleinen Werkzeuge oft nicht zur Stelle. Außerdem gelangten Staub und Feuchtigkeit durch die nötigen Löcher in das empfindliche Uhrwerk. Und das wirkte sich nachteilig auf Zuverlässigkeit und Lebensdauer der kostbaren Zeitmesser aus.

Folglich lag das Augenmerk begabter Uhrmacher auf der Entwicklung von Aufzugsalternativen, die ohne die ungeliebten Schlüssel auskamen. Die wohl früheste Lösung stammte vom Pariser Uhrmacher Pierre-Augustin Caron (1732–1799). Bei seiner Ringuhr, welche sich unter anderem Madame Pompadour an den Finger steckte, die Geliebte von König Ludwig XV., bewerkstelligte ein Drehring das Spannen des Federspeichers. Nur zur Zeigerstellung bedurfte es weiterhin eines Schlüssels.

Pierre Jaquet-Droz (1721–1790) aus La Chaux-de-Fonds entwickelte als vermutlich erster Uhrmacher den sogenannten Pumpaufzug. Hier erfolgte die Energiegewinnung durch mehrmaliges Ziehen und Drücken des Bügelknopfs.

Im Gegensatz zu ihren eher konventionell denkenden Zeitgenossen setzten Perrelet und womöglich in Lüttich auch sein belgischer Kollege Hubert Sarton auf eher Verwegenes: Wie ein Perpetuum mobile sollte sich das Uhrwerk selbst die zum Ticken nötige Energie zuführen, und zwar ähnlich den Pedometern, also Geräten zum Zählen der Schritte, mithilfe eines wippenden Gewichts.

Die Kalender zeigten das Jahr 1770, als Perrelet seine völlig neuartige „Erschütterungsuhr" vorstellte. Während des Gehens wippte die am Werk befestigte Schwungmasse rhythmisch auf und ab.

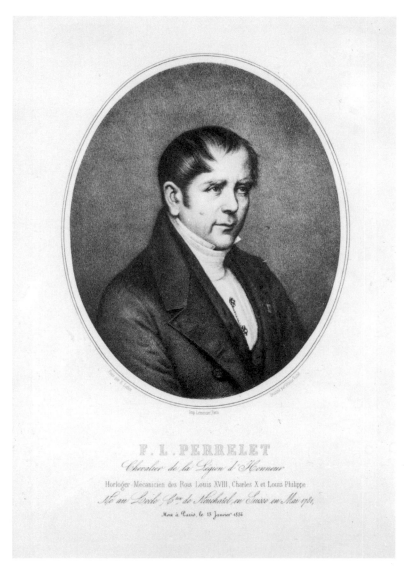

Abraham-Louis Perrelet

Movement of a pocket watch with pedometer winding and platinum oscillating weight, Charles Oudin, Paris, 1806
Werk einer Taschenuhr mit Pedometer-Aufzug und Platin-Schwungmasse, Charles Oudin, Paris, 1806

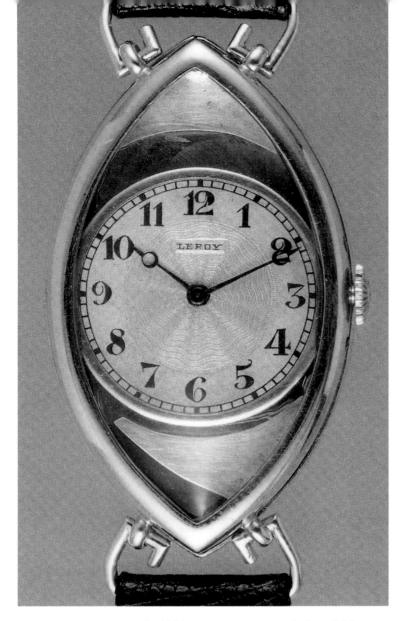

Leroy, automatic watch, 1922 ○ *Leroy, Automatikuhr, 1922*

a finger ring worn by King Louis XV's mistress Madame Pompadour. She still needed a key, but only to set the watch's hands.

Pierre Jaquet-Droz (1721–1790) from La Chaux-de-Fonds was probably the first watchmaker to develop the so-called "pump" winding mechanism. Repeatedly pulling and pushing a button on the bow provided it with power.

Unlike their more conventionally minded contemporaries, Perrelet and possibly also his Belgian colleague Hubert Sarton in Liège opted for a daring approach: like a perpetual motion machine, the movement supplied itself with the energy it needed to keep running. It accomplishes this with the aid of a rocking weight similar to those already in use in pedometers, i.e. devices for counting steps.

Perrelet unveiled his unprecedented "vibration watch" in 1770. An oscillating weight attached to its movement bounced rhythmically up and down whenever its wearer walked. A cleverly designed gear train converted the resulting kinetic energy into power stored in an elastic spring. In addition to this construction, Perrelet also invented one with a nearly silent rotor that could rotate unlimitedly above the movement. An alternator and reduction gear train enabled the rotor to tension the mainspring in both directions of motion. The gear train was connected to the barrel by a little chain—basically a miniaturized version of the chains that were commonly used to convey uniform driving force.

This first self-winding pocket watch seemed promising. Professor Horace-Bénédict de Saussure of the Société des Arts in Geneva reported in 1777 that a 15-minute walk had replenished his watch with enough power for fully eight days of autonomous ticking. The professor's praise seems exaggerated from today's perspective. Perrelet was eager to improve his first prototype. The reason is recounted in de Saussure's notebook *Voyage dans les Alpes*. A man kept this watch in his trouser pocket while he walked to the post office. When he returned from his errand, he discovered that his watch had suffered serious damage because Perrelet had neglected to include a safety mechanism to prevent the mainspring from becoming overwound. The self-proclaimed master watchmaker quickly and adroitly solved the problem. His improvement seemed to complete this chapter in the chronicle of self-winding watches.

Easier said than done

But only seemingly: as always, the pitfalls of the subject became apparent in the harsh world of everyday life. With the new "perpétuelles", these hazards resulted less from any shortcomings in Perrelet's craftsmanship than from the way pocket watches were worn and used. Distinguished gents usually kept their valuable timepieces safely inside the pocket of a jacket, vest or pair of trousers, or securely hanging from a belt, where the watch did not undergo sufficient motion to replenish its mainspring. Self-winding pocket watches accordingly never achieved lasting success. The equally ingenious watchmaker Abraham-Louis Breguet crafted much finer models, but these likewise failed to solve the problem. No better fate befell other watchmakers who turned their minds and hands to this important theme. Failures persisted into the 19th century. Louis Recordon, Jaquet-Droz père et fils, Jean Romilly, James Cox, Robert Robin, Charles Oudin, Jean-Antoine and Guillaume Godemar and others ultimately and grudgingly acknowledged the futility of their efforts. Sooner or later, pocket watches worn by owners whose daily regimens included the necessary amount of exercise inevitably showed severe signs of wear. The appeal of the self-winding pocket watch was further diminished by its typically big case, heavy weight and lavish price. To make matters worse, self-winding pocket watches were rendered even less appealing by the development of the modern crown-winding mechanism in 1838 and thereafter. Louis Audemars, Charles-Antoine LeCoultre and above all Jean-Adrien Philippe number among the pioneers in this discipline. Philippe optimized the crown-winding system, which has remained mostly unchanged to the present day: the crown not only serves to wind the mainspring, but can also be pulled outward to set the hands. After some twenty years of development, Philippe – who was also a partner of Antoine-Norbert de Patek – received patent protection for his ingenious crown-winding system on September 27, 1861. This not only solved the tedious key problem, but also temporarily eclipsed the self-winding mechanism.

From the pocket to the wrist

Analogous to their role in the history of the wristwatch, women likewise spearheaded the progress of the automatic wristwatch. The first model did not have an oscillating weight, but a kind of

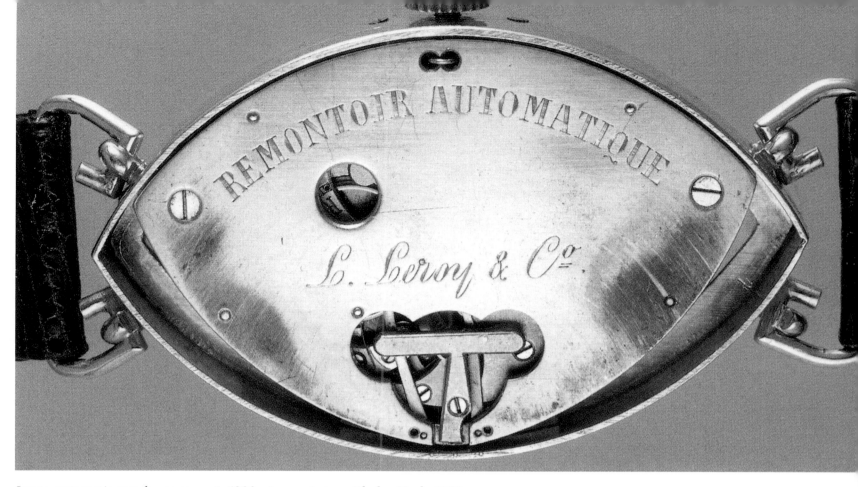

Leroy, automatic watch, movement, 1922 ◦ *Leroy, Automatikuhr, Werk, 1922*

Ein intelligentes Getriebe wandelte die so gewonnene kinetische Energie in Federkraft um. Neben dieser Konstruktion präsentierte Perrelet eine weitere mit unbegrenzt und nahezu lautlos über dem Werk drehendem Rotor. Dieser spannte die Zugfeder mithilfe eines Wechsel- und Reduktionsgetriebes in beide Bewegungsrichtungen. Getriebe und Federhaus verband die damals zur Erzeugung gleichförmiger Antriebskraft allgemein übliche Kette.

Diese erste Automatiktaschenuhr schien zu überzeugen. Professor Horace-Bénédict de Saussure von der Genfer „Société des Arts" berichtete 1777, dass ein 15-minütiger Spaziergang stattliche acht Tage Gangautonomie hervorgerufen habe. Aus heutiger Sicht erscheint die Lobpreisung reichlich übertrieben. Auf jeden Fall musste Perrelet sein erstes Exemplar rasch nachbessern. Der Grund findet sich in de Saussures Notizbuch *Voyage dans les Alpes*: Auf dem Weg zur Post führte ein Mann diese Uhr in der Hosentasche mit sich. Nach der Rückkehr wies sie ernsthafte Beschädigungen auf, weil Perrelet nicht an eine Sperre gegen das Überspannen der Zugfeder gedacht hatte. Zügig und geistreich löste der selbst ernannte Meister das Problem. Und damit wäre das Kapitel über die Geschichte des Selbstaufzugs eigentlich abgeschlossen.

Leichter gesagt als getan

Aber eben nur eigentlich. Wie immer zeigten sich auch hier die Tücken des Objekts erst im rauen Alltag. Bei den neuartigen „Perpétuelles" resultierten sie allerdings weniger aus etwa unzulänglicher Arbeit Perrelets als aus dem naturgemäßen Umgang mit Taschenuhren. Distinguierte Herren pflegten ihren wertvollen Zeitmesser sicher in der Jacke, Weste, Hose oder im Gürtel zu verstauen. Dort fehlte es den Uhren allerdings an der unverzichtbaren Bewegung. Von nachhaltigem Erfolg automatisch

aufziehender Taschenuhren kann also keine Rede sein. Selbst die deutlich feineren Modelle des ebenfalls genialen Uhrmachers Abraham-Louis Breguet schafften keine Abhilfe. Nicht besser erging es weiteren Uhrmachern, die sich – manche von ihnen erst im 19. Jahrhundert – der durchaus wichtigen Thematik annahmen. Am Ende mussten Louis Recordon, Vater und Sohn Jaquet-Droz, Jean Romilly, James Cox, Robert Robin, Charles Oudin, Jean-Antoine und Guillaume Godemar und andere zähneknirschend das Scheitern ihrer Bemühungen konstatieren. Wurden ihre Produkte regelmäßig mit dem nötigen Quantum an Bewegung genutzt, so stellten sich über kurz oder lang heftige Verschleißerscheinungen ein. Obendrein schmälerten voluminöse Gehäuse, stattliches Gewicht und ein üppiger Kaufpreis die Lust an der Selbstaufzugstaschenuhr. Zu allem Überfluss kam der Automatik ab 1838 auch noch der moderne Kronenaufzug in die Quere. Hier zählten zu den Pionieren Louis Audemars, Charles-Antoine LeCoultre und vor allem Jean-Adrien Philippe. Ihm ist das optimale und bis in die Gegenwart weitgehend unveränderte System zu verdanken, welches auch die Zeigerstellung per gezogener Krone ermöglicht. Nach rund zwanzigjähriger Entwicklungsarbeit erhielt Philippe, übrigens Partner von Antoine-Norbert de Patek, am 27.9.1861 patentrechtlichen Schutz für seinen genialen Kronenaufzug. Dieser löste nicht nur das leidige Schlüsselproblem, sondern bescherte auch dem Selbstaufzug ein vorübergehendes Aus.

Aus der Tasche ans Handgelenk

Analog zum Verlauf der Geschichte der Armbanduhr hatten Frauen auch bei der Automatikarmbanduhr die Nase vorn. Allerdings besaß das erste Modell keine Schwungmasse, sondern eine Art „Pumpaufzug". Im Bewusstsein, dass Frauen ihre Armbanduhr zum Händewaschen und während der Nacht ablegten, hatte sich der Erfinder einen Hebelmechanismus patentieren lassen. Dieser

Harwood watch, 1926 ◦ John Harwood

"pump" winding mechanism. Its inventor knew that women took off their wristwatches to wash their hands and before going to bed in the evening, so he devised a patented lever mechanism that tensioned the mainspring whenever the hinge of the rigid bracelet was opened or closed. Unfortunately, this construction never achieved long-term success.

Léon Leroy later harnessed the kinetic energy of the restless wrist. The scion of a famous Parisian watchmaking dynasty, he and his brother Louis co-founded the Leroy & Fils company in 1914. They made and delivered seven different automatic wristwatches with gold pendulum oscillating weights to seven customers between 1922 and 1929. Each movement was engraved with the names of its buyer and maker, the year of its manufacture and its serial number. In the event that these self-winding timepieces with pointed oval cases were left unworn for a lengthier interval, each watch was delivered with a key to wind the mainspring and set the hands.

The first serially manufactured self-winding wristwatch

John Harwood was one of the innovators who chafed against the traditionally conservative structures of the watchmaking industry in the Roaring Twenties. Several years came and went before Harwood was able to convince a manufacturer to produce his invention. The story began in the first months of 1922, when the English watchmaker was assiduously repairing all sorts of timepieces in his little workshop on the Isle of Man. Like many of his colleagues, he complained about the cases. Harwood wrote in his memoirs: "I saw the freshly cleaned movement on its owner's wrist as it continued its journey through life; I wondered how it was wound. In my mind's eye, I saw it stop running, or how various types of dust crept in through the opening for the winding shaft, because at that time there were no waterproof cases."

To solve this conundrum, Harwood envisioned a watch without

a winding stem. But its elimination required fundamental modifications in the winding and hand-setting system. "It was necessary to devise a way to wind the mainspring without deliberate human intervention." With these ideas in mind, Harwood created his first self-winding wristwatch by augmenting an ordinary 13-ligne Swiss movement with a weight that was attached to the side of the movement and free to swing back and forth. Harwood viewed this construction as cumbersome, so he continued to experiment. His next attempt was a prototype with a 10½-ligne movement and a weight attached to the movement's center. Manual winding was no longer possible and the bezel could be rotated to set the hands, thus solving the problem posed by the crown and the hole for its staff.

In Harwood's second and significantly optimized prototype, the movement was only about 20 mm thick and the case approximately 25 mm tall. After patenting this model in England, Germany, Switzerland and the USA, Harwood embarked on a journey in 1924. Especially in Switzerland, he saw opportunities for high-quality serial production. Although many companies agreed to meet with him and hear his ideas, real interest was shown only by the Adolph Schild SA ébauche factory in Grenchen and the adjacent Fortis watch factory. After long and tough negotiations, the Harwood Selfwinding Watch Co. was founded, but numerous technical problems remained to be overcome before serial production could begin. Industrial manufacturing of ébauches for Caliber 648 finally started in 1929. Produced by Fortis and (for the French market) by Blancpain, the "Harwood" was hailed as a sensational innovation by the press and experts. But despite all efforts, its complex construction still had several Achilles' heels: e.g. numerous screws, some of which tended to come loose and bring the movement to a standstill; a short-lived power reserve of only about 12 hours; and the lack of a manual winding mechanism. The global economic crisis that ensued after the stock market crashed in New York finally ended the biography of the first serially manufactured self-winding wristwatch in 1931.

spannte die Zugfeder beim Öffnen und Schließen des starren Spangenbands. Erfolgreich war diese Konstruktion auf lange Sicht nicht. Später nutzte Léon Leroy die kinetische Energie des viel bewegten Handgelenks. 1914 hatte der Spross einer berühmten Pariser Uhrmacherdynastie zusammen mit seinem Bruder Louis die Firma Leroy & Fils ins Leben gerufen. Zwischen 1922 und 1929 fertigte sie für sieben Kundinnen ebenso viele verschiedene Automatikarmbanduhren mit goldener Pendelschwungmasse. Alle Werke waren mit dem Namen der Käuferin und dem des Produzenten, dem Herstellungsjahr sowie der Seriennummer graviert. Für den Fall, dass die Zeitmesser mit spitzovalem Gehäuse länger ruhten, gab es einen Schlüssel zum Spannen der Zugfeder, Richten der Zeiger.

Die erste Serienarmbanduhr mit automatischem Aufzug

Einer, der die traditionsgemäß konservativen Strukturen des Uhrengewerbes in den Roaring Twenties zu spüren bekam, war John Harwood. Einige Jahre mussten verstreichen, bis er einen Produzenten für seine Erfindung begeistern konnte. Die Geschichte beginnt in den ersten Monaten des Jahres 1922. In seiner kleinen Werkstatt auf der Isle of Man reparierte der englische Uhrmacher Zeitmesser aller Art. Wie viele seiner Kollegen bemängelte auch er die Gehäuse. „Ich sah", formulierte Harwood in seinen Erinnerungen, „das frisch gereinigte Werk am Arm seines Besitzers, wie es seine Reise durchs Leben fortsetzte; ich fragte mich, wie es wohl aufgezogen wurde. Im Geiste sah ich, wie es stillstand oder wie sich die verschiedensten Stäubchen durch die Öffnung der Aufzugswelle einschlichen; zu jener Zeit gab es nämlich noch keine wasserdichten Schalen."

Der Ausweg war eine Armbanduhr ohne Aufzugswelle. Deren Eliminierung bedingte allerdings ein grundlegend modifiziertes Aufzugs- und Zeigerstellsystem. „Es galt, die Triebfeder ohne ein bewusstes Eingreifen des Menschen aufzuziehen." Auf der Grundlage dieser Gedanken und mit einem normalen, 13-linigen Schweizer Uhrwerk als Basis entstand eine erste Automatikarmbanduhr mit

seitlich am Werk befestigter Pendelschwungmasse. Wegen der unförmigen Konstruktion experimentierte Harwood weiter. Es folgte ein Prototyp mit 10½-linigem Uhrwerk und mittig darauf befestigtem Element. Auf die Möglichkeit des manuellen Aufzugs wurde verzichtet; zum Zeigerstellen diente der Glasrand. Damit galt das Problem Krone grundsätzlich als gelöst.

Beim zweiten, deutlich optimierten Prototyp maß das Basiswerk nur noch knapp 20, die zugehörige Schale circa 25 Millimeter. Damit ging Harwood nach der Patentierung in England, Deutschland, der Schweiz und den USA im Jahr 1924 auf Reisen. Speziell in der Schweiz sah er Möglichkeiten einer qualitativ hochwertigen Serienproduktion. Obwohl ihm viele Firmen Audienz gewährten, bekundeten nur die Rohwerkefabrik Adolph Schild SA in Grenchen sowie die gleich daneben ansässige Uhrenfabrik Fortis wirkliches Interesse. Nach langen und zähen Verhandlungen entstand die Harwood Selfwinding Watch Co. Bis zur Serienreife galt es aber noch viele technische Probleme zu überwinden. 1929 startete die Produktion der Rohwerke vom Kaliber 648. Presse und Fachleute feierten die von Fortis und – für den französischen Markt – von Blancpain hergestellte „Harwood" zwar als echte Sensation. Aber ungeachtet aller Bemühungen hafteten der aufwendigen Konstruktion weiterhin etliche Mängel an: viele Schrauben, von denen sich manche lösten und das Werk zum Stillstand brachten; geringe Gangautonomie von nur etwa 12 Stunden; das Fehlen eines Handaufzugs. Mit der vom New Yorker Börsenkrach ausgelösten Weltwirtschaftskrise endete 1931 die Biographie der ersten Serienarmbanduhr mit automatischem Aufzug.

Gekrönte Automatik

„Vielleicht hat nichts, vielleicht aber auch alles auf dieser Welt ewigen Bestand." Mit diesen Worten beginnt das letzte der vier Hefte des *Rolex Vademecums*. Zu lesen ist darin auch die provokativ gemeinte Frage, „ob dieser durch Erschütterung erzeugte Aufzug vorteilhaft und lebensfähig war." 1945, im Jahr der Publikation, waren Rüttelaufzüge so gut wie tot und Pendelschwungmassen nur noch Auslaufmodelle. Die Zukunft gehörte dem Rotor. Diese

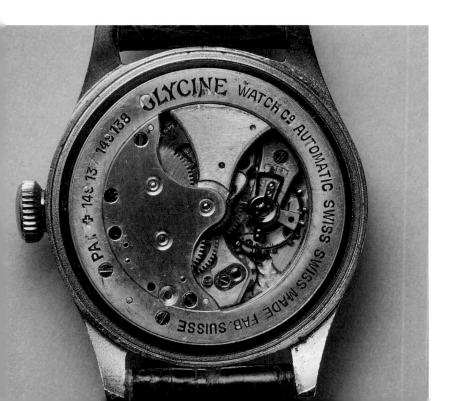

Left: Eugène Meylan SA (EMSA) Glycine, automatic hammer winding, 1931 ○ *Links: Eugène Meylan SA (EMSA) Glycine, Hammerautomatik, 1931* ○
Top: Rolls Baguette, automatic women's watch, 1930/1933 ○
Oben: Rolls Baguette, automatische Damenuhr, 1930/1933

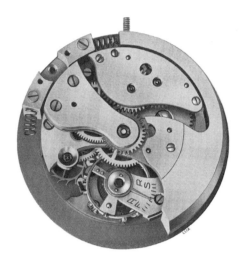

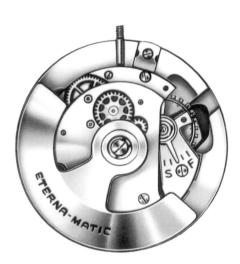

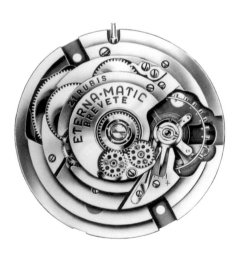

Top ◦ Oben: Cal. AS 1173,
successful hammer winding ◦ erfolgreiche
Hammerautomatik, 1941
Mid ◦ Mitte: first ◦ erste Eterna-Matic,
Cal. 1199, 1948 ◦ Bottom ◦ Unten:
Eterna-Matic without rotor ◦ ohne Rotor

Crowned automatic

"Nothing, or perhaps everything, in this world is eternal." Thus begins the last of the four volumes of the *Rolex Vademecum*. The same volume provocatively asks "whether vibration-generated self-winding was truly advantageous and viable." When the book was published in 1945, vibration-dependent winding mechanisms were as good as dead and weights that rocked back and forth were little more than outmoded dinosaurs. The future belonged to the rotor. Rolex's founder Hans Wilsdorf and his comrade-in-arms Emil Borer, who later became Rolex's technical director, shared this opinion as early as 1930. In the first volume of the *Vademecum*, Wilsdorf recalls: "The logical consequence of the Rolex Oyster was the creation of an automatic watch with a movement that automatically winds itself to guarantee uninterrupted running. This problem, which perennially occupied the minds of the best watchmakers in every era, was finally solved in 1931, when Rolex created the 'Perpetual' with its famous rotor. The waterproof case was an important prerequisite for this invention because a self-winding movement can only function unrestrainedly and with the desired regularity when it is enclosed inside a completely hermetically sealed case." Conversely, a hermetically sealed case with a screwed crown almost inevitably demanded a movement that did not need daily manual winding.

The technician Emil Borer set to work in Bienne in the late 1920s. His design was based on Perrelet's rotor technology. The completion of the "Rolex Perpetual" made headlines in 1931. In order to work as efficiently as possible, the oscillating weight conveyed energy to the barrel of 7.52-mm-tall modular Caliber NA 620 in only one direction of the weight's motion. Nevertheless, six hours of wearing the watch sufficed to fill its barrel with enough energy for 35 hours of continuous running.

The brand with a crown as its logo immediately applied for patent protection on almost all aspects of self-winding. Rolex accordingly enjoyed a virtual monopoly on the modern rotor self-winding system until 1948.

Only the Felsa ébauche manufacturer found a way to circumvent Rolex's nearly airtight patent protection. Caliber 692 "Bidynator," which debuted with a height of 5.8mm in 1942, included a rotor that achieved the unprecedented feat of conveying energy to the barrel in both directions of rotation.

In addition to Rolex and Felsa, the traditional watch manufacturer Eterna and its former sister movement-manufacturer ETA likewise ranked among the pioneers of automatic winding. The 5.35-mm-tall Eterna-Matic earned very favorable critiques from the press and buyers in 1949, i.e. one year after its debut. There were many good reasons for their praise. For the first time ever, the patented automatic movement was equipped with a robust ball-borne rotor that wound in both directions of rotation. Each of the five tiny steel ball bearings was a mere 0.65mm in diameter. A thousand of them weighed less than one gram. Just how forward-looking this design was is clearly evident in the fact that the currently most successful Swiss automatic calibers ETA 2824 and ETA 2892 and their clones (e.g. the Sellita SW200 and SW300) are descended from the Eterna-Matic, which was launched in 1948.

The path to global success

Trust must be earned. And this also holds true for automatic wristwatches, which cost about twice as much as comparable hand-wound models around 1940. The price alone acted as a deterrent. Would-be buyers also doubted whether the additional mechanism could reliably serve its purpose. Consequently, the industry was faced with the proverbial squaring of the circle: low prices required mass production, which in turn required a large clientele.

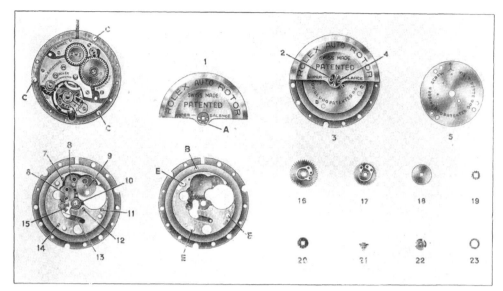

Exchange
parts for
selfwinding
8 ³/₄ ''' and
9 ³/₄ '''

Left ○ Links: Rolex, auto-rotor movement ○ Auto-Rotor-Werk ○ Right ○ Rechts: Rolex Oyster Perpetual, 1931

Auffassung hatten Rolex-Gründer Hans Wilsdorf und sein Mitstreiter Emil Borer, später Technischer Direktor von Rolex, schon 1930 geteilt. Im ersten Band des Vademecums erinnert sich Wilsdorf: „Die logische Folge der Rolex-Oyster war die Schaffung der automatischen Uhr, deren Werk sich selbsttätig immer wieder von neuem aufzieht und einen ununterbrochenen Gang gewährleistet. Dieses Problem beschäftigte schon die führenden Uhrmacher aller Zeiten. Mit der Schaffung der ‚Perpetual‘ samt ihrem berühmt gewordenen Rotor wurde es im Jahre 1931 durch Rolex endgültig gelöst. Eine wichtige Voraussetzung für diese Erfindung bildete die wasserdichte Uhr, denn nur in einem vollkommen hermetisch verschlossenen Gehäuse kann die automatische Uhr ungehindert und mit der gewünschten Regelmäßigkeit funktionieren."

Im Umkehrschluss bedingte die hermetisch verschlossene Schraubkronenschale beinahe zwangsläufig ein Uhrwerk, das man nicht täglich manuell aufziehen musste.

Irgendwann gegen Ende der 1920er-Jahre hatte sich der Techniker Emil Borer in Biel an die Arbeit gemacht. Seine Konstruktion basierte auf der Perrelet'schen Rotor-Technologie. Die Vollendung der „Rolex Perpetual" im Jahr 1931 sorgte schließlich für Schlagzeilen. Um möglichst effizient zu arbeiten, befüllte die Schwungmasse den Energiespeicher des 7,52 Millimeter hohen, modular aufgebauten Kalibers NA 620 in nur einer Bewegungsrichtung. Trotzdem bewirkte sechsstündiges Tragen beruhigende 35 Stunden Gangautonomie.

Der von der Marke mit dem Kronenlogo sofort beantragte Patentschutz deckte nahezu alle Facetten des Selbstaufzugs ab und sicherte der Manufaktur bis 1948 ein Quasi-Monopol für die moderne Rotor-Automatik.

Nur der Rohwerkefabrikant Felsa konnte die Rechte des Hauses Rolex umgehen. Beim 1942 vorgestellten Kaliber 692 „Bidynator" mit 5,8 Millimetern Bauhöhe agierte der Rotor erstmals in beide Drehrichtungen aktiv.

Neben Rolex und Felsa gehörten schließlich auch die traditionsreiche Uhrenmanufaktur Eterna und ihre damalige Werkeschwester ETA zu den anerkannten Automatik-Pionieren. 1949, im Jahr nach ihrer Vorstellung, erhielt die 5,35 Millimeter hohe Eterna-Matic aus guten Gründen ein ausgesprochen positives Presse- und auch Käuferecho. Erstmals in der Geschichte verfügte das patentierte Automatikwerk über einen robusten, in beide Drehrichtungen aufziehenden Kugellagerrotor. Jede der fünf winzigen Stahlkugeln besaß einen Durchmesser von 0,65 Millimeter. Tausend davon wogen weniger als ein Gramm. Wie zukunftsweisend diese Konstruktion war, lässt sich am besten daran ablesen, dass die gegenwärtig erfolgreichsten Schweizer Automatikkaliber ETA 2824 und ETA 2892 sowie deren Klone, zum Beispiel Sellita SW200 und SW300, von der 1948 lancierten Eterna-Matic abstammen.

Der Weg zum Welterfolg

Vertrauen muss man sich erarbeiten – das gilt auch für Automatikarmbanduhren. Verglichen mit gleichwertigen Handaufzugsmodellen kosteten sie um 1940 etwa das Doppelte. Allein das entfaltete schon eine abschreckende Wirkung. Hinzu kamen Bedenken, ob die zusätzliche Mechanik ihren Zweck erfüllen würde. Folglich stand die Industrie vor der sprichwörtlichen Quadratur des Kreises: Für niedrige Preise brauchte es eine Massenfertigung; die wiederum verlangte nach einem großen Kundenkreis.

Zum Ausweg in der Not wurde eine Art Tankuhr am Zifferblatt. Gemeint ist die Gangreserveanzeige zur Verifizierung des kontinuierlichen Energienachschubs. Ende der 1940er-Jahre kamen unterschiedlichste Systeme auf den Markt, die tatsächlich ihren Zweck erfüllten. Spürbare Fortschritte in Sachen Zuverlässigkeit und Präzision taten ein Übriges. Roskopf-Modelle mit Stiftankerhemmung sprachen breitere Bevölkerungsschichten an. Von nun an stand dem Siegeszug der Armbanduhr mit automatischem Aufzug nichts mehr im Wege.

Flacher dank Mikro

Allerdings begannen sich die Geister in den frühen 1950er-Jahren abermals zu scheiden. Immer mehr Kunden verlangten nach eleganteren und damit flacheren Automatikarmbanduhren. Und auf diesem Gebiet war guter Rat teuer. Überlieferte Konstruktionen waren in der Regel etwa 5,5 Millimeter hoch. Schuld daran trugen der Zentralrotor, das Automatikgetriebe sowie die zentrale Lagerung von Stunden-, Minuten- und Sekundenzeiger. Weniger Bauhöhe verlangte nach einer unkonventionellen, aus technischer

Part of the solution was a kind of fuel gauge, i.e. a power-reserve display to indicate the current status of the energy reservoir. A wide variety of systems that genuinely fulfilled their purpose came onto the market in the late 1940s. Significant advances in reliability and precision likewise contributed their fair share. Roskopf models with pin-pallet escapements appealed to a broader section of the population. From this moment on, nothing more stood in the way of the triumphant progress of the self-winding wristwatch.

Slimmer thanks to a microrotor

Opinions again began to differ in the early 1950s. Increasingly many customers wanted more elegant and thus slimmer automatic watches. This posed a new challenge for watchmakers. Traditional designs were usually about 5.5 mm tall. The high-rising culprits were the central rotor, the gear train for the self-winding mechanism, and the central bearing of the hour, minute and second hands. Lower overall height required an unconventional and—from a technical viewpoint—apparently absurd solution. The Buren Watch Company unveiled one such solution in June 1954. It was followed three years later by the first wristwatches encasing patented Caliber 1000, whose 4.2-mm-slim self-winding movement featured the remarkable innovation of a small rotor that was integrated, along with its associated winding mechanism, into the plane of the movement. The instantaneous success of the "Super Slender" attracted skeptics who doubted the efficiency of the novel microrotor. Eleven months later, Universal Genève applied for patent protection for a similar watch called the "Polerouter." The ensuing patent dispute was ended by a gentlemen's agreement. Piaget's Caliber 12P debuted in 1960. A mere 2.3 mm slim, it was enthroned in the Guinness Book of Records, where it reigned until 1978. Buren and Universal collected licensing fees for allowing Piaget to use the microrotor.

After the patents expired in 1972, other companies followed suit and developed microrotor calibers. The most prominent is Patek Philippe's 2.4-mm-slim Caliber 240, which is still manufactured today. This design is also used in Chopard's L.U.C 96.01-L and in Bulgari's 2.23-mm-slender BVL 138, which currently holds the record as the slimmest microrotor caliber. The Glashütte-based manufactories A. Lange & Söhne and Glashütte Original rely on a larger "three-quarter rotor."

Turning around the movement

Patek Philippe pursued an equally unusual path toward slimmer movements. This innovation was patented in 1964 and 1968. Inventive technicians relocated the ball-borne rotor to the periphery of the movement and exiled the hand-setting crown to the back of the case for self-winding Calibers 350 and 1-350, which were first manufactured in 1969. In the improved version (Caliber I-350), the manufactory eliminated several features, including the complex switching mechanism to polarize the rotor's motions.

Carl F. Bucherer adopted this principle in automatic Caliber CFB A1000, which was developed from 2005 onwards. Bucherer was aware that many aspects needed to be viewed from different vantage points, rethought and intelligently designed. Key differences to its predecessors were more efficient shock protection for the rotor and rollers with maintenance-free (ceramic) ball bearings. A peripheral rotating weight helped Piaget set another world record in 2018: the "Altiplano Ultimate Automatic" wristwatch, which encases ultra-slim Calibre 910P, is a mere 4.3 mm tall.

And the central rotor?

Ultra-slim calibers with rotors affixed to the center of the movement are, of course, also available. With an overall height of just 2.08 mm, Calibre 2000 was launched by Geneva-based Bouchet-Lassale SA in 1978 and holds the record in this discipline. Several attempts to improve it failed to make it genuinely suitable for everyday use, so it has long since disappeared from the market. A lengthier lifespan distinguishes 2.45-mm-slim Caliber 2120, which LeCoultre developed for Audemars Piguet and Vacheron Constantin in 1967. Its centrally positioned oscillating weight rotates audibly atop four peripherally positioned ruby rollers and includes a 21-karat gold segment. This slender caliber was joined in 1970 by Caliber 2121, a similarly low-rise movement with a jumping date display. After thorough reworking, this ultra-thin movement still ticks inside Audemars Piguet's "Royal Oak" and elsewhere.

The agony of choice

Looking back on decades of progress, one can see that the watch industry has produced an immensely broad and diverse spectrum of automatic calibers. The self-winding mechanism deserves to be regarded as the most successful additional function of mechanical wristwatches.

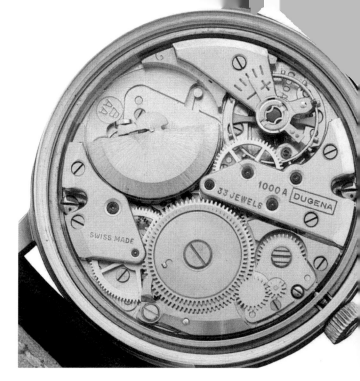

Left page ○ Linke Seite: Piaget Cal. 12P, the world's slimmest automatic movement at the time, equipped with microrotor ○ seinerzeit das flachste Automatikwerk der Welt, ausgestattet mit Mikrorotor, 1960
This page, from left ○ Diese Seite, von links: Dugena Super Automatic Super-Slender, c. 1960 ○ Dugena Super Automatic Super-Slender with microrotor and Buren 1000A caliber ○ mit Mikrorotor und Buren 1000A Kaliber

Sicht sogar widersinnigen Lösung. Eine solche stellte die Buren Watch Company im Juni 1954 vor. Drei Jahre später folgten die ersten Armbanduhren mit dem patentierten Kaliber 1000. Ihr 4,2 Millimeter flaches Automatikwerk verblüffte durch einen kleinen, in die Werksebene integrierten Rotor samt zugehörigem Aufzugsmechanismus. Die spontan erfolgreiche „Super Slender" rief unverzüglich Kritiker auf den Plan, welche die Effizienz des neuartigen Mikrorotors bezweifelten. Elf Monate später beantragte auch Universal Genève patentrechtlichen Schutz für eine ähnliche Uhr namens „Polerouter". Den anschließenden Patentstreit beendete ein Gentlemen's Agreement. 1960 betrat das Kaliber 12P von Piaget die Bühne. Mit lediglich 2,3 Millimetern präsentierte es sich auch im Guinness-Buch als echter Rekord, der bis 1978 hielt. Für die Nutzung des Mikrorotors kassierten Buren und Universal Lizenzgebühren.

Nach dem Auslaufen der Patente im Jahr 1972 warteten auch andere Firmen mit MikrororotorKalibern auf. Prominentester und bis heute hergestellter Repräsentant ist das 2,4 Millimeter hohe Kaliber 240 von Patek Philippe. Diese Bauart ist auch dem L.U.C 96.01-L von Chopard zu eigen sowie dem 2,23 Millimeter flachen BVL 138, der aktuelle Superlativ bei Mikrorotor-Kalibern aus dem Hause Bulgari. Auf einen größeren „Dreiviertelrotor" setzen die Glashütter Manufakturen A. Lange & Söhne und Glashütte Original.

Ums Werk gedreht

Einen ebenfalls ungewöhnlichen, 1964 und 1968 patentierten Weg zu flacheren Werken beschritt Patek Philippe. Unter den Kaliberbezeichnungen 350 und 1-350 entstanden ab 1969 Automatikwerke, bei denen findige Techniker das Rotor(kugel)lager an den Rand verlegt hatten und die Zeigerstellkrone auf die Gehäuserückseite. Beim verbesserten Kaliber I-350 verzichtete die Manufaktur unter anderem auf die komplexe Umschaltvorrichtung zur Polarisierung der Rotorbewegungen.

Dieses Prinzip griff Carl F. Bucherer bei dem ab 2005 entwickelten Automatikkaliber CFB A1000 auf. Und zwar im Bewusstsein, dass vieles aus anderen Blickwinkeln betrachtet, neu durchdacht und intelligent konstruiert werden musste. Ein wesentlicher Unterschied zu den Vorläufern bestand in einer effizienten Rotor-Stoßsicherung und Rollen mit wartungsfreien (Keramik-)Kugellagern. 2018 verhalf eine peripher drehende Schwungmasse der Manufaktur Piaget zu einem abermaligen Weltrekord. Samt Gehäuse trägt die „Altiplano Ultimate Automatic" mit dem Kaliber 910P am Handgelenk gerade einmal 4,3 Millimeter auf.

Und der Zentralrotor?

Ultraflaches mit mittig am Uhrwerk befestigtem Rotor gibt es natürlich auch. Unangefochtener Rekordhalter mit 2,08 Millimetern ist in diesem Bereich das 1978 vorgestellte Kaliber 2000 der Genfer Bouchet-Lassale SA Mangels Alltagstauglichkeit ist es allerdings trotz verschiedener Nachbesserungsversuche längst vom Markt verschwunden. Ganz im Gegensatz zum Kaliber 2120, das LeCoultre 1967 für Audemars Piguet und Vacheron Constantin entwickelt hatte. Seine zentral angeordnete und gelagerte Schwungmasse mit 21-karätigem Goldsegment dreht vernehmlich auf vier peripher angeordneten Rubinrollen. Zum 2,45 Millimeter flachen Werk gesellte sich 1970 die Version 2121 mit springender Datumsanzeige. Nach gründlicher Überarbeitung verrichtet dieses ultraflache Uhrwerk beispielsweise in der „Royal Oak" von Audemars Piguet weiterhin seinen Dienst.

Qual der Wahl

Blickt man heute zurück, so hat die Uhrenindustrie im Laufe der Jahrzehnte ein nahezu unüberschaubares Spektrum höchst unterschiedlicher Automatikkaliber hervorgebracht. Der Selbstaufzug kann wohl mit Fug und Recht als erfolgreichste „Zusatzfunktion" mechanischer Armbanduhren gelten.

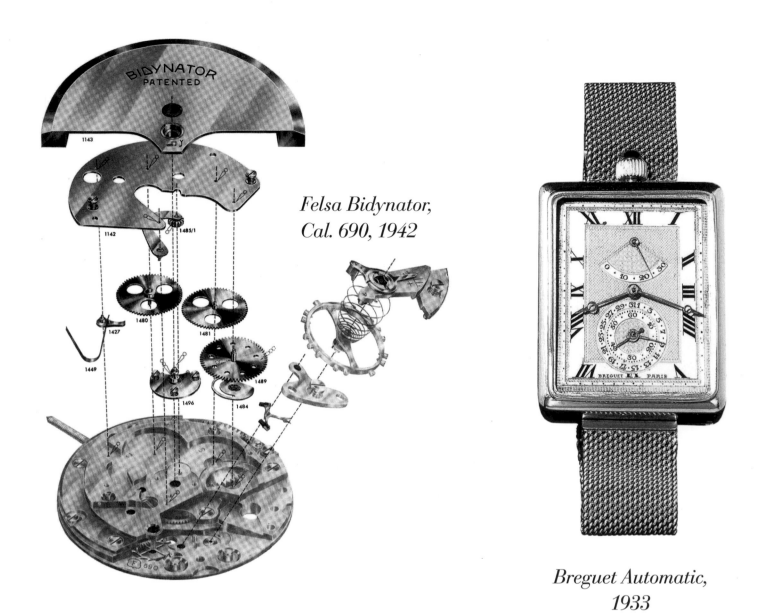

Felsa Bidynator, Cal. 690, 1942

Breguet Automatic, 1933

Oris Automatic, Cal. 605, 1952/1953

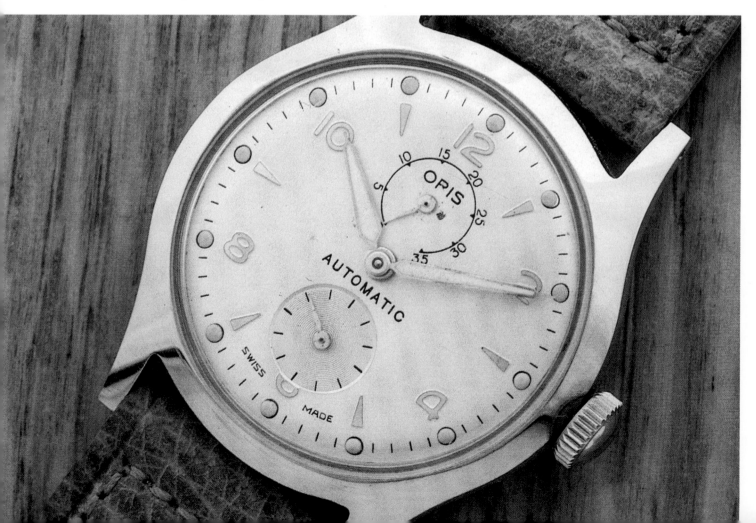

Longines,
Cal. 340, 1960

Patek Philippe,
Cal. 240, 1977

Tudor,
Cal. MT5612,
2015

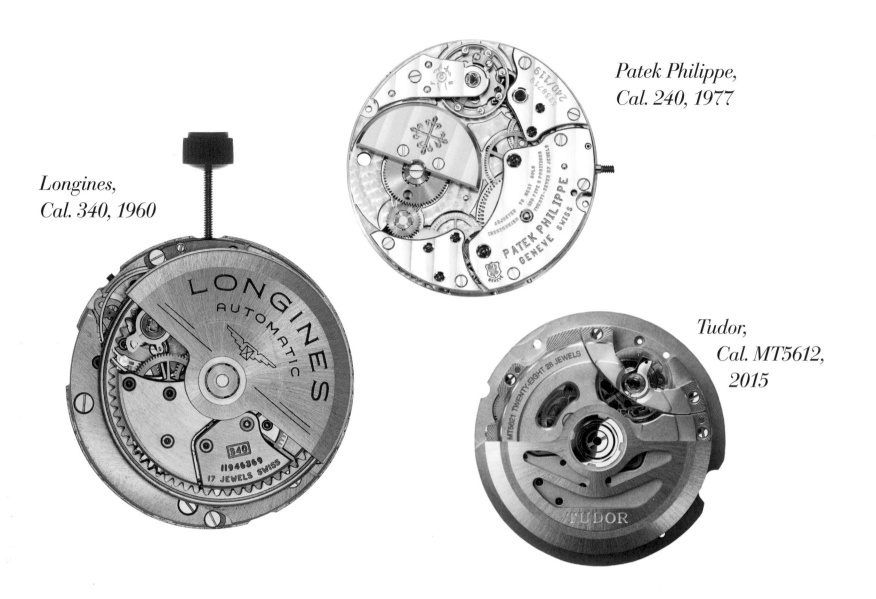

Patek Philippe, Ref. 3445 Automatic, 1965

Patek Philippe, Ref. 3445 Automatic,
Cal. 27-460 Monodate, 1965

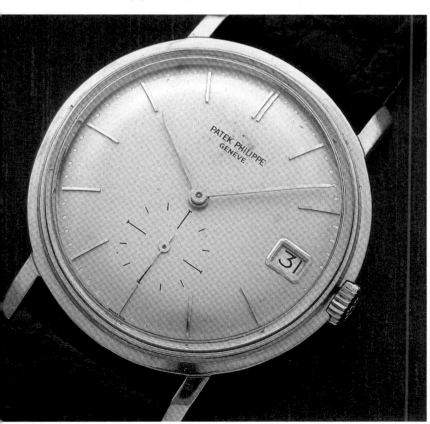

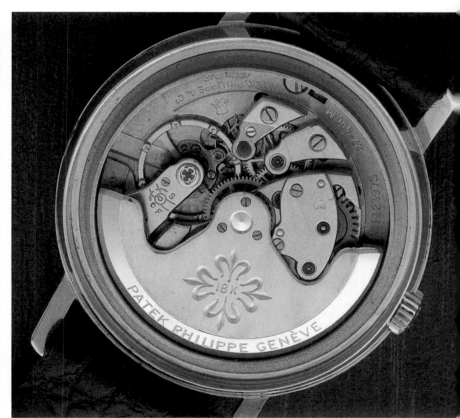

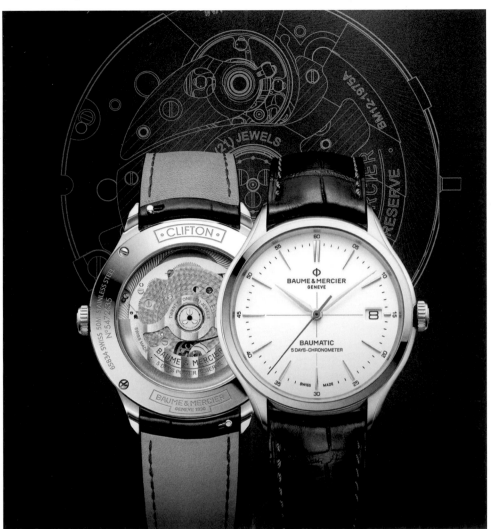

Baume & Mercier Clifton Baumatic,
Cal. BM12-1975A, 2018

01 *02* *03* *04*

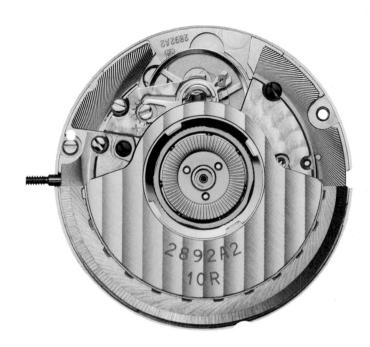

05

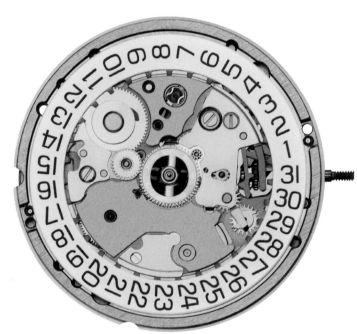

06

01. Chronoswiss Flying Grand Regulator Open
 Gear ReSec, Ref. CH-6927-REBK
02. Personalized made-to-order Blaken watch
 "Green Viper", based on Rolex Milgauss ○
 Auf Kundenwunsch personalisierte Blaken-Uhr
 "Green Viper", basierend auf Rolex Milgauss
03. Chopard Alpine Eagle, women's watch ○
 Chopard Alpine Eagle, Damenuhr
04. Chopard, Cal. 09.01-C
05. Jean Lassale, watch and Cal. 2000,
 world's slimmest automatic movement
 at this time, 1978 ○ Jean Lassale, Uhr und
 Kal. 2000, flachstes Automatikwerk
 zu seiner Zeit, 1978
06. ETA, Cal. 2892A2, produced since 1975 ○
 produziert seit 1975

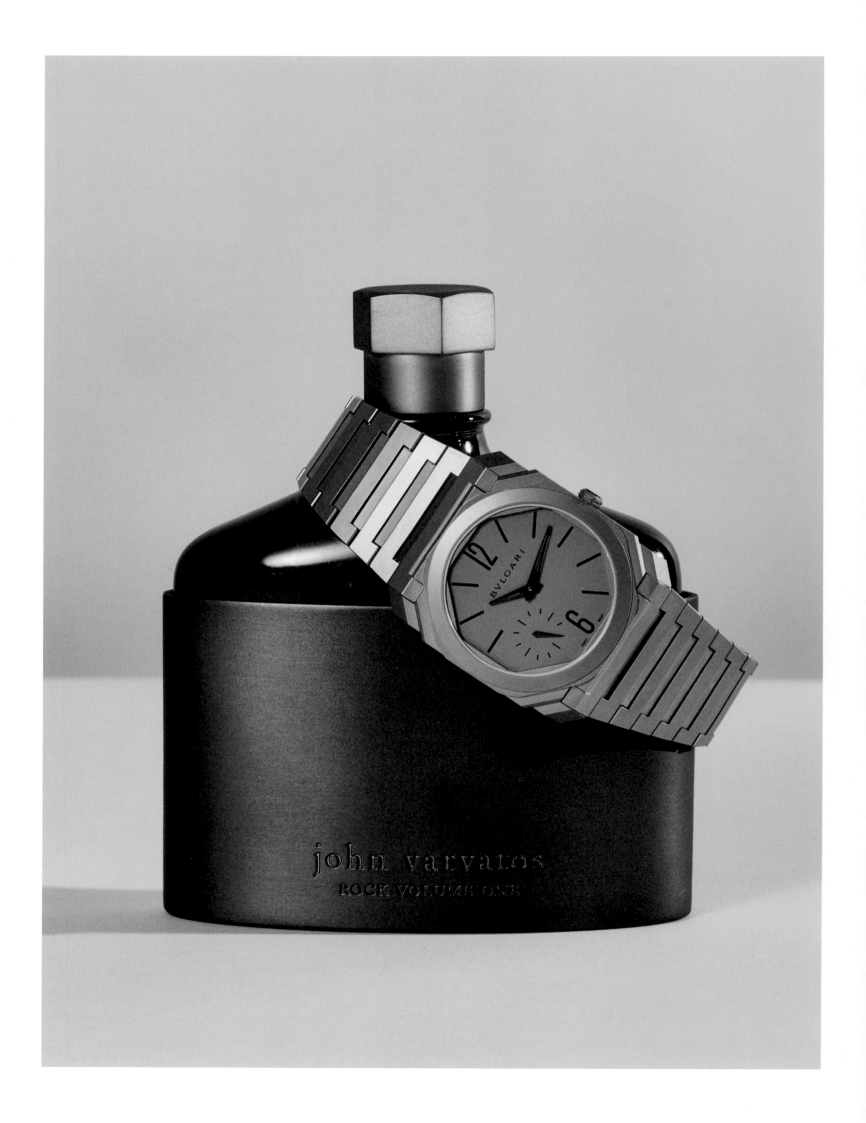

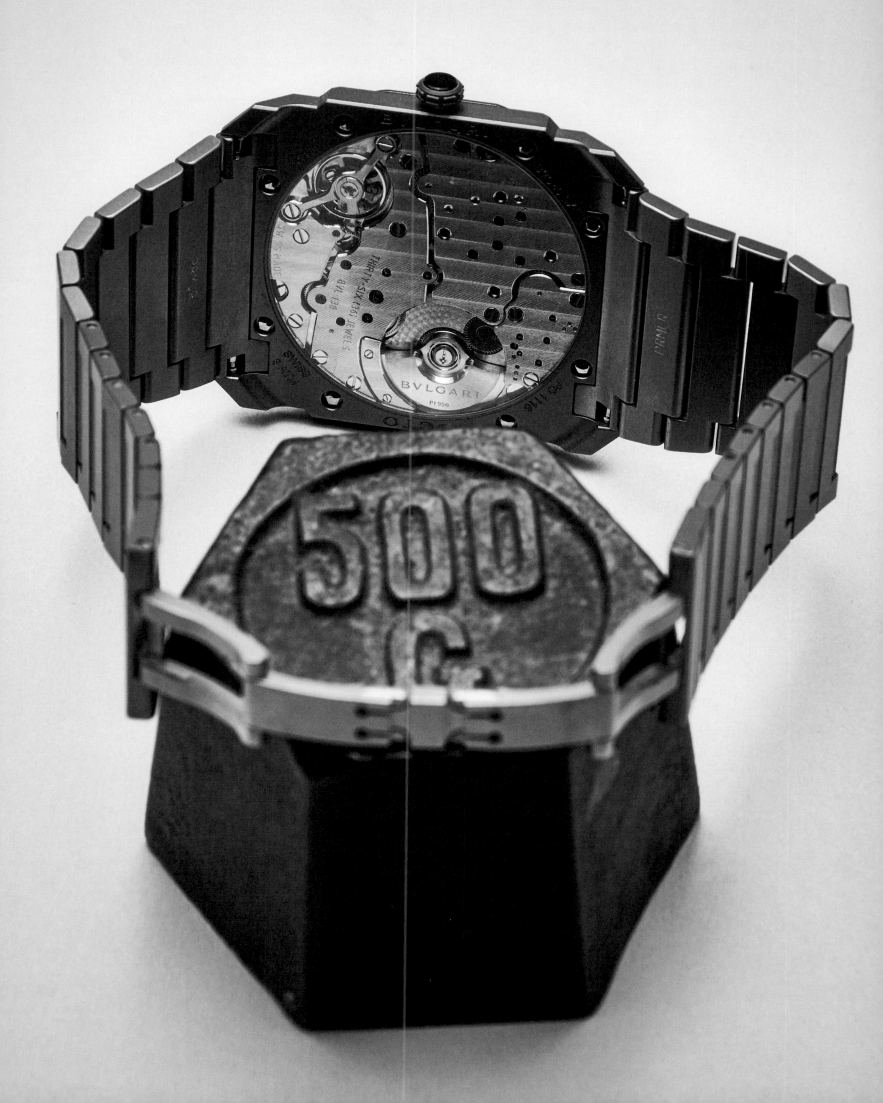

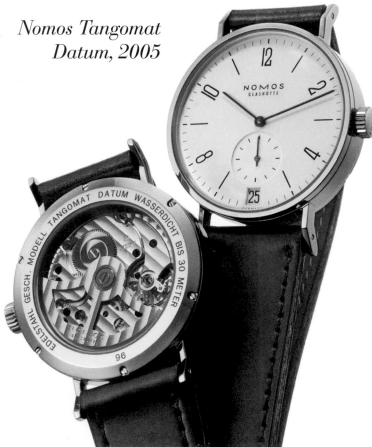

Nomos Tangomat
Datum, 2005

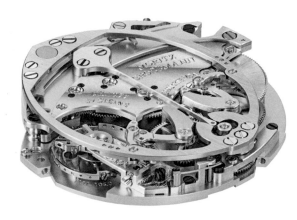

Moritz Grossmann Hamatic,
Cal. 106.0

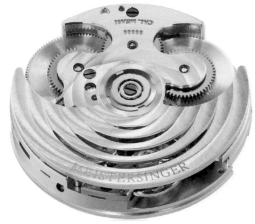

MeisterSinger,
Cal. MSA01 Circularis, 2016

Following pages ◦ Folgende Seiten:
Piaget Altiplano Ultimate Automatic

Carl F. Bucherer,
Cal. CFB A1000, 2008

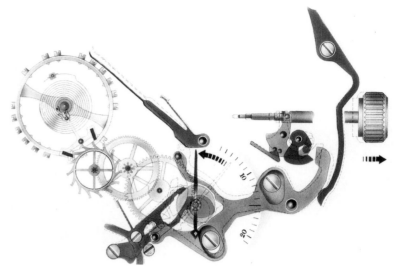

A. Lange & Söhne Langematik, Cal. L921,
zero-reset mechanism ◦ Zero-Reset-Mechanismus, 1997

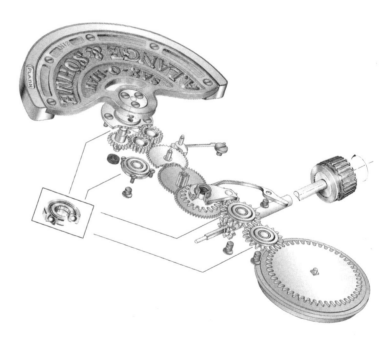

A. Lange & Söhne Langematik, Cal. L921,
self-winding system ◦ Selbstaufzugssystem, 1997

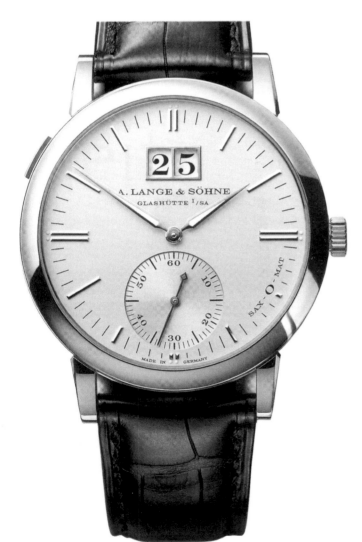

A. Lange & Söhne Langematik,
Cal. L921, 1997

Calendar
Kalender

With Watches through Years and Days

Many watch enthusiasts consider a timepiece without a date display to be only half of the proverbial loaf. After all, the date plays an immensely important role in business and everyday life. Calendaric facts have always been crucial when travelling, signing contracts, writing receipts and scheduling appointments, to mention only a few of countless date-dependent situations. Calendar displays, which often also include the day of the week and the name of the month, were therefore one of the earliest extra functions added to mechanical watches. In this context, it is makes no difference whether the date is shown in analogue manner by a hand or digitally by printed discs under windows in the dial.

Calendaric history in a nutshell

The question of what happened in Rome between October 5th and October 14th in 1582 can be answered with seven letters: Nothing. Absolutely nothing. Why? Because Pope Gregory XIII decreed that those ten days would be overleapt. After this jump, the eponymous Gregorian calendar began on October 15, 1582. The pope's decree completed an astronomically necessary reform that can be traced to a small error on the part of Gaius Julius Caesar. The Roman emperor was confronted with a multitude of calendaric systems, many oriented according to the moon, in use among the peoples who dwelt within his empire's geographically immense sphere of influence. Calendaric chaos prevailed inside the walls of Rome too, where prior inaccuracies had brought the calendar out of synchrony with the seasons. The discrepancy had grown so severe that three extra months had to be inserted into 46 BC, which had 445 days and was the longest year in Western history. Caesar's rebuilding of the calendaric system was inspired by the Egyptians, who calculated that each year contains approximately 365 days. The astronomer Hipparchus of Nicaea reckoned that one solar year lasts exactly 365.25 days, so three ordinary years of 365 days each are followed by one leap year, in which February has

29 days rather than merely 28. Each quadrennial leap year accordingly lasts 366 days. After the Julian calendar took effect in 45 BC, calendaric priests were responsible for ensuring the rule-compliant insertion of an additional leap day every four years. To honor Caesar's achievement, the Roman Senate changed the name of his birth from Quintilis to Julius, i.e. the name of the emperor's patrician lineage. And every month of Julius had 31 days.

After the statesman's assassination on the Ides of March in 44 BC, the priests erroneously added a leap day to every third year, thus throwing the calendaric world into disarray once again. Emperor Augustus, Caesar's principal heir, restarted the Julian calendar in 8 AD. Thanks to this timing, which may or may not have been coincidental, leap years can be identified simply by dividing the year by four: if there is no remainder, the year gets an extra day. Incidentally, the Roman Senate also renamed a month in Augustus's honor to thank him for having conquered Alexandria and subjugated Antonius and Cleopatra in the month of Sextilis in 31 BC. But the emperor felt slighted because the month that was renamed "Augustus" had only 30 days according to the old calendar. The renamed month had to be lengthened by one day. This meant that subsequent months needed to be rearranged and February had to be shortened to 28 days in ordinary years and 29 days in leap years.

Everything could have remained beautifully harmonious were it not for the fact that Caesar made a marginal but in the long run momentous error. He and the astronomer Sosigenes overestimated the length of the year by 11 minutes and 14 seconds, i.e. 0.0078 days. In the course of 1,600 years, this small annual discrepancy accumulated to the ten days mentioned above.

To prevent this error from recurring, a leap day was added to secular years (1600, 1700, 1800, etc.) only if the year was evenly divisible by 400. Thanks to Pope Gregory XIII and contrary to the usual four-year cycle, no 29th day is added to February in the years 1700, 1800, 1900, 2100, 2200, 2300, etc. The Gregorian modifications did not change the basic principles of the Julian calendar, i.e.

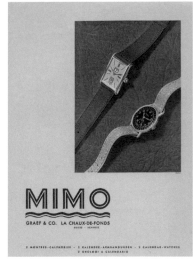

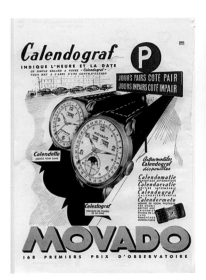

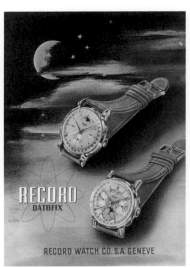

Previous pages ◦ Vorherige Seiten:
Nivrel Héritage Chrono La Grande Date (left ◦ links), Ulysse Nardin Marine Chronograph Annual Calendar (right ◦ rechts)

Mit Uhren durch Jahr und Tag

Die Tatsache, dass viele Uhrenliebhaber eine Armbanduhr ohne Indikation des Datums als halbe Sache bezeichnen, ist absolut verständlich. Schließlich spielt es im Geschäfts- und Alltagsleben eine ungemein wichtige Rolle. Beim Unterschreiben von Verträgen, Vereinbaren von Terminen, Abzeichnen von Quittungen oder Reisen, um nur ganz wenige Aspekte zu nennen, besitzen kalendarische Fakten nicht erst seit gestern elementares Gewicht. Daher gehören entsprechende Anzeigen, welche oft auch Wochentag und Monat beinhalten, zu den frühesten Zusatzfunktionen mechanischer Uhren. In diesem Zusammenhang spielt es keine Rolle, ob die Darstellung analog per Zeiger oder digital mithilfe von bedruckten Scheiben und Zifferblattausschnitten erfolgt.

Kalenderwissen in kurzen Zügen

Die Frage, was in Rom vom 5. bis 14. Oktober 1582 geschah, lässt sich mit sechs Buchstaben beantworten: nichts. Rein gar nichts. Denn auf Geheiß von Papst Gregor XIII. mussten diese zehn Tage ersatzlos ausfallen. Nach dieser Zwangsmaßnahme konnte der nach ihm benannte gregorianische Kalender am 15. Oktober 1582 in Kraft treten. Mit seinem Dekret hatte der Papst eine astronomisch bedingte Reform vollendet, welche bereits auf Gaius Julius Cäsar zurückging. Der römische Herrscher sah sich im geografisch immensen Einflussbereich seines Reiches einer Vielzahl von – oft am Mond orientierten – Kalendersystemen gegenüber. Auch in Rom selbst herrschte kalendarisches Chaos: Durch die bisherige Ungenauigkeit waren die Jahreszeiten durcheinandergeraten, sodass 46 v. Chr. drei Monate eingeschoben werden mussten – es war mit 445 Tagen das längste Jahr der abendländischen Geschichte. Bei seinem Umbau des Kalendersystems ließ sich Cäsar von den Ägyptern inspirieren, bei denen ein Jahr rund 365 Tage dauerte. Weil das Sonnenjahr laut dem Astronom Hipparchos vor Nicäa aber exakt berechnet 365,25 Tage währt, folgt auf drei „normale" Jahre mit jeweils 365 Tagen ein Schaltjahr – es ist um den 29. Februar verlängert und hat 366 Tage. Der julianische Kalender trat 45 v. Chr. in Kraft. Kalenderpriester sollten fortan das regelkonforme Einfügen des zusätzlichen Tages alle vier Jahre überwachen. Als gebührende Ehre für seine Leistung benannte der römische Senat Cäsars Geburtsmonat Quintilis in Julius um, den Namen seines Patriziergeschlechts. Und dieser Monat besaß 31 Tage.

Nach der Ermordung des Staatsmannes an den Iden des März 44 gestanden die Kalenderpriester fälschlicherweise bereits jedem dritten Jahr einen Schalttag zu. Und damit kam die kalendarische Welt erneut in Unordnung. Im Jahr 8 n. Chr. startete Kaiser Augustus, Cäsars Haupterbe, den julianischen Kalender neu. Zufall oder nicht: Seitdem lassen sich die Schaltjahre bequem per Division durch vier ermitteln. Übrigens bedankte sich der römische Senat auch bei Augustus mit der Umbenennung eines Monats: und zwar für die Eroberung Alexandrias und die Unterwerfung von Antonius und Kleopatra im Sextilis des Jahres 31 v. Chr. Weil der in Augustus umbenannte Monat nach alter Rechnung aber lediglich 30 Tage besaß, fühlte sich der Herrscher benachteiligt. Also musste der August um einen Tag verlängert werden, die Folgemonate entsprechend umgeordnet und der Februar auf 28 oder – in Schaltjahren – auf 29 Tage verkürzt werden.

Von nun an hätte alles so schön sein können, wenn Cäsar nicht ein marginaler, auf lange Sicht aber folgenreicher Fehler unterlaufen wäre: Er und der Astronom Sosigenes hatten die Jahreslänge um 11 Minuten und 14 Sekunden oder 0,0078 Tage zu lange berechnet. Im Laufe von rund 1600 Jahren hatte sich der winzige Betrag zu der eingangs erwähnten zehn Tagen aufsummiert.

Um solches künftig zu verhindern, erhielten von den Säkularjahren – 1600, 1700, 1800 etc. – künftig nur noch die durch 400 teilbaren einen Schalttag. Trotz des üblichen Vier-Jahres-Zyklus fehlte und fehlt also dank Papst Gregor XIII. der 29. Februar in den Jahren 1700, 1800, 1900, 2100, 2200, 2300 usw. An den Grundsätzen des julianischen Kalenders, sprich den Monatslängen sowie dem Schaltjahresrhythmus, änderten die gregorianischen Modifikationen allerdings nichts. Somit gilt das julianische Kalendersystem bis in die Gegenwart. Ihm folgen nahezu alle Kalenderuhren.

Kalender und Uhrmacher

Das menschliche Bestreben, das gleichförmige Verstreichen der Zeit durch ihre Unterteilung in gleich lange Abschnitte anschaulich darstellen zu können, hat um das Jahr 1300 mechanische Räderuhren hervorgebracht. Simple Zeitmesser waren ambitionierten

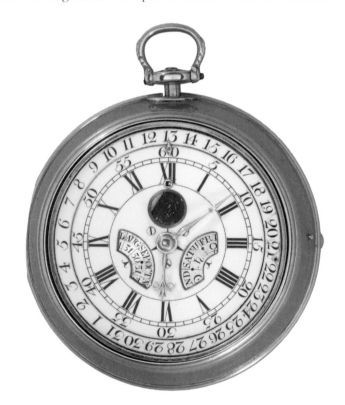

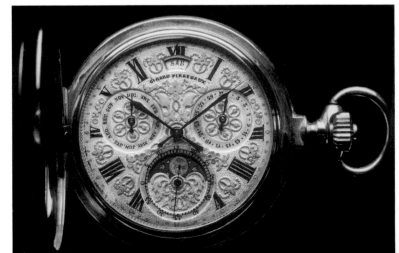

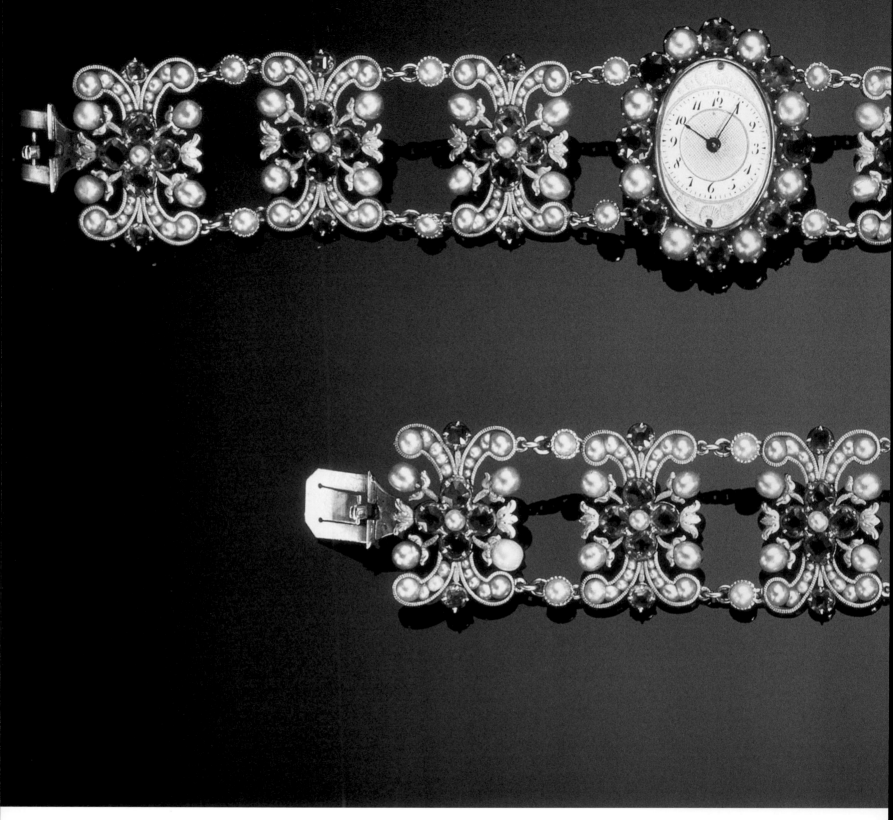

Page 52, from left: advertisement for Jaeger-LeCoultre calendar wristwatch, 1934 ◦ ad for Mimo calendar watches, 1941 ◦ ad for Movado Calendograf, 1947 ◦ ad for Record Datofix, 1948 ◦ Page 53, from top: Thomas Mudge, pocket watch with perpetual calendar, 1764 ◦ Girard-Perregaux Annual Calendar, 1908 ◦ Seite 52, von links: Anzeige für Jaeger-LeCoultre Kalenderuhr, 1934 ◦ Anzeige für Mimo Kalenderuhren, 1941 ◦ Anzeige für Movado Calendograf, 1947 ◦ Anzeige für Record Datofix, 1948 ◦ Seite 53, von oben: Thomas Mudge, Taschenuhr mit ewigem Kalender, 1764 ◦ Girard-Perregaux Jahreskalender, 1908

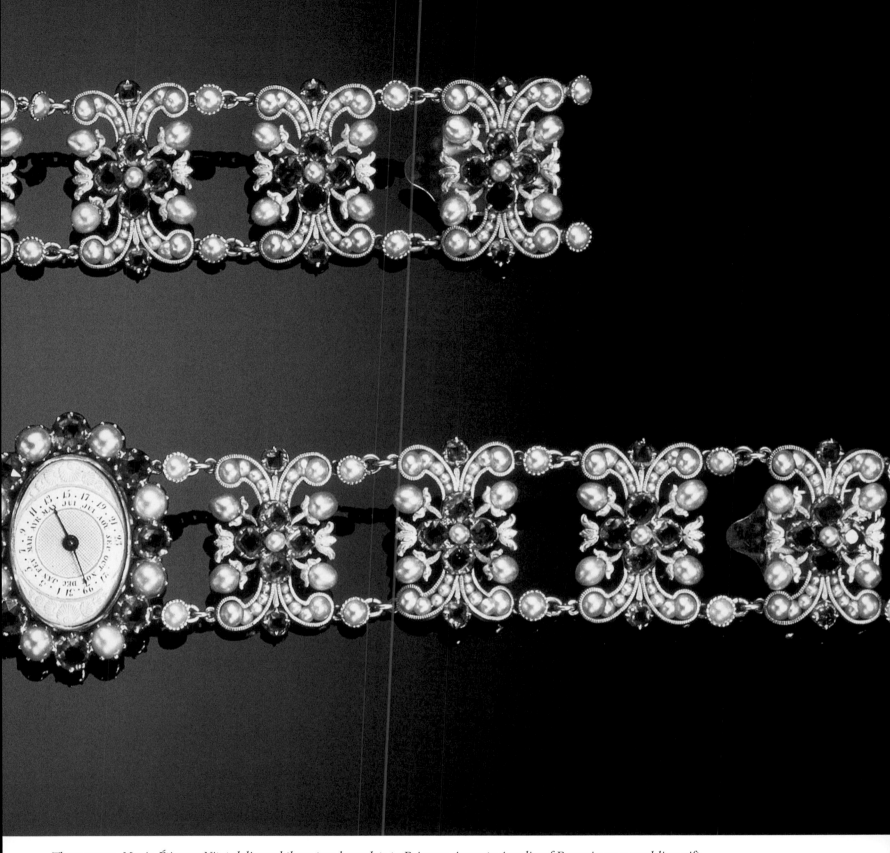

These pages: Marie-Étienne Nitot delivered these two bracelets to Princess Auguste Amalia of Bavaria as a wedding gift; one features a built-in clock, the other a calendar showing month and day, 1806
Diese Seiten: Marie-Étienne Nitot lieferte diese zwei Armbänder als Hochzeitsgeschenk an Prinzessin Auguste Amalia von Bayern aus; eines der Armbänder ist mit einer Uhr ausgestattet, das andere mit einem Kalender, der Monat und Tag anzeigt, 1806

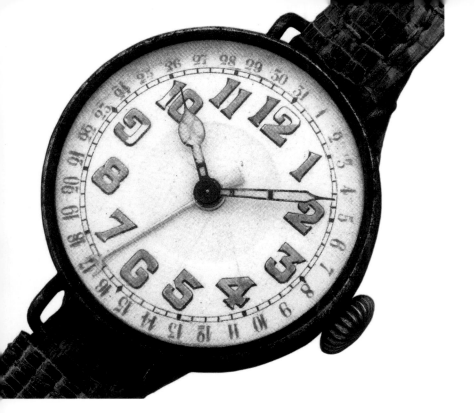

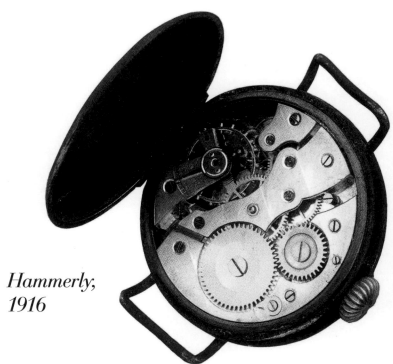

Hammerly,
1916

the lengths of the months and the quadrennial cycle of leap years, so the Julian calendar remains valid today. Nearly all simple calendar watches rely on it.

Calendars and clockmakers

Around 1300 AD, humankind's endeavor to show the uniform passage of time by dividing it into equally long intervals gave rise to the invention of mechanical geared clocks. But simple clocks were not complex enough to lastingly satisfy clockmakers' ambitions. The intermeshing of gears, pinions and levers offered many possibilities for augmenting these ticking artworks, e.g. by adding simple calendar movements from the 14th century onwards. These were followed by full calendars, which show the date, day of the week and month; some full calendars also indicate the age of the moon. The first portable timepieces with calendar movements were built in the 16th century. But in all instances, the date display remained correct for a maximum of 92 consecutive days, i.e. from July 1st to September 30th. The next day shown by the timepiece was the nonexistent September 31st, while the pages of paper calendars were correctly showing October 1st. This situation remains unchanged in simple representatives of this species of calendar watch, which require manual correction at midnight on the final day of every month with fewer than 31 days.

Date and calendar on the wrist

The calendar display and its additional benefits were surprisingly slow in finding their way onto the dials of wristwatches, which were initially dominated solely by the time-measuring function. This had nothing to do with incompetence on the part of watchmakers. The crafting of miniature calendar movements for ladies' pocket watches was a more or less commonplace task for practitioners of this creative profession, but perhaps these early watchmakers felt that a tear-off paper calendar was the better alternative. Repeater striking movements and chronographs accordingly found their way to the wrist long before the first date display.

A patent application, filed by A. Hammerly's long-forgotten Fabrique d'Horlogerie in 1915, related to two different constructions: one had a central date hand with a crescent-shaped tip pointing to red numbers; the other offered an additional digital day-of-the-week indication viewed through an aperture in the dial. The First World War was raging at this time, so each was optionally available with an overlying metal grid to protect the fragile watch glass. Also around 1915, Movado launched the first ladies' wristwatch with a date window in its broad bezel. H. Moser & Cie. built and sold a more complex version with date and day-of-the-week displays in 1916.

Audemars Piguet unveiled a pillow-shaped wristwatch with a simple full calendar and a moon-phase display in 1921. Similarly equipped rectangular models with analogue or digital indicators followed in 1924. One of them, delivered to a customer in the USA, was engraved with the inscription: "THIS IS THE FIRST CALENDAR WRISTWATCH EVER MADE BY US AND I BELIEVE IT TO BE THE ONLY ONE IN EXISTANCE [sic], E. GÜBELIN, LUCERNE, 1924, Switzerland."

In general, however, calendar wristwatches remained the exception in the 1920s. Chronographs predominated among the additional functions installed in wristwatches.

It was not until the next decade that many manufacturers launched new wristwatches with (mostly digital) date displays. Girard-Perregaux debuted a rectangular model with a date window in 1931. LeCoultre offered its day-date model with a date hand and a day-of-the-week window for 98 Swiss francs in 1937. Movado began selling a wristwatch with full calendar in 1939. But even in the stormy 1930s, the worldwide triumph of the wristwatch chronograph left little room for the evolution of calendar mechanisms.

Noteworthy progress was not made until the 1940s and especially with a milestone in 1945, when Hans Wilsdorf celebrated the 40th anniversary of his company with the launch of the Rolex "Datejust." Its name means "date just in time", i.e. the date display advances precisely at midnight. The window date at the "3" was not absolutely state of the art from a technical point of view, but in combination with the waterproof Oyster case and a chronometer-certified self-winding movement, the Datejust deserves to be regarded as "the mother of the modern date watch."

Uhrmachern auf Dauer jedoch zu wenig. Das mikrokosmische Ineinandergreifen von Rädern, Trieben und Hebelwerken eröffnete zahlreiche Möglichkeiten zur Aufwertung der tickenden Kunstwerke – ab dem 14. Jahrhundert zum Beispiel durch einfache Kalenderwerke. Vollkalendarien (Angabe von Datum, Wochentag und Monat), teilweise auch mit Mondalteranzeige, folgten alsbald. Den ersten tragbaren Uhren mit Kalenderwerk begegnet man im 16. Jahrhundert. In allen Fällen blieb die Datumsanzeige längstens 92 Tage hintereinander korrekt. Und zwar vom 1. Juli bis zum 30. September. Tags darauf zeigte die Uhr den 31. (September), obwohl im Kalender schon der 1. (Oktober) stand. An diesem Sachverhalt hat sich bei einfachen Vertretern dieser Spezies Uhr bis in die Gegenwart nichts geändert: Am Ende aller Monate mit weniger als 31 Tagen braucht es eine manuelle Korrektur.

Datum und Kalender am Handgelenk

Bei Armbanduhren ließ der Zusatznutzen eines Kalenders übrigens erstaunlich lange auf sich warten. Am Handgelenk dominierte anfangs ausschließlich die chronometrische Funktion. Mit uhrmacherischem Unvermögen hatte das freilich nichts zu tun. Miniatur-Kalenderwerke für Damentaschenuhren gehörten fast schon zum Alltag des kreativen Berufsstandes. Möglicherweise vertraten die Protagonisten der frühen Uhrmacherei jedoch die Auffassung, dass der Abreißkalender die bessere Alternative sei. Daher fanden Repetitionsschlagwerke oder Chronographen früher an den Unterarm als das Datum.

1915 begegnet man dann einem Patentantrag der längst vergessenen Fabrique d'Horlogerie von A. Hammerly. Er bezog sich auf zwei verschiedene Konstruktionen: eine mit zentralem Datumszeiger und halbmondförmiger Spitze, welche auf rote Zahlen deutete; eine weitere mit zusätzlicher digitaler Wochentagsindikation durch einen Zifferblattausschnitt. Wegen des Ersten Weltkriegs waren beide Versionen auch mit Schutzgitter für das bruchgefährdete Kristallglas erhältlich. Ebenfalls gegen 1915 lancierte Movado eine erste Damenarmbanduhr mit Fensterdatum im breiten Gehäuserand. 1916 realisierte H. Moser & Cie. die komplexere Version mit Datums- und Wochentagsindikation.

Audemars Piguet präsentierte 1921 eine kissenförmige Armbanduhr mit einfachem Vollkalendarium und Mondphasenanzeige. 1924 gesellten sich entsprechende rechteckige Modelle mit analoger oder digitaler Indikation hinzu. Eines davon, geliefert an einen US-amerikanischen Kunden, trug die Inschrift: „Dies ist unsere erste Kalenderarmbanduhr, und ich meine, es ist die erste überhaupt. E. Gübelin, Luzern, 1924, Schweiz."

Ganz allgemein jedoch blieben Kalenderarmbanduhren in den 1920er-Jahren eher die Ausnahme. Bei den Zusatzfunktionen dominierten Chronographen.

Erst im folgenden Jahrzehnt lancierten zahlreiche Fabrikanten neue Armbanduhren mit meist digitaler Datumsanzeige. 1931 brachte Girard-Perregaux ein rechteckiges Modell mit Fensterdatum auf den Markt. LeCoultre präsentierte 1937 für 98 Schweizer Franken sein Day-Date-Modell mit Datumszeiger und Wochentagsfenster. 1939 wartete Movado mit einem Vollkalendarium auf. Doch der weltweite Triumphzug des Armbandchronographen ließ auch in den stürmischen 1930er-Jahren der Kalenderarmbanduhr nur wenige Entfaltungsmöglichkeiten.

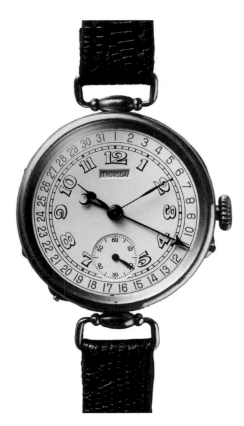

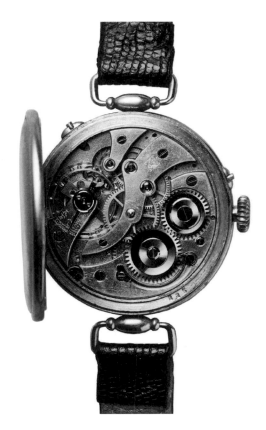

H. Moser & Cie., 1916

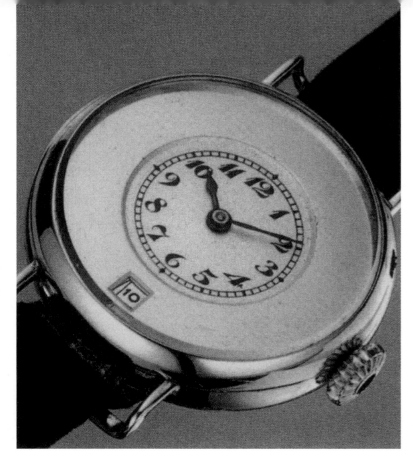

Movado, first ladies' wristwatch with a date window, 1915 o
Movado, erste Damenuhr mit Fensterdatum, 1915

Subsequent decades were marked by evolution. Constructions became more elegant, slimmer and progressively more perfect. Audemars Piguet and Vacheron Constantin introduced ultra-slim self-winding Calibers 2121 and 1121 in 1970: these movements, which are still available today, have a quickly switching date display in a window and are a mere 3.05 mm tall. The "creeping" or semi-jumping date display was joined by a date indicator that jumped to the next day's date punctually at midnight. Resetting was often necessary, so the industry developed a user-friendly quick-reset mechanism operated via the crown.

Prioritizing the date

Partly due to turbulent economic developments, the situation had changed significantly somewhat more than a century after the premiere of the first calendar wristwatches. The classic date display became a nearly indispensable "must" in daily life. The individual who wears a wristwatch with a date display tends to consult it regularly and for the most part unconsciously in the course of a busy workday.

The legibility of the date can be a problem because the dimensions of the movement that supports the date display limit the size of its numerals. The second wife of Rolex's founder Hans Wilsdorf knew all about this. Her weak eyesight clouded the pleasure she derived from her "Datejust." Fortunately, her rather vain husband typically spent two hours in the bath every morning. During his matutinal ablutions, a droplet of water chanced to fall toward the crystal of his wristwatch and land directly above the date display at the "3". The date indicator suddenly appeared much larger – and Wilsdorf conceived the ingenious built-in magnifying lens in the crystal above the date window.

The Solvil watch factory, founded by Paul Ditisheim, had already been pursuing a different path since 1930. Solvil launched trendy rectangular wristwatches under the names "Ditis" and "Calendar." Separate discs for the digits in the tens and ones columns enlarged the date display and improved its legibility. Helvetia debuted a similar model in 1934. Mimo followed suit with its "Mimometer" in 1939. Vénus, which manufactured ébauches, likewise opted for this advanced system in the mid-1940s. Afterwards, however, the large date vanished from the wristwatch scene for several decades.

The glorious revival of the watch manufacturer A. Lange & Söhne in Glashütte brought a breath of fresh air into the date-display scene in 1994. Lange's patented outsize date caused a sensation and subsequently became a signature feature for the manufactory. But the Saxons' unique selling point did not last long because the industry responded by designing similar alternatives. Nowadays everyone who wants a watch with a large date display can readily find one.

Perpetual lasts longest

All watches with simple calendar movements share a common denominator: they accurately display the date for only 92 consecutive days. This also applied to the devices with astronomical displays developed in the mid-17th century by Jean-Baptiste Duboule and Jacques Sermand. These two watchmakers in Geneva spent subsequent decades improving their mechanical calendars.

The London-based watchmaker Thomas Mudge is credited with having built the first pocket watch with a perpetual calendar. Completed in 1764, his masterpiece took into account the different lengths of the months in ordinary and leap years. From the 19th century onwards, the repertoire of nearly every renowned watch manufacturer included a perpetual calendar.

Audemars Piguet ranks among the pioneers of smaller calendar mechanisms installed directly under the dial. This family business delivered a ladies' pocket watch to a customer in Berlin in 1890. Its complex inner striking mechanism could chime the time to the nearest minute and it was also equipped with a perpetual calendar. The history of the first wristwatch with a perpetual calendar is inseparably linked to the name Patek Philippe. It resulted from a coincidence. A movement bearing the number 97975 was originally ensconced inside a small pocket-watch case. The calendar's hands speedily advanced to the next position at midnight, but unfortunately no one liked this timepiece enough to purchase it. The unwanted timepiece, which was completed in 1898, languished in a drawer until 1925, when the manufacture equipped the complex movement with a new case. This timepiece, which finally found its way to the wrist of a sufficiently wealthy gentleman on October 13, 1927, is priceless today.

Abraham-Louis Breguet completed his first pocket watch with perpetual calendar in 1795. His successors built the first true wristwatch (i.e. a timepiece that was originally designed to be worn on the wrist) with perpetual calendar in 1929. Due to the global economic crisis, this piece of jewelry with a tonneau-shaped white gold case did not find a buyer until 1934, when Jean Dollfus purchased it for 11,000 French francs as a gift for his brother Louis, who had completed his 500th hour of flight time in December 1933. An aficionado bought this watch for the impressive sum of 550,000 Swiss francs at an Antiquorum auction on April 14, 1991.

Bemerkenswerte Fortschritte gab es erst in den 1940er-Jahren, wobei 1945 ein Meilenstein gesetzt wurde: Zum 40. Firmenjubiläum brachten Hans Wilsdorf und seine Firma Rolex die „Datejust" auf den Markt. Der Name meint nichts anderes als „date just in time" oder übertragen: mitternächtliche Datumsschaltung. Technisch verkörperte das Fensterdatum bei „3" keineswegs den letzten Schrei. Im Verbund mit wasserdichter „Oyster"-Schale und chronometerzertifiziertem Automatikwerk trifft das Attribut „Mutter der modernen Datumsarmbanduhr" jedoch uneingeschränkt zu.

Die folgenden Jahrzehnte standen im Zeichen der Evolution. Die Konstruktionen wurden eleganter, flacher, vollkommener. Samt flott schaltendem Fensterdatum bauten die 1970 von Audemars Piguet und Vacheron Constantin vorgestellten und bis heute erhältlichen Automatikkaliber 2121 bzw. 1121 lediglich 3,05 Millimeter hoch. Zur „schleichenden" oder halbspringenden Datumsanzeige gesellte sich die pünktlich um Mitternacht auf den nächsten Tag schnellende. Und für die regelmäßig anstehenden Korrekturen entwickelte die Industrie unkompliziert handhabbare Schnellschaltungen per Krone.

Datum großgeschrieben

Unter anderem wegen der stürmischen ökonomischen Entwicklungen hat sich die Situation ein gutes Jahrhundert nach dem Lancement erster Kalenderarmbanduhren deutlich gewandelt. Die klassische Datumsanzeige avancierte zu einem Must. Im Alltagsleben ist sie beinahe unverzichtbar: Während eines stressigen Arbeitstags schielt Frau oder Mann, meist völlig unbewusst, regelmäßig darauf.

Nur bei der Ablesbarkeit hapert es gelegentlich, weil die Größe der Zahlen mit den Dimensionen des verbauten Uhrwerks korrespondiert. Von diesem Problem wusste die zweite Ehefrau des Rolex-Gründers Hans Wilsdorf ein Lied zu singen. Sie sah schlecht, und das trübte die Freude an ihrer „Datejust". Da traf es sich gut, dass ihr durchaus eitler Mann jeden Morgen zwei Stunden im Bad verbrachte. Dort fiel ein Tropfen Wasser aufs Glas seiner Armbanduhr. Und zwar exakt an der Stelle des Datums bei „3". Der beträchtliche Vergrößerungseffekt führte zur mehr als genialen Datumslupe.

Einen anderen Weg hatte die Uhrenfabrik Solvil, einst gegründet von Paul Ditisheim, schon ab 1930 beschritten. Unter den Namen „Ditis" und „Calendar" stellte sie trendige Rechteck-Armbanduhren vor. Bei ihnen steigerten getrennte Scheiben für Zehner- und Einerziffern des Datums die Ablesbarkeit. 1934 präsentierte Helvetia ein ähnliches Modell, 1939 folgte Mimo mit seinem „Mimometer". Mitte der 1940er-Jahre setzte auch der Rohwerkehersteller Vénus auf das fortschrittliche System. Danach verschwand das fortschrittliche Großdatum für einige Jahrzehnte von der Bildfläche.

Frischen Wind in die Datumsszene brachte erst 1994 das glorreiche Revival der Glashütter Uhrenmanufaktur A. Lange & Söhne. Ihr patentiertes Großdatum sorgte nicht nur für Furore, sondern entwickelte sich auch zu einer Art Markenzeichen. Der Alleinstellungsanspruch währte allerdings nicht sehr lange für die Sachsen. Die Branche reagierte mit der Konstruktion entsprechender Alternativen. Daher findet heute jeder, der eine Armbanduhr mit Großdatum sucht, das für ihn Passende.

Ewig währt am längsten

Alle Zeitmesser mit einfachem Kalenderwerk eint die bereits erwähnte, auf 92 Tage begrenzte Anzeigegenauigkeit. Das galt auch für die Kreationen mit astronomischen Anzeigen, die Jean-Baptiste Duboule und Jacques Sermand Mitte des 17. Jahrhunderts entwickelt hatten. Die folgenden Jahrzehnte standen im Zeichen permanenter Verfeinerung des kalendarischen Œuvre der beiden Genfer Uhrmacher.

Die vermutlich erste Taschenuhr mit ewigem Kalender ist dem Londoner Uhrmacher Thomas Mudge zu verdanken. Sein 1764 fertiggestelltes Meisterwerk berücksichtigte die unterschiedlichen Monatslängen in Normal- und Schaltjahren. Ab dem 19. Jahrhundert gehörten immerwährende Kalendarien dann zum Repertoire nahezu aller renommierten Uhrenhersteller.

Bei kleineren Schaltwerken unter dem Zifferblatt zählt Audemars Piguet zu den Pionieren. 1890 lieferte das Familienunternehmen eine Damentaschenuhr nach Berlin. Ihr kompliziertes Innenleben repetierte die Zeit minutengenau; außerdem verfügte es über einen ewigen Kalender.

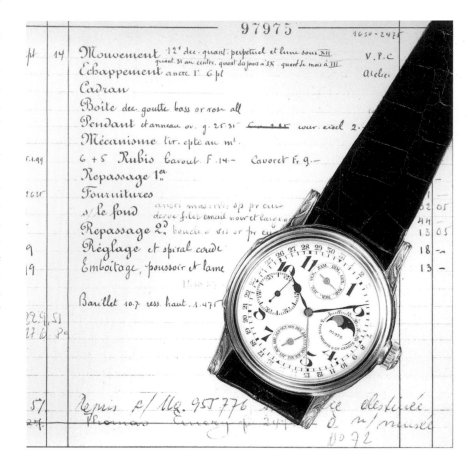

Patek Philippe, No. 97975,
first wristwatch with a perpetual calendar
erste Armbanduhr mit
ewigem Kalender, 1925/1927

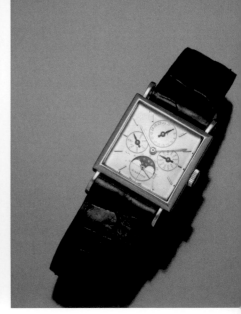

From left: Mars Dateur, 1930s ◦ Mimo's "Mimometer", with window date, 1930s ◦ Cartier, simple full calendar and moon-phase display, 1950s ◦ Von links: Mars Dateur, 1930er ◦ Mimos „Mimometer", mit Fensterdatum, 1930er ◦ Cartier, mit einfachem Vollkalendarium und Mondphasen, 1950er

Patek Philippe premiered a wristwatch with perpetual calendar and retrograde date hand in 1936. In 1938, Jaeger-LeCoultre proved that its reversible "Reverso" watch was destined for a higher degree of complexity. This one-of-a-kind timepiece was also equipped with a retrograde date hand, i.e. the pointer speedily returned to its starting point at the end of each month. In addition to keeping precious time, its rectangular hand-wound Caliber 410 QP also displayed the moon's phases.

Perpetual calendars in series

The few existing wristwatches with perpetual calendars were exclusively one-of-a-kind items until 1940. The history of watches with perpetual calendars, which were subsequently produced only in small series, was long associated with Patek Philippe. Reference 1518, which debuted in 1941, encased a manually wound 13-ligne caliber augmented by a Valjoux chronograph mechanism. The specialist Dubois Dépraz provided the calendar mechanism, which is installed under the dial. Watchmakers employed by family-owned Patek Philippe finely finished, decorated and assembled the mechanisms. A total of 281 specimens of Reference 1518 had been manufactured by 1954. Reference 2499, which shared the same inner mechanisms and was fabricated from 1950 to 1985, was reproduced 349 times. Models with an in-house manually wound movement also made a name for themselves from 1941 onwards: Patek Philippe built 210 specimens of Reference 1526 until 1952.

The world's first wristwatch with automatic winding and perpetual calendar premiered as Reference 3448 in 1962. Powered by Caliber 27 460 Q, this watch was built in an impressively large series of 586 specimens until 1982. Its successor (Reference 3450) debuted in 1981 and included both a leap-year indicator and a moon-phase display. When production ceased in 1985, Patek Philippe had sold 244 of these models. Further historical models with moon-phase displays are References 1526, 1591, 2438/1, 2497, 2571 and 3449. In accord with the wishes of its celebrity customer, a one-of-a-kind calendar watch was built without a moon-phase display in 1970. Only nine hand-wound wristwatches with perpetual calendars left Audemars Piguet's complications ateliers between 1957 and 1969. 13-ligne Caliber VZSS with a small seconds hand at "6 o'clock" served as the basic movement, which was complemented by a

calendar cadrature from Dubois Dépraz. Customers could choose between two different versions. In addition to an ordinary month hand at the "3," both versions also had a leap-year indicator and a moon-phase display. The latter was positioned either at the "12" or the "6."

The automatic wristwatch with perpetual calendar that Audemars Piguet introduced in 1978 was destined to achieve bestseller status. Its 3.95-mm-slim Caliber 2120/2800 QP (Quantième Perpétuel) combined 292 components. An impressive total of 7,291 specimens were built by 1993. These calibers inspired 70 different references, which were manufactured in at least 190 different versions, including the Royal Oak sports watch. Orientation in the leap-year cycle was lacking until the debut of 4.05-mm-tall Caliber 2120/2802 in 1997.

Watchmakers classify leap-year displays in two basic types. Either the month hand rotates around its axis only once every four years or the caliber includes an additional indication to show the current position in the four-year cycle. A leap-year indicator is almost indispensable for people who don't wear their watch every day, don't store it in a watch winder when it is not in use or have no desire to keep meticulous calendaric records. If worse comes to worst, the leap-year display in a watch that has spent a lengthy interval inside a safe must be manually advanced through four full years in order to update its calendar.

Variety after the quartz revolution

Historians of timekeeping generally agree that 1985 was "the year of the perpetual calendar." After dramatic years precipitated by the Quartz Crisis, the renaissance of mechanical watchmaking also led to the launch of a bevy of new calendar watches, which suddenly ticked inside the showcases of no fewer than fourteen different companies. Particularly spectacular among them was IWC's "Da Vinci." It was the world's first model with automatic chronograph (Valjoux Caliber 7750), four-digit year display and comparatively simple resetting via the crown. But the mechanism that Kurt Klaus had developed could only be reset forwards. Anyone who overshot the mark had two options: leave the timepiece unworn until its calendar was correct again or bring it to a watchmaker for servicing. Ulysse Nardin rectified this shortcoming with the patented

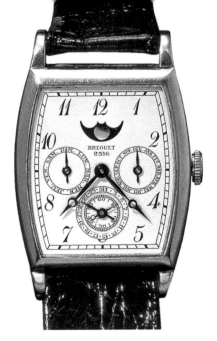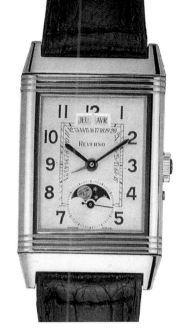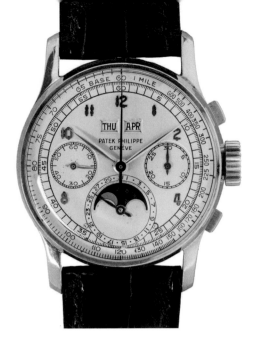

From left ◦ Von links: Breguet, perpetual calendar ◦ ewiger Kalender, 1929 ◦ Jaeger-LeCoultre Reverso Calendrier Retrograde, 1938 ◦ Patek Philippe, Ref. 1518, 1941

Die Geschichte der ersten Armbanduhr mit ewigem Kalendarium ist untrennbar mit dem Namen Patek Philippe verbunden – und entspringt einem Zufall. Ursprünglich schützte ein kleines Taschenuhrgehäuse das Uhrwerk mit der Nummer 97975. Bedauerlicherweise fand keine Dame Gefallen an diesem Zeitmesser mit Zeigern, die sich mitternachts blitzschnell in die nächste Position bewegten. Deshalb ruhte das bereits 1898 fertiggestellte Opus bis 1925 in einer Schublade. Dann verpasste die Manufaktur ihrem Ladenhüter eine neue Schale. Am 13. Oktober 1927 fand das heute unbezahlbare Stück endlich ans Handgelenk eines hinreichend betuchten Herrn.

Als Abraham-Louis Breguet seine erste Taschenuhr mit ewigem Kalendarium fertigstellte, schrieb man das Jahr 1795. Den Nachfolgern des Meisters ist 1929 die erste authentische – also von Beginn an als solche konzipierte – Armbanduhr mit ewigem Kalender zu verdanken. Infolge der Weltwirtschaftskrise fand das Schmuckstück mit einem tonneauförmigen Weißgoldgehäuse erst 1934 einen Käufer. Jean Dollfus erwarb die Uhr für 11 000 Französische Francs als Geschenk für seinen Bruder Louis, der im Dezember 1933 seine 500. Flugstunde absolviert hatte. Am 14. April 1991 ersteigerte sie ein Liebhaber bei Antiquorum für stolze 550 000 Schweizer Franken. 1936 lancierte Patek Philippe eine Armbanduhr mit ewigem Kalender und retrogradem Zeigerdatum. Jaeger-LeCoultre bewies 1938, dass seine Wendeuhr „Reverso" zu Höherem berufen war. Das Unikat besaß ebenfalls einen retrograden, also am Monatsende blitzschnell zurückspringenden Datumszeiger. Außerdem verfügte das rechteckige Handaufzugs-Formkaliber 410 QP neben der Zeit- auch über eine Mondphasenanzeige.

Ewige Kalender in Serie

Bis 1940 handelte es sich bei den wenigen Armbanduhren mit ewigem Kalender ausschließlich um Unikate. Die Geschichte der anschließend nur in Kleinserien hergestellten Exemplare ist über viele Jahre hinweg mit Patek Philippe verknüpft. 1941 debütierte die Referenz 1518. Ihr 13-liniges Basiskaliber mit Handaufzug und Chronograph stammte von Valjoux, das unter dem Zifferblatt positionierte Kalendarium lieferte der Spezialist Dubois Dépraz. Die Feinbearbeitung und Assemblage übernahmen die Uhrmacher der Familienmanufaktur Patek Philippe selbst. Bis 1954 entstanden davon insgesamt 281 Exemplare. Von der zwischen 1950 und 1985

fabrizierten Referenz 2499 mit dem gleichen Innenleben gab es 349 Stück. Auch Modelle mit hauseigenem Handaufzugswerk machten ab 1941 von sich reden. Von der Referenz 1526 fertigte Patek Philippe bis 1952 210 Stück.

Als Referenz 3448 präsentierte sich dann 1962 die weltweit erste Armbanduhr mit automatischem Aufzug und ewigem Kalender. Angetrieben wurde sie vom Kaliber 27460 Q; die stattliche Auflage betrug 586 Exemplare bis 1982. Das 1981 vorgestellte Nachfolgemodell 3450 besaß zusätzlich eine Schaltjahresanzeige. Als die Produktion im Jahr 1985 eingestellt wurde, hatte Patek Philippe davon 244 Stück verkauft. Auch bei dieser Uhr gehörte die Mondphasenanzeige sozusagen zur Standardausstattung. Weitere historische Referenzen mit Mondphasenanzeige heißen 1526, 1591, 2438/1, 2497, 2571 und 3449. Und dann gab es 1970 noch ein kalendarisches Einzelstück – bei dem fehlte der Mond. Ein prominenter Kunde wollte es so.

Im Hause Audemars Piguet verließen zwischen 1957 und 1969 nur neun Armbanduhren mit Handaufzug und immerwährendem Kalendarium die Komplikationen-Ateliers. Als tickende Basis diente das 13-linige Kaliber VZSS mit kleinem Sekundenzeiger bei der „6", das durch eine Kalenderkadratur von Dubois Dépraz ergänzt wurde. Zur Wahl standen zwei unterschiedliche Ausführungen. Neben dem normalen Monatszeiger bei „3" verfügten beide über eine Schaltjahresindikation sowie gegenüberliegend eine Mondphasenanzeige. Letztere befand sich entweder bei „12" oder im Süden des Zifferblatts. Absoluten Bestsellerstatus erlangte bei Audemars Piguet die 1978 vorgestellte Automatikarmbanduhr mit ewigem Kalender. Ihr 3,95 Millimeter flaches Kaliber 2120/2800 QP (Quantième Perpétuel) bestand aus insgesamt 292 Komponenten. Insgesamt entstanden bis 1993 stolze 7291 Stück, welche 70 verschiedene, in mindestens 190 verschiedenen Versionen fabrizierte Referenzen inklusive der Sportuhr „Royal Oak" beseelten. Orientierung im Schaltjahreszyklus gewährleistete allerdings erst das 1997 vorgestellte Kaliber 2120/2802 mit 4,05 Millimeter Bauhöhe.

Apropos Schaltjahresanzeige: Grundsätzlich unterscheiden Uhrmacher zwei Arten. Entweder dreht sich der Monatszeiger nur alle vier Jahre einmal um seine Achse, oder die Kadratur besitzt eine zusätzliche Indikation, welche die aktuelle Position im Vier-Jahres-Zyklus signalisiert.

Die Anzeige ist beinahe unerlässlich für all jene, die ihre Armbanduhr nicht permanent tragen, nach dem Ablegen zum Spannen der Zugfeder einem Umlaufgerät anvertrauen oder akribisch Buch

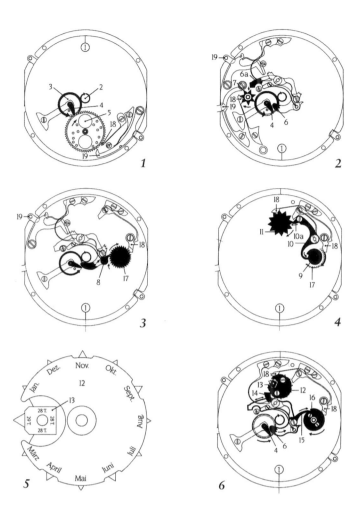

1　　2

3　　4

5　　6

Audemars Piguet, perpetual-calendar cadrature ◦
ewiger-Kalender-Kadratur

"Perpetual Ludwig" in 1996. Thanks to a new type of cadrature devised by Ludwig Oechslin, all indications—from the outsize date display through the month display to the year indicator—could be reset either forward or backwards simply by turning the crown. All indications remained synchronized during resetting. Its automatic Caliber UN-33 was based on a stripped-down version of Lemania Caliber 1354 from which the chronograph mechanism had been removed.

Not witchcraft

Gear-based perpetual calendars have remained the exception. Montblanc's Heritage Perpetual Calendar, for example, is one of the most recent representatives of this genre. The vast majority of perpetual calendars still rely on a conventionally designed cadrature consisting of 60 or more components. It supports numerous indications (date, day of the week, month, leap-year cycle and, in most instances, lunar phases) and performs its calendaric duties out of sight under the dial. Its basic functioning, described below using an Audemars Piguet calendar mechanism as an example, is quite logical and anything but witchcraft.

Figure 1:

The centrally located hour wheel (2) rotates once around its axis every 12 hours and propels the calendar movement, which is mounted on its own plate (1). The date must be advanced only once every 24 hours, so the hour wheel is connected to another wheel (3), which has twice as many teeth and therefore rotates only half as fast as the hour wheel. Mounted on this slow-moving wheel is a driver, the so-called "calendar-finger" (4), which rotates counterclockwise. First, it advances by one position the moon disc (5), which bears 59 teeth.

Figure 2:

Next, the calendar-finger (4) encounters the lower end of the main actuating lever (6) and pushes it upward. This causes the opposite end (6a) of the main actuating lever to move the day star (7) and the day hand to show the next day of the week.

Figure 3:

With the help of a small pawl (8), the date star (17) is now shifted forward by one tooth in a clockwise direction. The date hand jumps ahead to show the next date.

Figure 4:

The small month cam (9) is screwed to the underside of the date star (17). The lower end of the month rocker (10) slides along the month cam's curve until it falls over a small step at the end of the month. With the aid of its movable pawl (10a), the rocker pushes the month star (11) and the month hand advances 30° forward to show the next month.

The foregoing remarks explain the functioning of the calendar mechanism in months with 31 days. Thanks to a special switching mechanism, perpetual calendars also "know" the lengths of shorter months. The components of this mechanism are: the

führen wollen. Nach einer längeren Verweildauer im Tresor muss man händisch schlimmstenfalls vier Jahre durchschalten, um das Kalendarium zu aktualisieren.

Vielfalt nach der Quarz-Revolution

Als „Jahr des ewigen Kalenders" ist 1985 in die Geschichte der Zeitmessung eingegangen. Nach einschneidenden, quarzbedingten Krisenjahren äußerte sich die viel diskutierte Renaissance der Mechanik unter anderem in einer fast schon inflationären Lancierung neuer Modelle. Nicht weniger als 14 Firmen zeigten diese kalendarische Komplikation in ihren Vitrinen. Besonders spektakulär: Die IWC „Da Vinci" als weltweit erstes Modell mit Automatikchronograph, Kaliber Valjoux 7750, voll ausgeschriebener Jahreszahl und vergleichsweise simpler Korrekturmöglichkeit per Krone. Allerdings ließ sich der von Kurt Klaus entwickelte Mechanismus nur vorwärts verstellen. Wer dabei im Eifer des Gefechts über das Ziel hinausschoss, musste sein gutes Stück entweder so lange liegen lassen, bis das Kalendarium wieder stimmte, oder den Gang zum Service-Uhrmacher antreten. Dieses Manko beseitigte Ulysse Nardin 1996 beim patentierten „Perpetual Ludwig". Dank einer neuartigen Kadratur von Ludwig Oechslin lassen sich sämtliche Indikationen, angefangen beim Großdatum über die Monatsanzeige bis hin zur Jahreszahl, vor- und rückwärts über die Krone justieren. Zu diesem Zweck sind alle Indikationen exakt synchronisiert. Als Basis des Automatikkalibers UN-33 diente eine abgespeckte Version des vom Chronographenmechanismus befreiten Lemania 1354.

Audemars Piguet Royal Oak

Keine Hexerei

Derart räderbasierte Schaltwerke für das ewige Kalendarium sind allerdings eher die Ausnahme geblieben. Zu den neuesten Repräsentanten dieser Gattung gehört die Heritage Perpetual Calendar von Montblanc. Die überwiegende Mehrheit funktioniert wie eh und je mit einer konventionell gestalteten Kadratur. Sie besteht aus 60 oder mehr Komponenten und versieht ihren Dienst wegen der verschiedenen Indikationen (Datum, Wochentag, Monat, Schaltjahreszyklus und dazu meist auch noch Mondphasen) diskret unter dem Zifferblatt. Die grundsätzliche Funktion, nachfolgend beschrieben am Beispiel eines Schaltwerks von Audemars Piguet, ist ausgesprochen logisch und alles andere als Hexerei.

Abbildung 1:
Der Antrieb des auf einer eigenen Platine (1) montierten Kalenderwerks erfolgt über das zentral angeordnete Stundenrad (2). Dieses dreht sich in 12 Stunden einmal um seine eigene Achse. Nachdem die Kalenderangaben nur einmal innerhalb von 24 Stunden fortgeschaltet werden dürfen, steht das Stundenrad in Verbindung mit einem zweiten Rad (3), das die doppelte Zähnezahl aufweist, sich also halb so schnell dreht wie das Stundenrad. Auf diesem Zahnrad ist ein Mitnehmer, der sogenannte Kalenderfinger (4) montiert. Dieser dreht sich entgegen dem Uhrzeigersinn. Dabei schaltet er zuerst die Mondscheibe (5) mit ihren 59 Zähnen um eine Position weiter.

Abbildung 2:
Als Nächstes trifft der Kalenderfinger (4) auf das untere Ende des Hauptschalthebels (6) und schiebt dieses nach oben. Das entgegengesetzte Ende des Hauptschalthebels (6a) bewegt dadurch den Tagesstern (7) und zeiger auf den nächsten Wochentag weiter.

Abbildung 3:
Mithilfe der kleinen Schaltklinke (8) wird nun auch der Datumsstern (17) rechtsdrehend um einen Zahn fortgeschaltet. Der Datumszeiger springt auf den nächsten Tag.

Abbildung 4:
Mit der Unterseite des Datumssterns (17) verschraubt ist die kleine Monatsschnecke (9). Auf ihrer Kurve gleitet das untere Ende der Monatswippe (10), bis es am Monatsende über die kleine Stufe fällt. Mithilfe ihrer beweglichen Klinke (10a) schiebt die Wippe dabei Monatsstern (11) und zeiger um 30 Bogengrade auf den nächsten Monat weiter.
Soweit zur Funktion des Kalendermechanismus in Monaten mit 31 Tagen. Dass sich ewige Kalender selbst durch kürzere Monate nicht aus dem Takt bringen lassen, verdanken sie einem besonderen Schaltwerk. Es besteht aus einem mit dem Monatsstern verschraubten Monatsnocken (12) zur Bestimmung der Monatslänge, dem Schaltjahresnocken (13), dem oberen Schnabel (14) und der großen Schaltklinke (15) des Hauptschalthebels.

Abbildung 5:
Wichtigstes Teil des ewigen Kalenders ist der Monatsnocken (12), in dessen Umfang die unterschiedlichen Monatslängen einprogrammiert sind. Die erhabenen Stellen repräsentieren Monate von 31 Tagen Dauer, die Kerben solche mit nur 30 Tagen. Zudem besitzt er einen kreisrunden Ausschnitt, in dem der Schaltjahresnocken (13)

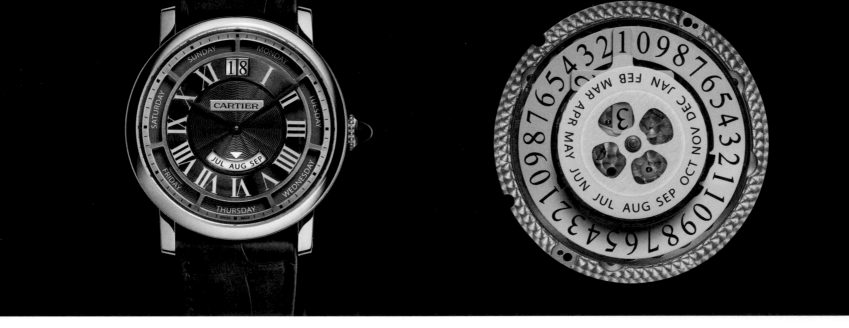

Cartier Rotonde de Cartier Annual Calendar, 2015 ∘ Cartier, annual calendar, Cal. 9908MC, under the dial ∘
Cartier Rotonde de Cartier Jahreskalender, 2015 ∘ Cartier, Jahreskalender, Kal. 9908MC, unter dem Zifferblatt

month cam (12), which is screwed to the month star to determine the length of each month; the leap-year cam (13); and the upper beak (14) and large pawl (15) of the main actuating lever.

Figure 5:

The most important part of the perpetual calendar is the month cam (12). The different lengths of the months are programmed in its circumference: raised areas represent 31-day months; notches correspond to 30-day months. It also has a circular cutout in which the leap-year cam (13) is rotated once each year through 90° by the calendar mechanism. Three of the leap-year cam's edges define the 28-day February in non-leap years; the fourth edge, which is further from the cam's center, specifies the 29-day February in leap years.

Figure 6:

The upper beak of the main actuating lever (14) glides along the month cam and constantly scans the length of the current month. In months with fewer than 31 days, the beak dips into the notches of the month cam, causing the lower end of the main actuating lever to move further to the left. At the end of these shorter months, the otherwise nonfunctional tip of the large pawl (15) falls over the step of the date cam (16), which is screwed to the date star (17). When the calendar-finger (4) triggers the main actuating lever (6), the large pawl (15) moves the date star (17) over the date cam (16) by an increment of two, three or four teeth to show first day of the new month. The month display simultaneously advances as described above.

Blocking springs (18) prevent unintentional jumping of the displays. The corrector (19) can be used to manually reset the date indicator, moon-phase display and day-of-the-week indicator, e.g. if the watch has been left unworn for a lengthier interval.

Much more or a bit less?

The Swiss watch industry is happy to help discriminating people for whom this type of perpetual calendar is not sufficiently long lasting to instill unending calendaric joy. When the Geneva-based watchmaker Svend Andersen unveiled his Perpetuel Secular Calendar in 1996, it was the first wristwatch that remained lastingly in synchrony with all the quirks of the Gregorian calendar. A far more complex innovation followed in 2009 with the Franck Muller brand's launch of the Aeternitas Mega 4, for which the Swiss master watchmaker Pierre-Michel Golay, who was born in 1935, developed an intelligent mechanism with two additional gear trains. Golay's brainchild tracks a cycle of 1,000 years. The first of the two gear trains contains one wheel each for 10, 100 and 1,000 years. This ensemble allows the indication of years even beyond a 1,000-year cycle. The second gear train relies on appropriately shaped and calculated cams to ensure that leap days are not added to secular years unless they are evenly divisible by 400. The mechanism also "knows" that a 29th day will be added to February in the years 2400, 2800, 3200, etc. It may be comforting to know this act, but considering that February 29th will not be absent from the usual four-year cycle until the secular year 2100, it seems highly unlikely that any current reader of this chapter will live long enough to witness the complication in action.

The "little brother" of the perpetual calendar is less complex but nonetheless very useful. Without manual assistance, a so-called "annual calendar" correctly tracks the lengths of 12 consecutive months from the beginning of March to the end of February. The year's shortest month can have either 28 or 29 days, so midnight on the final day of February is the only moment each year when it is necessary to manually adjust the annual calendar. Patek Philippe launched the first wristwatch of this type as Reference 5035 in 1996. Other watch brands followed suit and continued to demonstrate their creativity, so the spectrum of watches with annual calendars is now almost as wide as the range of watches with perpetual calendars.

vom Kalenderwerk einmal jährlich um 90 Grad gedreht wird. Drei seiner Kanten definieren den Monat Februar in Nicht-Schaltjahren (28 Tage); die vierte, mit größerem Abstand zum Zentrum des Nockens, den Februar mit 29 Tagen.

Abbildung 6:

Auf diesem Monatsnocken tastet der obere Schnabel des Hauptschalthebels (14) ständig die Länge des aktuellen Monats ab. In Monaten mit weniger als 31 Tagen taucht er in die Kerben des Monatsnockens ein, deshalb wird das untere Ende des Hauptschalthebels weiter nach links bewegt. Am Ende dieser Monate fällt die sonst funktionslose Spitze der großen Schaltklinke (15) über die Stufe der mit dem Datumsstern (17) verschraubten Datumsschnecke (16). Betätigt der Kalenderfinger (4) den Hauptschalthebel (6), schiebt statt der kleinen nun die große Schaltklinke (15) über die Datumsschnecke (16) den Datumsstern (17) auf einmal um zwei, drei oder vier Zähne auf den 1. des neuen Monats weiter. In der bereits dargestellten Weise wird gleichzeitig der Monat umgeschaltet. Die Sperrfedern (18) verhindern ein unbeabsichtigtes Springen der Anzeigen. Über die Korrektoren (19) lassen sich das Datum, die Mondphasen und die Tagesanzeige – z. B. nach längerem Liegen der Uhr – von Hand einstellen.

Darf es deutlich mehr oder auch etwas weniger sein?

Menschen, denen diese Art von ewigem Kalendarium immer noch zu wenig ist, verhilft die eidgenössische Uhrenindustrie gerne auch zu grenzenlosem Kalenderglück. Die erste, den gregorianischen Kalender beherzigende Armbanduhr hat der Genfer Uhrmacher Svend Andersen 1996 in Gestalt des „Perpetuel Secular Calendar" vorgestellt. Deutlich komplizierter ist die 2009 lancierte „Aeternitas Mega 4" aus dem Hause Franck Muller. Der Schweizer Meister-Uhrmacher Pierre-Michel Golay, Jahrgang 1935, hat für diese Uhr einen intelligenten Mechanismus mit zwei zusätzlichen Räderwerken entwickelt. Der folgt einem Zyklus von 1000 Jahren. Das erste der beiden Räderwerke beinhaltet je ein Rad für 10, 100 und 1000 Jahre. Dieses Ensemble gestattet die Indikation der Jahre auch über einen Jahrtausendzyklus hinaus. Das zweite bewirkt mithilfe entsprechend berechneter und geformter Nocken das Entfallen der Schalttage in allen nicht durch 400 teilbaren Säkularjahren. Gleichzeitig ist dem Mechanismus aber auch geläufig, dass 2400, 2800, 3200 etc. einen 29. Februar aufweisen werden. Das ist grundsätzlich gut zu wissen. Mit Blick auf die Tatsache, dass der 29. Februar erst im Säkularjahr 2100 wieder ausfällt, wird allerdings kein Leser eine derartige Komplikation benötigen.

Weitaus hilfreicher ist dagegen der kleine Bruder des ewigen Kalenders. Zwölf Monate ohne manuelle Nachhilfe kommt der Jahreskalender aus. Und zwar jeweils von Anfang März bis Ende Februar. Da der kürzeste Monat entweder 28 oder 29 Tage haben

kann, heißt es dann einmal Hand anlegen, um das Schaltwerk für die nächsten 365 Tage zu programmieren. Patek Philippe brachte die erste Armbanduhr dieses Typs im Jahr 1996 als Referenz 5035 auf den Markt. Weil andere Uhrenmarken dem Beispiel folgten und ihre Kreativität auch weiterhin beweisen, ist das Spektrum inzwischen fast so breit wie jenes der Armbanduhren mit ewigem Kalender.

Franck Muller Aeternitas Mega 4, 2009

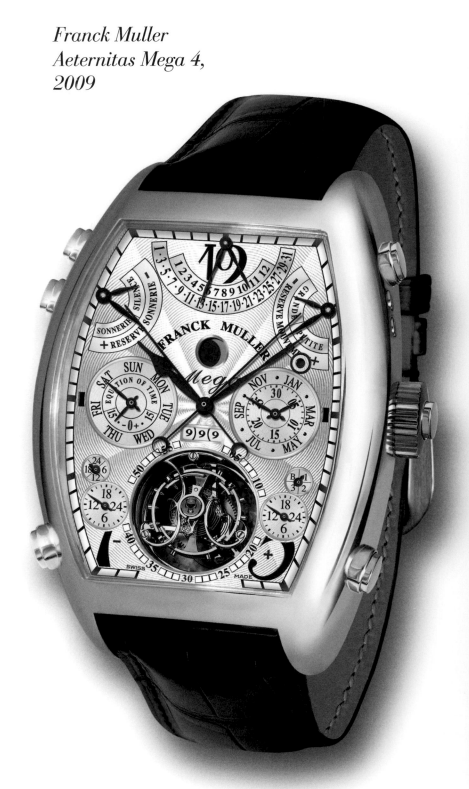

Clockwise from top left: Rolex, first Datejust, 1945 ◦ Chanel J12, ceramic, 2019 ◦ Junghans max bill Automatic Bauhaus, 2019 ◦
Chopard, date display, Cal. L.U.C 1-96, 1996 ◦ Grand Seiko, Cal. 9S27, automatic wristwatch for women, 2018 ◦
Von oben links im Uhrzeigersinn: Rolex, erste Datejust, 1945 ◦ Chanel J12, Keramik, 2019 ◦ Junghans max bill Automatic Bauhaus, 2019 ◦
Chopard, Datumsanzeige, Kal. L.U.C 1-96, 1996 ◦ Grand Seiko, Kal. 9S27, Automatikuhr für Damen, 2018

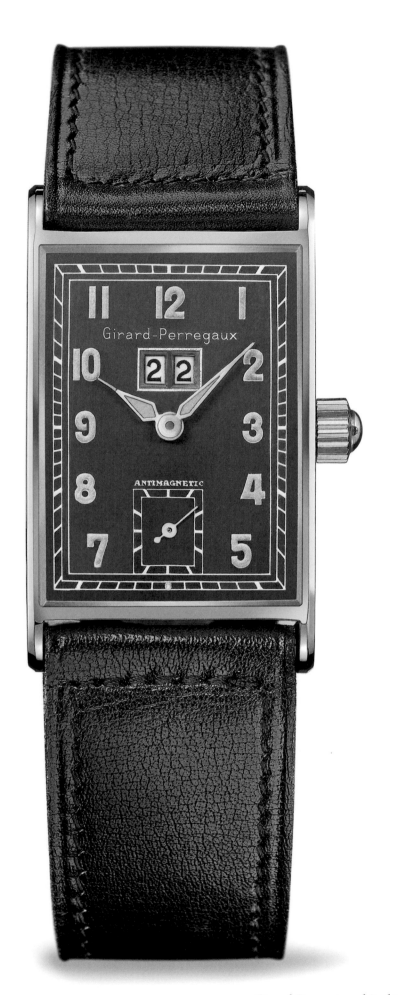

H. Moser & Cie. Venturer Big Date
Purity, Ref. 2100-0402, 2018

Girard-Perregaux, big date
Girard-Perregaux, Großdatum

01

02

03

04

05

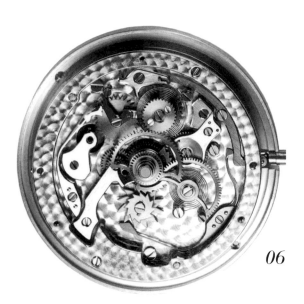

06

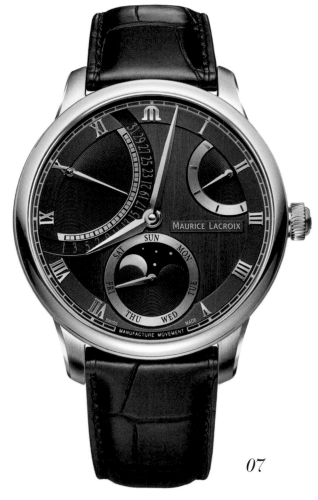

07

01. *Imexal, weekday ◦ Wochentag*
02. *Oris Big Crown Pointer Date, 80th Anniversary Edition ◦ Edition zum 80. Jahrestag, 2018*
03. *Date hands from left to right ◦ Zeigerdatum, von links nach rechts: Frédérique Constant, Enigma BMW, Mühle*
04. *Ferdinand Berthoud pocket watch, retrograde date ◦ Ferdinand Berthoud Taschenuhr, retrogrades Datum*
05. *Roger Dubuis Three Retrograde, c. 1998*
06. *Roger Dubuis, retrograde display below the dial ◦ retrograde Anzeige unter dem Zifferblatt*
07. *Maurice Lacroix Masterpiece Calendar Retrograde*

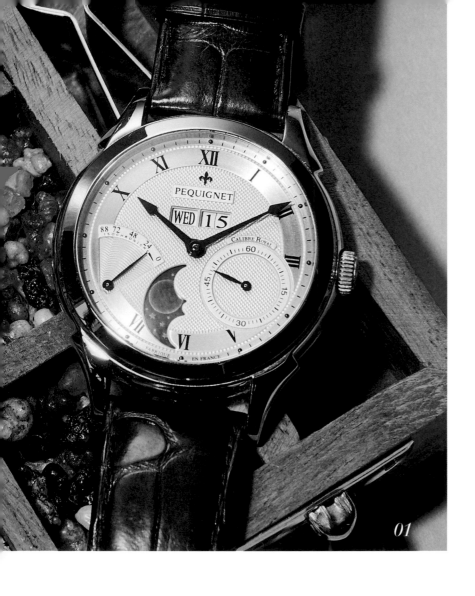

01

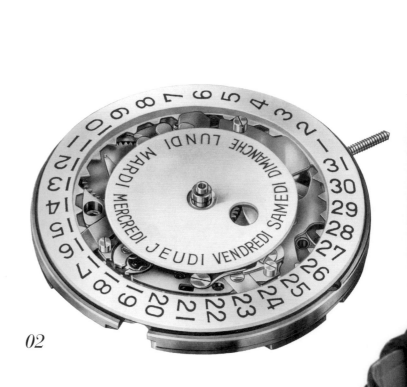

02

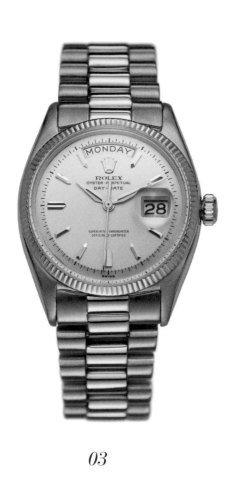

03

04

05

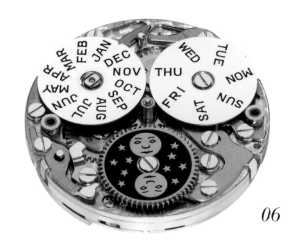

06

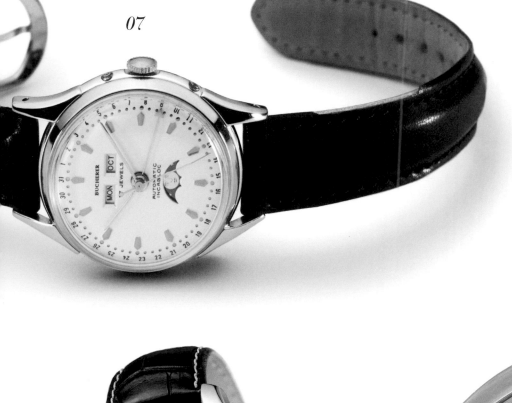

07

01. Pequignet Rue Royale
02. Felsa Day-Date, Cal. 4018
03. Rolex, 1st Day-Date, 1956
04. Sinn 103 Ti Ar
05. Tutima M2 Coastline, Ref. 6150-04
06. Blancpain, Cal. 6395
07. Carl F. Bucherer Incabloc Automatic, 1950
08. Longines Master Collection
09. Lang & Heyne Moritz

09

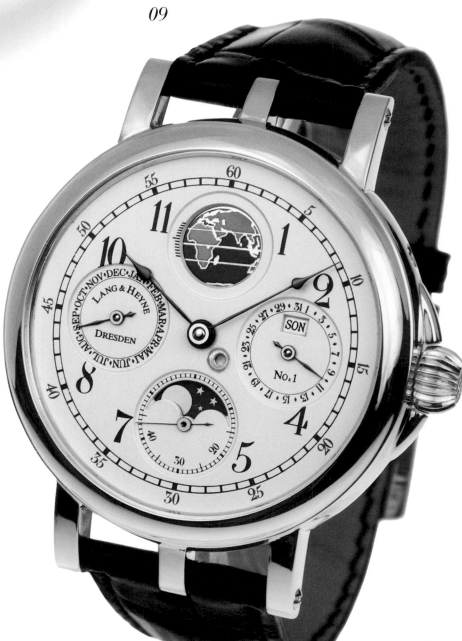

08

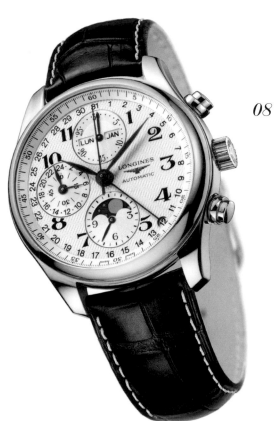

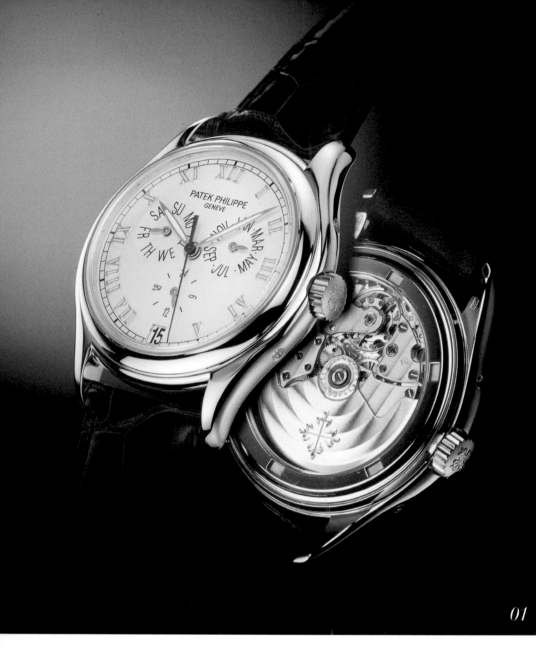

01

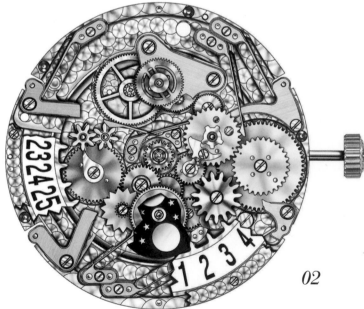

02

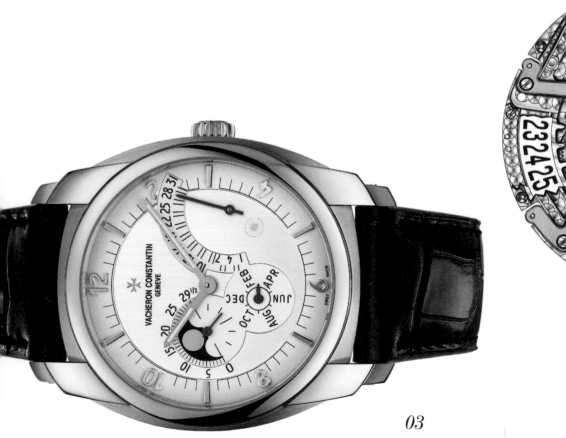

03

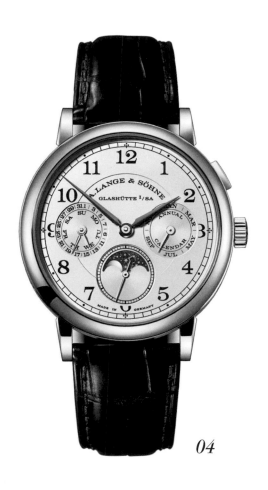

04

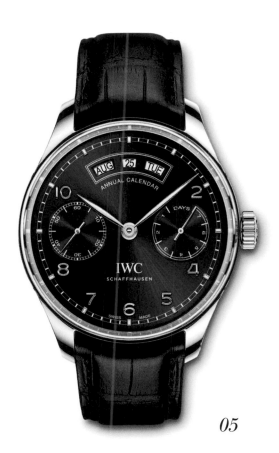

05

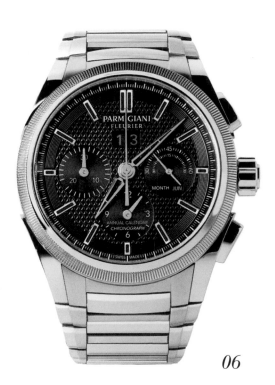

06

08

07

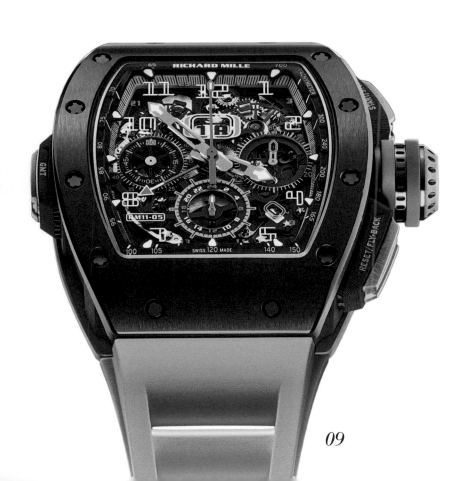

09

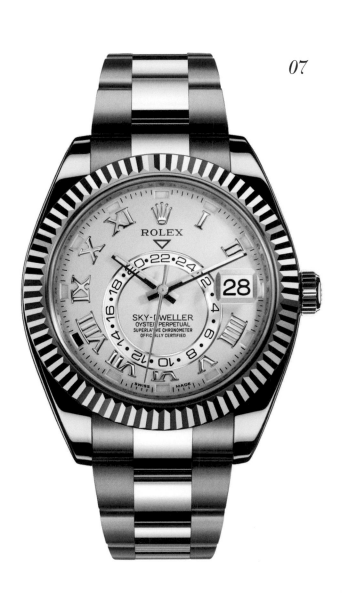

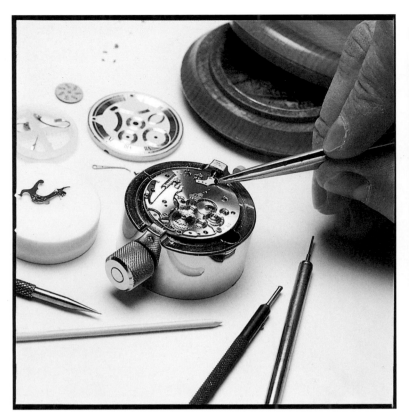

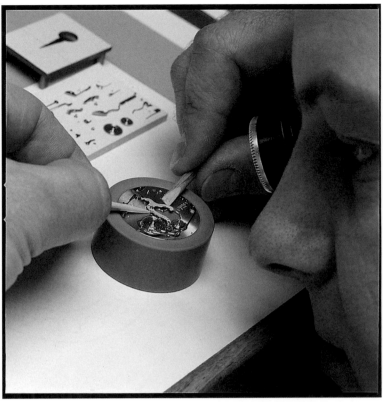

*This page, above: assembly of Lemania's perpetual calendar ◦ Diese Seite, oben: Montage eines ewigen Kalenders von Lemania
Right page ◦ Rechte Seite: MB&F Legacy Machine Perpetual, 2015*

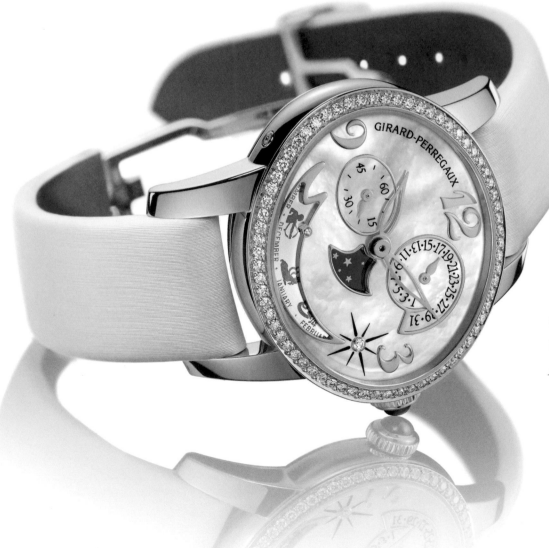

*Girard-Perregaux
Cat's Eye
Annual Calendar, 2009*

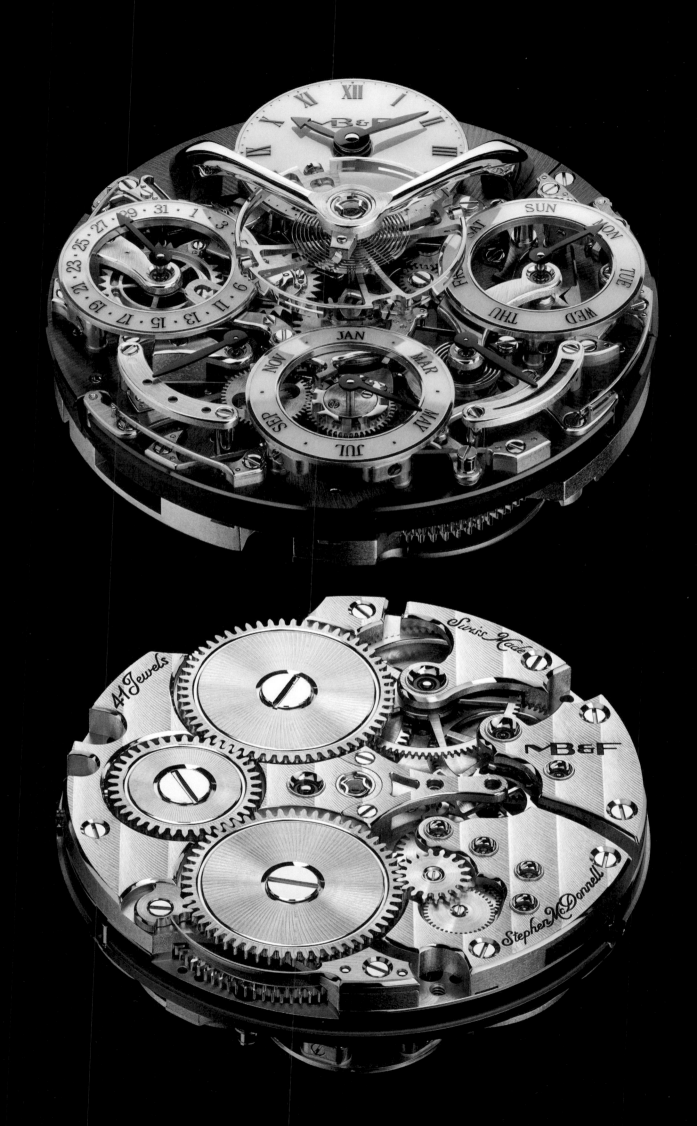

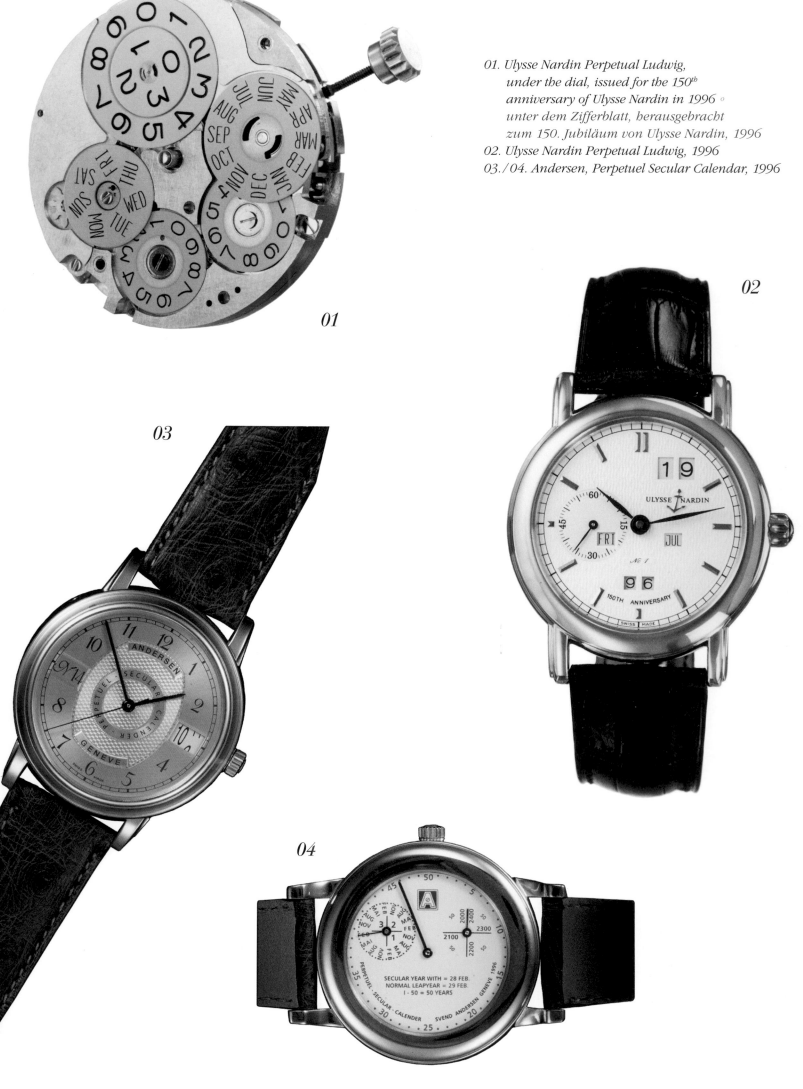

01. *Ulysse Nardin Perpetual Ludwig,*
 under the dial, issued for the 150th
 anniversary of Ulysse Nardin in 1996 ∘
 unter dem Zifferblatt, herausgebracht
 zum 150. Jubiläum von Ulysse Nardin, 1996
02. *Ulysse Nardin Perpetual Ludwig, 1996*
03./04. *Andersen, Perpetuel Secular Calendar, 1996*

01

02

03

04

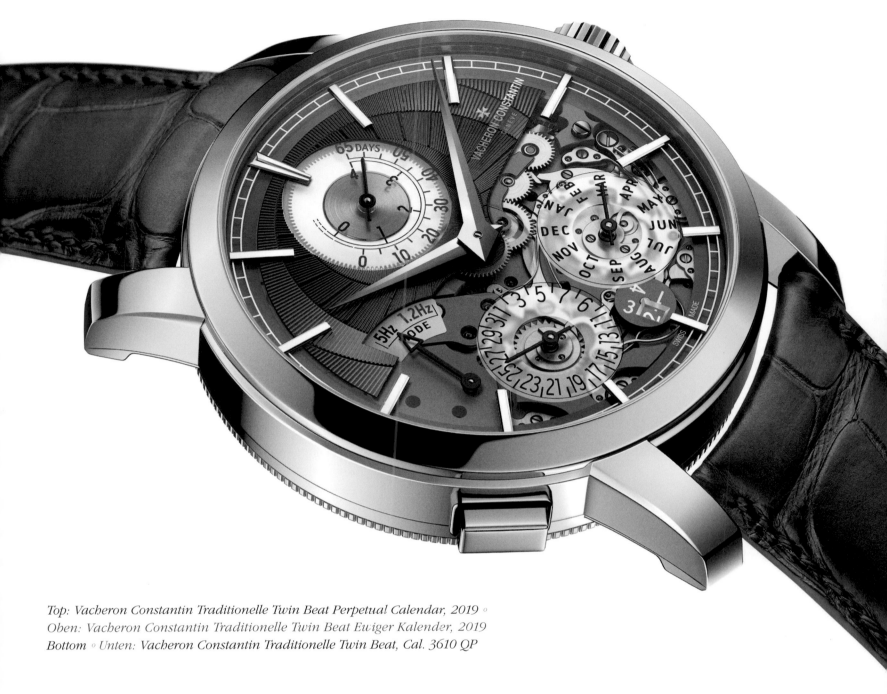

Top: Vacheron Constantin Traditionelle Twin Beat Perpetual Calendar, 2019 ∘
Oben: Vacheron Constantin Traditionelle Twin Beat Ewiger Kalender, 2019
Bottom ∘ Unten: Vacheron Constantin Traditionelle Twin Beat, Cal. 3610 QP

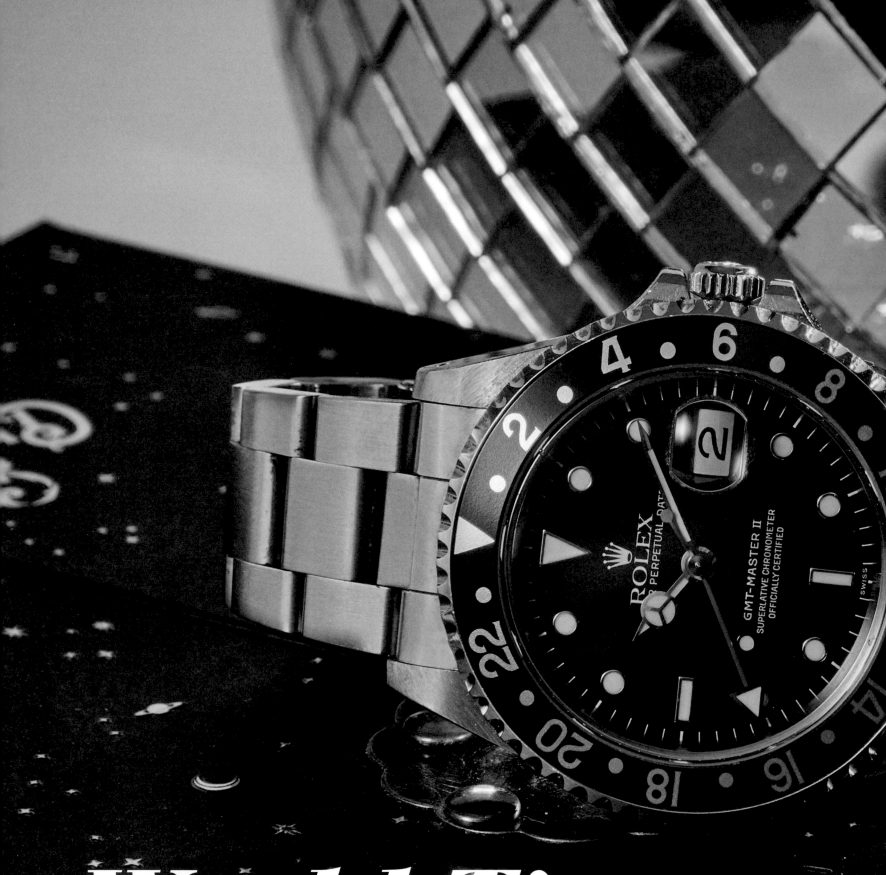

World Time
Weltzeit

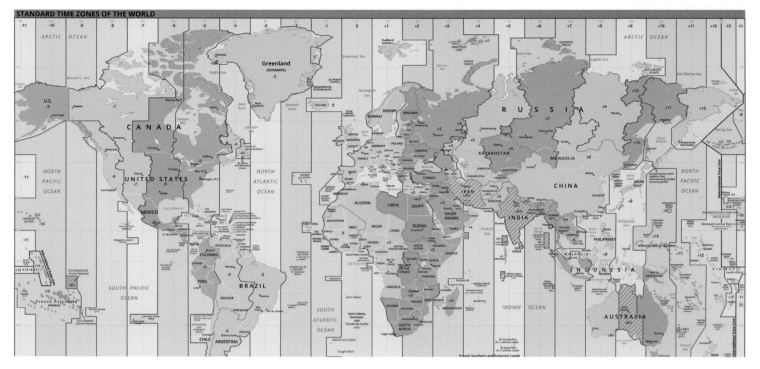

Previous pages ○ Vorherige Seiten: Rolex GMT-Master II, Ref. 16700 ○ This page: world time zones map ○ Diese Seite: Zeitzonenkarte

Time Around the Globe

A wager against time

Lady Luck and a daily newspaper ultimately rescued Phileas Fogg, whose tale begins with a daring wager at a London club. After precise strategic planning, the wealthy Briton set off on his journey *Around the World in Eighty Days*. Also involved in his adventure: his faithful valet Passepartout and a precise Breguet pocket watch. Despite meticulous chronicling, when the globe-girdling travelers returned, they thought they were one day late and had lost the bet. But the protagonist of Jules Verne's novel, which was published in 1873, had miscounted. In the heat of battle, Fogg had done his calculations without taking into account the effects of the Earth's rotation, which causes high noon to advance westward by 15° of longitude every hour. Consequently, local noon arrives in London a bit later than in Berlin. The French writer used this astronomically determined fact to keep his readers in suspense until the very last moment.

Time chaos on rails

When the German philosopher and writer David Friedrich Strauß enthusiastically reported in 1841 about his impression of "magically flying" by rail, he had no idea of the hardships that would soon beset the operators of railway networks. The problem caused by the different local times from place to place is painfully evident in a timetable of the Royal Bavarian State Railways published in 1864: "When it is 12 noon in Munich, it is 11:57 in Augsburg, 12:52 in Berchtesgaden, 11:54 in Kempten, 12:7½ in Passau, et cetera...."
A glance at an atlas reveals the geographical locations of the above-mentioned cities and the associated time dilemma. Two towns lie to the east of the Bavarian capital, the other two lie westward—and each city's local time applied to all rail traffic there. Passau's clocks accordingly showed seven and a half minutes past noon at

the selfsame moment when both hands on the clock in Munich Station pointed straight up.

The same situation prevailed on the other side of the Atlantic Ocean. Along any arbitrarily chosen parallel of latitude, compensating for the Earth's rotation required the addition of one minute to the clock for every 20 kilometers of westward travel; a corresponding subtraction was needed when traveling eastward. Railway timetables had to take into account 18 different local times along the relatively short route between Boston and the capital city of Washington, D.C. No fewer than 144 officially recognized times were valid throughout the whole of North America in the mid-19th century.

Remedy is necessary, but difficult

It was virtually impossible to lastingly assure reliable and above all safe rail transport under the jumbled circumstances described above. Special unified times, valid for entire routes or at least for larger sections, were instituted to help railway managers coordinate their timetables. There were 71 different railway times in the New World in 1873. Furthermore, the manager of a station where several lines crossed usually had to keep his eye on three different clocks: one for local time, a second for westbound trains, and a third for eastbound trains.
The situation was somewhat ameliorated in 1880 by reducing the chaos to only 44 different local times, but this didn't really solve the problem. Many towns were obliged to subordinate their clocks to the standard time at the largest city in their region, e.g. Boston, Chicago, New York or Philadelphia.
Alongside diverse inconveniences, the large number of local times also brought considerable dangers. Two trains might reckon time according to different time systems, but both ran along the same track. Accidents were almost unavoidable. Serious consequences

Zeit rund um den Globus

Wette gegen die Zeit

Am Ende halfen Phileas Fogg Genosse Zufall und eine Tageszeitung. Begonnen hatte alles mit einer gewagten Wette in einem Londner Club. Nach exakter strategischer Planung startete der vermögende Brite zu seiner *Reise um die Erde in 80 Tagen*. Mit von der Partie: sein ergebener Adlatus Passepartout und eine präzise Taschenuhr aus dem Hause Breguet. Trotz akribischer Buchführung wähnten sich die Weltreisenden nach der Rückkehr einen Tag zu spät. Dabei hatte sich der Hauptakteur des 1873 publizierten Romans von Jules Verne schlichtweg nur verzählt. Im Eifer des Gefechts hatte Fogg seine Rechnung ohne die Auswirkungen der Erdrotation gemacht. Ihr zufolge wandert der Mittag pro Stunde um 15 Längengrade in westlicher Richtung. Folglich schlägt es in London später 12 Uhr mittags als beispielsweise in Berlin. Und genau diesen astronomisch bedingten Sachverhalt nutzte der französische Schriftsteller für Spannung bis zum letzten Moment.

Zeit-Chaos auf Schienen

Als der deutsche Philosoph und Schriftsteller David Friedrich Strauß 1841 begeistert vom Eindruck des „zauberhaften Fliegens" in der Eisenbahn berichtete, ahnte er nichts von den heraufziehenden Nöten der Betreiber des Schienennetzes. Die Problematik der quasi von Ort zu Ort verschiedenen Zeiten zeigte sich am 1864 veröffentlichten Fahrplan der Königlich Bayerischen Staatseisenbahnen: „Wenn es in München 12 Uhr mittags ist, dann in Augsburg 11 Uhr 57, in Berchtesgaden 12 Uhr 52, in Kempten 11 Uhr 54, in Passau 12 Uhr 7½ usw. ..."

Schon ein kurzer Blick in den Atlas fördert die geografische Lage der genannten Städte und das damit verbundene Zeit-Dilemma ans Tageslicht. Zwei Ortschaften liegen östlich, die beiden anderen westlich der bayerischen Landeshauptstadt – und deren Ortszeit galt für den gesamten Bahnverkehr. Demzufolge zeigten die Passauer Uhren bei der Abfahrt eines Zuges siebeneinhalb Minuten nach 12 Uhr, während die Zeiger am Münchner Bahnhof beide exakt in der Senkrechten standen.

Das Gleiche spielte sich jenseits des Atlantischen Ozeans ab. Entlang eines beliebig gewählten Breitengrads verlangte die Kompensation der Erdrotation in westlicher Richtung alle 20 Kilometer nach Addition einer Minute zur vorhergehenden, ostwärts war die entsprechende Subtraktion vorzunehmen. Allein schon auf der relativ kurzen Strecke zwischen der Hauptstadt Washington, D.C. und Boston mussten die Eisenbahnfahrpläne 18 verschiedene Lokalzeiten berücksichtigen. Das ganze Nordamerika des mittleren 19. Jahrhunderts kannte 144 offiziell anerkannte Zeiten.

Abhilfe tut not, ist aber schwierig

Unter den genannten Umständen ließ sich auf Dauer logischerweise kein zuverlässiger und vor allem kein sicherer Eisenbahnverkehr gestalten. Spezielle Einheitszeiten – verfügt für ganze Strecken oder zumindest größere Abschnitte – sollten die Manager beim Koordinieren der Fahrplanabläufe unterstützen. 1873 existierten in der Neuen Welt insgesamt 71 verschiedene Eisenbahnzeiten. Darüber hinaus mussten die Leiter von Stationen, an denen sich mehrere Bahnlinien kreuzten, meist drei Uhren im Auge behalten: jene für die Zeit vor Ort sowie jeweils eine für die in westliche und östliche Richtung fahrenden Züge.

From left: Comparative Timetable ◦ Seikosha, pocket watch for railwaymen, Japan ◦
Von links: Vergleichende Tabelle US-amerikanischer Zeiten ◦ Seikosha, Eisenbahnertaschenuhr, Japan

COMPARATIVE TIME-TABLE, SHOWING THE TIME AT THE PRINCIPAL CITIES OF THE UNITED STATES, COMPARED WITH NOON AT WASHINGTON, D. C.		
NOON AT WASHINGTON, D. C.	NOON AT WASHINGTON, D. C.	NOON AT WASHINGTON, D. C.
Albany, N. Y......12 14 P.M.	Indianapolis, Ind..11 26 A.M.	Philadelphia, Pa...12 08 P.M.
Augusta Ga.......11 41 A.M.	Jackson, Miss.....11 08 "	Pittsburg, Pa.....11 48 A.M.
Augusta, Me......11 31 "	Jefferson, Mo.....11 00 "	Plattsburg, N. Y..12 15 P.M.
Baltimore, Md....12 02 P.M.	Kingston, Can.....12 02 P.M.	Portland, Me......12 28 "
Beaufort, S. C...11 47 A.M.	Knoxville, Tenn...11 33 A.M.	Portsmouth, N. H.12 25 "
Boston, Mass.....12 24 P.M.	Lancaster, Pa.....12 03 P.M.	Pra. du Chien, Wis.11 04 A.M.
Bridgeport, Ct...12 16 "	Lexington, Ky.....11 29 A.M.	Providence, R. I..12 23 P.M.
Buffalo, N. Y....11 53 A.M.	Little Rock, Ark..11 00 "	Quebec, Can......12 23 "
Burlington, N. J..12 09 P.M.	Louisville, Ky....11 26 "	Racine, Wis.......11 18 A.M.
Burlington, Vt...12 16 "	Lowell, Mass......12 23 P.M.	Raleigh, N. C.....11 53 "
Canandaigua, N.Y.11 59 A.M.	Lynchburg, Va....11 51 A.M.	Richmond, Va.....11 58 "
Charleston, S. C..11 49 "	Middletown, Ct...12 18 P.M.	Rochester, N. Y...11 57 "
Chicago, Ill......11 18 "	Milledgeville, Ga..11 35 A.M.	Sacketts H'bor, NY.12 05 P.M.
Cincinnati, O.....11 31 "	Milwaukee, Wis...11 17 A.M.	St. Anthony Falls..10 56 A.M.
Columbia, S. C...11 44 "	Mobile, Ala.......11 16 "	Salem, Mass......12 26 P.M.
Columbus, O......11 36 "	Montpelier, Vt....12 18 P.M.	St. Augustine, Fla..11 42 "
Concord, N. H....12 23 P.M.	Montreal, Can....12 14 "	St. Louis, Mo.....11 07 "
Dayton, O........11 32 A.M.	Nashville, Tenn...11 21 A.M.	St. Paul, Min.....10 56 "
Detroit, Mich....11 36 "	Natchez, Miss.....11 03 "	Sacramento, Cal... 9 02 "
Dover, Del.......12 06 P.M.	Newark, N. J......12 11 P.M.	Savannah, Ga.....11 44 A.M.
Dover, N. H......12 37 "	New Bedford, Mass.12 25 "	Springfield, Mass..12 18 P.M.
Eastport, Me.....12 41 "	Newburg, N. Y....12 12 "	Tallahassee, Fla...11 30 A.M.
Frankfort, Ky....11 30 A.M.	Newburyport, Ms..12 25 "	Toronto, Can.....11 51 "
Frederick, Md....11 59 "	Newcastle, Pa....12 01 "	Trenton, N. J.....12 10 P.M.
Fredericksburg, Va.11 58 "	New Haven, Conn..12 17 "	Troy, N. Y.......12 14 "
Fredericton, N. Y.12 42 P.M.	New London, " ...12 20 "	Tuscaloosa, Ala...11 18 A.M.
Galveston, Texas..10 49 A.M.	New Orleans, La...11 08 A.M.	Utica, N. Y......12 08 P.M.
Gloucester, Mass..12 26 P.M.	Newport, R. I.....12 23 P.M.	Vandalia, Ill......11 18 A.M.
Greenfield, " ...12 18 "	New York, N. Y...12 12 "	Vincennes, Ind....11 19 "
Hagerstown, Md...11 58 A.M.	Norfolk, Va.......12 03 "	Wheeling, Va.....11 45 "
Halifax, N. S.....12 54 P.M.	Northampton, Ms..12 18 "	Wilmington, Del...12 06 P.M.
Harrisburg, Pa....12 01 "	Norwich, Ct......12 20 "	Wilmington, N. C..11 56 A.M.
Hartford, Ct.....12 18 "	Pensacola, Fla....11 20 A.M.	Worcester, Mass...12 21 P.M.
Huntsville, Ala...11 21 A.M.	Petersburg, Va....11 59 "	York, Pa.........12 02 "

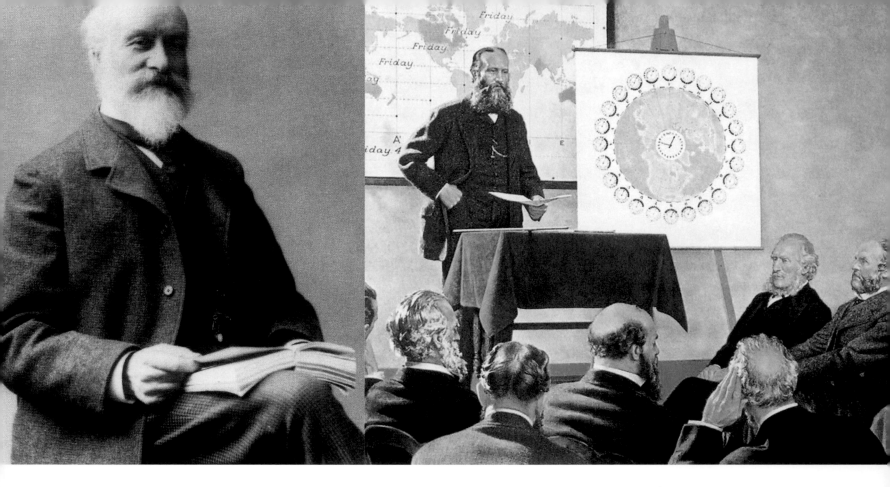

were evident even in the vastness of the oceans. No fewer than 11 nations each relied on their own nautical charts. In case of distress or other dangers, only ships flying the same flag could intelligibly compare their geographical positions. Sooner or later, there seemed to be no alternative other than the establishment of a globally coordinated time system.

A universal genius helps

Sandford Fleming is the man who deserves credit for having solved a major problem. This multitalented Canadian engineer with Scottish roots was one of the founding fathers of the Royal Society of Canada and championed the construction of a trans-Canadian railway line. His duties as chief engineer for the construction of two national railway lines led to a nervous breakdown in 1876, followed by convalescence in Ireland. While passing through the Irish village of Bundoran, the weak-nerved convalescent had to spend an uncomfortable night in the deserted railway station. Although Fleming had expected his train to depart from Bundoran at 5:35 in the afternoon, it finally left the station on schedule at 5:35 the next morning. This 12-hour delay caused Fleming to miss the connecting train to the ferry that was supposed to carry him to London, which left him with plenty of time to think things over. Why, he asked himself, do we redundantly divide each day into two sets of 12 hours designated by identical numbers for ante- and postmeridian hours? If hours were counted continuously from zero to 24, Fleming would never have suffered his misfortunate inconvenience. With these thoughts in mind, a centennial project began to take shape.

A conference and its consequences

After his return to the New World, Sandford Fleming and U.S. President Chester A. Arthur initiated the International Meridian Conference. 41 delegates from 26 nations gathered in Washington, D.C. on October 1, 1884. The attendees included representatives from Russia, various Western European countries, the USA, a number of Caribbean nations and a large part of Latin America. Japan was the sole participating Asian country. Liberia represented the African continent. The Ottoman Empire served as the delegate for the Islamic world. Most countries sent their permanent ambassador and the chief astronomer of their national observatory as representatives.

The path toward world time was in sight, but it was obstructed by fierce debates and tough negotiations. One bone of contention was the definition of the prime meridian. Many nations objected to the idea of maps that would use Greenwich to define zero degrees of longitude. France tried to make its acquiescence contingent upon Britain's agreement to switch to the metric system, but ultimately failed to assert its demand. As a result, La Grande Nation decided to use maps without the city of Greenwich and temporarily defined its own prime meridian as running through the heart of Paris. To assure that French time was synchronized with the times used elsewhere around the globe, they defined GMT as "Paris Mean Time retarded by 9 minutes and 21 seconds."

Sandford Fleming had already foreseen something like this. By establishing Greenwich as the zero point, all non-British nautical charts and maps, along with the longitudes drawn on them, would instantly become obsolete. His proposal to the French government was that the prime meridian ought to run through the middle of the Pacific Ocean, where it would not cross any nation's territory. Fleming's proposal was well-intentioned, but the International Date Line spoke against it. That important meridian would have passed right through Greenwich and accordingly given one date to Western Europe and Great Britain and a different date to the Americas.

Thus, ever since the International Meridian Conference, the world's day begins at midnight near London. The next calendar day begins in the middle of the Pacific Ocean when it is noon in Greenwich. An orderly progression is assured by 24 individual time zones,

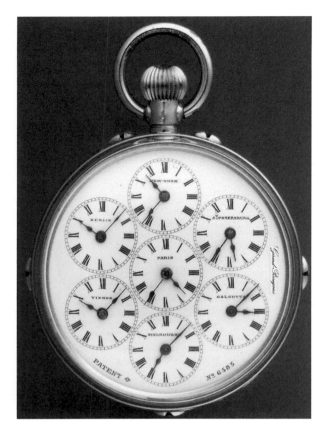

From left: Sir Sandford Fleming ◦ International Meridian Conference ◦ Girard-Perregaux, time-zone pocket watch, c. 1900 ◦
LeRoy, pocket watch with time-zone indication, 1880 ◦ Von links: Sir Sandford Fleming ◦ International Meridian Conference ◦
Girard-Perregaux, Zeitzonentaschenuhr, ca. 1900 ◦ LeRoy, Taschenuhr mit Weltzeitindikation, 1880

Durch die Beschränkung auf nur noch 44 unterschiedliche Lokalzeiten hatte sich die Lage bis 1880 zwar entspannt, aber keineswegs ins Positive gewendet. Viele Orte mussten sich der Standardzeit der größten Stadt einer Region unterordnen, also zum Beispiel Boston, Chicago, New York oder Philadelphia.

Abgesehen von zahlreichen Unannehmlichkeiten brachte die Vielzahl an Ortszeiten auch erhebliche Gefahren mit sich. Trotz unterschiedlicher Zeitsysteme verkehrten die Züge auf dem gleichen Gleiskörper. Ergo waren Unfälle praktisch unvermeidbar. Gravierende Auswirkungen zeigten sich selbst in den Weiten der Ozeane. Nicht weniger als elf Nationen nutzten eigene Seekarten. Bei Seenot oder anderen Gefahren konnten nur unter gleicher Flagge fahrende Schiffe ihre Positionen austauschen. Über kurz oder lang führte an einer global koordinierten Zeit kein Weg vorbei.

Ein Universalgenie hilft

Sandford Fleming hieß der Mann, dem die Lösung eines großen Problems zu verdanken ist. Der vielseitig begabte kanadische Ingenieur mit schottischen Wurzeln zählt zu den Gründungsvätern der Royal Society of Canada und trieb mit Verve den Bau einer transkanadischen Eisenbahnlinie voran. Die Position als Chefingenieur für den Bau zweier nationaler Eisenbahnlinien führte 1876 zu einem Nervenzusammenbruch und einem Erholungsurlaub in Irland. In der dortigen Ortschaft Bundoran musste der Genesene unbequem im menschenleeren Bahnhof übernachten. Statt wie angenommen um 5 Uhr 35 abends ging der Zug zur gleichen Zeit am Morgen. Nachdem Fleming deshalb auch den Anschlusszug zur Fähre Richtung London versäumte, hatte er viel Zeit zum Nachdenken. Eine Frage lautete, warum man den Tag in jeweils zwölf gleichlautende Tages- und Nachtstunden unterteilte. Weil Flemings Missgeschick

ihm bei fortlaufender Zählung bis 24 erspart geblieben wäre, nahm ein erdumspannendes Jahrhundertprojekt seinen Lauf.

Eine Konferenz und ihre Folgen

Zurück in der Neuen Welt initiierte Sandford Fleming zusammen mit dem amerikanischen Präsidenten Chester A. Arthur die International Meridian Conference. Am 1. Oktober 1884 versammelten sich in Washington, D.C. 41 Delegierte aus 26 Nationen. Russland und die Länder Westeuropas gehörten dazu, die Vereinigten Staaten von Amerika, einige karibische Staaten und ein großer Teil Lateinamerikas. Als einziges asiatisches Land war Japan akkreditiert. Liberia repräsentierte den afrikanischen Kontinent und das Osmanische Reich die islamische Welt. Die meisten Länder entsandten ihren ständigen Botschafter und den Chefastronomen ihres nationalen Observatoriums als Repräsentanten.

Auf dem Weg zur Weltzeit kam es während der Verhandlungen immer wieder zu heftigen Debatten. Einer der Streitpunkte war die Definition des Nullmeridians. Karten mit Greenwich als Repräsentant des nullten Längengrads passten etlichen Nationen gar nicht ins Konzept. Frankreich knüpfte seine Zustimmung an einen Wechsel Großbritanniens zum metrischen System, konnte sich aber nicht durchsetzen. Daraufhin entschied sich die Grande Nation für Landkarten ohne den Ort Greenwich. Vorübergehend ließ sie ihren eigenen Nullmeridian durch Paris laufen. Damit die französische Zeit gleichwohl mit jener der restlichen Welt übereinstimmte, setzte man sie um 9 Minuten und 21 Sekunden gegenüber Greenwich zurück.

So etwas hatte Sandford Fleming übrigens schon vorhergesehen. Durch eine Festlegung auf Greenwich würden alle nicht-britischen See- und Landkarten samt ihrer Längengrade über Nacht obsolet.

each spanning 15° of longitude. The internationally agreed time differs by one full hour from one zone to the next. Mindful of the inconvenience he had suffered in Ireland, Fleming also advocated for a continuous 24-hour count. All delegations agreed, with the sole exception of the USA, which did not want to abandon its habit of counting 12 hours before noon (a.m.) and a corresponding dozen after midday (p.m.).

A glance at a current world-time map shows that for geographical reasons alone, the boundaries of the various time zones cannot always be identical with the respective longitudes. Political interests further complicate matters. The original 24 time zones have accordingly become 37 zones, some of which were defined to promote the interests of the nation whose government decreed them.

Early time-zone timepieces

Clocks and watches that display more than just the time at one location existed even before the Meridian Conference in Washington. For example, a few creative craftsmen were already making them in the mid-19th century for people who regularly traveled between several different locations. Clients included cosmopolites and ship captains who wanted to know the time at different metropolises around the globe. These universal timepieces were accordingly equipped with two or sometimes several pairs of hands. The world-time system that would ultimately be adopted in 1884 did not yet exist, so the timepieces were furnished with keys for setting their hands to the correct minute according to the current local time. Some dials were printed with the names of preset and synchronized cities. These individual setting options did not change much in the early 20th century. The chronometric future of world time did not really get underway until the 1930s.

From Geneva to the world

What prompted Louis Cottier to turn his attention to time zones can no longer be explained retrospectively. In accordance with his training and experience, he devoted himself in his atelier to designing and fabricating complicated mechanisms, including jumping hour displays, automatons and musical mechanisms. At some point, he conceived the idea of a display that would let its user simultaneously read the times in all 24 zones from one dial.

After Cottier had completed the first prototypes, he set out find a customer. His search bore fruit at Patek Philippe in his hometown of Geneva. With Cottier's help, the family-owned company debuted its first "Heure Universelle" (or "HU") wristwatch in 1937. Its 24-hour ring was propelled by a hand-wound movement and the city names on its dial were synchronized with Greenwich Mean Time (GMT). The owner of rectangular pink gold Reference 515 could not change its display to show any other time zone. Patek Philippe and Louis Cottier soon collaborated again to rectify this shortcoming. Genuinely universal Reference 542 with its engraved rotating bezel was launched the same year. On a long-distance journey, the wearer simply positioned the current time zone at the "12." Afterwards, a glance at the dial sufficed to know the times around the globe. Reference 1415 HU, a unique watch with an integrated chronograph, was created at the request of a wealthy

Left: prototype of a time-zone dial by Emmanuel Cottier, c. 1885 ◦ *Prototyp eines Weltzeitzifferblattes von Emmanuel Cottier, ca. 1885*
Right ◦ *Rechts: Louis Cottier* ◦

Daher plädierte er zusammen mit der französischen Regierung für einen nationenfreien Nullmeridian mitten durch den Pazifik. Gegen diesen Kompromissvorschlag sprach jedoch die internationale Datumsgrenze. Sie wäre dann genau durch Greenwich gelaufen und hätte Westeuropa samt Großbritannien ein anderes Datum beschert als Amerika.

Somit beginnt der Welttag seit der Internationalen Meridiankonferenz um Mitternacht nahe London. Wenn es in Greenwich 12 Uhr mittags ist, beginnt mitten im Pazifik der nächste Kalendertag. Für Ordnung sorgten 24 jeweils 15 Längengrade überdeckende Zeitzonen. Von einer zur anderen verschiebt sich die international vereinbarte Zeit um eine ganze Stunde. Wegen seiner schlechten Erfahrungen in Irland setzte sich Fleming auch für eine durchgängige 24-Stunden-Zählung ein. Bis auf die USA, welche nicht von 12 Stunden vor (a.m.) und nach (p.m.) Mittag lassen mochten, stimmten alle Anwesenden zu.

Ein Blick auf die aktuelle Weltzeitkarte belegt, dass die Zeitzonengrenzen allein schon aus geografischen Gründen nicht exakt mit den jeweiligen Längengraden übereinstimmen können. Politische Interessen tun ein Übriges. So sind aus den ursprünglich 24 inzwischen 37 teilweise opportun festgelegte Zeitzonen geworden.

Frühe Zeitzonenuhren

Uhren, die mehr anzeigen als nur die Zeit eines einzigen Ortes, gab es bereits vor der Washingtoner Meridiankonferenz. Kreative Handwerker fertigten sie beispielsweise schon Mitte des 19. Jahrhunderts für Menschen, welche sich regelmäßig zwischen mehreren Ortschaften bewegten. Adressaten waren auch Kosmopoliten und Schiffskapitäne, die wissen wollten, was es in verschiedenen Metropolen rund um den Globus gerade geschlagen hat. Zu diesem

Zweck verfügten diese universalen Zeitmesser über zwei oder mitunter auch mehrere Zeigerpaare. Da es das 1884 beschlossene Weltzeit-System noch nicht gab, konnte die Einstellung mit Hilfe eines Schlüssels minutengenau auf die jeweilige Ortszeit vorgenommen werden. Einige Exemplare trugen auf dem Zifferblatt aber auch schon die Namen fest voreingestellter und synchronisierter Städte. An diesen individuellen Einstellmöglichkeiten änderte sich auch im frühen 20. Jahrhundert nichts Wesentliches. Die chronometrische Weltzeit-Zukunft nahm in den 1930er-Jahren ihren Lauf.

Aus Genf in die Welt

Was Louis Cottier dazu bewog, sich dem Thema Zeitzonen zuzuwenden, lässt sich retrospektiv nicht mehr aufklären. Entsprechend seiner Ausbildung und Erfahrung beschäftigte er sich im eigenen Atelier mit der Konstruktion und Herstellung komplizierter Mechanismen, darunter springende Stundenanzeigen, Automaten und Spielwerke. Irgendwann reifte auch die Idee zu einer Indikation, mit deren Hilfe Interessierte alle 24 Zonenzeiten des Globus simultan von einem Zifferblatt ablesen konnten.

Nach der Fertigstellung erster Prototypen brauchte es nur noch einen Kunden. Und der fand sich im ebenfalls in Genf ansässigen Familienunternehmen Patek Philippe. 1937 präsentierte es mit Cottiers Hilfe die erste Armbanduhr vom Typ „Heure Universelle", kurz HU genannt. Der vom Handaufzugswerk angetriebene 24-Stunden-Ring und die Städteangaben auf dem Zifferblatt waren fest mit der Greenwich Mean Time (GMT) synchronisiert. Eine Umstellung auf andere Zeitzonen konnte der Besitzer dieser rechteckigen Rotgold-Referenz 515 selbst nicht vornehmen. Aber Patek Philippe und Louis Cottier arbeiteten gemeinsam an der Beseitigung dieses Mankos. Noch im gleichen Jahr stand die wirklich universell nutzbare

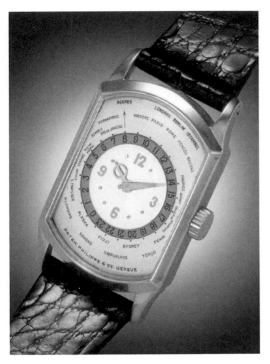 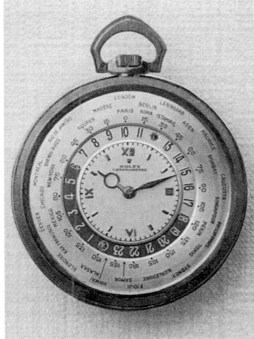 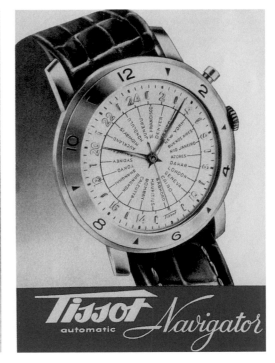

From left: Patek Philippe, first world-time wristwatch, 1937 ◦ Rolex, world-time pocket watch by Louis Cottier, 1945 ◦ ad for Tissot Navigator, 1952 ◦
Von links: Patek Philippe, erste Weltzeitarmbanduhr, 1937 ◦ Rolex, Weltzeittaschenuhr von Louis Cottier, 1945 ◦ Anzeige für Tissot Navigator, 1952

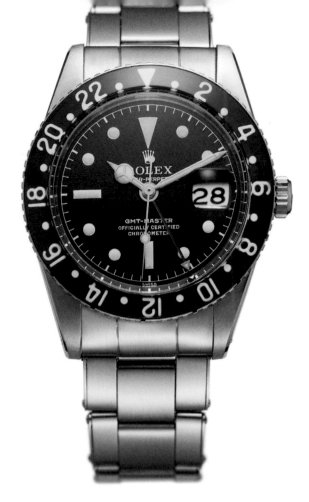

Rolex GMT-Master I, 1955

customer in 1940. Louis Cottier's clever development earned him such a fine reputation that his business outgrew its workshops and had to move to a new location elsewhere in his familiar Carouge district in 1947. Though he now occupied larger premises, he continued to make most of his prototypes entirely by hand. Renowned watch brands such as Agassiz, Rolex and Vacheron Constantin were among his clients.

It is clear that Cottier's heart beat in a special way for Patek Philippe. He consistently evolved the groundbreaking HU mechanism for the Stern family. In 1948, Louis Cottier was granted a patent for a system with an internal city-name ring that could be rotated by turning a second crown at the "9." This design found its way to the wrist with Reference 2523 HU, which debuted in 1953.

Universal is too much

Having the whole world on the wrist is all well and good, but two hour hands usually suffice: one for local time and another for home or reference time. Reduction to the essentials has less to do with saving money and much more to do with a tidily comprehensible dial. This prompted Patek Philippe and Louis Cottier to develop a relatively simple adjustment mechanism. It is based on the fact that the minute hand seldom needs resetting because nearly all time zones differ from their counterparts by full hours. Half-hour zones prevail in India and Newfoundland, for example, and quarter-hour zones are used in Nepal and New Zealand's Chatham Islands.

It is therefore quite sufficient to be able to move the hour hand forward or backward in hourly increments, independently of the minute hand. Another pioneering achievement, Patek Philippe's Reference 2597 HS, made this possible in 1959. A subsequent model debuted with a second and independently adjustable hour hand

for local time in 1962. Around 1960, Louis Cottier designed and built for Patek Philippe a below-the-dial mechanism for two wholly separate time displays. It could also handle time-zone differences of less than one full hour and thus endowed Reference 3452/1 with impressive capabilities.

Louis Cottier, the pioneer of world-time mechanisms, passed away in 1966 at the age of 71.

World-time bestsellers

Watches made by Patek Philippe traditionally sell for high prices and are accordingly reserved for a correspondingly affluent clientele. Around 1960, Sultana catered to the market in predominantly Islamic countries by offering a world-time wristwatch that was by no means inexpensive yet nonetheless considerably less costly. It had two pairs of hands to help devout Muslims punctually fulfill their daily duties of prayer. Louis Cottier created its below-the-dial mechanism, so the time-setting process was the same as for Patek Philippe's Reference 3452/1. A comparatively simple, standard, manually wound movement from Fabrique d'Horlogerie de Fontainemelon (FHF) provided the power.

Already in 1953, Tissot had introduced its world-time "Navigator" with an in-house self-winding movement. Unlike the Cottier-based HU models for Agassiz, Patek Philippe, Rolex or Vacheron Constantin, here a central city-name disc rotated through 360° every day. Other brands (e.g. Ardath) vied for customers' favor by launching wristwatches encasing a pair of small and thus separately adjustable calibers that ordinarily powered petite watches for ladies. Some wristwatches included city names or time-zone maps on their dials for visual appeal, but were not equipped with a built-in time-zone function.

Hans Wilsdorf deserves credit for creating the longest-running and best-selling world-time watch. Pan Am (Pan American World Airlines) contacted Rolex in 1953. The airline, which was very renowned at the time, wanted a reliable, robust and precise wristwatch that would enable its wearers to simultaneously read both local and reference time. Rolex's cosmopolitan and widely travelled founder sketched his basic ideas during a stay at the luxurious Hôtel Ritz in Paris. Based on these drawings, his engineers in Geneva developed the truly groundbreaking "GMT Master," which Rolex launched with the highest cosmopolitan potential as Reference 6542 in 1955.

One unmistakable feature was an additional 24-hour hand; another was a corresponding 24-hour bezel for setting and displaying the time in a second zone. The rotatable bezel contained a Plexiglas insert with printing on its underside to minimize glaring reflections. Pan Am's decision makers were so enthusiastic that they chose this practical wristwatch as the airline's official timepiece. Flight crews wore a model with a black dial; ground staff relied on a version with a white face.

When the second generation premiered in 1960, Rolex announced that 20 out of 21 aircraft navigators considered the professional features of the "GMT Master" to be particularly helpful.

A quantum leap occurred in 1982 with the "GMT-Master II," Reference 16760, whose 12-hour hand could be incrementally

Referenz 542 mit gravierter Drehlünette zur Verfügung. Bei Fernreisen wanderte die Repräsentantin der jeweiligen Zeitzone zur „12". Danach war mit einem Blick klar, was es wo rund um den Erdball gerade schlägt. In Gestalt der Referenz 1415 HU entstand 1940 auf Wunsch eines begüterten Kunden auch ein Unikat mit Chronograph. Durch seine intelligente Entwicklung verschaffte sich Louis Cottier derart hohes Ansehen, dass er 1947 seine Werkstätten vergrößern und innerhalb seines Stadtteils Carouge umziehen musste. Auch im neuen Domizil fertigte er die meisten seiner Prototypen vollständig von Hand. Zum Kundenkreis gehörten inzwischen auch Uhrenmarken wie Agassiz, Rolex und Vacheron Constantin.

Ganz offensichtlich schlug Cottiers Herz in besonderer Weise für Patek Philippe. Für die Familie Stern entwickelte er den bahnbrechenden HU-Mechanismus konsequent weiter. 1948 erlangte Louis Cottier das Patent für ein System mit innenliegendem, per zweiter Krone bei der „9" verstellbaren Städtenamen-Drehring. Ans Handgelenk fand die Konstruktion zum Beispiel in der 1953 lancierten Referenz 2523 HU.

Universal ist zu viel

Die ganze Welt am Handgelenk ist schön und gut. Aber wie schon in früheren Zeiten reichen in der Regel zwei Stundenzeiger völlig aus: einer für die Orts- und ein anderer für die Heimat- oder Referenzzeit. Bei der Reduktion auf das Wesentliche geht es weniger ums Geld als vielmehr um die Übersicht auf dem Zifferblatt. Dieses Faktum bewog Patek Philippe und Louis Cottier zur Entwicklung eines vergleichsweise simplen Verstellmechanismus. Er basiert auf der Tatsache, dass der Minutenzeiger in den meisten Fällen ohnehin bleiben soll, wo er sich gerade befindet. Nur wenige Zeitzonen weichen nämlich nicht um eine ganze Stunde von den übrigen ab. Halbstunden-Zonen gibt es beispielsweise in Indien und Neufundland, viertelstündige in Nepal sowie auf den neuseeländischen Chatham-Inseln.

Also reicht es im Grunde genommen völlig aus, den Stundenzeiger unabhängig von den Minuten schrittweise vor- oder zurückstellen zu können. Genau das konnte ab 1959 eine weitere Pionierleistung von Patek Philippe, die Referenz 2597 HS. Das Jahr 1962 brachte ein gleichfalls patentiertes Modell mit unabhängigem zweiten Stundenzeiger für die Lokalzeit. Schließlich konstruierte Louis Cottier gegen 1960 wiederum für Patek Philippe einen Unterzifferblatt-mechanismus für zwei völlig getrennte Zeitanzeigen. Sie bewältigte auch Abweichungen von weniger als einer Stunde und verhalf der Referenz 3452/1 zu ihren Fähigkeiten.

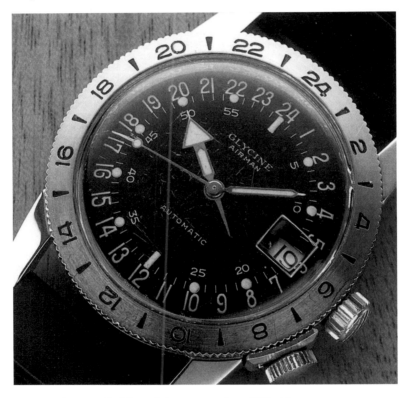

Louis Cottier, der konstruktive Weltzeit-Pionier, starb 1966 im Alter von 71 Jahren.

Weltzeit-Bestseller

Uhren von Patek Philippe haben traditionsgemäß ihren Preis und bleiben daher einem hinreichend zahlungskräftigen Publikum vorbehalten. Keineswegs billig, aber doch für deutlich weniger Geld offerierte Sultana gegen 1960 für muslimische Länder zur Erfüllung der Gebetspflicht eine Armbanduhr mit zwei Zeigerpaaren. Da der Unterzifferblattmechanismus von Louis Cottier stammte, erfolgte das Einstellen wie bei der Referenz 3452/1 von Patek Philippe. Als Antrieb diente jedoch ein vergleichsweise simples Standard-Handaufzugswerk von der Fabrique d'Horlogerie de Fontainemelon (FHF).

Schon 1953 hatte Tissot seinen Weltzeit-„Navigator" mit hauseigenem Automatikwerk vorgestellt. Im Gegensatz zu den Cottier-basierten HU-Modellen für Agassiz, Patek Philippe, Rolex oder Vacheron Constantin rotierte eine zentral angeordnete Städtenamen-Scheibe jeden Tag um 360 Grad. Andere Marken wie beispielsweise Ardath schickten Armbanduhren mit zwei kleinen und damit völlig separat einstellbaren Damenuhr-Kalibern ins Rennen um die Käufergunst. Optisch attraktiv, aber ohne Zeitzonen-funktion präsentierten sich Armbanduhren mit Städtenamen oder Zeitzonenkarten auf dem Zifferblatt.

Der bis in die Gegenwart unangefochtene Dauerbrenner und Bestseller ist Hans Wilsdorf zu verdanken. 1953 wandten sich die Pan American World Airlines, kurz Pan Am, an Rolex. Die damals sehr renommierte Fluglinie begehrte eine gleichermaßen zuverlässige wie robuste und präzise Armbanduhr zum simultanen Ablesen der Orts- und Referenzzeit. Während eines Aufenthaltes im Pariser Luxushotel Ritz skizzierte der weltgewandte und weit gereiste Rolex-Gründer seine grundlegenden Gedanken. Auf deren Grundlage entwickelten seine Genfer Techniker die wahrhaft bahnbrechende „GMT-Master". Rolex brachte die Armbanduhr mit höchstem kosmopolitischen Potenzial 1955 als Referenz 6542 auf den Markt.

Ein untrügliches Merkmal bestand in einem zusätzlichen 24-Stunden-Zeiger, das andere im dazu passenden 24-Stunden-Glasrand zum Ein- und Darstellen der zweiten Zonenzeit. In diesem Drehring befand sich zur Vermeidung störender Reflexionen eine rückwärtig bedruckte Acrylglas-Einlage.

Die Pan-Am-Manager zeigten sich derart begeistert, dass sie diese praktische Armbanduhr zum offiziellen Zeitmesser der

Previous page: Glycine Airman, with additional 24-hour hand, 1956 ◦ Vorherige Seite: Glycine Airman, mit zusätzlichem 24-Stunden-Zeiger, 1956 ◦ This page: Patek Philippe, time-zone wristwatch by Louis Cottier, Ref. 3452, 1961 ◦ Diese Seite: Patek Philippe, Zeitzonenarmbanduhr von Louis Cottier, Ref. 3452, 1961

repositioned either forward or backward by pulling the crown half-way out and then turning the button in one direction or the other. As a replacement for the elimination of its quickset mechanism, the date display reset itself either forward or backward in synchrony with the 12-hour hand. Rolex has continuously improved this model and recently equipped it with a scratch-resistant Cerachrom bezel. It thus comes as no surprise to know that customers patiently wait for delivery of their stainless steel "Oyster Perpetual GMT-Master II." After all, in return for their patience, they get to wear the mother of all professional time-zone wristwatches.

Diversity in demand

Understandably, many competitors followed in the footsteps of Patek Philippe and Rolex. These latecomers likewise wanted to profit from the fact that people were traveling farther and more frequently. Relatively little horological effort is needed to add a permanently running 24-hour hand. Two simple gears suffice. But even the independent adjustability of this hand doesn't really help globetrotters.

Most cosmopolites want to read local time as usual from the 12-hour hand, so it must be adjusted along with the minute hand. Another watch is needed for comparison to assure that the minute hand is still accurately set after the hour hand has been adjusted backwards or forwards. This is why wristwatches that encase, for example, Eta's automatic Caliber 2893-1 or 7754 are particularly well suited for duty on the wrists of bankers, stockbrokers or telephone salespeople. Jaeger-LeCoultre and Panerai, to name but two brands, equip their new movements with an independently adjustable 12-hour hand, even when the dial hosts no reference-time hand.

As Patek Philippe had done with Reference 2597 HS, some manufacturers use a time-zone mechanism with two 12-hour hands. The hand for home time should be coupled with a 24-hour indicator here. This helps wearers avoid phoning home when their families are asleep.

Would you like a little more?

In an era of frequent and spontaneous travel, many manufacturers are crowding onto the market with new time-zone wristwatches. The variety of displays is almost unlimited. Glashütte Original and Vacheron Constantin have wristwatches in their portfolios that "know" all 37 time zones. Greubel Forsey offers its customers a rotating globe. Montblanc woos would-be buyers with cambered time-zone discs. And Louis Vuitton tempts purchasers with rotating cubic elements. A. Lange & Söhne's "Lange 1 Time Zone" lets its wearer switch the display of local and home time make and forth from one pair of hands to another. Jaeger-LeCoultre's "Reverso Duoface" has dials on the front and back of its reversible case. And Patek Philippe installs world-time and minute-repeater mechanisms in a single complicated watch.

The combination of a time-zone indication and an alarm was already mentioned elsewhere in this volume. World-time watches with tourbillons are also available. Art lovers can opt for a dial adorned with a miniature enamel painting or equally extraordinary cloisonné enamel. In a nutshell: there is almost nothing that does not exist. As always, it all boils down to the depth of the purchaser's purse.

Time-zone epilogue

Now that we've reached the end of this chapter, the time has come to reveal a little secret about world time. Clever jetsetters can actually experience and relive one day in their lives twice. When crossing the 180th meridian (i.e. the International Date Line) in an easterly direction (e.g. on a flight from Japan to Hawaii), travelers can set their watches back a full 24 hours. They accordingly relive the same date a second time. But all who depart from the beautiful Pacific isles, no matter in which direction their journey may take them, inevitably lose the time they only seemingly gained.

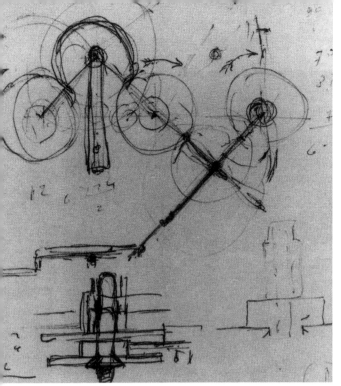

From left: drawing of Patek Philippe time-zone watch by Louis Cottier ◦ Le Phare Sultana, c. 1960 ◦ Von links: Skizze von Louis Cottier zur Patek Philippe Zeitzonenuhr ◦ Le Phare Sultana, ca. 1960

Fluggesellschaft erkoren: mit schwarzen Zifferblättern für die Flugzeugcrews und für das Bodenpersonal in Weiß.

Mit dem Start der zweiten Generation im Jahr 1960 verkündete Rolex, dass 20 von 21 Flugzeugnavigatoren die professionellen Eigenschaften der „GMT-Master" als besonders hilfreich betrachteten. Einen Quantensprung brachte 1982 die „GMT-Master II", Referenz 16760. Ihr 12-Stunden-Zeiger ließ sich per halb gezogener Krone schrittweise vor- oder zurückstellen. Als Ersatz für die wegfallende Schnellschaltung folgte die Datumsanzeige in beiden Richtungen. Seitdem hat Rolex dieses Modell kontinuierlich verbessert und zuletzt mit einem kratzfesten Cerachrom-Glasrand ausgestattet. Dass Menschen für eine stählerne „Oyster Perpetual GMT-Master II" Schlange stehen, ist somit kein Wunder. Immerhin bekommen sie die Mutter aller professionellen Zeitzonenarmbanduhren.

Vielfalt gefragt

Verständlicherweise taten es zahlreiche Mitbewerber den Marken Patek Philippe und Rolex gleich. Sie wollten ebenfalls davon profitieren, dass Menschen immer öfter und vor allem auch weiter reisten. Relativ wenig Aufwand verursacht die Ergänzung eines permanent mitlaufenden 24-Stunden-Zeigers. Zwei Zahnräder genügen. Aber auch seine unabhängige Verstellbarkeit hilft Globetrottern nicht wirklich weiter.

Weil sie die Zeit wie gewohnt vom 12-Stunden-Zeiger ablesen wollen, muss dieser samt dem Minutenzeiger verstellt werden. Damit nach dem Vorwärts- oder Rückwärtsdrehen wieder alles minutengenau stimmt, braucht man zum Vergleich eine andere Uhr. Deshalb können sich Armbanduhren beispielsweise mit den Automatikkalibern ETA 2893-1 oder ETA 7754 vor allem an den Handgelenken von Bankern, Börsenmaklern oder Telefonverkäufern optimal entfalten. Jaeger-LeCoultre und Panerai, um an dieser Stelle nur zwei Marken zu nennen, spendieren neuen Uhrwerken von Hause aus selbst dann einen unabhängig verstellbaren 12-Stunden-Zeiger, wenn kein Referenzzeit-Pendant vorhanden ist.

Wie einst schon Patek Philippe bei der Referenz 2597 HS verwenden manche Hersteller ein Zeitzonendispositiv mit zwei 12-Stunden-Zeigern. In diesem Fall sollte der für die Heimatzeit mit einer 24-Stunden-Indikation gekoppelt sein. Auf diese Weise lassen sich Anrufe zu nachtschlafender Zeit vermeiden.

Darf es etwas mehr sein?

Im Zeitalter ungestümer Reiseaktivitäten drängen viele Manufakturen mit neuen Zeitzonenarmbanduhren auf den Markt. Die Fülle an Indikationen ist beinahe grenzenlos. Glashütte Original und Vacheron Constantin haben Armbanduhren im Programm, die sozusagen alle 37 Zonenzeiten kennen. Greubel Forsey offeriert seinen Kunden einen rotierenden Globus, Montblanc bietet bombierte Zeitzonenscheiben und Louis Vuitton drehende Würfelelemente. Bei der „Lange 1 Zeitzone" ermöglicht A. Lange & Söhne das Umschalten der Anzeige von Lokal- und Heimatzeit zwischen zwei Zeigerpaaren. Die „Reverso Duoface" von Jaeger-LeCoultre besitzt Zifferblätter auf der Vorder- und Rückseite des Wendegehäuses. Patek Philippe koppelt Weltzeit und Minutenrepetition.

Die Kombination der Zeitzonenindikation mit einem Wecker fand schon an anderer Stelle Erwähnung. Weltzeituhren mit Tourbillon sind ebenfalls zu haben. Wer Kunst liebt, bekommt ein einzigartiges Zifferblatt mit Emailmalerei oder mit nicht minder feinem Cloisonné-Email. Kurzum gibt es fast nichts, was es nicht gibt. Und wie immer ist alles eine Frage des verfügbaren Budgets.

Zeitzonen-Epilog

Ganz zum Schluss sei noch ein kleines Geheimnis rund um die Weltzeit verraten. Schlaue Jetsetter können einen Tag ihres Lebens tatsächlich zweimal er- und durchleben. Beim Überqueren des als Datumsgrenze definierten 180. Meridians in östlicher Richtung zum Beispiel von Japan nach Hawaii dürfen sie ihre Uhr um ganze 24 Stunden zurückstellen. Damit gibt es diesen Tag gleich zwei Mal. Wer den schönen Ort egal in welche Richtung wieder verlässt, verliert unweigerlich die natürlich immer nur scheinbar gewonnene Zeit.

*Breitling Unitime
BR-45*

*Enicar
Sherpa Jet GMT*

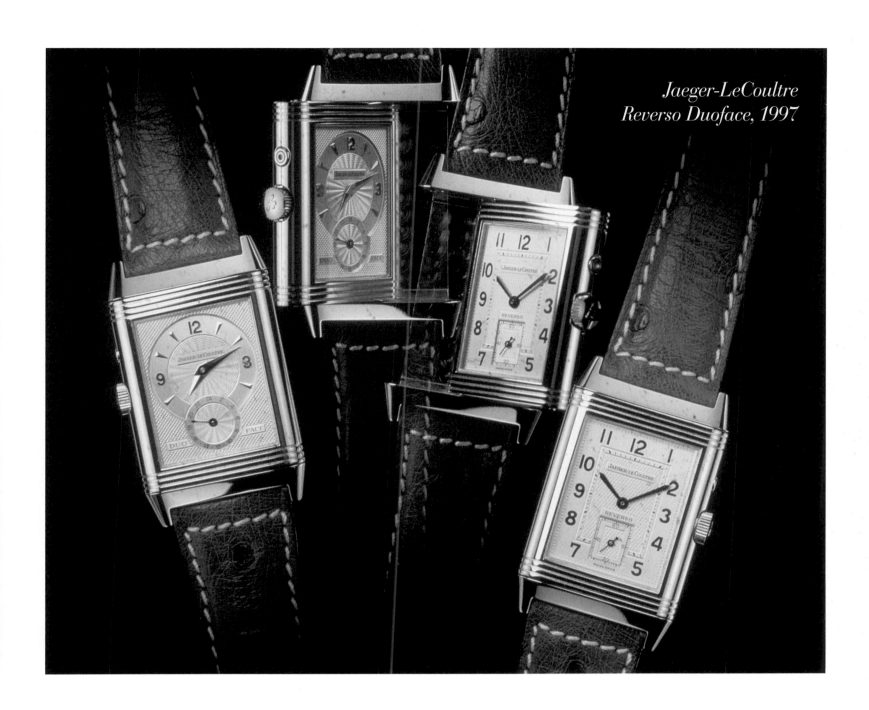

*Jaeger-LeCoultre
Reverso Duoface, 1997*

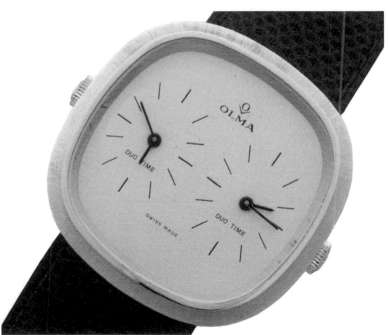

Olma Duo Time, AS 1978-2, 1970s

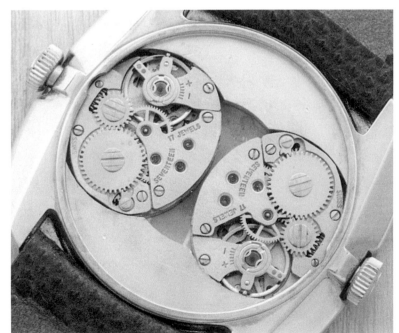

Patek Philippe,
Ref. 2597 HS, 1962

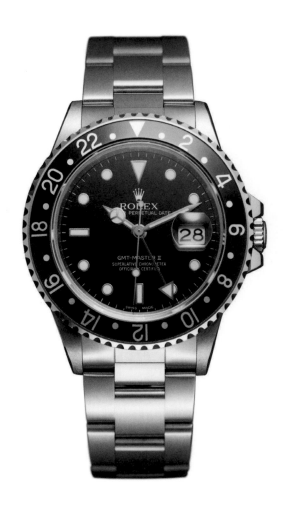

Rolex GMT-Master II,
1982

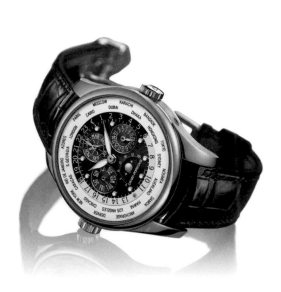

Girard-Perregaux WW.TC

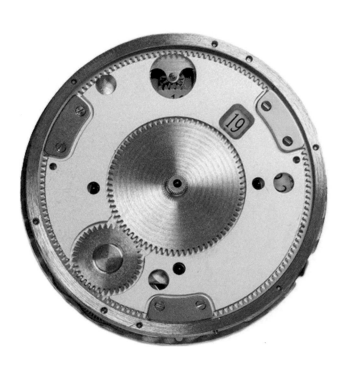

Girard-Perregaux WW.TC, under the dial ◦
unter dem Zifferblatt

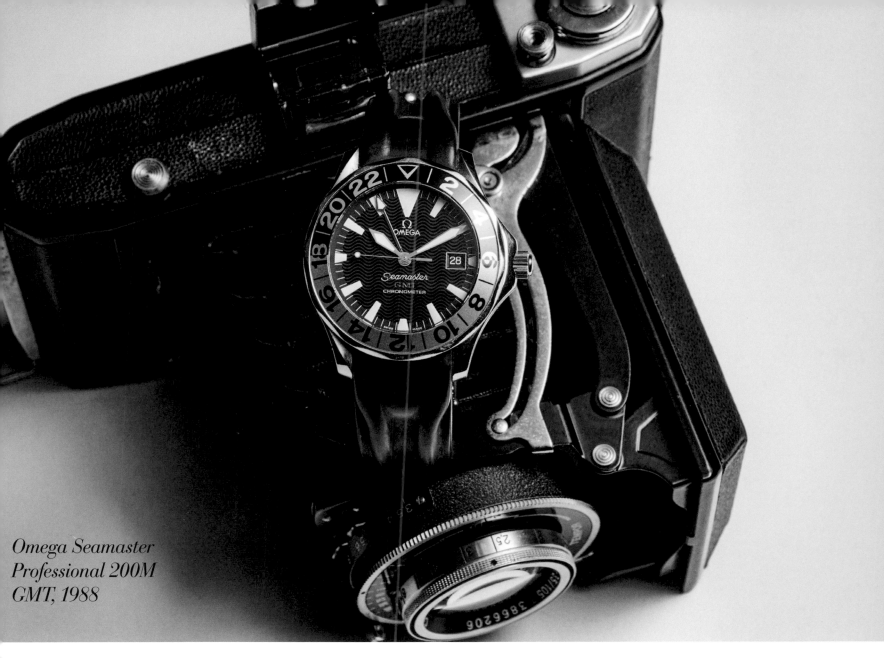

Omega Seamaster
Professional 200M
GMT, 1988

Ulysse Nardin GMT
Plus Minus

Wempe Zeitmeister
GMT, Ref. WM650011

Hublot Big Bang Unico
GMT Carbon, 2017

Oris Big Crown
ProPilot Worldtimer, Ref. 7151

Tudor Black Bay GMT,
Ref. 79830, 2018

Porsche Design 1919 Globetimer
UTC All Titanium & Blue

IWC Pilot's Watch UTC
Spitfire Edition MJ271, 2019

Previous pages ◦ Vorherige Seiten: Ebel Voyager GMT Worldtime

Jaeger-LeCoultre Master Compressor
Extreme World Chronograph Platine

Nomos Glashütte
Zürich World Time,
Ref. 805

Glashütte Original Grande
Cosmopolite Tourbillon, 2012

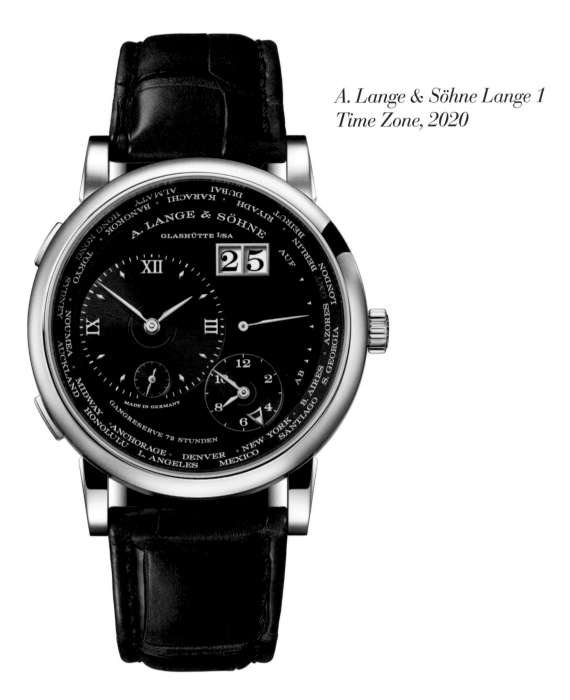

A. Lange & Söhne Lange 1
Time Zone, 2020

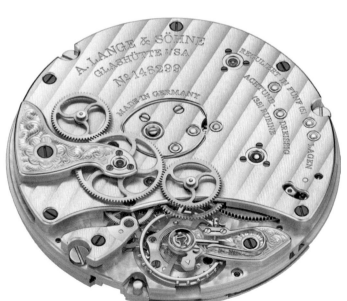

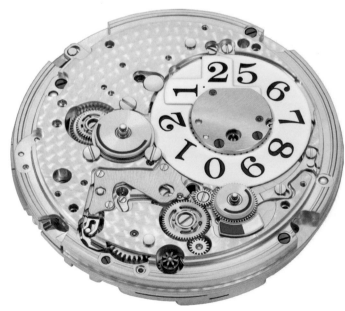

A. Lange & Söhne Lange 1 Time Zone,
Cal. L141.1, 2020

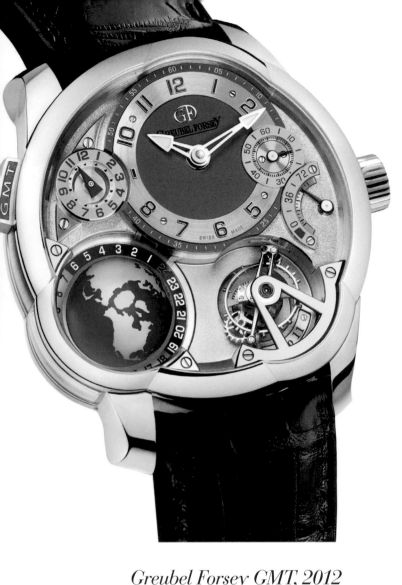

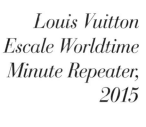

Greubel Forsey GMT, 2012

Patek Philippe Alarm
Travel Time, Ref. 5520P, 2019

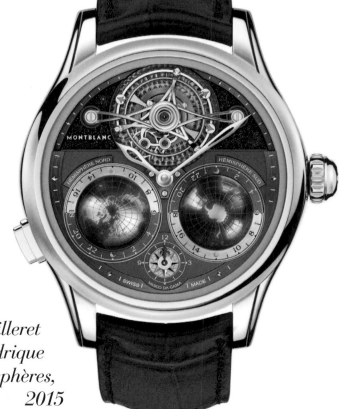

Montblanc Villeret
Tourbillon Cylindrique
NightSky Geosphères,
2015

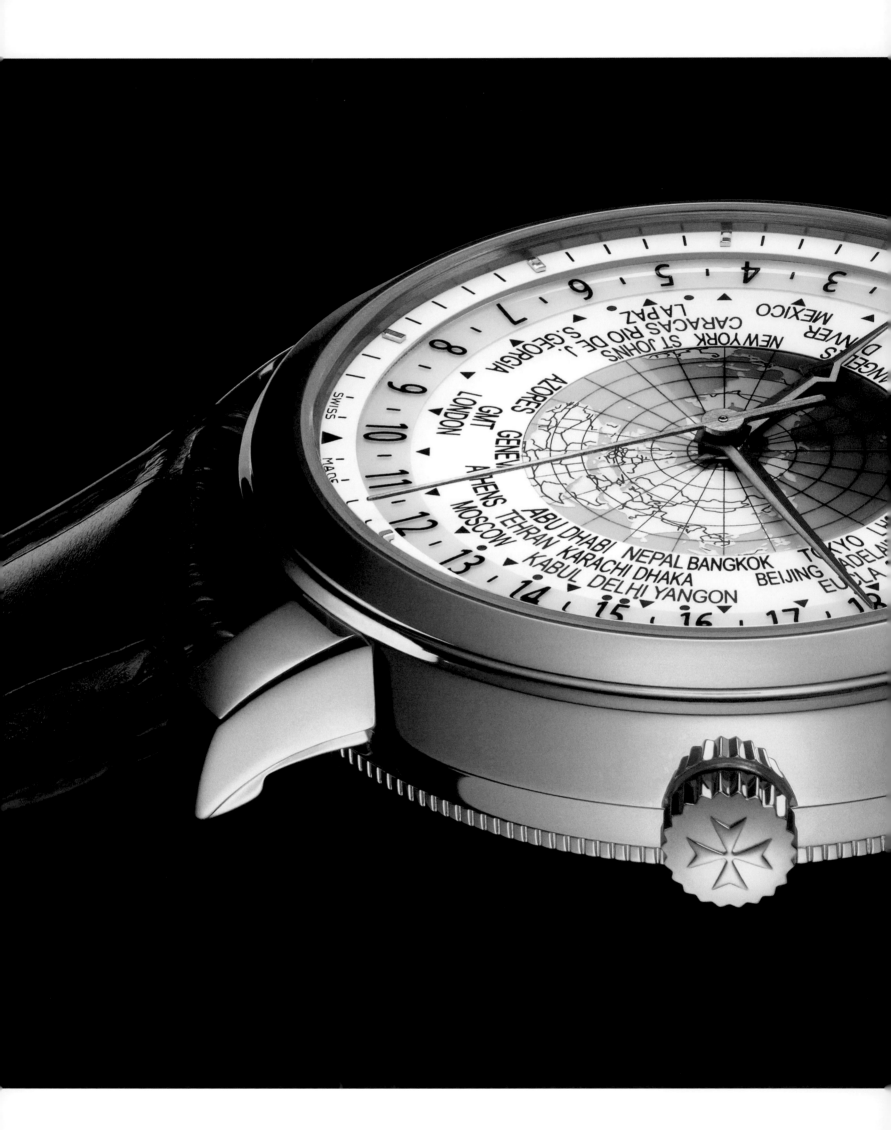

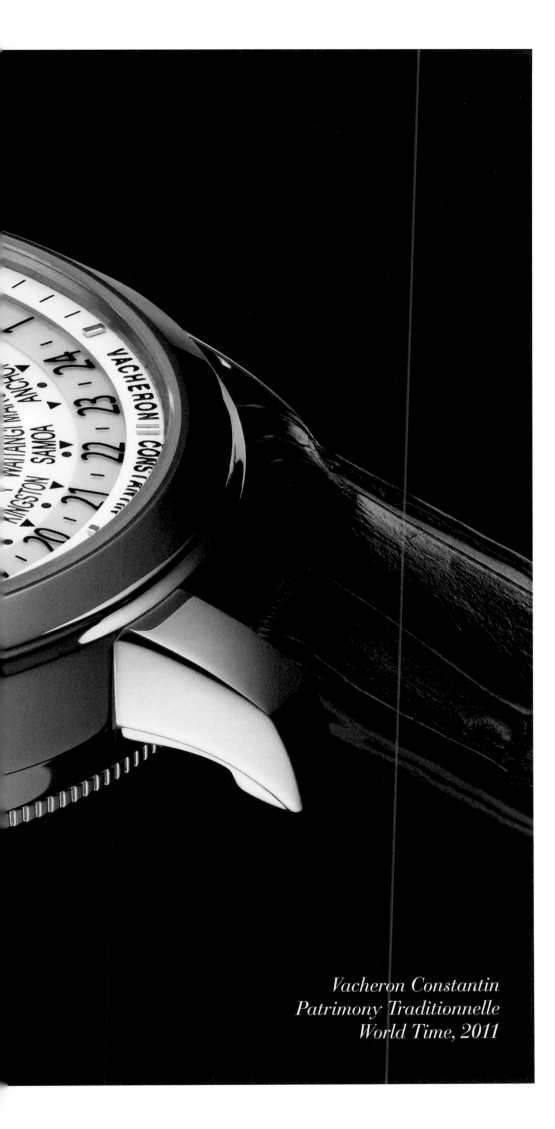

*Vacheron Constantin
Patrimony Traditionnelle
World Time, 2011*

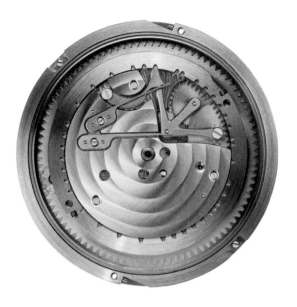

*Vacheron Constantin Patrimony Traditionnelle
World Time, Cal. 2460 WT, 2011*

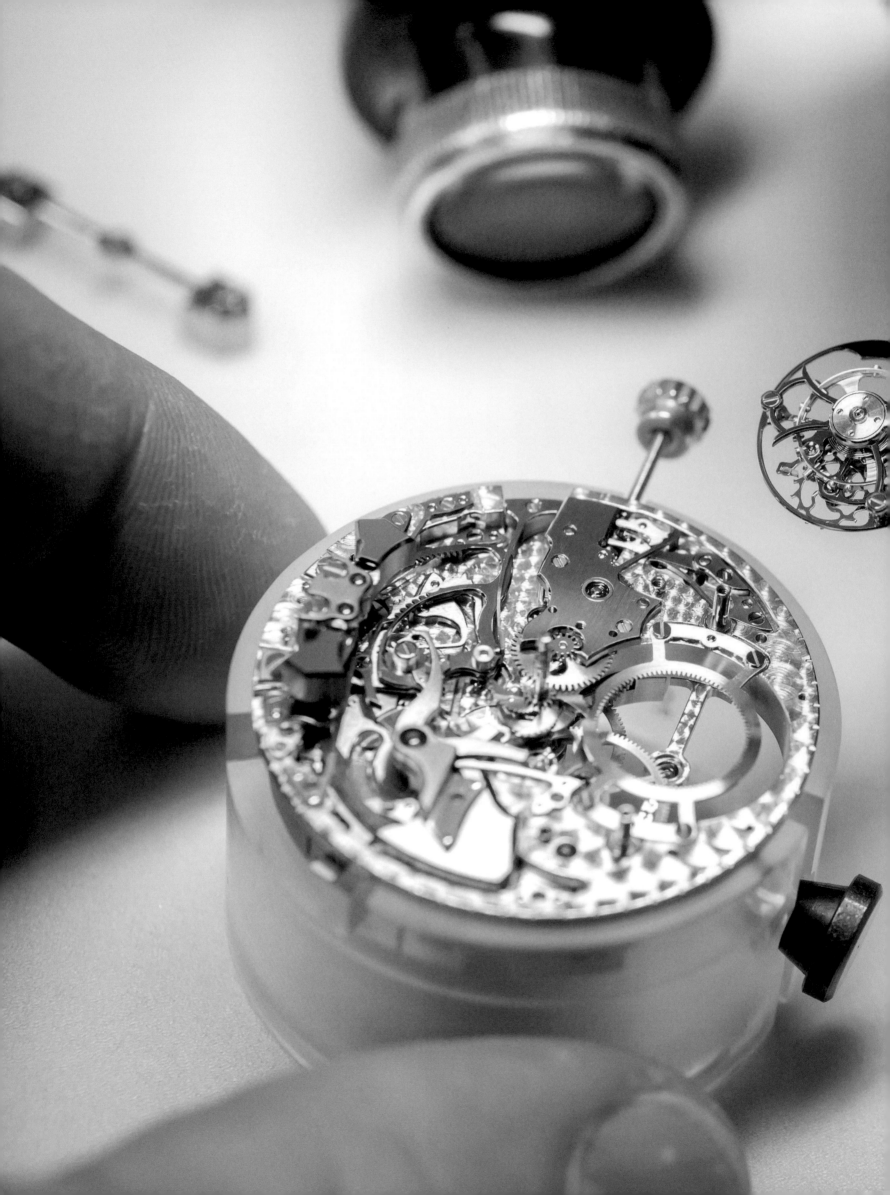

Tourbillon

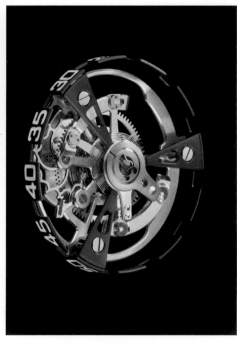

Previous pages ○ Vorherige Seiten: Girard-Perregaux Tourbillon Minute Repeater, assembly of the tourbillon cage ○ Montage des Tourbillon-Käfigs, 2016 ○ This page, from left ○ Diese Seite, von links: Bulgari Serpenti Seduttori, smallest tourbillon ○ kleinstes Tourbillon, 2020 ○ Cartier Pasha Tourbillon, Cal. 492 ○ Concord C1 Tourbillon, 2009

Ticking Whirlwinds

Whirling prologue

No doubt about it: for those who can afford it, a tourbillon is a very desirable complication in a wristwatch. Its fascination largely derives from the fact that the rotations of the ticking whirlwind typically occur in full view under a circular aperture in the dial. The tourbillon's action can thus be viewed without having to take the watch off and flip it over. But the fact that the tourbillon is in readily visible also means that it is often exposed to sunlight. This is not good for its mechanism, which depends on lubrication. In the long run, ultraviolet light decomposes the oil that is indispensable for the whirlwind's correct functioning and durability. This is why some manufacturers conceal the rotating carriage inside the case. Yet another aspect bears consideration in wristwatches. The tourbillon was developed more than two hundred years ago for pocket watches, which are usually not moved very much and are typically worn in a vertical orientation, where the beneficial effect of the tourbillon's rotations can fully make themselves felt. The situation on the wrist is entirely different. Watches fastened to this nimble joint constantly change their orientation with respect to gravity – and the ill effects of gravity are precisely what the classic tourbillon was invented to counteract. Fans of the little whirlwind certainly do not dispute this fact, but they continue to adore the tourbillon mechanism that Abraham-Louis Breguet patented in Paris more than two centuries ago. They feel pride when someone asks them about their wristwatch and its feat of precision mechanics. Unlike the tourbillon's inventor, these tourbillonophiles aren't particularly interested in to-the-second timekeeping. They simply enjoy the mechanical spectacle of its rotations. Nowadays no renowned brand can do without a tourbillon wristwatch in

its collection. The tourbillon is hailed as an expression of horological expertise, although—as the renowned master watchmaker Michel Parmigiani once said—it is much easier to fabricate than a chronograph. This is also why Chinese manufacturers are flooding the watch world with inexpensive tourbillons. But it would be a sacrilege to compare these cut-rate knockoffs with the exquisite whirling mechanisms crafted by the technicians and craftsmen of the crème de la crème de la haute horlogerie.

It all began with Abraham-Louis Breguet

It behooves us to cast a backward glance at the history of timekeeping and the biography of the tourbillon. Abraham-Louis Breguet, the mechanism's godfather, was eager to improve the precision of mechanical pocket watches and thus turned his mind to a subject which interested only a tiny fraction of the population in his era: namely, those few individuals whose depth of discernment is equal to the profundity of their purses and who cultivate a penchant for specialness. Each tourbillon pocket watch was handmade in those days, so even if they had been in greater demand, production in larger numbers would have been impossible. This is corroborated by the fact no more than approximately 500 movements with rotating carriages had been built prior to 1986, when Audemars Piguet debuted the world's first serially manufactured one-minute tourbillon wristwatch. Computer-controlled precision manufacturing of its tiny components facilitated the miniaturization needed to fabricate components for tourbillons in larger quantities, and this led to their democratization. Watchmakers subsequently finish,

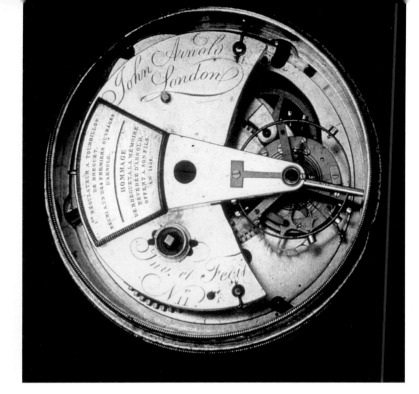

From left: Tourbillon No. 169 by Abraham-Louis Breguet, with an inscripted homage to his friend John Arnold, 1808 ○ Patent application by Breguet, 1801 ○ Von links: Tourbillon Nr. 169 von Abraham-Louis Breguet, mit einer eingravierten Widmung an seinen Freund John Arnold, 1808 ○ Patentantrag von Breguet, 1801

Tickende Wirbelwinde

Wirbelnder Prolog

Keine Frage: Für alle diejenigen, welche es sich leisten können, verkörpert das Tourbillon in Armbanduhren eine besonders erstrebenswerte Komplikation. Die Faszination resultiert nicht zuletzt auch aus der Tatsache, dass sich die unermüdlichen Rotationen des tickenden Wirbelwinds zumeist in einem kreisrunden Zifferblattausschnitt abspielen. Daher lässt sich das dynamische Geschehen am Handgelenk zu jedem Zeitpunkt beobachten, ohne dafür das gute Stück zuerst abschnallen und dann auch noch umdrehen zu müssen. Genau dieses Faktum ist jedoch alles andere als gut für die auf Schmiermittel angewiesene Mechanik. UV-Licht zersetzt nämlich auf Dauer das für einwandfreie Funktion und Langlebigkeit unverzichtbare Öl. Exakt deshalb verstecken manche Manufakturen das filigrane Drehgestell nachgerade schamhaft im Gehäuseinneren. Bei Armbanduhren gilt es zudem einen weiteren Aspekt zu bedenken. Das Tourbillon entstand vor mehr als 200 Jahren explizit für Taschenuhren, welche in der Regel wenig bewegt und vor allem in senkrechter Position getragen werde. Hier kann sich die segensreiche Wirkung des Drehgangs voll und ganz entfalten. Ganz anders sehen die Dinge am Handgelenk aus. Hier befestigte Uhren sind ständigen Lageänderungen ausgesetzt. Und genau das wirkt dem Funktionsprinzip des klassischen Tourbillons entgegen. Eingefleischte Fans dieser Zusatzfunktion ficht das freilich nicht an. Sie schwören auf das, was sich Abraham-Louis Breguet einst in Paris patentieren ließ. Und sie sind stolz darauf, wenn sie auf ihre offensichtliche feinmechanische Errungenschaft angesprochen werden. Auf die Sekunde kommt es ihnen im Gegensatz zum einfallsreichen Erfinder ohnehin nicht an. Was zählt, ist das außergewöhnliche, über jeden theoretischen Zweifel erhabene Schauspiel. Nicht ohne Grund kann heutzutage keine renommierte Marke in ihrer Kollektion auf ein Tourbillon verzichten. Es gilt als Ausdruck uhrmacherischer Kompetenz, obwohl die Realisation, wie der renommierte Uhrmachermeister Michel Parmigiani einmal erwähnte, deutlich leichter fällt als die eines Chronographen. Das ist auch der Grund, warum chinesische Hersteller die Uhrenwelt mit Billig-Tourbillons überfluten. Selbige jedoch mit dem zu vergleichen, was die Techniker und Handwerker der Crème de la Crème hervorbringen, wäre ein echtes Sakrileg.

Es begann mit Abraham-Louis Breguet

Und damit heißt es zurückblicken in die Geschichte der Zeitmessung und die Biografie des Tourbillons. Abraham-Louis Breguet, dem geistigen Vater, ging es um die Steigerung der Präzision mechanischer Taschenuhren und damit um ein Thema, welches seinerzeit nur einen verschwindend kleinen Teil der Bevölkerung interessierte. Gemeint sind Menschen mit dem nötigen Kleingeld, die schon immer das Besondere zum Maß ihrer Ansprüche machten. Nachdem jedes Stück in reiner Handarbeit entstand, war an eine größere Verbreitung auch gar nicht zu denken. Für diese These spricht auch die Tatsache, dass bis 1986, als Audemars Piguet das weltweit erste Serien-Minutentourbillon fürs Handgelenk vorstellte, gerade einmal

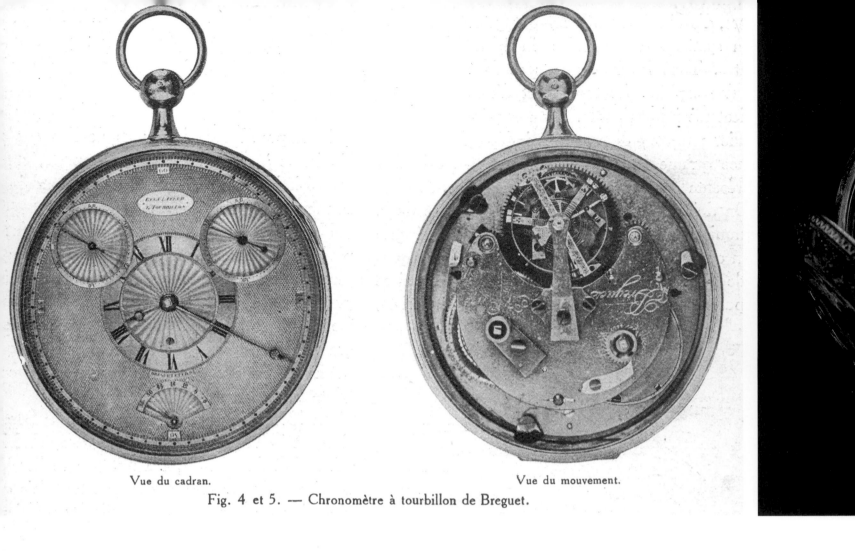

Vue du cadran. Vue du mouvement.

Fig. 4 et 5. — Chronomètre à tourbillon de Breguet.

assemble and finely adjust the whole, which, in the organism of a mechanical movement, embodies far more than merely the sum of a tourbillon's fifty or more components.

Sources of error

Even before the tourbillon, people wanted and needed to measure time with great precision. Clock- and watchmakers have been striving for progressively greater precision ever since the invention of mechanical geared clocks. The guild's members were well aware that numerous factors are detrimental to accuracy. Grappling with this problem filled many books.

Temperature ranks among the worst culprits. The metal of the rate regulator in a mechanical movement expands when warmed and contract when cooled. The 18th-century English watchmaker John Arnold was one of several researchers who sought to mitigate the ill effects of this physical phenomenon. Arnold counteracted expansion and contraction by attaching the little bimetallic strips to the balance wheel. Historians of horology credit his compatriot Thomas Earnshaw with the invention of the steel balance wheel, which was covered with brass and slit at the arms. This feat of horological legerdemain compensated for the effects of thermal factors on the length and elasticity of the balance spring, which is made of temperature-sensitive steel and is indispensable in a portable watch.

Magnetism and gravitation are the archfiends of portable timepieces. Gravity has a more or less severe influence on their rate, and especially the rate of pocket watches, which are usually worn in a vertical position. Optimal accuracy is achieved when the center of gravity of the balance and hairspring is exactly above the center of the balance staff. This is the only orientation in which no part of the oscillating ensemble is more strongly attracted towards the center of the Earth than any other part. This sounds plausible, but achieving it confronts watchmakers with a nearly insoluble task. Meticulous work enables the delicate balancing act to succeed, but the joy is short-lived because center-of-gravity errors inevitably return and detract from the timepiece's hard-won precision. These errors accelerate or decelerate the balance's rotation and the timepiece's rate suffers accordingly.

A patented invention

Irked by this problem, Abraham-Louis Breguet sought a solution. The French statesman Talleyrand aptly described this ingenious watchmaker with Swiss roots as a devil whose next stratagem could never be predicted. Thanks to Breguet's ingenuity, craftsmanship and famous name, his timepieces attracted the admiration of noblemen, clergymen and the wealthy bourgeoisie. Like his colleagues, Breguet was eager to find a way to counteract gravity's detrimental effects. He ultimately realized that it was simply impossible to permanently rid the oscillating system of center-of-gravity errors, but the master watchmaker refused to concede defeat. After protracted pondering, a clever solution came to mind: if elimination is impossible, then only compensation can succeed. But even for a genius, much effort was needed to conceive and build a mechanism that could compensate for center-of-gravity errors. It took Breguet several years before he was able to apply for a patent on his clever invention.

A letter with remarkable contents reached the French Minister of the Interior on the twenty-fourth day of the month of Floréal in the ninth year of the French revolutionary calendar. Its well-formulated sentences began with the words: "Citizen Minister, I have the honor

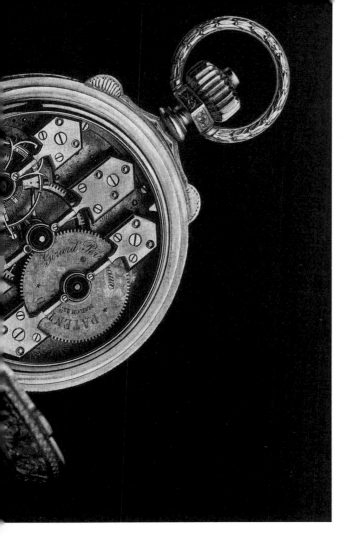

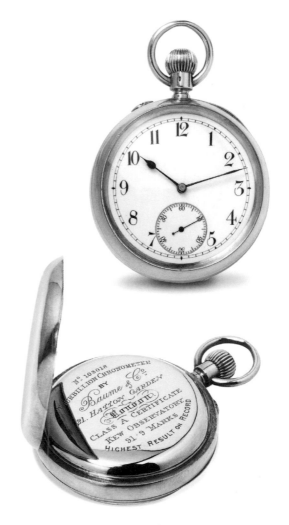

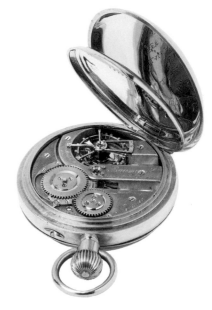

From left ◦ Von links: Breguet tourbillon ◦ Girard-Perregaux La Esmeralda Tourbillon, with the characteristic "three bridges" ◦ mit den bekannten „drei Brücken", 1889 ◦ Baume & Mercier Tourbillon Chronometer, No. 103018, 1892

500 Uhrwerke mit Drehgang entstanden. Größere Stückzahlen, damit verbunden eine Demokratisierung sowie extreme Miniaturisierung, sind insbesondere auch einer rechnergesteuerten Präzisionsfertigung der teilweise winzigen Komponenten zu verdanken. Uhrmachern obliegt danach die Feinbearbeitung, Montage und Regulierung des Ganzen, welches im Gesamtorganismus eines mechanischen Uhrwerks mehr ist als die Summe seiner gut fünfzig zusätzlichen Teile.

Fehlerquellen

Natürlich wollte und musste man die Zeit auch schon vor dem Tourbillon sehr genau messen. Im Grunde genommen bemühten sich die Uhrmacher seit der Erfindung mechanischer Räderuhren um stetig höhere Präzision. In diesem Zusammenhang war der Zunft durchaus bekannt, dass sehr unterschiedliche Faktoren der Ganggenauigkeit abträglich sind. Die Auseinandersetzung mit dieser Problematik füllte zahlreiche Bücher.

Zu den entscheidenden Störenfrieden gehört die Temperatur. Unter ihrem Einfluss dehnt sich das für den Gangregler mechanischer Uhrwerke verwendete Metall aus. Oder es zieht sich zusammen. Dieser physikalischen Gegebenheit galten beispielsweise die Forschungen des englischen Uhrmachers John Arnold, der im 18. Jahrhundert lebte. Er befestigte kleine Bimetallstreifen am Unruhreif, welche den Veränderungen entgegenwirkten. Seinem Landsmann Thomas Earnshaw schreiben Uhr-Historiker die Erfindung des mit Messing umfangenen und an den Schenkeln aufgeschnittenen Stahl-Unruhreifs zu. Dieser Kniff diente dazu, die Auswirkungen thermischer Faktoren auf die Länge

und Elastizität der in tragbaren Uhren unverzichtbaren Unruhspirale aus temperaturempfindlichem Stahl zu kompensieren. Neben Magnetismus ist die Erdanziehungskraft der größte Feind aller nicht stationären Zeitmesser. Speziell bei den meist in senkrechter Position getragenen Taschenuhren beeinflusst die Gravitation das Gangverhalten mehr oder minder stark. Optimale Genauigkeit wird dann erreicht, wenn sich der Schwerpunkt von Unruh und Unruhspirale exakt im Zentrum der Unruhwelle befindet. Nur in diesem Fall strebt keine Stelle des oszillierenden Ensembles dem Erdmittelpunkt entgegen. Was in der Theorie plausibel klingt, stellt die Uhrmacher in der Praxis vor eine nahezu unlösbare Aufgabe. Sorgfältiges Arbeiten lässt den diffizilen Balanceakt durchaus gelingen. Aber die Freude daran hält sich in zeitlich überschaubaren Grenzen. Über kurz oder lang kehren die der Präzision abträglichen Schwerpunktfehler beinahe zwangsläufig zurück. Durch das Beschleunigen oder Bremsen der Unruhrotationen gehen die Uhren schlicht und einfach falsch.

Erfindung mit Patent

Dieses Problem ließ Abraham-Louis Breguet nicht ruhen. Völlig zurecht hatte der französische Staatsmann Talleyrand den genialen Uhrmacher mit eidgenössischen Wurzeln einmal bewundernd als Teufel bezeichnet, von dem man nie wissen könne, was er als Nächstes tun werde. Wegen des Einfallsreichtums, der Qualität und des großen Namens blickten Mitglieder des Adels, Klerus und begüterten Bürgertums auf seine feinen Zeitmesser. Wie seinen Kollegen machten auch Breguet die

to present you with a note containing details of a new invention that can be used in timepieces, which I have named 'Régulateur à Tourbillon'. I hereby apply for a design patent for a period of ten years. With this invention, I have succeeded, by means of compensation, in preventing the errors caused by displacement of the movement and shifts in the center of gravity. Moreover, and to a degree far exceeding the current state of our knowledge, my invention also corrects other errors that more or less severely affect the accuracy of the timepiece's movement. After careful consideration of these advantages, with the ability to perfect the methods of production and considering the considerable costs which I have already incurred, I have decided to apply for a patent to establish the date of my invention and to compensate me for my expenses." The letter's author rejected half measures from innermost conviction, so his little whirlwind must already have been endowed with a high degree of perfection and functional reliability when he wrote the application that he submitted on May 14, 1801.

The mechanism for which Breguet sought patent protection was a very special construction. Even horological laymen could understand it relatively easily—in theory, at least. But its technical and artisanal realization was quite another story. Building it imposed the utmost demands on its craftsmen because Breguet's innovation mounted the oscillating and escapement system (i.e. the balance, hairspring, pallet anchor and escape wheel) inside or upon a delicate rotating carriage, which usually completed one rotation around its axis every sixty seconds. This constant rotation caused the center-of-gravity errors to rotate through 360 degrees, thus cyclically accelerating and retarding the motion of the vertically oriented balance in the pocket watch so that its alternately speedier and slower motions nearly cancelled each other out. In other words, the rate of a timepiece equipped with a tourbillon gained slightly during the first thirty seconds of each minute, only to lose the same amount of time during the second half of the minute. The result is an elegant zero-sum game. When the balance is in a horizontal position, all points along its circumference are equally distant from the Earth's center. Gravity, lacking a target, exerts

no detrimental effect. This is why marine chronometers, which are designed to keep time with the utmost precision, are gimbal-mounted. This assures that the balance and hairspring always oscillate in the optimal horizontal orientation, even in heavy seas.

Easier said than done

A superficial understanding of the tourbillon's functional principle as described above could lead one to conclude that less care is needed when designing and manufacturing a pocket watch equipped with a tourbillon. Nothing could be farther from the truth. Exactly the opposite is evident in horological practice. The fabrication of fine and precise tourbillon watches of the highest quality was, is and always will be reserved for a select few outstanding individuals.

Even after Breguet's death, only the best watchmakers could build tourbillons that lived up to their name and truly served their intended purpose. This elite fraternity includes Georges Favre-Bulle, Sylvian Jean-Mairet, Urban Jürgensen, Victor Kullberg, Albert Pellaton-Favre, Jämes Pellaton and Constant Girard-Perregaux. At Glashütte in Saxony, A. Lange & Söhne and Alfred Helwig, who taught at the town's watchmaking school, made names for themselves with their groundbreaking tourbillon constructions. Helwig had deepened his knowledge of chronometry at Wempe in Hamburg from 1908 to 1909 and later perfected the flying tourbillon without a front bearing bridge.

A little technology is also necessary

For the practical implementation of the original tourbillon, Breguet positioned the balance wheel in the center of the rotating cage. The bearing of the conventionally oscillating rate regulator was

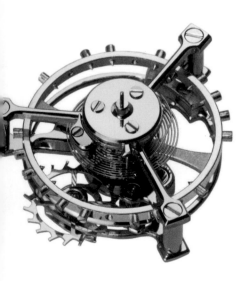 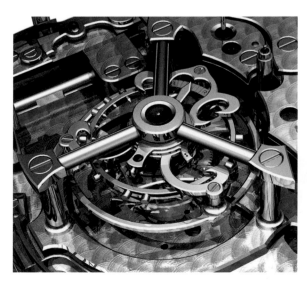 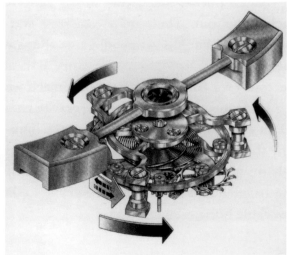

From left: Audemars Piguet, cage of a conventional tourbillon ∘ Maîtres du Temps Chapter One Tourbillon, rotating carriage with balance, 2008 ∘ Patek Philippe, tourbillon rotating carriage, 2006 ∘ Von links: Audemars Piguet, Käfig eines konventionellen Tourbillon ∘ Maîtres du Temps Chapter One Tourbillon, Drehgestell mit Unruh, 2008 ∘ Patek Philippe, Tourbillon-Drehgestell, 2006

Auswirkungen der Gravitation immer wieder zu schaffen. Irgendwann kam er sogar zu dem Schluss, dass es unmöglich sei, die leidigen Schwerpunktfehler im Schwingsystem dauerhaft zu eliminieren. Klein beigeben stand andererseits aber auch nicht zur Debatte. Nach einigem Grübeln zeichnete sich eine intelligente Problemlösung durch Kompensation ab. Fortwährender Ausgleich war jedoch selbst für ein Genie mit erklecklichem Aufwand verbunden. Deswegen dauerte es auch einige Jahre, bis Breguet seine trickreiche Erfindung endlich zum Patent anmelden konnte.

Der französische Revolutionskalender zeigte den 24. Floréal des Jahres IX, als den französischen Innenminister ein Schreiben mit bemerkenswertem Inhalt erreichte. „Bürger Minister", stand da in wohlüberlegten Sätzen zu lesen, „ich habe die Ehre, Ihnen eine Notiz zu überreichen, mit Einzelheiten über eine neue Erfindung, die bei Zeitmessern angewendet werden kann und die ich ‚Régulateur à Tourbillon' genannt habe. Hiermit beantrage ich ein Konstruktionspatent für die Zeitdauer von zehn Jahren. Es ist mir mit dieser Erfindung gelungen, mittels Kompensation die Fehler, die durch Verlagerung des Werks und Verschiebungen des Schwerpunkts entstehen, zu verhindern. Ferner behebe ich andere Fehler, welche die Genauigkeit des Werks mehr oder weniger beeinträchtigen, in einer Weise, die den bisherigen Stand unseres Wissens bei Weitem übersteigt. Nach reiflicher Überlegung dieser Vorteile und mit der Fähigkeit, die Produktionsmethoden zu perfektionieren, und in Anbetracht meiner beträchtlichen Kosten beschloss ich, ein Patent zu beantragen, um das Datum meiner Erfindung zu bestimmen und um mich für meine Auslagen zu kompensieren."

Weil der Autor Halbheiten aus innerster Überzeugung ablehnte, dürfte der kleine „Wirbelwind" beim Verfassen des am 14. Mai 1801 eingereichten Gesuchs bereits über ein bemerkenswertes Maß an Perfektion und Funktionssicherheit verfügt haben.

Das zur Patentierung eingereichte Konstrukt hatte es in der Tat in sich. Selbst uhrmacherische Laien konnten es relativ leicht nachvollziehen – gedanklich jedenfalls. Ganz anders gestaltete sich die technische und handwerkliche Umsetzung. Sie stellte an den Ausführenden höchste Anforderungen, weil Breguet das Schwing- und Hemmungssystem, also Unruh, Unruhspirale, Anker und Ankerrad in oder auf einem filigranen Drehgestell montierte. Selbiges rotierte in der Regel einmal pro Minute um seine Achse. Weil sich die Schwerpunktfehler durch diesen Kunstgriff beständig um 360 Grad drehten, hoben sich akzelerierende und retardierende Momente in senkrechter Lage der damit ausgestatteten Taschenuhr gegenseitig weitgehend auf. Mit anderen Worten: Der mit einem Tourbillon ausgestattete Zeitmesser ging 30 Sekunden vor und in der zweiten Minutenhälfte um den gleichen Wert nach. Folglich konnte man von einem wirksamen Nullsummenspiel sprechen. Bei waagrechter Unruhlage spielt die Gravitation mangels Angriffsfläche übrigens keine Rolle. Aus diesem Grund sind die Uhrwerke bei den auf bestmögliche Präzision getrimmten Marinechronometern kardanisch aufgehängt, sodass Unruh und Unruhspirale auch bei starkem Seegang immer in der optimalen Flachlage schwingen.

Leichter gesagt als getan

Das beschriebene Funktionsprinzip des Tourbillons könnte bei oberflächlicher Beschäftigung den Schluss nahelegen, dass man bei Konstruktion und Herstellung entsprechender Taschenuhren weniger Sorgfalt aufwenden müsse. Aber das wäre ein Trugschluss. In der uhrmacherischen Praxis zeigt sich genau das Gegenteil. Die Anfertigung feiner und präziser Drehganguhren auf höchstem Niveau war, ist und bleibt nur wenigen Menschen vorbehalten.

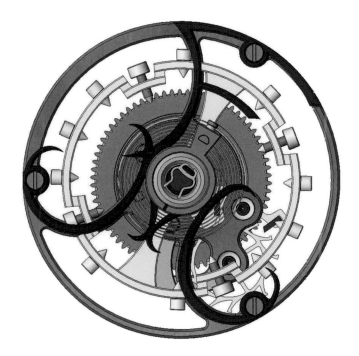 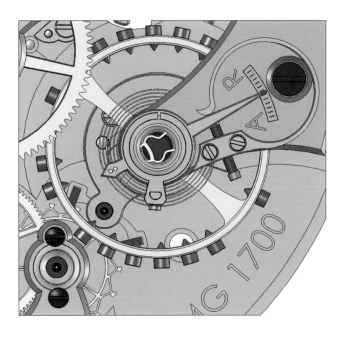

From left: Franck Muller, tourbillon versus classic balance rate regulator ◦ Von links: Franck Muller, Tourbillon versus klassischer Unruh-Gangregler

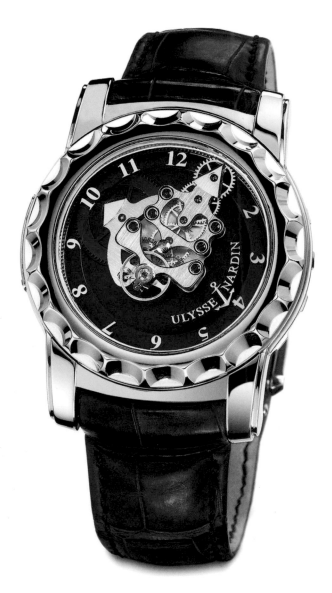

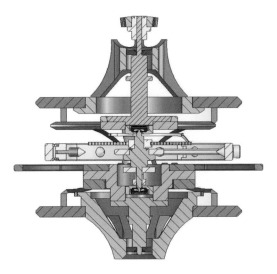

Franck Muller, classic tourbillon
klassisches Tourbillon

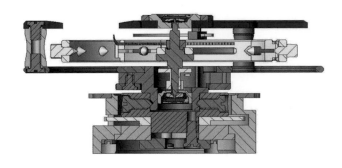

Franck Muller, flying tourbillon
fliegendes Tourbillon

Ulysse Nardin Freak,
Ref. 010-88, 2001

also accomplished in the traditional manner by means of a shaft, which culminated at each end in a pivot that rotated in a pierced jewel. Breguet also used a shaft to mount the turning carriage.

The pinion of the escape wheel protruded slightly from the bottom of the rotating cage. The second wheel pinion was attached at the center of the cage's underside. The fourth wheel was screwed rigidly and concentrically to the lower plate. As the last mobile component of the normal gear train, the third wheel set the fourth wheel in motion, thus propelling the tourbillon. The leaves of the escape wheel's pinion meshed with the teeth of the fixed fourth wheel. The rotations of the tourbillon cage left these with no option other than to roll continually, thus turning the escape wheel and maintaining the balance's oscillations in the usual manner via the lever and its fork. This arrangement ensures that the escapement and balance rotate continuously through 360 degrees.

Alternatives to the tourbillon

Ambitious watchmakers modified the mechanism as the centuries passed. Their aim was to improve and simplify the tourbillon. Incidentally, it makes no difference whether the balance inside the tourbillon oscillates centrally or eccentrically: central positioning requires a specially shaped pallet anchor with a lateral fork;

eccentric positioning calls for a classical pallet anchor. The latter arrangement sometimes tempts people to suppose that this is a carousel rather than a tourbillon. This distinction, however, does not depend on the location of the balance inside the rotating cage, but on its power source. In a tourbillon, the rotation of the cage is indispensable for the balance's oscillations and thus for the functioning of the timepiece. In a carousel, the movement continues to run merrily along even if the rotating cage is halted.

A clearly visible and by no means marginal difference in tourbillon constructions can be credited to Alfred Helwig, the German master watchmaker who invented the "flying" bearing for the little whirlwind. His innovation probably debuted in 1922 in a pocket watch with the number 3022. There is no bearing bridge at the front to obstruct the view of the horological spectacle, so the tourbillon seems to "fly" or float freely in its allotted space. Of course, even the instructor at the school of watchmaking in Glashütte could not magically defy the laws of physics. His flying tourbillon requires two bearings, but they are concealed on the underside of the rotating cage. As in earlier mechanisms, the power is provided by the leaves of a pinion, which is mounted on the long rearward shaft of the rotating cage. Because of its elongated construction, watchmakers sometimes use the word "tower" to denote the removable bearing of a flying tourbillon. Screwed to the plate, the tower requires a little trick from its disassembler: the rear bearing plate

Ergo waren auch nach dem Ableben Breguets nur Spitzenkräfte in der Lage, Tourbillons so zu realisieren, dass sie ihrem Namen alle Ehre machten und den intendierten Zweck auch tatsächlich erfüllten. Zum elitären Zirkel gehörten unter anderem Georges Favre-Bulle, Sylvian Jean-Mairet, Urban Jürgensen, Victor Kullberg, Albert Pellaton-Favre, Jämes Pellaton und Constant Girard-Perregaux. Im sächsischen Glashütte machten sich vor allem A. Lange & Söhne sowie Alfred Helwig, seines Zeichens Lehrer an der dortigen Uhrmacherschule, durch bahnbrechende Tourbillon-Konstruktionen einen Namen. Letzterer hatte von 1908 bis 1909 bei Wempe in Hamburg seine Kenntnisse auf dem Gebiet der Chronometrie vertieft und das fliegende Tourbillon ohne vordere Lagerbrücke vervollkommnet.

Ein wenig Technik muss auch sein

Zur praktischen Umsetzung des Ur-Tourbillons an dieser Stelle nur so viel: Breguet ordnete die Unruh im Zentrum des Drehgestells an. Die Lagerung des wie üblich oszillierenden Gangreglers erfolgte auf bewährte Weise mit Hilfe einer Welle, deren beide Zapfen in Lochsteinen drehten. Auch das Drehgestell lagerte Breguet mit Hilfe einer Welle.

Ankerrad- oder Hemmungstrieb ragten unten ein wenig aus dem Drehgestell heraus. Auf der Unterseite im Zentrum hatte der Meister auch den Sekundentrieb befestigt. Und das zugehörige Sekundenrad war starr und konzentrisch dazu mit der unteren Platine verschraubt. Somit setzte das Kleinbodenrad als letztes Mobile des normalen Räderwerks den Sekundentrieb und damit auch das Drehgestell in Bewegung. Die Zähne des Hemmungstriebs griffen in diejenigen des fixierten Sekundenrads. Bedingt durch die Rotationen des Drehgestells blieb ihnen gar nichts anderes übrig, als permanent abzurollen, das Ankerrad zu drehen und die Unruhschwingungen auf übliche Weise über den Anker mit seiner Gabel aufrechtzuerhalten. Dass Unruh und Hemmung bei dieser Anordnung kontinuierlich um 360 Grad rotieren, mag sich von selbst verstehen.

Alternativen zum Tourbillon

Natürlich modifizierten ehrgeizige Uhrmacher das oben Beschriebene im Laufe der folgenden Jahrhunderte mit schöner Regelmäßigkeit. Ihnen ging es darum, das Tourbillon zu verbessern, aber auch zu vereinfachen. Keinen Unterschied macht es übrigens, ob die Unruh im Käfig mittig oder außermittig oszilliert. Die zentrale Anordnung bedingt einen speziell geformten Anker mit seitlicher Gabel. Hingegen verlangen Drehgangkonstruktionen mit dezentral positionierter Unruh nach einem klassischen Anker. Letztgenannte Konstruktionen verleiten Unkundige gelegentlich zur Feststellung, dass es sich um ein Karussell und nicht um ein Tourbillon handele. Diese Unterscheidung hängt jedoch nicht vom Platz der Unruh im Drehgestell ab, sondern von der Antriebsform. Bei Tourbillons sind die Rotationen des Käfigs unabdingbare Voraussetzung für die Unruhschwingungen und damit für die Funktion des Ganzen. Hingegen läuft das Uhrwerk beim sogenannten Karussell trotz angehaltenem Drehgestell munter weiter.

Ein deutlich sichtbarer und deshalb keineswegs marginaler Unterschied bei Tourbillon-Konstruktionen ist Alfred Helwig zu verdanken. Der deutsche Uhrmachermeister ersann die „fliegende" Lagerung des Drehgestells. Diese gab vermutlich 1922 in einer Taschenuhr mit der Nummer 3022 ihren Einstand. Hier stört keine vorderseitige Lagerbrücke den Blick auf das uhrmacherische Schauspiel. Es schwebt oder „fliegt" sozusagen im Raum. Natürlich konnte auch der Lehrer an der Glashütter Uhrmacherschule nicht zaubern. Sein „fliegendes" Tourbillon verlangt ebenfalls nach zwei Lagern. Selbige verstecken sich jedoch auf der Unterseite des Drehgestells. Wie gehabt erfolgt der Antrieb auch hier über einen Zahntrieb, befestigt auf der langen hinteren Welle des Drehgestells. Wegen des langgestreckten Aufbaus bezeichnen Uhrmacher die abnehmbare Lagerung fliegender Tourbillons mitunter als Turm. Er ist mit der Platine verschraubt und verlangt beim Montieren nach einem Trick. Zuerst muss die hintere Lagerplatte entfernt werden. Anschließend lässt sich der im Presssitz befestigte Sekundentrieb abziehen.

So oder so erfordern Arbeiten am filigranen Tourbillon die nötige Durchdringung der Materie, extreme Sorgfalt und ein Höchstmaß an handwerklichem Geschick. Nur dann stellt sich die beabsichtigte Ganggenauigkeit ein. Nachlässigkeit oder Mängel in der Konstruktion führen dazu, dass sich Uhren mit Tourbillon ihren konventionell ausgeführten Geschwistern ohne Drehgang in Sachen Präzision geschlagen geben müssen. Selbst für Spitzenkräfte ihres Metiers stellten Tourbillons als uhrmacherische Delikatessen immer schon eine immense Herausforderung dar. Dementsprechend rar und teuer waren die weitestgehend von Hand gefertigten Tourbillon-Taschenuhren. Bei Sammlern gehören diese raren Prachtstücke zu den ganz großen Favoriten.

Fehlanzeige am Handgelenk

Wie eingangs schon erwähnt, sind Tourbillons in Armbanduhren eher eine Augenweide denn Garanten für höhere Ganggenauigkeit. Ständige Bewegungen und Lageveränderungen am Unterarm führen das Tourbillon-Prinzip eigentlich ad absurdum. Beim Blick in die Geschichte des ans Handgelenk geschnallten Zeitmessers zeigt sich, dass Tourbillons bis in die 1940er-Jahre überhaupt kein Thema waren. Warum auch? Frauen dominierten das Geschehen rund um die Armbanduhr nicht zuletzt aus modischen Gründen, und Männer ließen nur ungern von ihrer Taschenuhr.

Tourbillons für Wettbewerbe

Erst im Jahr 1945 entdeckten die Genfer Familienmanufaktur Patek Philippe und der dort tätige Spezialist André Bornand das Potenzial des Drehgangs. Aber nicht für den Alltag, sondern für die jährlich stattfindenden Chronometerwettbewerbe der Kategorie D. 1949, 1951 und 1953 nahm ein rundes Taschenuhrwerk mit 30 Millimetern Durchmesser und Anker-Tourbillon mit

must be removed first; the friction-fit second wheel pinion can be extracted afterwards.

Working on a tourbillon demands thorough familiarity with the subject, great care and skillful craftsmanship. All three are essential to achieve the intended accuracy of the timepiece's rate. Carelessness or a flaw in the tourbillon's construction means that the watch will keep time less accurately than a conventional counterpart without a whirlwind. Tourbillons are horological delicacies that have always posed an immense challenge, even for top professionals in this specialty. Tourbillon pocket watches, which were mostly handmade, were and are rare and costly. These exceptional gems rank among the greatest favorites of collectors.

Unnecessary on the wrist

As mentioned above, a tourbillon in a wristwatch is more a feast for the eyes than a guarantor of accuracy. The nimble motions of the forearm continually change the wristwatch's orientation with respect to gravity. And this makes a tourbillon redundant.

A look at the history of wristwatches finds that tourbillons were absent until the 1940s. And for good reason: partly impelled by the prevailing fashion, ladies dominated the wristwatch market, while gents typically remained reluctant to swap a safely stowed pocket watch for a vulnerable wristwatch.

Tourbillons for competitions

Patek Philippe and the specialist André Bornand, who worked for the Geneva-based family manufacture, first discovered the potential of the rotating cage in 1945. It was not destined for everyday use, but for entry in Category D of the annual chronometer competitions. A circular pocket-watch movement with a diameter of 30 mm and a lever tourbillon competed with varying degrees of success in 1949, 1951 and 1953. Likewise at Patek Philippe's behest, André Zibach and Eric Jaccard began working in 1950 on tonneau-shaped wristwatch Caliber 34, whose 702 square millimeters of surface area precisely complied with the conditions for competition in Category D. The tourbillon version, logically named Caliber 34 T, enjoyed great success in competitions at Geneva Observatory from 1958 to 1966. Work on movement number 866.502 began in 1960. This contestant won the competition with a score of 54.83 points in 1962. Its bronze-beryllium tourbillon cage weighs a mere 1.018 grams and completes one rotation around its axis in the unusual interval of 50 seconds. Master régleur André Bornand was again responsible for its outstanding rate results. The Guillaume balance with golden mass and regulating screws, along with its freely "breathing" Breguet hairspring with inner end curve, oscillated at a frequency of three hertz. Patek Philippe built five specimens of this watch. One of them is kept in the museum of Beyer Jewelers in Zurich. This watch sold for 650,000 Swiss francs at the Patek Philippe anniversary auction in 1989 and is now worth several times that amount.

Marcel Vuilleumier similarly turned his attention to this theme in 1948. The director of the school of watchmaking at Le Sentier in the Vallée de Joux was aware of the strains suffered by a tourbillon inside a watch strapped to an agile wrist. He therefore opted for a slower rotational speed of 7½ minutes rather than the usual 60 seconds. Using Vuilleumier's plans, Jean-Pierre Matthey-Claudet from Evilard built ten experimental wristwatches for Omega. After being finely adjusted by Gottlob Itt, these tourbillon watches were sent to Kew Observatory near London for an evaluation of their rate performance.

All good things come in threes. In this instance, number three was the Lip watch brand in Besançon, France, which installed its one-minute tourbillon in a rectangular (7¾ x 11-ligne) movement. An aperture in the dial offered a clear view of the 11.5-mm-diameter rotating cage, which also served as a second hand. It is likely that only one of these rectangular timepieces was built. According to current knowledge, there was no second wristwatch of this type until 1986.

The tourbillon's democratization

Audemars Piguet brought life into the tourbillon scene in 1986. The family-owned manufacture's unveiling of a tourbillon timepiece at the watch fair in Basel was a superlative world premiere. The company in the "Valley of the Tinkerers" had invested a king's ransom of more than one million Swiss francs in the development of this product. The result was the world's first, smallest and slimmest self-winding wristwatch with a one-minute tourbillon. The overall height was kept to a mere 4.8 mm thanks to a trick in the construction: the back of the watch's case also served as the base plate for its movement. A platinum-iridium weight swung back and forth to power the self-winding mechanism. A pawl- and ratch-wheel system conveyed the weight's kinetic energy to the barrel. The mainspring stored enough energy to give the watch an approximately 50-hour power reserve. Computer-controlled machining centers milled the rotating cage from strong yet lightweight titanium. The crown of the 32.5 x 28.5 mm movement was located on the back of the case. Audemars Piguet declines to divulge exact statistics, but experts believe that the total number of specimens of this watch exceeds the sum of all other tourbillons constructed before it. The tourbillon went on to become a must for affluent fans of exquisite mechanisms. Hardly any watch brand with ambitions to rank among the elite could escape the fascination of the whirlwind.

Vive la diversité!

This additional rotating complication was firmly established in the wristwatch scene when the tourbillon celebrated its 200th birthday in 2001. A tourbillon was seen as proof of extraordinary micromechanical competence. Brands that had not even known the word "tourbillon" a few years earlier suddenly felt obliged to include at least one in their portfolio. The range of available products grew almost exponentially. In all likelihood, 2008 will probably be remembered in the history of watchmaking as "The Year of the Tourbillon." Never before had there been a greater variety.

unterschiedlichen Erfolgen teil. 1950 begannen die Herren André Zibach und Eric Jaccard ebenfalls im Auftrag von Patek Philippe mit den Arbeiten am tonneauförmigen Armbanduhrkaliber 34, dessen Fläche von 702 Quadratmillimetern ebenfalls exakt auf die Wettbewerbskategorie D abgestimmt war. Die Version mit Tourbillon nannte sich logischerweise 34 T. Sie partizipierte von 1958 bis 1966 mit großem Erfolg an den Wettbewerben des Genfer Observatoriums. 1962 nahm auch das 1960 begonnene Uhrwerk mit der Nummer 866.502 am Chronometerwettbewerb teil und siegte mit 54,83 Punkten. Der feine, 1018 Gramm leichte Käfig aus Berylliumbronze rotiert alle 50 Sekunden um seine Achse. Für die herausragenden Gangergebnisse zeichnete abermals der Meister-Regleur Andre Bornand verantwortlich. Die Guillaume-Unruh mit goldenen Masse- und Regulierschrauben und die frei schwingende Breguetspirale mit innerer Endkurve oszillierten mit 3 Hertz. Von dieser Uhr fertigte Patek Philippe übrigens fünf Exemplare. Eines befindet sich im Museum des Zürcher Juweliers Beyer. Die Uhr konnte 1989 im Rahmen der Patek-Philippe-Jubiläumsauktion für 650 000 Schweizer Franken verkauft werden. Inzwischen ist sie ein Mehrfaches dieses Betrages wert.

1948 setzte sich Marcel Vuilleumier ebenfalls mit der komplexen Materie auseinander. Der damalige Direktor der Uhrmacherschule in Le Sentier, Vallée de Joux, erkannte die hohe Beanspruchung des Tourbillons am bewegten Handgelenk. Deshalb setzte er auf eine langsame Umlaufzeit des Drehgestells: 7½ Minuten anstelle der allgemein üblichen Minute. Mit Hilfe der Konstruktionspläne Vuilleumiers stellte Jean-Pierre Matthey-Claudet aus Evilard für Omega zehn Versuchsarmbanduhren her. Nach der Regulierung durch Gottlob Itt gingen die Tourbillons zu einer Bewertung der Gangresultate an das britische Kew-Observatorium bei London. Nummer drei war die Uhrenmarke Lip, Besançon. Ihr Minutentourbillon verbauten die Franzosen in einem 7¾ x 11-linigen Formwerk. Wie bei den vorgenannten Exemplaren zeigte sich der Käfig mit 11,5 Millimetern Durchmesser in einem Zifferblattausschnitt. Dadurch diente er auch als Sekundenzeiger.

Vermutlich gab es von diesem rechteckigen Zeitmesser nur ein einziges Exemplar. Mehr Armbanduhren dieses Typs gab es nach gegenwärtigem Kenntnisstand bis 1986 nicht.

Demokratisierung des Tourbillons

Bewegung in die Tourbillon-Szene brachte Audemars Piguet im Jahr 1986. Mit dem während der Basler Uhrenmesse erstmals gezeigten Modell lancierte die Familienmanufaktur nicht nur eine Weltpremiere, sondern zugleich auch einen Superlativ. In die Entwicklung des Produkts hatte das im „Tal der Tüftler" beheimatete Unternehmen die damals überaus stattliche Summe von mehr als einer Million Schweizer Franken investiert. Das Resultat der Bemühungen: die weltweit erste, kleinste und flachste Automatikarmbanduhr mit Minutentourbillon. Bei der Realisierung einer Gesamthöhe von lediglich 4,8 Millimetern half ein konstruktiver Trick: Nutzung des Gehäusebodens als Werksplatine. Den Selbstaufzug bewerkstelligte eine Platin-Iridium-Pendelschwungmasse. Ein System aus Schalt- und Sperrklinken leitete die kinetische Energie an das Federhaus weiter. Die darin gespeicherte Energie reichte für rund 50 Stunden Gangautonomie. Aus gleichermaßen festem wie leichtem Titan frästen computergesteuerte Fertigungszentren das Mini-Drehgestell. Die Krone des insgesamt 32,5 x 28,5 Millimeter messenden Uhrwerks fand sich auf der Rückseite. Über genaue Zahlen schweigt sich Audemars Piguet beharrlich aus. Aber dem Vernehmen nach entstanden von dieser Weltpremiere mehr Exemplare als von allen anderen Tourbillons zuvor. Anschließend entwickelte sich das Armbandtourbillon zu einem Muss für zahlungskräftige Mechanikfreaks. Der faszinierenden Ausstrahlung des Drehgangs konnte sich kaum eine Uhrenmarke mit Haute-Horlogerie-Anspruch entziehen.

From left: Omega Tourbillon, rotating every 7.5 minutes, 1947 ○ LIP Besançon Tourbillon, 1967 ○ Patek Philippe Tourbillon, Ref. 3834, 1960, won first prize at Geneva Astronomical Observatory timing contest, 1962 ○ Von links: Omega Tourbillon, rotiert alle 7,5 Minuten, 1947 ○ LIP Besançon Tourbillon, 1967 ○ Patek Philippe Tourbillon, Ref. 3834, 1960, gewann den ersten Platz beim Zeitmessungswettbewerb des Genfer Observatoriums, 1962

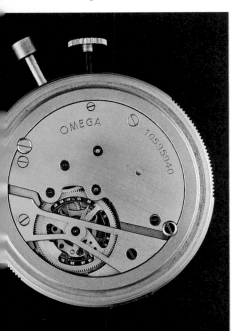

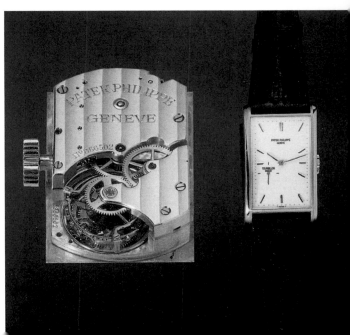

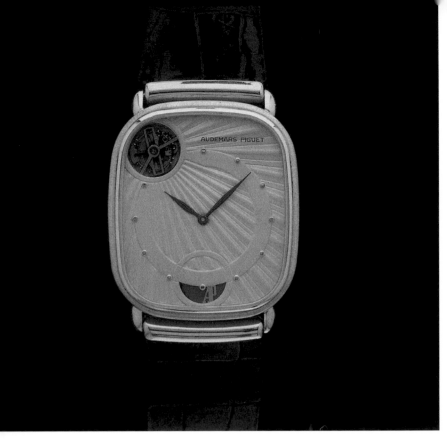
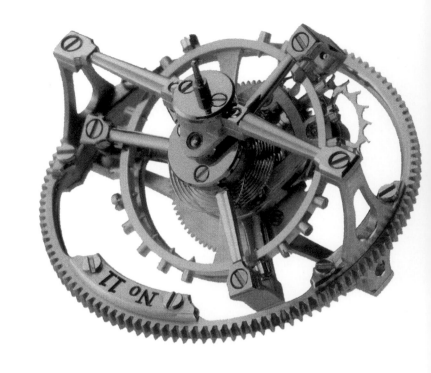

From left: Audemars Piguet, first serially manufactured tourbillon, 1986 ∘ Greubel Forsey, double tourbillon, 2004 ∘ Von links: Audemars Piguet, erstes Serientourbillon, 1986 ∘ Greubel Forsey, Doppeltourbillon, 2004

The spectrum extends from the classic through the "flying" to the spherical, i.e. a three-dimensional rotating tourbillon. Movements with more than one tourbillon are not rare. Breguet, for example, installed two independent tourbillons on a plate that rotates around its axis once every twelve hours.

Greubel Forsey offers a double tourbillon: a large rotating cage with a diameter of approximately 15 mm contains a smaller cage. This petite tourbillon contains the oscillating and escapement system and is inclined at a 30° angle to the plane of rotation of its larger companion. Roger Dubuis crafts a double tourbillon with two cages rotating alongside one another and connected by a differential. These little carriages were formerly made of manually sawn and finished steel, but computer-controlled technology now offers strong and lightweight alternatives. Tourbillons made of titanium, aluminum or even carbon are not rarities. In place of pallet levers and escape wheels made of steel, some of these components are now crafted from much lighter, maintenance-free and non-magnetic silicon. Cartier transformed the entire movement into a tourbillon. The whirlwind in Piaget's "Polo Tourbillon Relatif" rotates at the tip of the minute hand, where the little tourbillon seems wholly detached from the movement. Montblanc has launched an exclusive "Exo Tourbillon" without a classic cage: the balance oscillates in front of the rotating carriage, thus allowing its diameter to be larger, and the hairspring serves as a connecting link between the two components. Parmigiani Fleurier debuted the world's first 30-second tourbillon.

The combination of a tourbillon and an automatic winding system scarcely requires further mention. Tourbillon wristwatches with marathon power reserves of a week or more likewise need no additional discussion. In 1994, A. Lange & Söhne presented its first tourbillon "Pour le Mérite" with a traditional chain-and-fusée system for nearly constant torque. IWC and a few other makers launched mechanisms to assure a constant flow of force from the mainspring to the rate regulator. In 2008, the Glashütte-based luxury manufacturer A. Lange & Söhne unveiled the world's first tourbillon wristwatch with a balance that can be momentarily halted for to-the-second time setting.

Ladies' watches with tourbillons are no longer rarities. In addition to the world's thinnest movement of this kind, in the spring of 2020 Bulgari debuted the smallest tourbillon wristwatch, designed explicitly for the slimmer wrists of the fair sex.

The whirlwind in Panerai's Caliber P.2005 is somewhat like a chicken on a rotisserie. Wristwatches are only rarely oriented in the hanging position that is usual for pocket watches, so the balance wheel in Panerai's construction rotates perpendicularly to the longitudinal axis of its staff.

This situation attracted inventive minds at Jaeger-LeCoultre, Franck Muller, Girard-Perregaux and other elite manufactures. The constantly changing orientation of a wristwatch prompted these ingenious people to create spherical tourbillons with two or even three planes of rotation. These instruments accommodate almost any position of the forearm.

Jaeger-LeCoultre installs a classic tourbillon in the "Reverso Grande Complication à Triptyque," but this rotating cage contains a new type of chronometer escapement with a rocker. Its construction and its materials, which include silicon, make lubricant oil superfluous and counteract the notorious tendency to "trip."

Ulysse Nardin's "Freak" implemented the principle of the carousel in 2001. Its hand-wound movement performs the functions ordinarily assigned to an hour hand and minute hand. The upper part, known as the "carousel tourbillon," is equipped with a visible balance wheel and completes one rotation around its axis each hour. Zenith outwits gravity by keeping the oscillating and escapement system in a horizontal position, just as it is positioned in a marine chronometer. The oscillating and escapement system in the "Defy Tourbillon Zero G," which is not really a tourbillon at all, is housed inside a gimbal-mounted container, which assures that it always lies flat. A platinum rotor powers the self-winding mechanism.

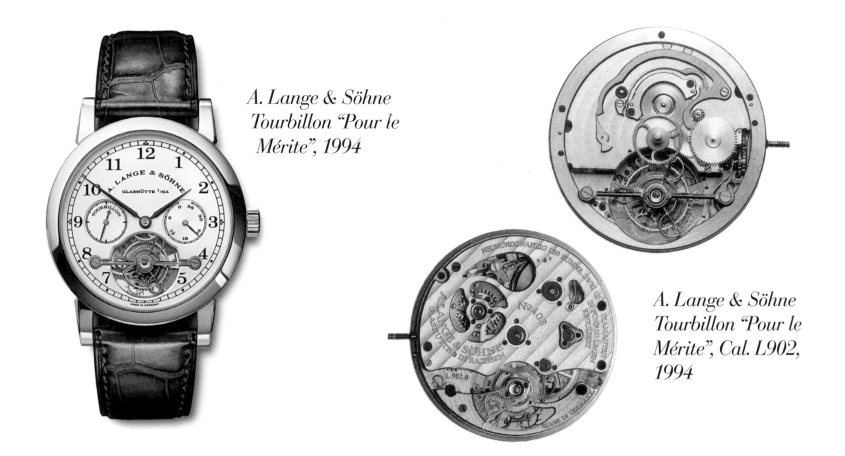

*A. Lange & Söhne
Tourbillon "Pour le
Mérite", 1994*

*A. Lange & Söhne
Tourbillon "Pour le
Mérite", Cal. L902,
1994*

Es lebe die Vielfalt

2001, im Jahr des 200. Jubiläums des Tourbillons, hatte sich die rotierende Zusatzfunktion schon fest in der Armbanduhren-szene verankert. Sie galt als illustrer Beleg für außerordentliche mikromechanische Kompetenz. Im Zuge dessen fühlten sich auch Marken zu Tourbillons berufen, welche das Wort einige Jahre zuvor noch nicht einmal gekannt hatten. Folglich wuchs das Angebot beinahe exponentiell. In der Uhrengeschichte wird 2008 möglicherweise als das „Jahr des Tourbillons" in Erinnerung bleiben. Nie zuvor gab es eine größere Vielfalt.

Die aktuelle Bandbreite reicht von der klassischen über das „fliegende" bis hin zum sphärischen, sprich dreidimensional drehenden Tourbillon. Keineswegs selten sind Uhrwerke mit mehreren Drehgängen. Breguet montierte zwei unabhängige Tourbillons auf einer Platine, welche sich einmal in zwölf Stunden um ihre Achse dreht.

Bei Greubel Forsey zieht im Innern eines großen Drehgestells mit ungefähr 15 Millimetern Durchmesser ein kleinerer, um 30 Grad geneigter Käfig mit dem Schwing- und Hemmungssystem seine Kreise. Doppeltourbillons mit zwei nebeneinander arbeitenden und per Differenzial verbundenen Käfigen offeriert beispielsweise Roger Dubuis.

Während die feinen Käfige einst aus manuell gesägtem und finissiertem Stahl bestanden, stehen mittlerweile dank computergesteuerter Fertigungstechnologie gleichermaßen feste wie leichte Materialalternativen zur Verfügung. Drehgestelle aus Titan, Aluminium oder auch Karbon sind alles andere als Exoten. An die Stelle stählerner Anker und Ankerräder treten teilweise solche aus deutlich leichterem, wartungsfreiem und amagnetischem Silizium. Cartier beispielsweise machte das ganze Uhrwerk zu einem Tourbillon. Bei Piagets „Polo Tourbillon Relatif" rotiert das Drehgestell scheinbar losgelöst vom eigentlichen Uhrwerk an der Spitze des Minutenzeigers. Montblanc hat

ein exklusives „Exo Tourbillon" ohne klassischen Käfig aus der Taufe gehoben. Hier oszilliert die Unruh vor dem eigentlichen Drehgestell, weshalb der Durchmesser größer ausfallen kann. Als Bindeglied dient die Unruhspirale. Parmigiani Fleurier präsentierte das weltweit erste 30-Sekunden-Tourbillon.

Das Tourbillon mit automatischem Aufzug bedarf fast schon keiner Erwähnung mehr. Ebenso die Drehgang-Armbanduhr mit langer Gangautonomie von einer Woche oder mehr. Bereits 1994 präsentierte A. Lange & Söhne ihr erstes Tourbillon „Pour le Mérite" mit überliefertem Kette-Schnecke-System für ein weitgehend konstantes Aufzugsdrehmoment. Stabilen Kraftfluss vom Federhaus zum Gangregler praktizieren inzwischen auch andere Manufakturen wie beispielsweise IWC. 2008 präsentierte die Glashütter Nobelmanufaktur Lange auch das weltweit erste Armbandtourbillon mit Unruhstopp zum sekundengenauen Einstellen der Uhrzeit.

Damenuhren mit Drehgang gehören heutzutage ebenfalls zum Alltag. Neben dem weltweit flachsten Uhrwerk dieser Art präsentierte Bulgari im Frühjahr 2020 auch das kleinste – explizit fürs zarte Geschlecht entwickelt.

Bei Panerai funktioniert der Drehgang im Kaliber P.2005 salopp formuliert wie ein Hähnchen am Grillspieß. Wegen der spezifischen Tragebedingungen von Uhren am Handgelenk rotiert die Unruh um exakt 90 Grad versetzt in Richtung ihrer eigenen Welle, denn Armbanduhren befinden sich naturgemäß ja nur selten in der bei Taschenuhren üblichen Hängeposition.

Mit diesem Sachverhalt haben sich unter anderem auch Jaeger-LeCoultre, Girard-Perregaux oder Franck Muller auseinandergesetzt. Wegen der ständig wechselnden Lagen von Armbanduhren entstanden hier sphärische Tourbillons mit zwei oder gar drei Drehrichtungen. Sie tragen nahezu jeder Position des Unterarms Rechnung.

In der „Reverso Grande Complication à Triptyque" verwendet Jaeger-LeCoultre zwar nur ein klassisches Tourbillon. In dessen Käfig arbeitet jedoch eine neuartige Chronometerhemmung

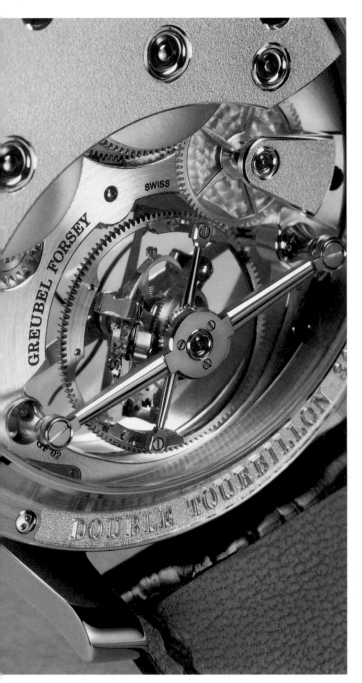
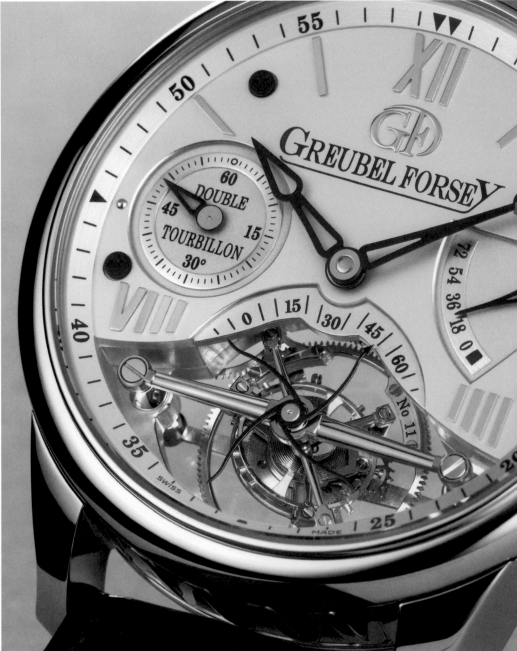

Greubel Forsey, double tourbillon ◦ Doppeltourbillon, 2004

A tourbillon plus other complications

The foregoing remarks make it clear that the tourbillon still has plenty of appeal, notwithstanding the limitations cited above. By combining the charming whirlwind with other additional functions, the complexity of wristwatches can be expanded seemingly forever. This is especially true because designers can replace the classic oscillating and escapement system in existing movements with a similar system borne inside a rotating carriage. TAG Heuer demonstrated this with its automatic Caliber Heuer 02T. The "Carrera" equipped with this system also has a chronograph. The same applies to Vacheron Constantin's "Traditional Tourbillon Chronograph," which sells for a much costlier price. A few watches combine a tourbillon with an equation-of-time display, a time-zone indicator, a perpetual calendar, a minute repeater or all of the above. Skeletonized versions show everything and conceal nothing. Patek Philippe unites a traditionally rear-mounted and thus hidden tourbillon with a gorgeous rendition of the starry sky. The preceding models are just a few examples.

The prices of tourbillon wristwatches were initially in the six-digit dollar, euro or franc range, but democratization has been joined by socialization, so to speak. A coffee roaster offered and speedily sold out its stock of Chinese-made tourbillon watches, each of which sold for a modest sum in the three-digit ballpark. Whirling manufacture craftsmanship of Swiss provenance is now available for well under 20,000 dollars, euros or francs.

This leads to only one conclusion: no one needs a tourbillon for accurate timekeeping on the wrist, but the complication seems likely to survive and thrive for decades to come. In summary, it is more than clear: today, 220 years after it was first patented, the tourbillon is anything but an endangered species.

mit Wippe. Konstruktion und Materialwahl, darunter auch Silizium, machen Öl überflüssig. Außerdem erteilen sie dem berüchtigten „Galoppieren" eine klare Absage.

Das Prinzip des Karussells hat Ulysse Nardin schon 2001 bei seinem Modell „Freak" realisiert. Dabei übernimmt das Handaufzugswerk die Indikation der Stunden und Minuten höchstpersönlich. Der obere, Karussell-Tourbillon genannte Part mit der sichtbaren Unruh bewegt sich einmal pro Stunde um seine Achse.

Zenith schlägt der bösen Schwerkraft ein ganz anderes Schnippchen, indem das Schwing- und Hemmungssystem analog zu Marinechronometern immer waagrecht arbeitet. Beim „Defy Tourbillon Zero G", das ergo gar kein Tourbillon ist, befindet sich das Schwing- und Hemmungssystem in einem kardanisch aufgehängten und deshalb immer flach liegenden Container. Den Aufzug besorgt ein Platinrotor.

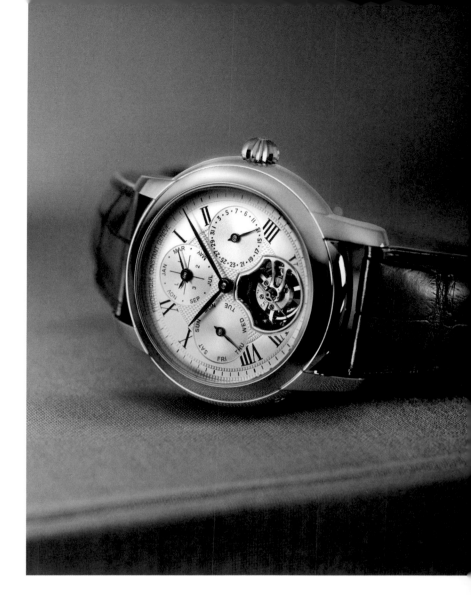

Tourbillon plus

Spätestens nach diesen Ausführungen sollte klar geworden sein, dass das Tourbillon trotz der genannten Einschränkungen jede Menge Reize besitzt. Durch die Kombination mit weiteren Zusatzfunktionen lässt sich die Komplexität von Armbanduhren scheinbar unendlich erweitern. Dies vor allem auch deshalb, weil findige Konstrukteure in bereits existenten Uhrwerken das klassische Schwing- und Hemmungssystem durch einen Drehgang ersetzen können, wie TAG Heuer beim Automatikkaliber Heuer 02T bezogen. Die damit ausgestattete „Carrera" besitzt auch einen Chronographen. Ähnliches gilt für den in deutlich höheren Preisregionen angesiedelten Vacheron Constantin „Traditionelle Tourbillon Chronograph". Daneben gibt es Tourbillons mit Äquationsanzeige, Zeitzonendispositiv, ewigem Kalendarium, Minutenrepetition oder gar allem zusammen. Skelettversionen verbergen nichts, aber auch gar nichts. Patek Philippe kombiniert das traditionsgemäß rückwärtig und damit versteckt montierte Tourbillon mit einem illustren Sternenhimmel. Das alles sind nur einige Beispiele.

Bewegten sich die Preise für Armbandtourbillons anfänglich im sechsstelligen Dollar-, Euro- oder Frankenbereich, hat sich inzwischen neben der Demokratisierung sozusagen auch eine Sozialisierung breitgemacht. Ein Kaffeeröster offerierte logischerweise sehr schnell ausverkaufte Tourbillons chinesischer Provenienz für einen dreistelligen Eurobetrag. Wirbelnde Manufakturarbeit aus der Uhr-Schweiz ist bereits für deutlich unter 20 000 Dollar, Euro oder Franken zu haben.

Damit bleibt nur ein Fazit: Obwohl niemand ein Tourbillon zum präzisen Bewahren der Zeit am Handgelenk braucht, wird diese uhrmacherische Komplikation auch die nächsten Jahrzehnte problemlos fortbestehen. Alles zusammen belegt mehr als deutlich, dass sich Tourbillons auch 220 Jahre nach ihrer Patentierung nicht überlebt haben.

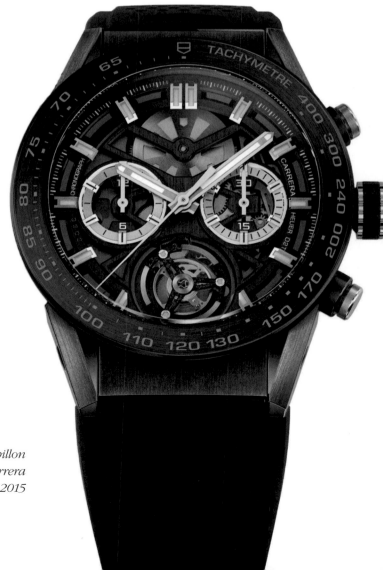

From top ◦ Von oben: Frédérique Constant Classic Tourbillon Perpetual Calendar, Cal. FC-975, 2017 ◦ TAG Heuer Carrera Tourbillon, Cal. Heuer 02T, Ref. CAR2A8Y.FT6044, 2015

Top ◦ Oben: *Bulgari Octo Finissimo Tourbillon, the world's slimmest tourbillon ◦ weltweit flachstes Tourbillon, 2014*

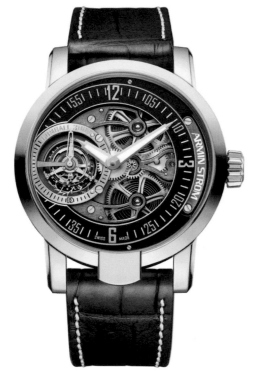

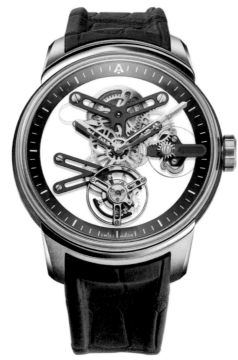

Angelus U20 Ultra-Skeleton Tourbillon, 2016

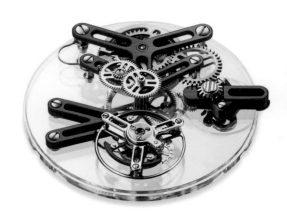

Armin Strom Gumball 3000 Tourbillon, 2015

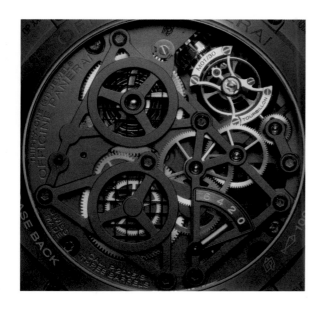

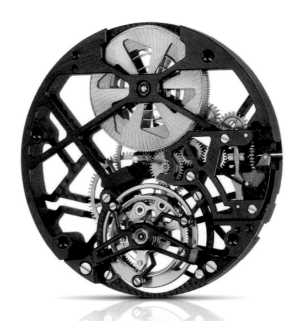

From left ◦ Von links: Panerai Lo Scienziato Radiomir Tourbillon GMT, Cal. P.2005, 2010 ◦ Hublot, Cal. HUB 6010

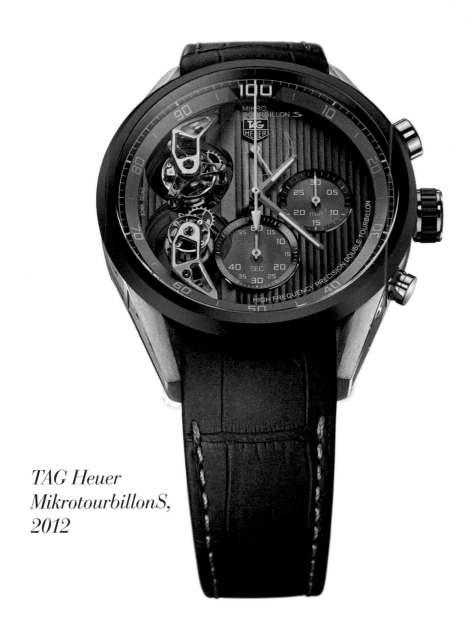

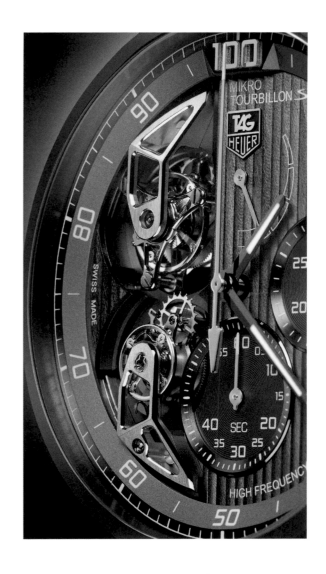

TAG Heuer
MikrotourbillonS,
2012

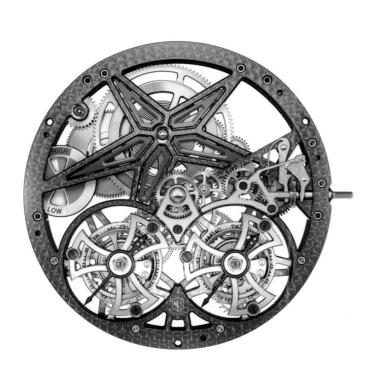

Roger Dubuis Excalibur Spider Pirelli, Double Flying Tourbillon,
Ref. RDDBEX0599, 2016

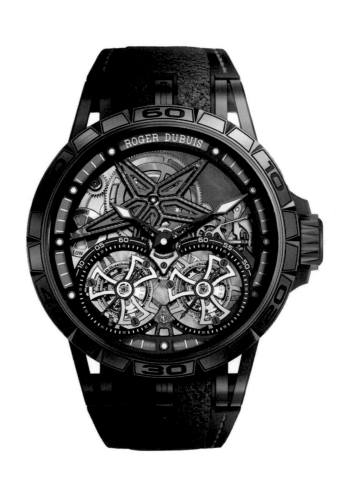

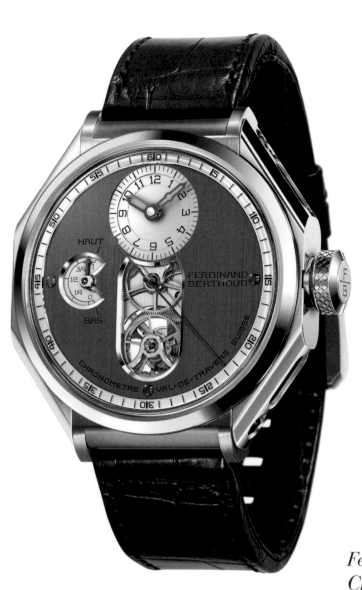

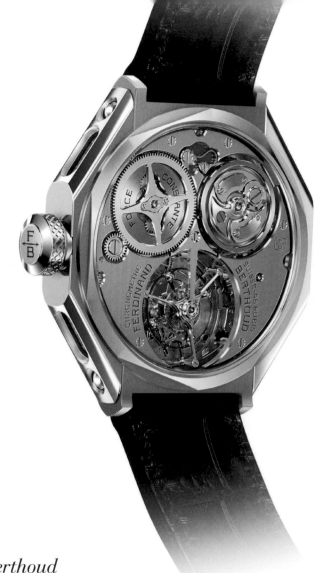

*Ferdinand Berthoud
Chronomètre FB 1.1,
Cal. FB-T.FC, 2016*

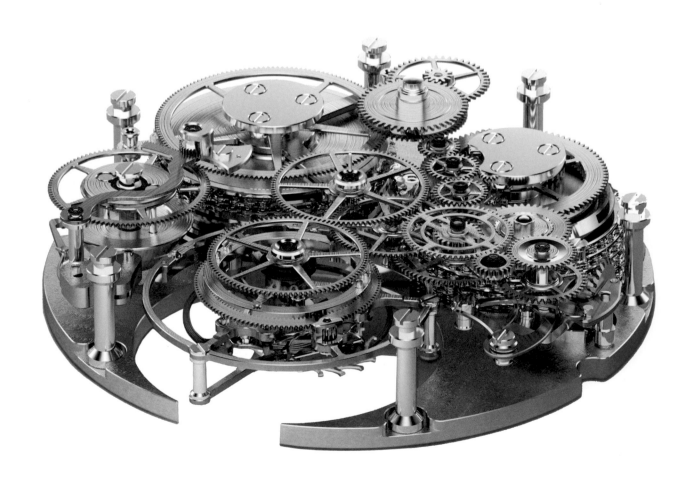

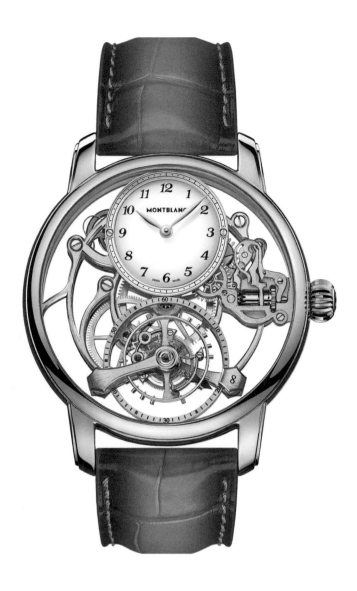

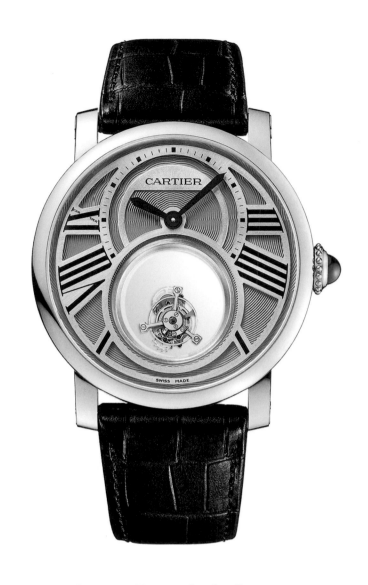

Montblanc Star Legacy
ExoTourbillon Skeleton LE8,
Ref. 126096, limited edition,
2020

Cartier Rotonde de Cartier
Mysterious Double Tourbillon,
2012

Bottom, from left: Lemania, tourbillon skeleton ◦ Corum, tourbillon with sapphire plate ◦
Unten, von links: Lemania, Tourbillon-Skelett ◦ Corum, Tourbillon mit Saphirplatine

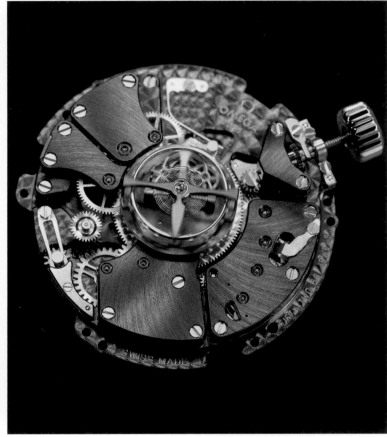

Top ◦ Oben: Omega, Cal. 2635, central tourbillon ◦ Zentraltourbillon

Left ◦ Links: Zenith Academy Tourbillon, with chain-and-fusée transmission ◦ mit Kette-Schnecke-Antrieb, 2016

Right & bottom ◦ Rechts & unten: Cyrus Klepcys Vertical Tourbillon Skeleton ◦ Cal. CYR625, limited edition

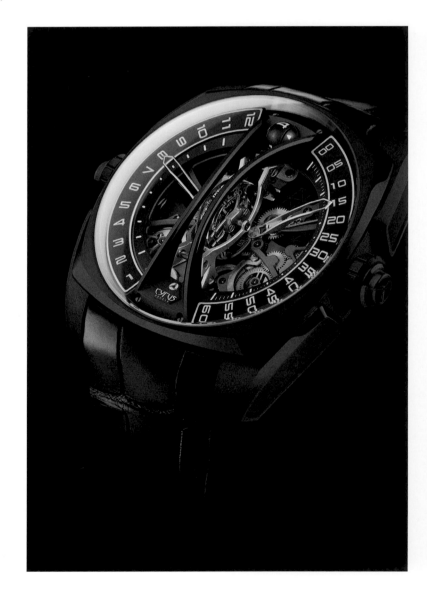

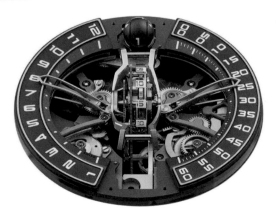

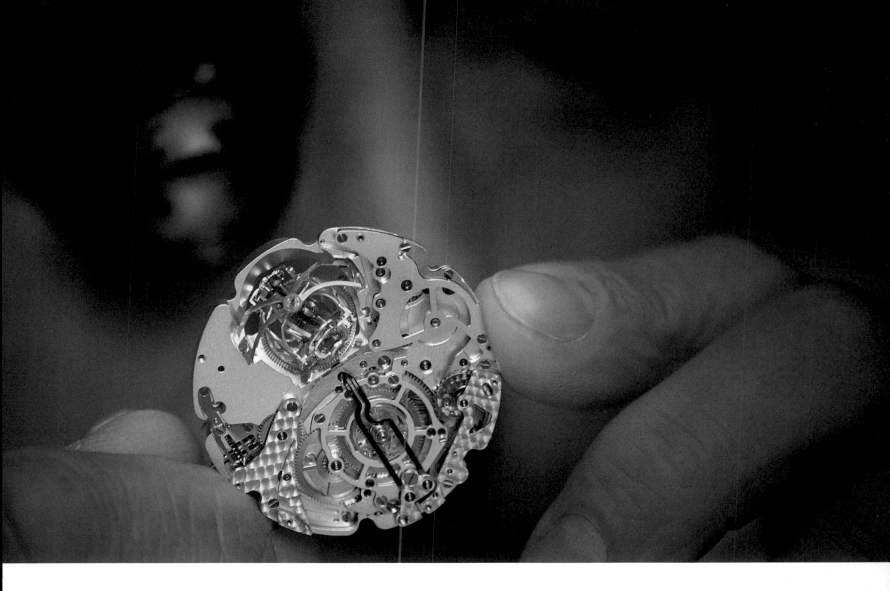

Top & bottom left ◦ Oben & unten links: Jaeger-LeCoultre Gyrotourbillon 1
Bottom right ◦ Unten rechts: Girard-Perregaux Tri-Axial Tourbillon, rotating carriage ◦ Drehgestell, 2014

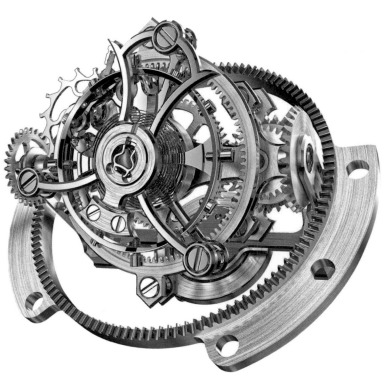

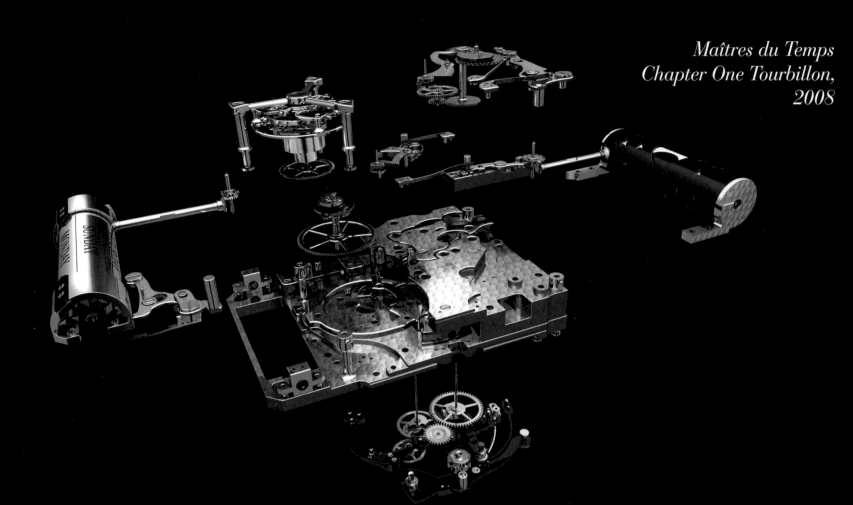

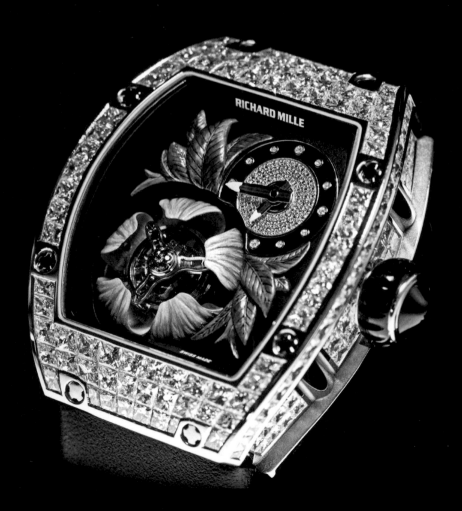

Richard Mille RM 19-02
Tourbillon Fleur, 2015

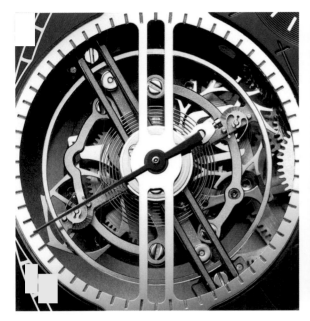

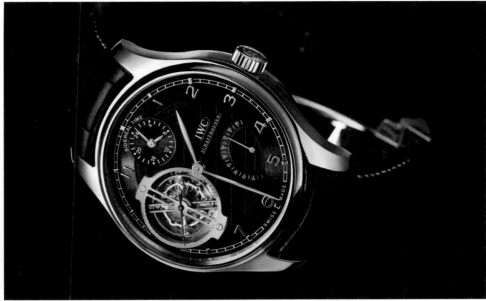

IWC Portugieser Sidérale Scafusia, with constant-force tourbillon ◦ mit Konstantkraft-Tourbillon, 2011

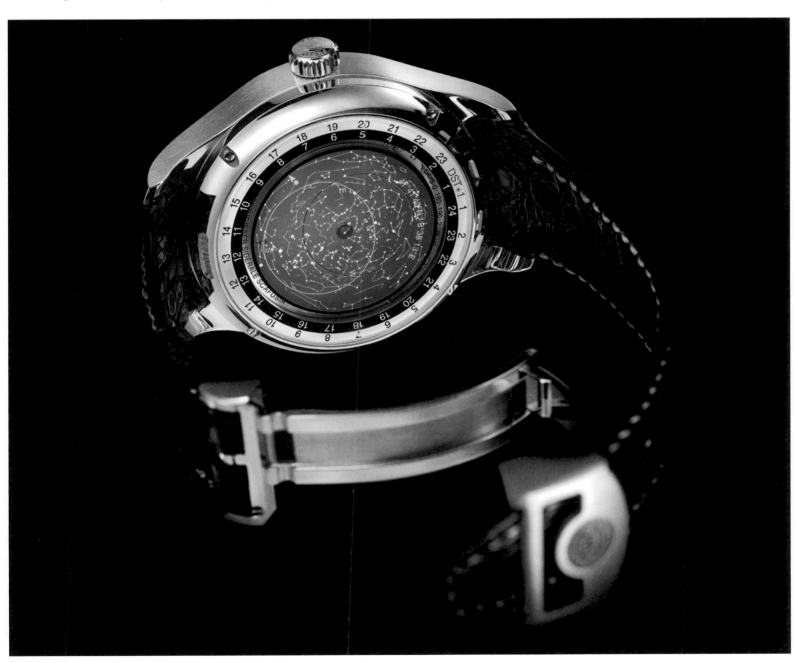

Following pages ◦ Nächste Seiten: Hublot LaFerrari Tourbillon, with sapphire case ◦ mit Saphirgehäuse, 2016

*Glashütte Original Tourbillon
Alfred Helwig, 1998*

*Baume & Mercier Clifton 1892
Flying Tourbillon, 2014*

*Parmigiani Fleurier Tonda
1950 Tourbillon Galaxy, 2016*

Hermès Cape Cod Tourbillon, 2020

Hublot Big Bang Tourbillon, 2012

Chanel Première Flying Tourbillon, 2013

Left page, bottom: limited hand-skeletonized edition of Chronoswiss Regulateur Tourbillon ∘ Linke Seite, unten: limitierte, handskelettierte Edition der Chronoswiss Regulateur Tourbillon
This page, from left ∘ Diese Seite, von links: Louis Vuitton Tambour eVolution Tourbillon Volant, 2014 ∘ Girard-Perregaux Cat's Eye Tourbillon, with three gold bridges ∘ mit drei goldenen Brücken ∘ Piaget Polo Tourbillon, 2006

Repetition

Audible Time

"A creature of a higher order makes the whole history of the world repeat itself, just as one makes repeater timepieces chime the time." Europe was in the throes of a turbulent era when Georg Christoph Lichtenberg put this aphorism on paper. Whether the German physicist and writer, who was born in 1742, was able to have time audibly repeated on demand is not known. Clocks with striking mechanisms had been around for about a century, but they were costly and therefore reserved for the affluent few, who appreciated not having to light a candle in the dark in order to read the time. A sophisticated mechanism, activated by pushing a button, audibly chimed the current time.

Flashback to the 17th century

This sonorous chapter of mechanical timekeeping begins with a bitter dispute over patents that two competing parties had simultaneously registered in 1687. One claimant was the English watchmaker Daniel Quare. His opponents were the clergyman and mechanic Edward Barlow and the renowned watchmaker Thomas Tompion. Their bone of contention was the invention of a pocket watch with a quarter-hour repeater.

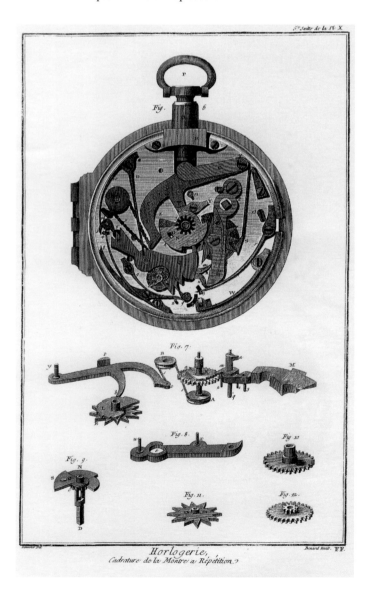

Horlogerie,
Cadrature de la Montre a Répétition

The litigants were unable to reach an agreement, and the responsible authorities did not know what to do, so no less august a personage than the English king turned his attention to the dispute. After thoroughly perusing the two models, King James II declared the winner to be none other than Quare, the lone wolf. The monarch's decision was well founded: Quare's construction was much more practical and convenient. A single button sufficed to trigger its striking mechanism. The rival product needed to be triggered twice: once for the full hours and once again for the quarter hours. The winner of the competition was indeed worthy of the royal accolade: Daniel Quare went on to double the precision of audible time indication with his 1695 debut of a 7½-minute (eighth-of-an-hour) striking mechanism. Other masters of this trade soon followed in Quare's footsteps. Samuel Watson unveiled a pocket watch with a five-minute repeater in 1710. And around 1750, Thomas Mudge premiered the highest level of accuracy in a repeater timepiece. On command, his pocket watch emitted clearly audible chimes to announce the hours, quarter hours and minutes.

Sonic evolution

From then on, watchmakers strove to achieve technical refinements and, above all, to miniaturize the necessary mechanisms. One shortcoming was that insufficient operation of the push-piece led to incorrect chiming. Daniel Quare again proved his horological mettle here. His brainchild, a horizontal "all-or-nothing" mechanism, assures that a repeater strikes either precisely or not at all. Quare's invention was good, but it was still far from perfect. Julien Le Roy (1686–1759), court watchmaker to Louis XV, incorporated the needed improvements in a perfected design, which was presented in Paris around 1740. Le Roy's innovation remains a significant feature of high-quality repetition watches to this day. Even a layman can recognize it at a glance. If the push-piece or slider that triggers the striking mechanism is shifted only slightly, the result is nothing but the quiet sound of the striking mechanism as it idles without chiming. Audible errors were and are impossible.

Repeater timepieces: mellifluous and frugal

Also around 1740, melodious but relatively voluminous bells were gradually abandoned as resonating bodies inside the timepieces' cases. Instead, the hammers that chimed the time now struck directly against the inner wall of the case. This freed space inside the watch, which its makers could fill with larger, more reliable and more accurate movements.

The first use of painstakingly tuned gongs is attributed to the renowned watchmaker Abraham-Louis Breguet in 1783. His gongs wind around the movement. With their help, repeater pocket

*Previous pages ◦ Vorherige Seiten: Tutima Hommage Minute Repeater
Left ◦ Links: Julien Le Roy, pocket watch with quarter-hour repetition ◦
Taschenuhr mit Viertelrepetition*

Was die Zeit geschlagen hat

„Ein Geschöpf höherer Art lässt die ganze Geschichte der Welt repetieren, so wie man die Uhren repetieren lässt." Als der 1742 geborene Georg Christoph Lichtenberg seinen Aphorismus zu Papier brachte, erlebte Europa turbulente Zeiten. Ob sich der deutsche Physiker und Schriftsteller die Zeit auf Wunsch repetieren lassen konnte, ist nicht überliefert. Uhren mit Schlagwerk, die es seit etwa hundert Jahren gab, waren teuer und blieben deshalb nur wenigen Menschen vorbehalten. Sie schätzten es, bei Dunkelheit zum Ablesen der Uhrzeit nicht umständlich eine Kerze anzünden zu müssen. Ein Knopfdruck genügte, und ein ausgeklügelter Mechanismus tat unüberhörbar kund, was es gerade geschlagen hatte.

Rückblende ins 17. Jahrhundert

Am Anfang dieses klangvollen Kapitels mechanischer Zeitmessung steht ein handfester Streit, ausgelöst durch Patente, die zwei konkurrierende Parteien gleichzeitig im Jahr 1687 angemeldet hatten. Einer der Anspruchsteller hieß Daniel Quare, ein englischer Uhrmacher, seine Kontrahenten waren der Pfarrer und Mechaniker Edward Barlow und der renommierte Uhrmacher Thomas Tompion. Im Mittelpunkt stand die Erfindung einer Taschenuhr mit Viertelstunden-Repetition. Weil sich die Widersacher partout nicht einigen konnten und die zuständigen Behörden keinen Rat wussten, nahm sich der englische König höchstpersönlich dieser leidigen Angelegenheit an. Nach eingehender Prüfung der beiden Modelle erklärte Jakob II. den Einzelkämpfer Quare zum Sieger. Der Monarch hatte seine Entscheidung aus guten Gründen getroffen, denn die Konstruktion von Quare war deutlich praktischer und komfortabler. Zur Auslösung des Schlagwerks genügte ein einziger Drücker. Das rivalisierende Produkt verlangte dagegen nach zwei Handgriffen: einen für die Stunden und einen zweiten für die Viertelstunden. Der Gewinner des Wettstreits erwies sich der königlichen Ehrung auf jeden Fall würdig, denn 1695 verdoppelte Daniel Quare die Präzision der akustischen Zeitangabe durch das 7½-Minuten- oder Achtelstunden-Schlagwerk. Danach waren andere Meister ihres Fachs an der Reihe: 1710 präsentierte Samuel Watson eine Taschenuhr mit Fünf-Minuten-Repetition. Und gegen

1750 stellte Thomas Mudge das Höchstmaß an Repetitionsgenauigkeit vor. Wenn gewünscht, verkündete seine Taschenuhr die Stunden, Viertelstunden und Minuten mit deutlich wahrnehmbaren Schlägen.

Klangliche Evolution

Von nun an bemühten sich die Uhrmacher um technische Feinheiten und vor allem auch um kleinere Mechanismen. Ein nicht zu unterschätzendes Manko bestand darin, dass die unzureichende Betätigung des Drückers zu falschem Repetieren führte. Hier konnte Daniel Quare seine uhrmacherischen Qualitäten einmal mehr unter Beweis stellen. Ihm ist eine horizontal wirkende „Alles-oder-nichts-Sicherung" zu verdanken. Das Konstrukt bewirkte, dass Repetitionsschlagwerke entweder genau oder gar nicht in Aktion treten. Von Perfektion war es aber noch ein gutes Stück entfernt. Die führte erst Julien Le Roy (1686–1759) herbei. Der Hofuhrmacher von Ludwig XV. trat gegen 1740 in Paris mit einer vervollkommneten und deshalb zukunftsträchtigen Ausführung an die Öffentlichkeit. Bis heute ist sie ein signifikantes Merkmal hochwertiger Repetitionsuhren, das selbst Laien auf Anhieb erkennen. Wenn sie den Drücker oder Schieber zur Schlagwerksauslösung nur ein wenig bewegen, herrscht außer einem leisen Rauschen des „leer" ablaufenden Schlagwerks schlicht und einfach Stille. Akustische Irrtümer waren und sind damit ausgeschlossen.

Repetition im Zeichen von Klang und Ökonomisierung

Ebenfalls gegen 1740 verabschiedeten sich die zwar wohlklingenden, aber auch relativ voluminösen Glockenschalen als Klangkörper sukzessive aus den Gehäusen. Stattdessen schlugen die Hämmer zum Darstellen der Zeit nun unmittelbar an die Gehäusewandung. Dieser Kunstgriff sparte Platz, welchen die Uhrmacher für größere, zuverlässigere und auch genauere Uhrwerke nutzen konnten.

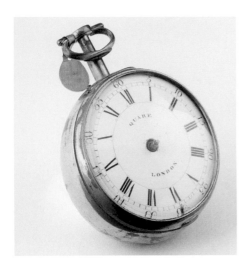 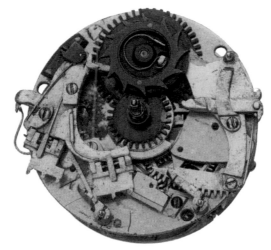 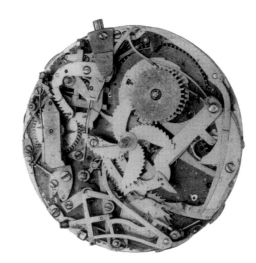

From left: Daniel Quare, repeater pocket watch, c. 1710 ○ Thomas Tompion and Edward Barlow, No. 63 quarter-hour repeater, late 17th century ○ Thomas Mudge, minute repeater, 1755 ○ Von links: Daniel Quare, Repetitionstaschenuhr, ca. 1710 ○ Thomas Tompion und Edward Barlow, Nr. 63 Viertelrepetition, spätes 17. Jahrhundert ○ Thomas Mudge, Minutenrepetition, 1755

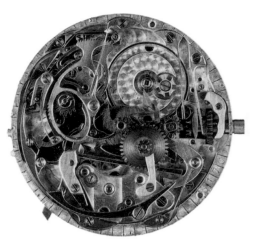

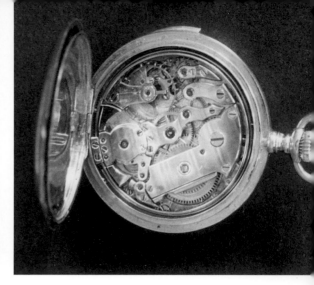

From left: Audemars Piguet, 10-ligne movement with minute repeater, 1899 ○ Ten-pfennig coin ○ Women's pocket watch with minute repeater, early 20th century ○ Von links: Audemars Piguet, 10-liniges Uhrwerk mit Minutenrepetition, 1899 ○ Zehn-Pfennig-Münze ○ Damentaschenuhr mit Minutenrepetition, frühes 20. Jahrhundert

watches retained their pleasant sound, but could now be much slimmer than repeaters with conventional bells.

Thanks to these diverse improvements, repeater pocket watches enjoyed increasing popularity from the mid-19th century onwards. Of course, the production of greater numbers of timepieces almost inevitably went hand in hand with economization, which affected both the manufacturing process and the design per se. Manufacturers cut production costs for simpler movements by eliminating the comparatively costly all-or-nothing protective mechanism. Fine machining and meticulous decoration of components were likewise sacrificed on the altar of thrift. Surprisingly, the invention of electric light by Göbel and Edison at the end of the 19th century scarcely diminished the popularity of fine repeater watches, which were originally invented for convenient use in the dark. Even under artificial illumination, the discreet charm of this horological complication lost none of its appeal. It continues to reveal its marvelous audible capabilities only to those who know about its existence and how to bring it to life.

Smaller, slimmer, more delicate

Smaller striking constructions became indispensable toward the end of the 19th and in the early years of the 20th century. There were two basic reasons. As so often in the history of timekeeping, one reason had to do with fashion: along with the vogue for close-fitting garments, high society demanded progressively slimmer watches. The other was due to a new clientele: along with the progress of women's liberation, increasingly many ladies now also wanted portable guardians of time that could strike whenever madam's fingertip gave the command.

Both reasons spurred horological ambition. Competition provided further motivation. From then on, ébauche manufacturers rose to the challenge, as did brands that processed ébauches into complete watches.

Swiss manufacturers in Geneva, in the Jura arc of western Switzerland and above all in the secluded Vallée de Joux played a major role in the miniaturization of repeater movements. Watchmakers fought tooth and nail for every tenth of a millimeter. These efforts enabled them to lower the height of the movements, including the minute-repeating cadrature, to a mere three millimeters. And they accomplished this height reduction in movements with a diameter of only approximately twenty millimeters, while simultaneously ensuring that miniaturization did not detract from efficient functioning. Together, these efforts formed the foundation for the production of repeater watches that met all the requirements of the prevailing fashion, whether to wear traditionally in a pocket, as a pendant on a necklace or integrated into a brooch, and—after the turn of the century—also strapped to the wrist.

These complex mechanisms, especially the ones from the Joux Valley, were not exclusively encased in Swiss watches. Some ticked under the dials of watches from England, the ancestral home of the repeater striking mechanism. The noble German brands A. Lange & Söhne and Julius Assmann, both based at Glashütte in Saxony, likewise encased Swiss repeater mechanisms in their watches.

A 13.5-mm-diameter movement with minute repeater deserves to be hailed as a superlative that has never been bested. Faculty and students at the school of watchmaking in Vallée de Joux deserve credit for designing and constructing it. When this Lilliputian watch debuted in 1921, it was not even suitable for production in homeopathically small series, but it was nonetheless a resounding confirmation of the remarkable skills of Switzerland's best watchmakers. Incidentally, this also applies to somewhat larger calibers with diameters of eight lignes (18.05 mm). These were manufactured in small series and therefore occasionally appear on the collector's market. They are protected by correspondingly petite cases, because—in contrast to current trends for larger timepieces—yesteryear's watchmakers were keen to demonstrate their ability to achieve superlative minimalism, both inside and outside the cases.

The first repeaters for the wrist

Research in the archives of chronometry finds that Audemars Piguet unveiled the first wristwatch with minute-repeater mechanism in September 1892. As early as 1885, the family-owned manufacture launched a 14-ligne hunter caliber with minute repeater and perpetual calendar. A customer from Berlin ordered this 31.5-mm microcosm, which was ensconced inside the case of a pocket watch. In 1891, Audemars Piguet also premiered what was then the world's tiniest minute-repeater movement: its diameter was a mere eight lignes (18.05 mm). Thanks to their small dimensions, both products would have been ideal for wristwatches, but the time was obviously not yet ripe for them. The tide turned just one year later, when Louis Brandt & Frère explicitly commissioned a wristwatch

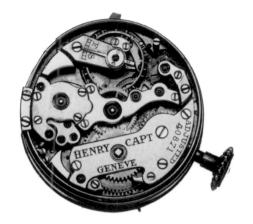

From left: smallest movement (6-ligne) with minute repeater by watchmaking school Le Sentier, c. 1946 ○ One-rappen coin ○ 8.5-ligne movement with minute repeater by Henry Capt, early 20th century ○ 50-rappen coin ○ Von links: kleinstes Uhrwerk (13,53 mm) von der Uhrmacherschule Le Sentier, ca. 1946 ○ Ein-Rappen-Münze ○ 8,5-liniges Uhrwerk mit Minutenrepetition von Henry Capt, frühes 20. Jahrhundert ○ 50-Rappen-Stück

Dem bedeutenden Uhrmacher Abraham-Louis Breguet wird die erstmalige Verwendung sorgfältig gestimmter Tonfedern im Jahr 1783 zugeschrieben. Die ringförmigen Gongs winden sich ums Uhrwerk. Mit ihrer Hilfe bauten Repetitionstaschenuhren unter Beibehaltung des angenehmen Klangs wesentlich flacher, als es die Verwendung besagter Glocken erlaubt hatte.

Angesichts dieser Fülle unterschiedlicher Verbesserungen erfreuten sich Taschenuhren mit Repetitionsschlagwerk ab Mitte des 19. Jahrhunderts zunehmender Beliebtheit. Mit steigenden Stückzahlen ging jedoch beinahe zwangsläufig das Thema Ökonomisierung einher. Das betraf einerseits den Herstellungsprozess, andererseits auch die Konstruktion. Bei einfacheren Werken verzichteten die Fabrikanten nun aus Kostengründen auf die vergleichsweise aufwendige Alles-oder-nichts-Sicherung. Auch die Feinbearbeitung der Komponenten fiel dem Rotstift zum Opfer. Erstaunlicherweise tat die Erfindung des elektrischen Lichts durch Göbel und Edison gegen Ende des 19. Jahrhunderts der Popularität feiner Repetitionsuhren – die ja gerade für den bequemen Gebrauch ohne Licht erfunden worden waren – kaum Abbruch. Ihr diskreter Charme sprach für diese uhrmacherische Komplikation. Sie gab und gibt ihre großartigen akustischen Fähigkeiten nur demjenigen preis, welcher darum weiß und sie zu klingendem Leben erwecken kann.

Kleiner, flacher, delikater

Gegen Ende des 19. und Anfang des 20. Jahrhunderts führte an kleineren Schlagwerkskonstruktionen kein Weg vorbei. Und zwar aus zwei elementaren Gründen: Einer davon resultierte – wie so oft in der Geschichte der Zeitmessung – aus modischen Erwägungen. Einhergehend mit der Kleidermode verlangte die bessere Gesellschaft nach immer flacheren Uhren. Der andere steht in Zusammenhang mit einem neuen Kundenkreis: Im Zuge fortschreitender Emanzipation verlangten immer mehr Frauen ebenfalls nach „schlagenden" Hüterinnen der Zeit.

Beides zusammen beflügelte den uhrmacherischen Ehrgeiz. Ein Übriges tat der Wettbewerb. Rohwerkeproduzenten fühlten sich fortan ebenso herausgefordert wie jene Fabrikanten, die deren Erzeugnisse zu fertigen Uhren verarbeiteten.

Maßgebliche Verdienste um die Miniaturisierung der Repetitionsschlagwerke haben sich zweifellos eidgenössische Hersteller in Genf, im Westschweizer Jurabogen und allen voran im abgeschiedenen Vallée de Joux erworben. In zäher Kleinarbeit kämpften Uhrmacher um jeden Zehntelmillimeter. Auf diese Weise gelang es, die Bauhöhe der Werke einschließlich Minutenrepetitionskadratur auf 3 Millimeter

zu reduzieren – und das bei nur rund 20 Millimetern Durchmesser. Die Funktionstüchtigkeit hatte darunter nicht zu leiden. Alle Anstrengungen zusammen bildeten das Fundament für die Herstellung von Repetitionsuhren, die allen modischen Anforderungen genügten: egal ob traditionell in der Tasche, an Halskette oder Brosche und nach der Jahrhundertwende auch am Handgelenk getragen.

Die komplexen Mechanismen, insbesondere aus dem Joux-Tal, fanden sich nicht nur in Schweizer Uhren. Sie agierten auch unter dem Zifferblatt von Uhren aus England, der Heimat des Repetitionsschlagwerks. Die im sächsischen Glashütte beheimateten Nobelmarken A. Lange & Söhne und Julius Assmann setzten ebenfalls auf Zugekauftes aus der Schweiz.

Als nie mehr unterbotener Superlativ kann ein 13,5 Millimeter kleines Uhrwerk mit Minutenrepetition gelten. Für seine Anfertigung zeichneten Mitarbeiter und Schüler der Uhrmacherschule im Vallée de Joux verantwortlich. Zwar eignete sich der 1921 vorgestellte Winzling nicht einmal für Miniserien, doch war er ein klingender Beweis für die extreme Leistungsfähigkeit der eidgenössischen Spitzenuhrmacher. Das gilt übrigens auch für die etwas größeren Kaliber mit Durchmessern von 8 Linien oder 18,05 Millimetern. Sie entstanden in Kleinserien und tauchen deswegen gelegentlich am Sammlermarkt auf. Sie sind geschützt von entsprechend kleinen Gehäusen, denn im Gegensatz zu aktuellen Trends wollten die Uhrenhersteller ihre Fähigkeit zu minimalistischen Höchstleistungen auch äußerlich eindrucksvoll demonstrieren.

Erste Zeit-Klänge vom Handgelenk

Beim Studium der chronometrischen Archive stößt man im September 1892 auf die erste Armbanduhr mit Minutenrepetition. Sie ist verknüpft mit dem Namen Audemars Piguet. Schon 1885 hatte die Familienmanufaktur ein 14-liniges Savonnette-Kaliber mit Minutenrepetition und ewigem Kalender auf den Markt gebracht. Der Kunde für den 31,5 Millimeter messenden und in einem Taschenuhrgehäuse verstauten Mikrokosmos lebte in Berlin. 1891 lieferte Audemars Piguet auch das damals weltweit kleinste Uhrwerk mit Minutenrepetition, Durchmesser 8 Linien oder 18,05 Millimeter. Mit ihren geringen Dimensionen hätten sich beide Produkte vorzüglich für Armbanduhren geeignet, aber die Zeit war offensichtlich noch nicht reif. Doch schon ein Jahr später wendete sich das Blatt. Louis Brandt & Frère gab explizit eine Armbanduhr mit Minutenrepetition in Auftrag. Ob das noch stark an Taschenuhren erinnernde Gehäusedesign

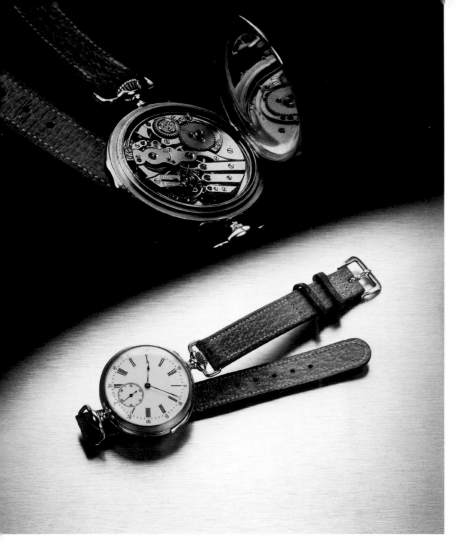

Omega, first wristwatch with minute repeater ○ erste Armbanduhr mit Minutenrepetition, 1892

with minute repeater. The accompanying documents do not make it clear whether its case's design, which was still strongly reminiscent of a pocket watch, was requested by the buyers in Bienne or developed by Audemars Piguet. Be that as it may, the mellifluous artifact encasing a 13-ligne lever movement and bearing the number 2416 left its watchmakers' ateliers in September 1892. LeCoultre & Cie. in nearby Le Sentier supplied the ébauche in Lépine style, i.e. with the winding crown opposite the small second hand. A slider at the "3" triggered the striking mechanism. The dust cover of its gold case is engraved as follows: L. Brandt & frère Bienne (Suisse), 1, Rue d'Hauteville Paris. Hors Concours. Membre du Jury Paris 1889, which means "Not in the competition. Member of the jury, Paris, 1889." This was the same year that the fourth Exposition Universelle was held in Paris. No fewer than 28 million people flocked to the world's fair, for which the Eiffel Tower was erected. The engraved phrase "Hors Concours" suggests that this unprecedented timepiece belonged to César Brandt, a juror in 1889, and that it was not eligible to participate in the competition for coveted medals at the Chicago World's Fair in in 1893.

Repeater wristwatches in the early 20ᵗʰ century

Other wristwatches with minute-repeater mechanisms appeared only after 1910. Their small movements, which were originally intended for duty inside pocket watches, ticked in wristwatches with pillow- or tonneau-shaped cases. But their numbers were relatively few compared with the far larger quantities of men's minute-repeater pocket watches.

According to the traditional understanding among respectable gents, a watch belonged inside a pocket and not on a wrist. This was especially true for watches equipped with complex repeater movements. As Johannes Mario Simmel wrote in his novel *It Can't Always Be Caviar:* "Thomas Lieven smiled dreamily, drew a golden repeater watch from his pocket and popped the lid open. The silvery bright chime of a built-in striking mechanism announced the time."

Nor should we ignore the question of cold hard cash. The ébauche and the completion of a 12-ligne (27 mm) caliber with minute repeater cost about twice as much as a 17-ligne (38.5 mm) caliber.

Renowned and experienced manufacturers such as Audemars Piguet, Haas Neveux, Charles Henri Meylan, Patek Philippe and Vacheron Constantin consequently wouldn't begin fabricating a repeater wristwatch unless they had previously received a binding order. Repeater movements built without preordained buyers often found their purchasers only after years had gone by or after having been ensconced inside several different cases. Jämes Aubert, Louis-Elisée Piguet, Victorin Piguet and LeCoultre belonged to the small and elite circle of competent ébauche suppliers.

Minute repeaters for the wrist ultimately achieved the greatest popularity among the various types of striking movements. Wristwatches with quarter-hour, eighth-of-an-hour or five-minute striking mechanisms were exceptions. Until the 1930s, such timepieces were exclusively for wealthy connoisseurs who could afford the luxury of owning something that was both special and, strictly speaking, wholly unnecessary in everyday life.

More than repeaters

Can't means won't. And this adage naturally also applies to watchmaking. The next step in complexity from an ordinary minute repeater is a so-called "carillon." For example, clockworks equipped with these musical mechanisms strike the quarter hours with more than two hammers on a corresponding number of differently tuned gongs. Four gongs are needed to play the famous Westminster Quarters melody.

The "grande sonnerie" is rightly regarded as the ne plus ultra among striking mechanisms. It automatically chimes the full hours with a low-pitched tone and the quarter hours with higher-pitched note. As a rule, most can be switched into "petite sonnerie" mode, which chimes only the full hours. In some constructions, the petite sonnerie also rings the quarter hours without a preceding full-hour strike. An additional barrel is indispensable to power the automatic chiming and the repeater mechanism, which is triggered by pressing a button. The two "fuel tanks" are "refilled" by turning the winding crown: rotated in one direction, it tightens the mainspring to power the ordinary timekeeping movement; turned in the other direction, it replenishes the reserve of power in the mainspring to animate the striking mechanism. As in "simple" repeater watches, here too the number of hammers and gongs can vary. Of course, there is also a deactivated (silent) mode.

von den in Biel ansässigen Bestellern so gewünscht war oder von Audemars Piguet entwickelt wurde, geht aus den zugehörigen Dokumenten nicht hervor. Auf jeden Fall verließ das klingende Objekt mit 13-linigem Ankerwerk und der Nummer 2416 bereits im September 1892 die Ateliers. Das Rohwerk in Lépine-Bauweise (Aufzugskrone gegenüber der kleinen Sekunde) stammte von LeCoultre & Cie. aus dem benachbarten Le Sentier. Die Auslösung des Schlagwerks erfolgte über einen Schieber bei „3". Der Staubdeckel des Goldgehäuses trägt die Gravur: L. Brandt & frère Bienne (Suisse), 1, Rue d'Hauteville Paris. Hors Concours. Membre du Jury Paris 1889 (Übersetzt: Außer Konkurrenz. Mitglied der Jury Paris 1889). In besagtem Jahr 1889 hatte in Paris die vierte Weltausstellung stattgefunden; ein von 28 Millionen Menschen besuchtes Ereignis, für das eigens der Eiffelturm errichtet worden war. „Außer Konkurrenz" lässt vermuten, dass diese Weltpremiere als Eigentum eines Jurors von 1889, nämlich César Brandt, bei der 1893 abgehaltenen Weltausstellung in Chicago nicht am Wettbewerb um die begehrten Medaillen partizipieren durfte.

Repetitionsarmbanduhren im frühen 20. Jahrhundert

Weitere Armbanduhren mit Minutenrepetition tauchen erst in den Jahren nach 1910 auf. Die kleinen, ursprünglich für Taschenuhren konzipierten Werke tickten in kissen- oder tonneauförmigen Schalen am Handgelenk. Verglichen mit der Zahl von Herrentaschenuhren mit Minutenrepetition hielt sich ihre Verbreitung jedoch in sehr überschaubaren Grenzen.

Gemäß dem überlieferten Verständnis honoriger Männer gehörten Uhren ganz generell in die Tasche und nicht ans Handgelenk. Für solche mit aufwendigem Repetitionsschlagwerk galt das in besonderer Weise. So, wie von Johannes Mario Simmel im Agentenroman *Es muss nicht immer Kaviar sein* festgehalten: „Thomas Lieven lächelte verträumt und holte eine goldene Repetieruhr hervor. [...] Er ließ den Deckel aufspringen. Silberhell kündigte ein eingebautes Schlagwerk die Zeit."

Nicht zu vergessen das liebe Geld: Rohwerk und Fertigstellung eines 12-linigen Kalibers mit Minutenrepetition (Durchmesser 27 Millimeter) kosteten etwa das Doppelte eines solchen mit 17 Linien, was umgerechnet rund 38,5 Millimeter Durchmesser sind.

Folglich starteten renommierte und einschlägig erfahrene Hersteller wie Audemars Piguet, Haas Neveux, Charles Henri Meylan, Patek Philippe oder Vacheron & Constantin erst nach fester Bestellung mit der Produktion derartiger Armbanduhren. Ins Blaue gefertigte Stücke fanden oft erst nach Jahren und / oder mehreren Gehäuseänderungen ihren Käufer. Zum kleinen Kreis kompetenter Rohwerkelieferanten zählten unter anderem James Aubert, Louis-Elisée Piguet, Victorin Piguet oder LeCoultre.

Unter den verschiedenen Schlagwerken erlangten am Handgelenk letztendlich Minutenrepetitionen die größte Beliebtheit. Demgegenüber bildeten Armbanduhren mit Viertel, Achtel oder Fünf-Minuten-Schlagwerk die Ausnahme. In jedem Fall waren solche Zeitmesser bis in die 1930er-Jahre reine Liebhaberobjekte für Menschen mit einem ordentlich gefüllten Portemonnaie. Sie konnten und wollten sich den Luxus des Besonderen, aber im Alltagsleben eigentlich Unnötigen leisten.

Mehr als Repetition

Etwas mehr geht immer. Diese Erkenntnis trifft natürlich auch auf die Uhrmacherei zu. Die Steigerung zur normalen Minutenrepetition ist eine solche mit sogenanntem Carillon, zu Deutsch Glockenspiel. Damit ausgestattete Uhrwerke schlagen beispielsweise die Viertelstunden mit mehr als zwei Hämmern auf entsprechend viele unterschiedlich gestimmte Tonfedern. Vier braucht es für die berühmte Westminster-Tonfolge.

Als höchste Schule der Schlagwerkskunst gilt mit Fug und Recht die „Grande Sonnerie". Das „Große Schlagwerk" verkündet automatisch die vollen Stunden mit tiefem und die Viertelstunden mit hohem Ton. In der Regel ist eine Umstellung auf die „Petite Sonnerie" möglich; in diesem Fall ist lediglich die Zahl der vollen Stunden zu hören. Bei manchen Konstruktionen tut das „Kleine Schlagwerk" auch die Viertelstunden ohne vorausgehenden Stundenschlag kund. Unumgänglich ist ein zusätzliches Federhaus für Selbstschlag und die per leichtem Knopfdruck auslösbare Repetition. Das „Befüllen" der dann zwei Energiespeicher erfolgt durch Hin- und Herdrehen der

Haas Neveux & Cie., minute repeater ○ *Minutenrepetition, 1929*

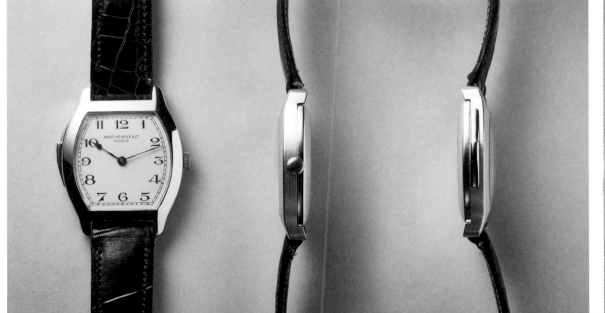
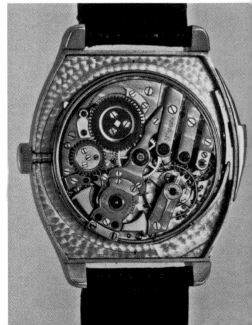

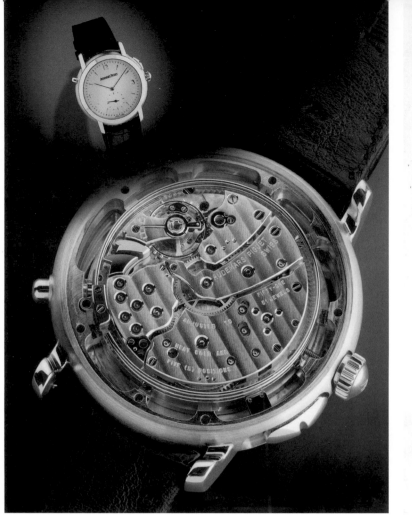

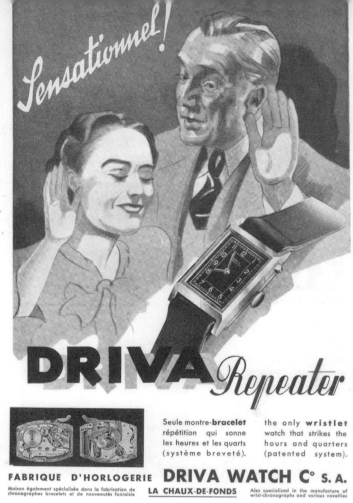

From left: Audemars Piguet Grande Sonnerie, late 20ᵗʰ century ○ Ad for Driva Repeater, quarter repeater, 1937○ Von links: Audemars Piguet Grande Sonnerie, spätes 20. Jahrhundert ○ Anzeige für Driva Repeater, Viertelrepetitionsuhr, 1937

Striving for democratization

As part of his quest for sales incentives in the 1930s, the watch manufacturer Achille Hirsch came across the erstwhile "fashion watch of the elite." Hirsch owned the Driva Watch Co., which was founded in La Chaux-de-Fonds in 1875. His search also discovered the exorbitant prices of the few available models. But what he had in mind was an affordable wristwatch with a modern rectangular case and a robust movement. To cut costs, the quarter-hour striking mechanism would have to be reduced to the bare necessities and accordingly equipped with only one gong. After the "Driva Repeater" had been readied for serial production in 1937, the *Journal Suisse d'Horlogerie* wrote: "This wristwatch has become its owner's inseparable companion, by day as well as by night. Simply pressing the slider on the 'Driva Repeater' lets its wearer hear the time in the early morning before dawn. And this watch chimes the time on the same level as its owner's pillow. With a little help from the 'Driva Repeater,' the wearer can avoid seeming rude by looking at the dial of his watch." Notwithstanding this hymn of praise, relatively few buyers were found, probably because of the model's price: 45 Swiss francs was a costly sum for a wristwatch with a case made of nickel. The first and only edition of approximately 1,500 timepieces continued to sell sluggishly until the late 1940s.

The "Tinkler" from Angelus in Le Locle likewise cannot be considered a success story. The world's first wristwatch with automatic winding and quarter-hour repeater debuted in 1957. The prerequisite for economical movement production by AS SA, which manufactured ébauches, would have been an order of at least 10,000 units. After studying the market, Angelus decided not to take the risk. Disappointingly slow sales in Germany and Switzerland of only 100 test watches with steel cases doomed this model, which deterred many potential purchasers because of its high price (approximately 300 Swiss francs).

One modularly constructed and therefore relatively inexpensive creation with automatic movement and five-minute repeater has nonetheless survived to the present day. Kelek in La Chaux-de-Fonds first ordered the striking module from the local specialist Dubois Dépraz in the Vallée de Joux in 1975. The button to trigger the repeater is typically positioned at "7 o'clock." Chronoswiss currently offers this construction with quarter-hour repeater.

Chiming modern times

It seemed as though the end had finally come for watchmaking's most visually discreet yet also most fascinating complication after the early 1960s, when the last remaining classic, high-quality, minute-repeater movements had been encased in wristwatches, most of which were sold to buyers in the United States. Suitable movements were no longer available, so new watch models were not an option. As a result, fine minute-repeater wristwatches could be purchased only at auctions or from exclusive dealers.

After a lengthy "chimeless" intermezzo, Jean-Claude Biver and his brand Blancpain caused a sonic sensation in 1986. For the first time in decades, a new mechanical movement with minute repeater had been developed. Its creator was Biver's partner Jacques Piguet of Frédéric Piguet, which manufactured ébauches. The odyssey from basic sketches to the start of a first small series consumed 10,000 hours of manpower and cost more than a million Swiss francs, a

Left and middle: Angelus Tinkler, quarter repeater, Cal. AS 1580, 1958/1959 ◦ Right: Driva Repeater, 1937 ◦ Links und Mitte: Angelus Tinkler, Viertelrepetition, Kal. AS 1580, 1958/1959 ◦ Rechts: Driva Repeater, 1937

Aufzugskrone. In einer Richtung wirkt sie auf die Zugfeder des Geh-, in der anderen Richtung auf jene des Schlagwerks ein. Wie bei den „einfachen" Repetitionsuhren kann auch hier die Zahl der verwendeten Hämmer und Tonfedern variieren. Und einen Ruhemodus gibt es selbstverständlich auch.

Demokratisierungsbemühungen

Auf der Suche nach Kaufanreizen stieß der Uhrenfabrikant Achille Hirsch in den 1930er-Jahren auf die frühere „Modeuhr der Elite". Die Recherchen des Inhabers der 1875 in La Chaux-de-Fonds gegründeten Driva Watch Co. beförderten aber auch das hohe Preisniveau der verfügbaren Modelle ans Tageslicht. Hirsch schwebte jedoch eine bezahlbare Armbanduhr mit modernem Rechteckgehäuse und robustem Uhrwerk vor. Die Viertelstunden-Schlagwerksmechanik musste sich also auf das unbedingt Notwendige beschränken und besaß dementsprechend nur eine Tonfeder. Nachdem der „Driva Repeater" 1937 Serienreife erlangt hatte, stand im *Journal Suisse d'Horlogerie* Folgendes zu lesen: „Die Armbanduhr ist ein untrennbarer Weggefährte ihres Besitzers geworden, bei Tag ebenso wie während der Nacht. Der ‚Driva Repeater' bietet die Möglichkeit, die Zeit am frühen

Driva Repeater, movement and under the dial ◦
Uhrwerk und unter dem Zifferblatt

Morgen noch vor der Dämmerung durch einfache Betätigung des Schiebers zu erfahren. Und die Armbanduhr gibt die Zeit auf einer Ebene mit dem Kissen kund. Mit Hilfe des ‚Driva Repeaters' kann

man es vermeiden, durch den Blick auf seine Uhr unhöflich zu erscheinen." Die Tatsache, dass sich trotz dieser Lobeshymne nur relativ wenige Käufer fanden, lässt sich wohl auf den Preis zurückführen: Er lag bei 45 Schweizer Franken. Und das war sehr viel für eine Armbanduhr mit Nickelgehäuse. Daher zog sich der Verkauf der ersten und einzigen Edition von rund 1500 Exemplaren bis in die späten 1940er-Jahre hin.

Auch der „Tinkler" von Angelus in Le Locle kann beim besten Willen nicht als Erfolgsstory gelten. Die weltweit erste Armbanduhr mit automatischem Aufzug und Viertelstunden-Repetition debütierte 1957. Voraussetzung für die ökonomische Werkeproduktion beim Ebauchesfabrikanten AS SA wäre die Bestellung von mindestens 10 000 Stück gewesen. Auf dieses Risiko wollte sich Angelus nach Marktstudien jedoch nicht einlassen. Der äußerst schleppende Verkauf von nur hundert Versuchsuhren mit Stahlgehäuse in Deutschland und der Schweiz machte alle Pläne zunichte. Offensichtlich schreckte der beträchtliche Preis von rund 300 Schweizer Franken viele Interessenten ab.

Eine modular aufgebaute und deshalb relativ preiswerte Kreation mit Automatikwerk und Fünf-Minuten-Repetition hält sich hingegen bis in die Gegenwart: Kelek, La Chaux-de-Fonds, hatte das Schlagwerksmodul 1975 im Vallée de Joux beim dortigen Spezialisten Dubois Dépraz geordert. Der Auslösedrücker befindet sich meistens bei „7". Bei Chronoswiss ist das Konstrukt mittlerweile auch mit Viertelstunden-Repetition erhältlich.

Klingende Neuzeit

Nachdem die letzten hochwertigen klassischen Uhrwerke mit Minutenrepetition zu Beginn der 1960er-Jahre in Armbanduhrgehäuse eingebaut und größtenteils in die Vereinigten Staaten verkauft worden waren, schien das Aus für die optisch diskreteste, aber auch faszinierendste Komplikation gekommen. Mangels geeigneter Rohwerke stellten neue Modelle keine Option dar. Folglich gab es feine Armbanduhren mit Minutenrepetition nur noch im Rahmen von Versteigerungen oder bei exklusiven Händlern zu kaufen.

Nach längerer Klangpause sorgte Jean-Claude Biver mit seiner Marke Blancpain 1986 für eine Sensation. Sein Partner Jacques Piguet vom Rohwerkefabrikanten Frédéric Piguet hatte erstmals seit vielen Jahrzehnten ein neues mechanisches Uhrwerk mit Minutenrepetition entwickelt. Der Weg von den grundlegenden Skizzen bis hin zum Start einer ersten Kleinserie erforderte einen Personalaufwand von 10 000 Stunden und verschlang die für damalige Verhältnisse extrem hohe Summe von gut einer Million Schweizer Franken.

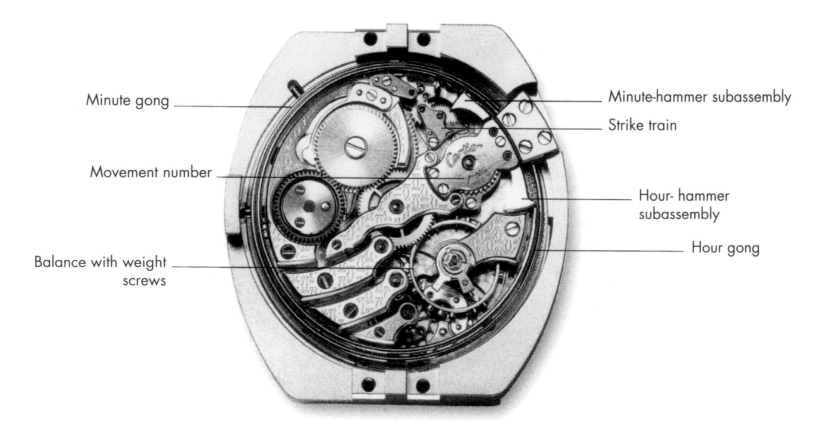

Cartier, minute repeater, Cal. 909 MC, back ○ *Minutenrepetitionsuhrwerk, Kal. 909 MC, Rückseite*

veritable king's ransom by the standards of the time.

Minute repeaters went on to celebrate an astonishing comeback. Spurred by the unparalleled hype surrounding mechanical movements, Audemars Piguet, Breguet, Bulgari, Cartier, Roger Dubuis, Gérald Genta, Franck Muller, Girard-Perregaux, Jaeger-LeCoultre, IWC, Patek Philippe, Vacheron Constantin and several other brands unveiled new repeater wristwatches. The latest trend prioritizes ultra-slim, skeletonized or inverted constructions that reveal their intricacies to appreciative beholders. We still don't know what time really is, but we do know one thing: it never stands still.

Technical repetitorium

Conventionally designed repeater wristwatches are not very visually impressive at first glance, but onlookers' jaws are apt to drop when the watch's owner activates the release mechanism and triggers the timepiece to chime the time to the nearest minute. The concert begins with low-pitched tones corresponding to the number of hours. Double tones follow to ring out the quarter hours. Finally a single high-pitched tone resounds for each minute that has elapsed since the last full quarter-hour. At 12:59 p.m. for example, a dozen low notes are sounded first, followed by three double chimes and then fourteen high-pitched tones—a total of 29 audible signals.

This sonic extravaganza naturally consumes plenty of energy. Pressing a button or pushing a slider on the case's flank tensions a spring, which supplies the power required by the striking mechanism. Approximately 100 components, including some very tiny ones, comprise the device, which is traditionally installed out of sight beneath the dial.

Exact synchronization of the cadrature with the positions of the watch's hands is a prerequisite for accurate chiming. The hands are accordingly installed at the very end of the assembly process.

Special cams convey the time from the movement to the striking mechanism.

Striking the hour

As its name suggests, the hour cam is responsible for audibly announcing the full hours. The hour cam is a spirally shaped component with twelve individual steps distributed over 360 degrees of arc. It is mounted on the hour pinion of the movement. Together with the hour pinion, the hour cam completes one full revolution every twelve hours.

When the striking mechanism is triggered, a little pin grazes along the current step of the hour cam. As the number of hours increases, so too does the level of the steps. For example, the eighth step comes into play between 8:00 and 8:59 a.m. The lever that now comes into action moves into the corresponding gap (in this example, the eighth one) of a complexly shaped rack. The power source of the striking mechanism propels the rack until it stops. Along the way, the rack causes the hammer lift shaft to rise eight times, thus causing the little hammer to strike the lower-pitched gong eight times in succession. A flat, precisely adjusted, steel spring provides the necessary power. The falling motion of the hammer tensions a little additional spring mechanism, which lifts the hammer immediately after it strikes the gong, thus assuring that the impact produces a bright, undamped sound.

The quarter hours made audible

The quarter-hour cam, which is mounted on the cannon pinion, is equipped with three double cams corresponding respectively to the first, second and third quarter of each hour. No cam is needed for the fourth quarter because this is when the mechanism strikes

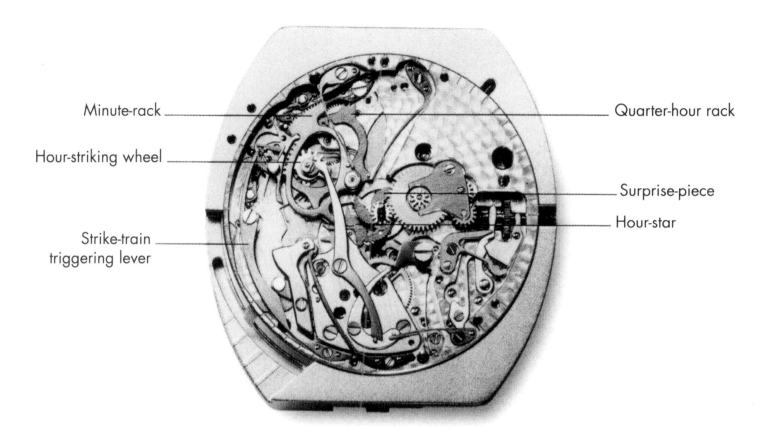

Minute-rack

Hour-striking wheel

Strike-train
triggering lever

Quarter-hour rack

Surprise-piece

Hour-star

Cartier, minute repeater, Cal. 909 MC, under the dial ○ *Minutenrepetitionsuhrwerk, Kal. 909 MC, unter dem Zifferblatt*

Anschließend feierte die Minutenrepetition ein erstaunliches Comeback. Angefacht durch den beispiellosen Mechanik-Hype präsentierten beispielsweise Audemars Piguet, Breguet, Bulgari, Cartier, Roger Dubuis, Gérald Genta, Franck Muller, Girard-Perregaux, IWC, Jaeger-LeCoultre, Patek Philippe oder Vacheron Constantin neue Repetitionsarmbanduhren. Angesagt sind nun ultraflache, skelettierte oder umgedrehte Konstruktionen, bei denen sich alles vor dem Auge des Betrachters abspielt. Die Zeit bleibt bekanntlich niemals stehen.

Technisches Repetitorium

Auf den ersten Blick machen konventionell gestaltete Repetitionsuhren am Handgelenk nicht sonderlich viel her. Doch spätestens nach dem Betätigen des wie auch immer gearteten Auslösemechanismus und dem minutengenauen Schlagen der Zeit geraten Anwesende regelmäßig in Staunen. Zuerst ist die Zahl der Stunden mit tiefem Klang zu hören. Doppeltöne repräsentieren anschließend die Viertelstunden. Für jede verstrichene Minute nach der letzten vollen Viertelstunde erklingt danach noch ein hoher Ton. Um 12:59 Uhr sind also erst zwölf tiefe Töne zu hören, dann folgen drei Doppelschläge und anschließend 14 hohe Laute. Macht summa summarum 29.

Das akustische Spektakel kostet natürlich Kraft. Die erhält der Schlagwerksmechanismus durch das Spannen einer Feder während des Auslösevorgangs per Drücker oder Schieber im Gehäuserand. Der Mechanismus ist übrigens traditionell unter dem Zifferblatt angeordnet und wird von Uhrmachern aus rund 100 teilweise winzigen Komponenten assembliert.

Voraussetzung für präzises Repetieren der Zeit ist eine exakte Synchronisierung der Kadratur mit der Zeigerstellung. Zu diesem Zweck erfolgt die Zeigermontage ganz zum Schluss. Spezielle Nockenräder reichen die Zeit vom Uhrwerk an die Schlagwerkskadratur weiter.

Stundenschlag

Wie dem Namen zu entnehmen, ist die Stundenstaffel für das Repetieren der vollen Stunden zuständig. Das schneckenförmige Gebilde mit insgesamt zwölf Stufen, welche sich über 360 Bogengrade verteilen, sitzt auf dem Stundenrohr des Uhrwerks. Zusammen mit diesem vollzieht es alle zwölf Stunden eine volle Umdrehung.

Beim Auslösen des Schlagwerks touchiert ein kleiner Stift die augenblicklich zutreffende Stufe besagter Schnecke. Mit zunehmender Stundenzahl steigt auch das Treppenniveau. Beispielsweise ist zwischen 8 Uhr und 8:59 Uhr die achte Stufe an der Reihe. Der nun in Aktion tretende Einfallhebel begibt sich in den zugehörigen, in diesem Fall also achten, Zwischenraum einer komplex geformten Zahnstange. Fachleute sprechen von einem Rechen. Die Kraftquelle des Schlagwerks bewegt diesen Rechen bis zum Anschlag und bewirkt ein achtmaliges Anheben der Hammerhebewelle, welche den kleinen Hammer so oft nacheinander gegen die tief gestimmte Tonfeder schlagen lässt. Den Schwung liefert eine flache, exakt auf den Mechanismus angestimmte Stahlfeder. Die Fallbewegung des Hammers spannt ein kleines Zusatzfederwerk, welches den Hammer nach nur kurzem Anklopfen der Tonfeder zum Zweck eines ungedämpften Klanges wieder abhebt.

Die Viertelstunden hörbar gemacht

Die Viertelstundenstaffel sitzt auf dem Minutenrohr. Sie verfügt über drei Doppelnocken für das erste, zweite und dritte Viertel jeder Stunde. Das vierte Viertel ist logischerweise entbehrlich, weil der Mechanismus die auf jede volle Stunde folgenden Minuten unmittelbar schlägt. Das Abtasten erfolgt nach Abschluss des Ertönens der jeweiligen Stundenzahl analog zur Stundenstaffel. Allerdings muss das Schlagwerk zur Darstellung der Viertelstunden per Doppelschlag die beiden Hämmer kurz nacheinander anheben.

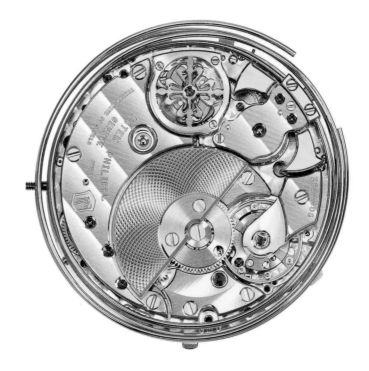

From left: Patek Philippe, Cal. R 27 PS, with minute repeater and classic gongs; Cal. R 27 Q with minute repeater and "cathedral" gongs ◦ Von links: Patek Philippe, Kal. R 27 PS mit Minutenrepetition und klassischen Tonfedern; Kal. R 27 Q mit Minutenrepetition und „Kathedral"-Tonfedern

the full hour, followed by as many minutes as have elapsed after that full hour and before the first quarter hour. The quarter-hour cam is scanned after the mechanism has chimed the full hour, analogous to the hour cam. Here, however, the striking mechanism must raise and release two hammers in quick succession to signal each quarter hour with a double strike.

To the minute

The minute cam is a star-shaped component with four curved arms, each bearing fourteen tiny teeth. It rotates together with the cannon pinion and comes into action only at the end of each chiming sequence. Each of its fourteen teeth corresponds to one minute past the full or quarter hour. The individual minutes are announced by strikes of a hammer against the higher-pitched gong. Finally, another important component of high-quality repeater mechanisms is a small plate appropriately called the "surprise piece." Concealed beneath the minute cam, the surprise piece suddenly advances when the first minute is struck, thus enlarging the tiny scanning surface to improve the mechanism's reliability.

The equally important insulator immobilizes one of the two hammers while the other hammer is striking. All in all, this assembly increases the striking mechanism's reliability and reduces its energy consumption.

Also important

To assure that the chimes don't succeed each other too quickly, their tempo is limited to no more than 1.5 strikes per second. Between 20 and 25 seconds are accordingly needed to chime 12:59 p.m. A kind of "cruise control" governs the speed. High-quality constructions of bygone years relied on a small escapement, which emitted a clearly audible buzzing sound. Centrifugal regulators, which are found in many of today's repeater watches, are delightfully silent.

Perfecting the quality of the chiming sound is a perennial challenge. Tiny influences can enhance or detract from the sonic pleasure. Wristwatches, due to their smaller size, are clearly at a disadvantage compared to pocket watches. Furthermore, the fleshy wrist itself tends to dampen the vibrations. Renowned manufacturers accordingly invest a great deal of time and money to optimize the sound. The gongs—their material, fabrication, shape, length, affixing and fine-tuning—are crucial. The ultimate goal is to achieve a harmonious and sufficiently loud sound. So-called "cathedral" gongs, which Patek Philippe and a number of other manufacturers use in some calibers, are more than 1.5 times longer than conventional gongs and accordingly emit more audible sound waves. Carbon steel has long since ceased to be the sole material used for gongs: Chopard, for example, uses sapphire; Roger Dubuis relies on an alloy with a secret formula; and Jaeger-LeCoultre connects the gongs to the sapphire crystal above the dial, thus achieving the effect of a loudspeaker.

The duration and strength of the impacts of the little hammers against the gongs are equally important. The twin objectives are to make each strike as quick and forceful as possible and to assure that the hammer quickly moves away from the gong after each impact.

Finally, the physical aspects of sound transmission must also be borne in mind. In addition to audible frequencies, inaudible ones are important too. The case's material plays a major role here. Platinum is very dense and therefore dampens the sound volume more than gold. Less precious materials such as steel, titanium or carbon are ideal, but these substances are traditionally not associated with elite luxury. Nonetheless, in repeater watches, the quality of the chiming sound takes precedence over the preciousness of the materials.

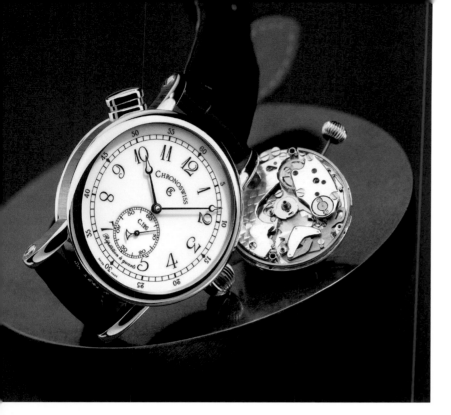
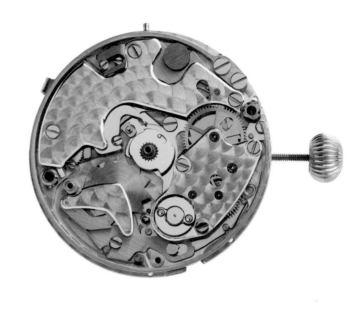

From left ○ Von links: Chronoswiss Sirius Répétition à Quarts, quarter repeater ○ Viertelrepetition, 2015 ○ Chronoswiss Cal. C.126

Auf die Minute genau

Bei der Minutenstaffel handelt es sich um eine Art Stern. Er besitzt vier geschwungene Arme mit jeweils 14 winzigen Zähnen, rotiert gleichfalls mit dem Minutenrohr und tritt erst ganz zum Schluss in Aktion. Jeder der 14 Zähne repräsentiert eine Minute nach der vollen Stunde oder vollen Viertelstunde, dargestellt durch Anschlagen der hell gestimmten Tonfeder.

Eine wichtige Komponente hochwertiger Repetitionsmechanismen ist schließlich der sogenannte Vorfall, eine kleine Platte unter der Minutenstaffel. Sie schiebt sich beim Schlagen der ersten Minute nach vorne und vergrößert so zur Steigerung der Zuverlässigkeit die naturgemäß winzige Abtastfläche.

Der ebenfalls bedeutsame Isolator legt einen der beiden Hämmer still, während der andere seine schlagende Arbeit absolviert. Insgesamt sorgt diese Baugruppe für eine verlässlichere und weniger kräftezehrende Funktion.

Ebenfalls wichtig

Damit sich das Zählen nicht zu einem Wettrennen gestaltet, beschränken Konstrukteure die Schlagzahl auf ungefähr eineinhalb pro Sekunde. 20 bis 25 Sekunden dauert demnach das akustische Darstellen von 12:59 Uhr. Eine Art Tempomat regelt die Ablaufgeschwindigkeit. Hochwertige Konstruktionen früherer Jahre besaßen eine kleine, deutlich vernehmbar schnarrende Ankerhemmung. Die Zentrifugalregler, die in vielen Repetitionsuhren unserer Tage zu finden sind, zeichnen sich dagegen durch Lautlosigkeit aus.

Kopfzerbrechen bereitet traditions- und naturgemäß die Klangqualität. Kleinigkeiten können die akustische Dimension beleben oder auch stören. Wegen ihrer geringeren Größe sind Armbanduhren gegenüber Taschenuhren in dieser Hinsicht eindeutig im Nachteil. Darüber hinaus übt das Handgelenk eine dämpfende Wirkung aus. Kein Wunder, dass renommierte Manufakturen viel Geld in Optimierungsmaßnahmen investieren. Von ausschlaggebender Bedeutung

sind Material, Fertigung, Form, Länge, Befestigung und Abstimmung der Tonfedern. Ziel aller Bemühungen ist ein harmonischer und hinreichend lauter Klang. Exemplare vom Typ „Cathedral", welche z. B. Patek Philippe in manchen Kalibern verbaut, sind gut eineinhalbmal so lang wie konventionelle. Dadurch senden sie mehr hörbare Wellen aus. Längst ist Karbonstahl nicht mehr das allein selig machende Gongmaterial. Chopard verwendet beispielsweise Saphir. Roger Dubuis setzt auf eine geheim gehaltene Legierung. Jaeger-LeCoultre verbindet die Tonfedern mit dem vorderen Saphirglas und erzielt so die Wirkung eines Lautsprechers.

Nicht minder bedeutsam sind Dauer und Härte des Schlags der kleinen Hämmer gegen die Gongs. Möglichst kurz und dynamisch, lautet hier die Devise. Auf jeden Fall müssen sie sich nach der Berührung wieder von den Gongs entfernen.

Nicht zu vergessen sind schließlich die physikalischen Aspekte der Klangübertragung. Neben den wahrnehmbaren kommt es stets auch auf unhörbare Frequenzen an. In diesem Zusammenhang spielt das Gehäusematerial eine wichtige Rolle. Platin besitzt eine hohe Dichte, dämpft das Klangvolumen deshalb mehr als Gold. Ideal ist wenig Edles wie Stahl, Titan oder mittlerweile auch Karbon. Traditionsgemäß lassen sich solche Materialien nur schwer mit Top-Luxus vereinbaren – aber bei Repetitionsuhren spielt der Klang nun einmal die erste Geige.

Repetition eines komplexen Themas in aller Kürze:

Wer hören möchte, wie spät es gerade ist, muss sich die aufwendigste aller mechanischen Zusatzfunktionen ans Handgelenk legen. Repetitionsschlagwerke geben die aktuelle Zeit auf Wunsch mehr oder minder genau akustisch wieder. Je nach Ausführung des Schlagwerks unterscheidet man die

Angelus Répétition, five-minute repeater, front and movement ◦ Fünf-Minuten-Repetition, Zifferblatt und Uhrwerk

Briefly recapitulating a complex topic:

Anyone who wants to hear the time can do so by strapping the most elaborate of all mechanical additional functions to their wrist. Repeater striking mechanisms can be triggered to chime the time with varying degrees of precision. Depending on its design, connoisseurs distinguish among the following striking mechanisms.

Quarter-hour repetition, aka "quarter repetition"

This variant can be commanded to strike the hours and quarter hours. Each full hour is represented by one strike against a low-pitched gong. A double chime signals each quarter hour: a blow against a low-pitched gong is immediately followed by an impact against a higher-pitched gong.

7½-minute or eighth-of-an-hour repetition

This type of repeater not only announces the full hours, but also rings the quarters and eighths of an hour. The quarter hours are struck against a low-pitched gong: one double strike for each quarter. The additionally elapsed eighth-hour intervals are represented by strikes against a higher-pitched gong. One treble beat means that the minute hand is in the first half of the elapsing quarter-hour (0 to 7½ minutes); two high-pitched chimes indicate that the minute hand is in the second half of the current quarter hour.

Five-minute repeaters

Watchmakers have devised two variants of this complication. One version signals the full hour with a low tone, followed by one high tone for each five-minute interval that has elapsed after the full hour. The other version rings the full hour (low tone), the subsequent quarter hours (double chime consisting of a low and a high tone), and finally each five-minute interval after the last quarter hour (high tone).

Minute repeaters

Analogous to the abovementioned five-minute repeater, a minute repeater chimes the hours, the quarter hours, and the minutes that have elapsed since the last quarter hour. Like a domestic clock, it strikes the hours and quarters "in passing," i.e. automatically and without human intervention. At the touch of a button, it can be triggered to chime the hours, quarter hours and minutes.

Repeater with carillon (musical mechanism)

This repeater differs from the others in that, for example, it chimes the quarter hours by causing three or more hammers to strike variously pitched gongs. A quartet of gongs is required to play the famous Westminster Quarters melody.

Grande sonnerie

The grande sonnerie is the ne plus ultra among striking mechanisms. Powered by a designated barrel, it automatically rings the full hours and quarter hours. Most grandes sonneries are equipped with a small slider, which can be shifted to choose among the following settings:

- Grande sonnerie: strikes the number of hours on the full hour and also strikes at "quarter past," "half past" and "quarter to" by first chiming the most recent full hour and then announcing the number of quarter hours that have elapsed since then.
- Petite sonnerie: chimes only the full hours.
- Silence: as the name suggests, all automatically activated chiming functions are switched off.

A grande sonnerie is also equipped with a minute-repeater mechanism, which can be triggered to chime the hours, quarters and minutes whenever desired.

Jaeger-LeCoultre Master Minute Repeater, 2005

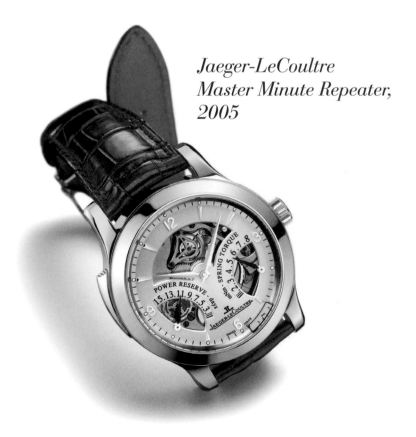

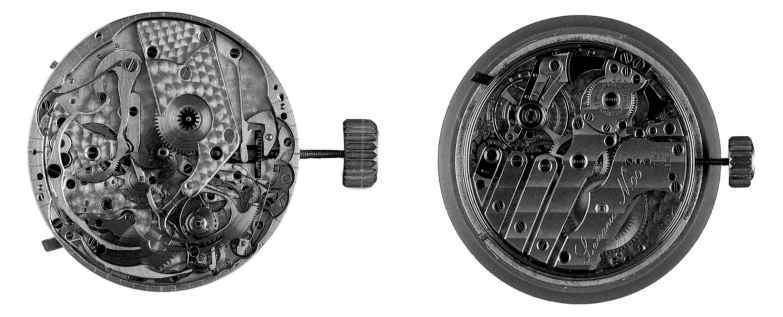

Lemania, Cal. 567, minute repeater, back and under the dial ○ Minutenrepetition, Rückseite and unter dem Zifferblatt

Viertelstunden-Repetition oder kurz Viertelrepetition

Sie schlägt auf Anforderung die Stunden und Viertelstunden. Für jede Stunde erfolgt ein Schlag auf eine tief gestimmte Tonfeder. Die Viertelstunden werden durch Doppelschläge auf die tief und eine höher gestimmte Tonfeder dargestellt.

7½-Minuten- oder Achtelrepetition

Diese Repetitionsart sagt neben den vollen Stunden auch die Viertel- und Achtelstunden an.

Erstere werden wiederum durch das Anschlagen einer tief gestimmten Tonfeder wiedergegeben. Für jede Viertelstunde erfolgt ein Doppelschlag. Die zusätzlich verstrichenen Achtelstunden-Intervalle repräsentieren Schläge auf eine höher gestimmte Tonfeder. Ein Schlag bedeutet, dass sich der Minutenzeiger in der ersten Hälfte der folgenden Viertelstunde (0 bis 7½ Minuten) befindet. Zwei besagen, dass er die zweite Hälfte dieser Zeitspanne erreicht hat.

Fünf-Minuten-Repetition

Hiervon existieren zwei Varianten:

Diejenige, welche die volle Stunde per tiefem Ton sowie anschließend die Zahl der danach verstrichenen Fünf-Minuten-Intervalle per hohem Ton verkündet, und diejenige mit Stunden- (tiefer Ton), Viertelstunden- (tiefer und hoher Ton) sowie Fünf-Minuten-Schlag (hoher Ton).

Minutenrepetition

Sie verkündet die Stunden, Viertelstunden sowie die anschließend verstrichenen Minuten analog zur zuletzt beschriebenen Fünf-Minuten-Repetition.

Wie eine Pendule schlägt sie die Stunden und Viertelstunden „im Vorbeigehen" völlig selbstständig. Auf Knopfdruck repetiert sie aber auch die Stunden, Viertelstunden und Minuten.

Repetition mit Carillon (Spielwerk)

Diese Repetition unterscheidet sich von den anderen dadurch, dass sie beispielsweise die Viertelstunden mit drei oder mehr Hämmern auf unterschiedlich gestimmte Tonfedern schlägt. Ein Gong-Quartett ermöglicht die berühmte Westminster-Tonfolge.

Grande Sonnerie

Allerhöchste Schule verkörpert die Grande Sonnerie. Das „Große Schlagwerk" mit eigenem Federhaus tut Stunden und Viertelstunden absolut selbsttätig kund. Mithilfe eines kleinen Schiebers lassen sich meist folgende Einstellungen wählen:

- Grande Sonnerie: Schlägt die jeweilige Stundenzahl zur vollen Stunde sowie die Zahl der Stunden und Viertelstunden um „Viertel nach", „halb" und „Viertel vor".
- Petite Sonnerie (Kleines Schlagwerk): Schlägt nur jeweils die vollen Stunden.
- Ruhe: Wie der Name schon andeutet, sind alle Selbstschlagfunktionen abgeschaltet.

Mithilfe eines ebenfalls integrierten Minutenrepetitionsmechanismus schlägt sie auf Anforderung auch die Stunden, Viertelstunden und Minuten.

Audemars Piguet Grande Sonnerie, with minute repeater and carillon, movement and under the dial ○ mit Minutenrepetition und Carillon, Werk und unter dem Zifferblatt

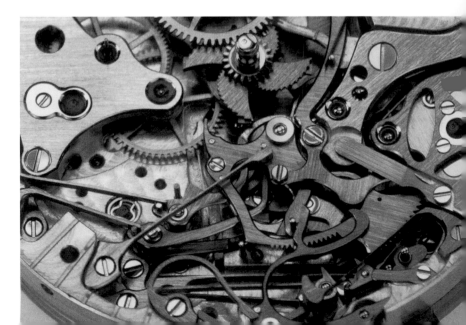

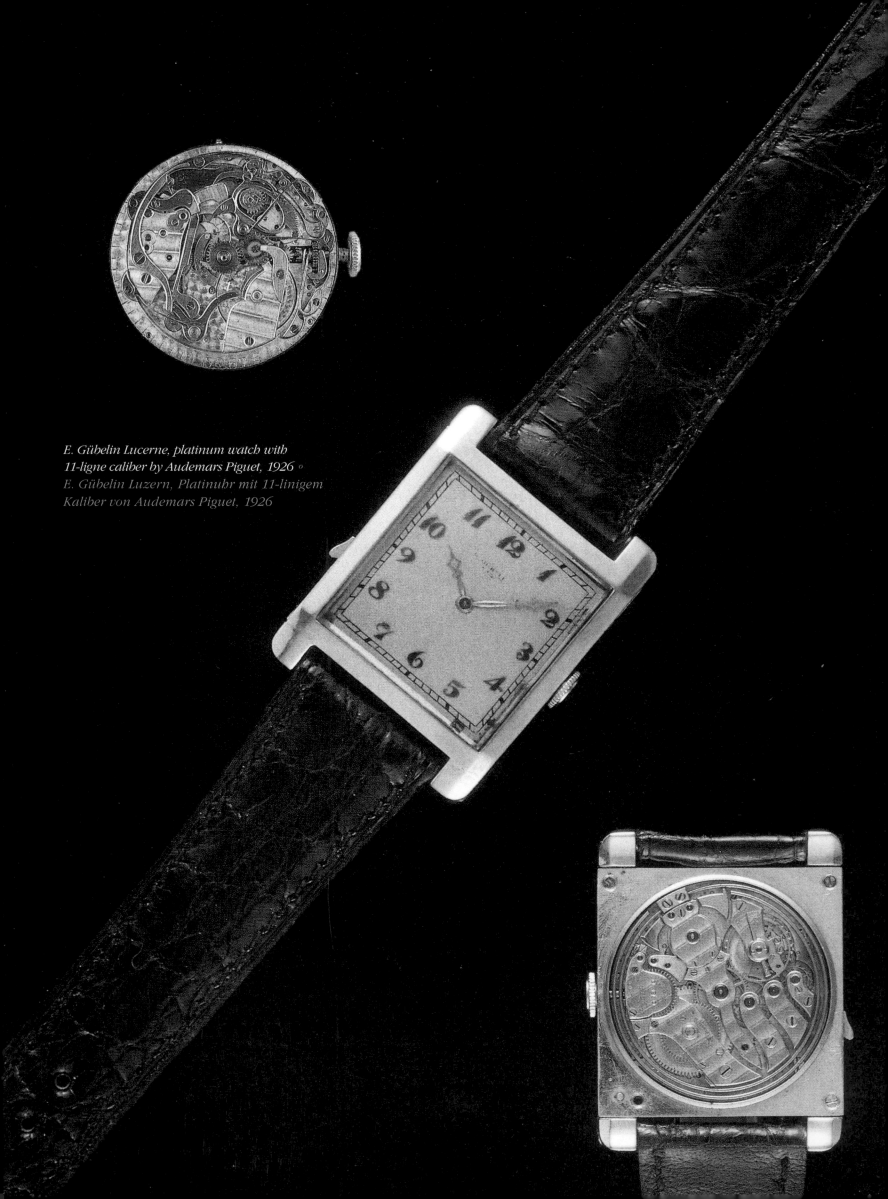

*E. Gübelin Lucerne, platinum watch with
11-ligne caliber by Audemars Piguet, 1926* ∘
*E. Gübelin Luzern, Platinuhr mit 11-linigem
Kaliber von Audemars Piguet, 1926*

Left ◦ Links: Patek Philippe, custom-made minute repeater with engraving, 1926 ◦ Patek Philippe, auf Wunsch angefertigte Minuten-repetitionsuhr mit Gravur, 1926 ◦ Above ◦ Oben: Cartier Tortue Minute Repeater, 1931

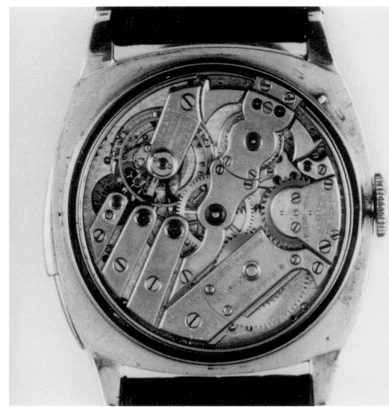

Vacheron Constantin, minute repeater, front and movement, c. 1940s
Vacheron Constantin, Minutenrepetition, Zifferblatt und Werk, ca. 1940er

Audemars Piguet John Shaeffer
Minute Repeater, 1907

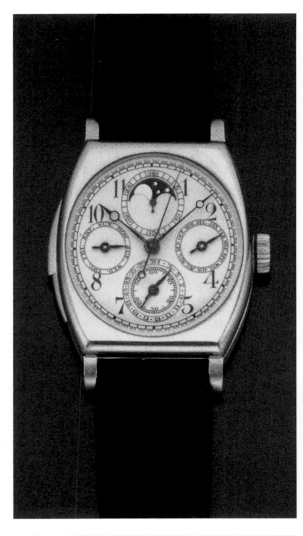

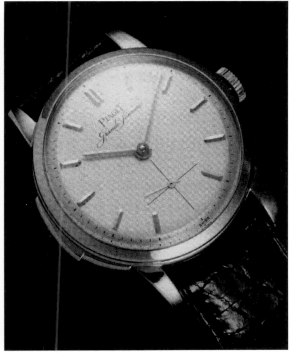

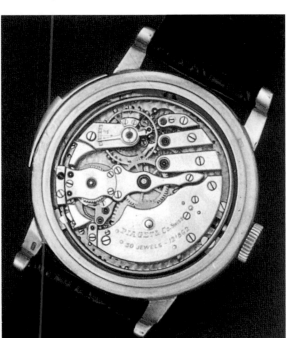

Left top and bottom: James Schulz, No. 13511, minute-repeating perpetual calendar and single-button chronograph, c. 1930 ○ Links oben und unten: James Schulz, Nr. 13511, Monopusher-Chronograph mit Minutenrepetition und ewigem Kalender, ca. 1930

Right top, mid, and bottom: Piaget Grande Sonnerie, minute repeater, 1955 ○ Rechts oben, Mitte und unten: Piaget Grande Sonnerie, Minutenrepetition, 1955

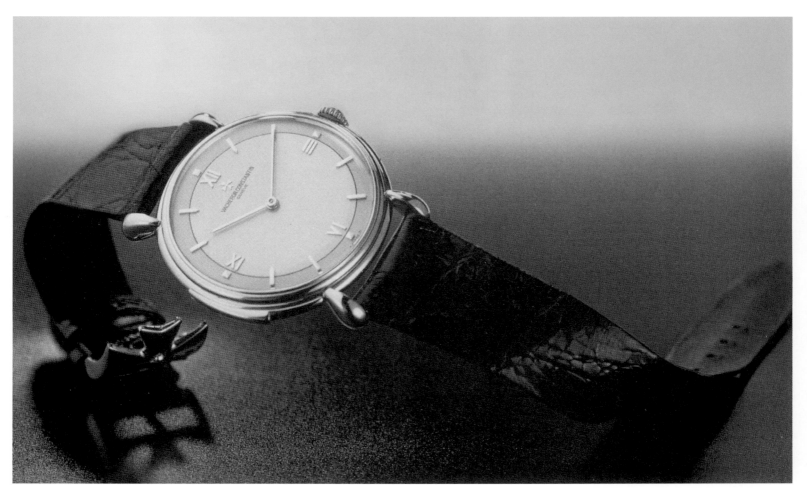

Vacheron Constantin, minute repeater, with 13-ligne caliber, limited edition of 38 pieces ○ Minutenrepetition, mit 13-linigem Kaliber, limitiert auf 38 Stück, 1942–1951

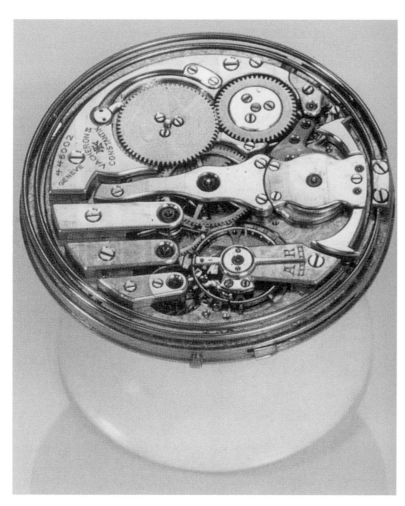

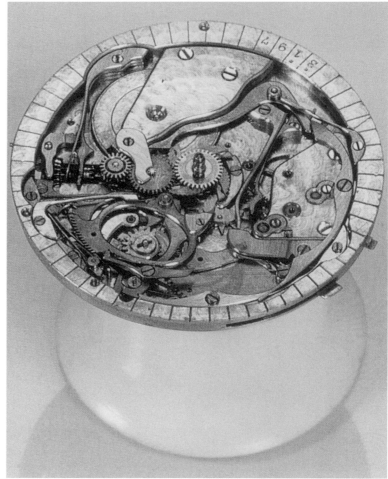

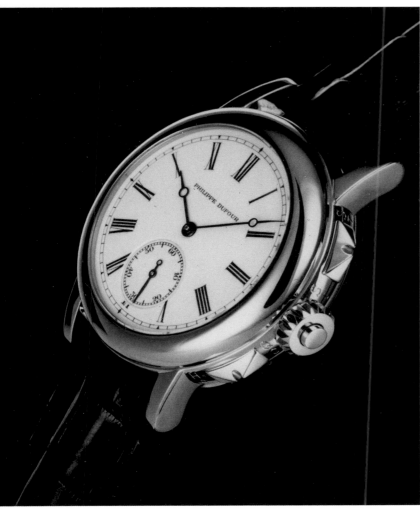

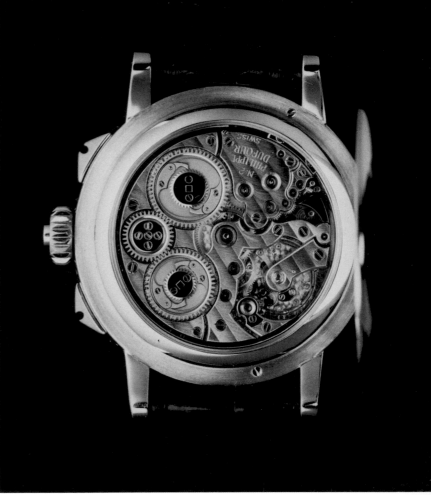

Top: Girard-Perregaux Minute Repeater Tourbillon with gold bridges, assembly of a gong ○ Oben: Girard-Perregaux Minute Repeater Tourbillon mit Goldbrücken, Montage der Tonfeder ○ Bottom ○ Unten: Philippe Dufour Grande Sonnerie, 1990s

A. Lange & Söhne Zeitwerk, Cal. L043.5, striking mechanism ∘ Schlagwerkmechanismus

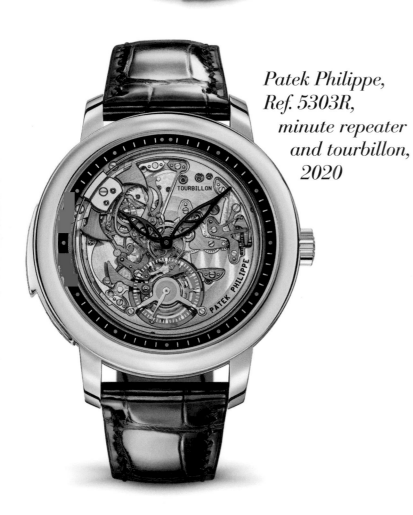

A. Lange & Söhne Zeitwerk, Cal. L043.5, 2015

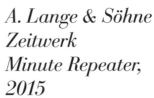
A. Lange & Söhne Zeitwerk Minute Repeater, 2015

Patek Philippe, Ref. 5303R, striking hammers ∘ Schlagwerkhämmer

Patek Philippe, Ref. 5303R, minute repeater and tourbillon, 2020

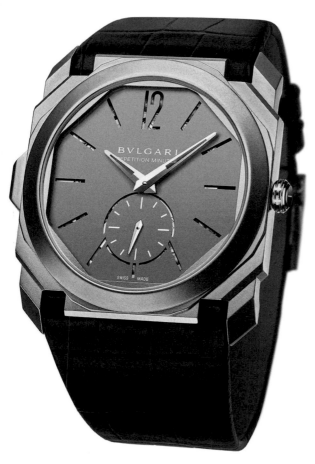

*Bulgari Octo Finissimo
Minute Repeater, 2016*

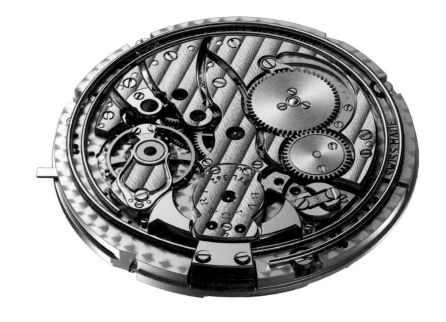

Bulgari, Cal. BVL 362, 2016

*Hublot Classic Fusion Tourbillon
Cathedral Minute Repeater Carbon
"Lang Lang," 2016*

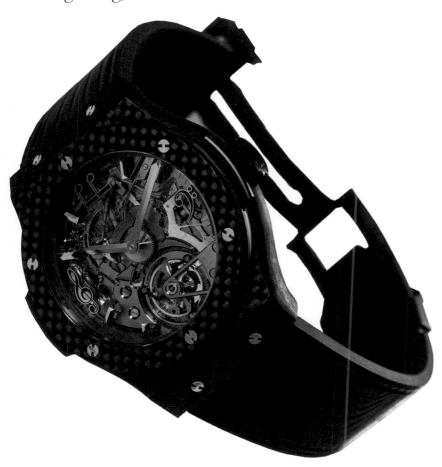

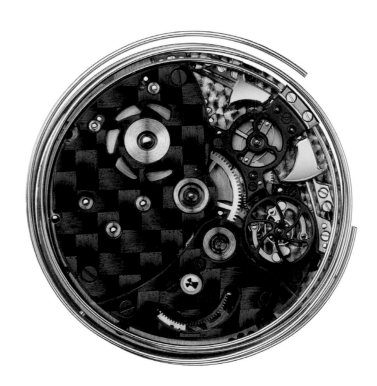

Hublot, Cal. HUB 8100

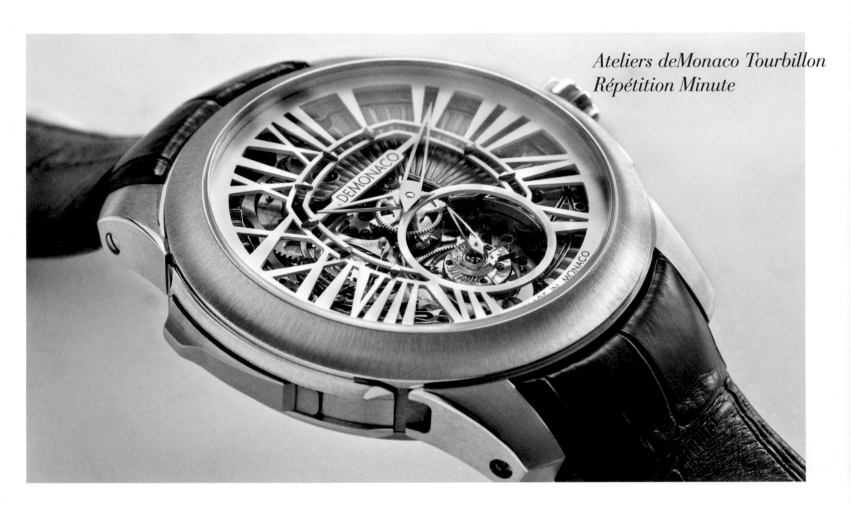

Ateliers deMonaco Tourbillon
Répétition Minute

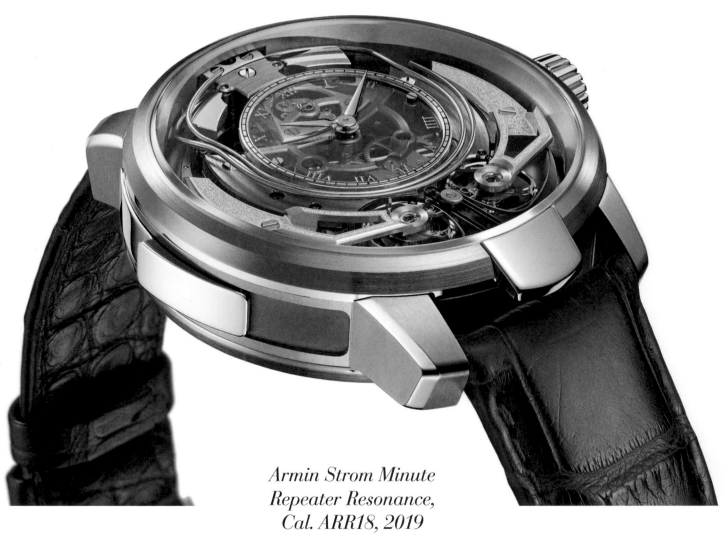

Armin Strom Minute
Repeater Resonance,
Cal. ARR18, 2019

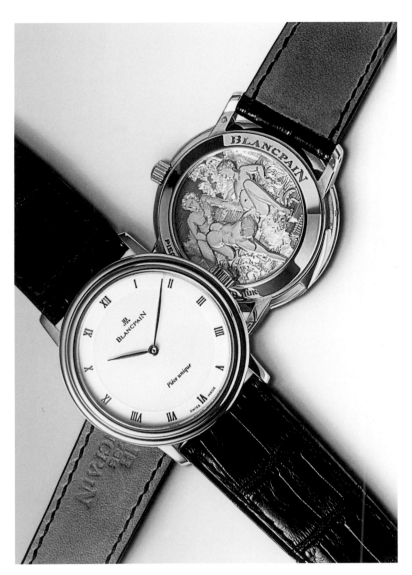

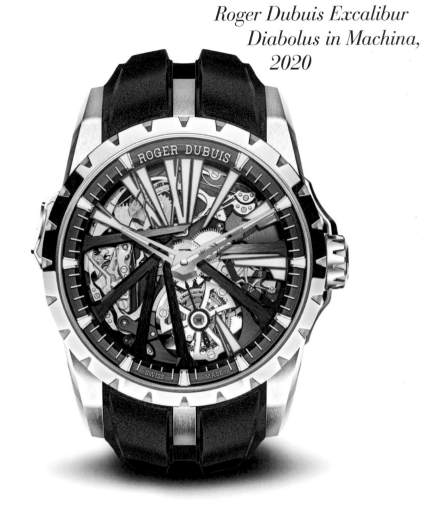

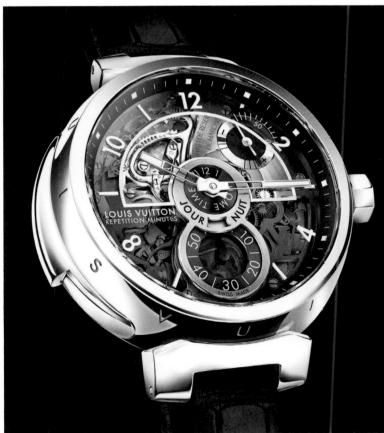

Top left: Blancpain, special edition with erotic motive on the back ◦ Oben links: Blancpain, Spezialanfertigung mit erotischem Motiv auf der Rückseite ◦ Bottom, from left ◦ Unten, von links: Louis Vuitton Tambour Minute Repeater, 2014 ◦ H. Moser & Cie. Swiss Alp Watch Concept Black, tourbillon and minute repeater without dial and hands ◦ Tourbillon und Minutenrepetition ohne Zifferblatt und Zeiger, 2019

Corum Heritage Minute Repeater, 2016

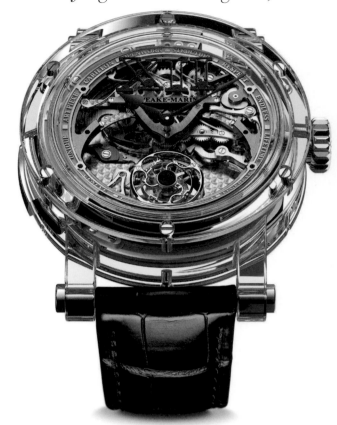

Speake-Marin Minute Repeater Flying Tourbillon Légèreté, 2019

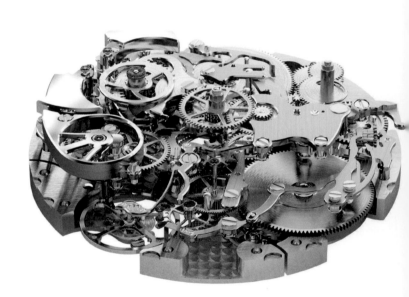

Chopard, Cal. L.U.C 08.01-L

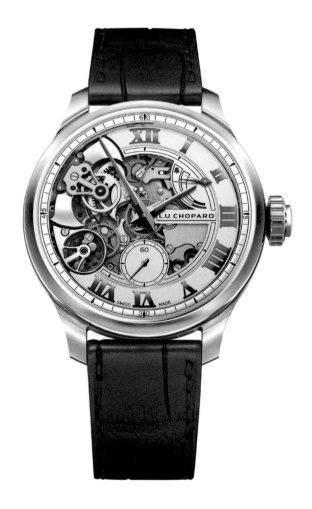

Chopard L.U.C Full Strike, 2018

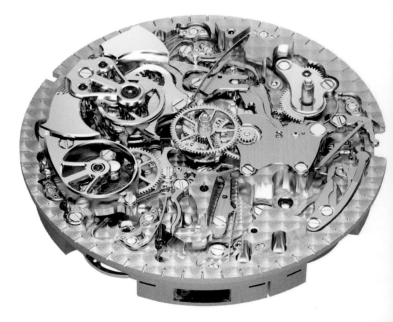

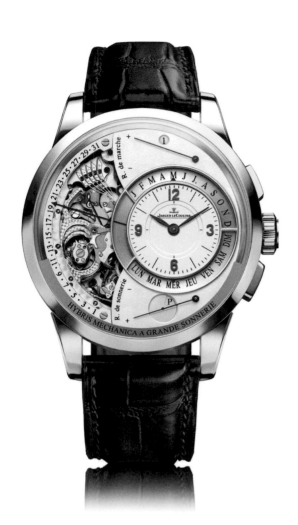

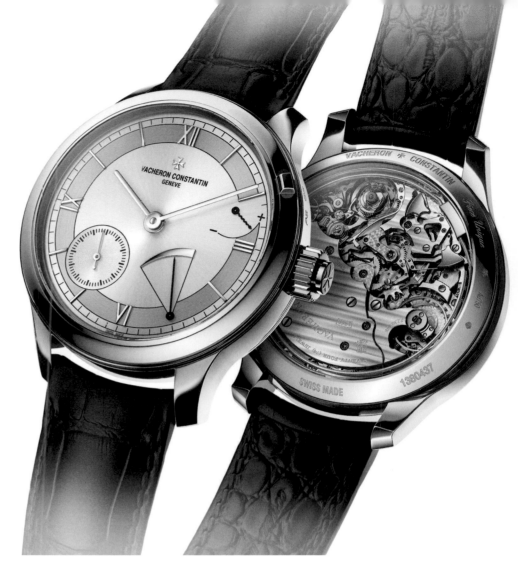

Jaeger-LeCoultre Duomètre Hybris
Mechanica à Grande Sonnerie, 2013

Vacheron Constantin Les Cabinoties
Symphonia Grande Sonnerie, 2017

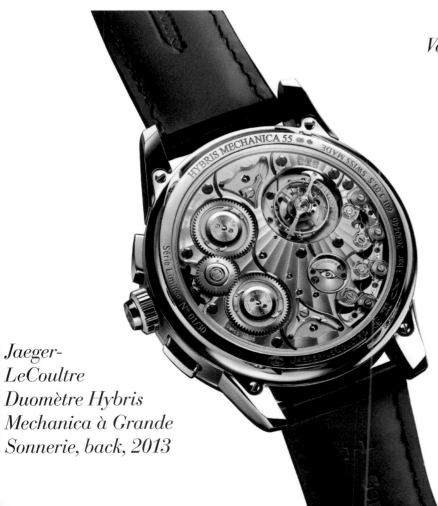

Vacheron Constantin,
Cal. 1731

Jaeger-
LeCoultre
Duomètre Hybris
Mechanica à Grande
Sonnerie, back, 2013

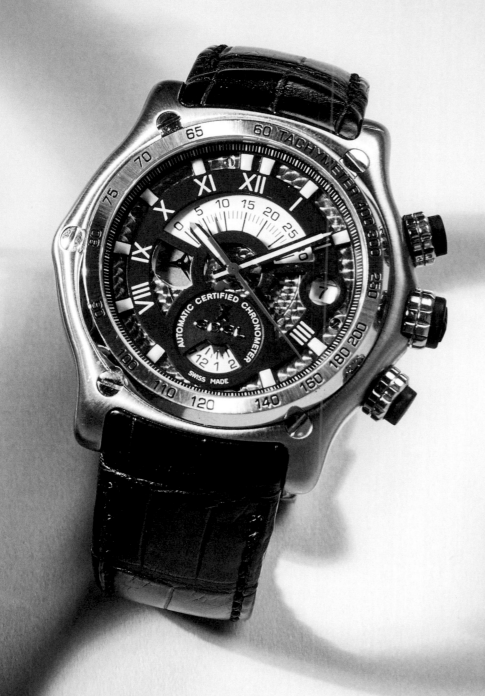

Chronograph

What Time has Written

Chronographs through the ages

"Success has many fathers, but failure is an orphan." A look into the annals of watchmaking, or more precisely into the chapter on chronographs, confirms the truth of the first half of that adage. Chronographs are sophisticated instruments for recording the duration of an event or observation. Compared with ordinary stopwatches, which achieve basically the same feat, a chronograph has a decisive advantage: while it measures an elapsing interval, its other hands continue to track the time of day or night. A chronograph thus accomplishes two tasks simultaneously and its user always knows what time it is. Etymologically, the word is derived from ancient Greek, combining chronos (time) and graphie (to write) to create a new word that literally means "that which writes time" or figuratively means "time recorder." The chronograph is by far the most popular additional function performed by today's mechanical and electronic wristwatches. There are at least two reasons for this popularity. Firstly, chronographs are extraordinarily versatile in dealing with the time that Faust would have loved to have stopped in Goethe's drama: "Oh, stay! You are so beautiful!" Alas, poor Faust! As every child knows, nothing can halt time's inexorable passage. But thanks to a separate gear train, a chronograph can at least offer the illusion of being able to cheat mankind's most precious asset every now and then. A push of a button sets the chronograph's hands in motion, another push stops them, and a third sends them hurrying back to their zero positions so the game can begin anew.

Another reason for the chronograph's boom is the impressive appearance of a "time writer" on its wearer's wrist. Admiring glances are irresistibly attracted by the two buttons beside its crown and by a main dial with contrasting discs for the elapsed-time function. The fact that a chronograph can also measure elapsing and elapsed intervals plays only a minor role nowadays. When it comes to cooking spaghetti al dente, a smartphone is the better choice: it sounds an alarm when the pasta is ready. There's no need to repeatedly consult the chronograph's hands, so you can leave the timekeeping to your phone and do something else, for example, try to find the missing colander.

Nevertheless, classic chronograph wristwatches still have plenty of genuine uses. Here are a few examples:

Appointment reminder

To be discreetly reminded of an upcoming meeting, start the chronograph and then stop it when its elapsed-seconds hand points to the hour or minute of the impending rendezvous. Afterwards, every glance at its dial is an unobtrusive reminder that something is scheduled at that specific time.

Knot in a handkerchief

People used to tie knots in their handkerchiefs as reminders. A chronograph can easily replace such a knot. If a good idea, an ingenious inspiration in the middle of the night or any other event mustn't be forgotten but writing it down isn't possible right now, simply let the chronograph run for a few seconds and stop it. Afterwards the halted hand, which no longer points vertically toward the "12," will serve as a reminder that a thought was worth remembering.

Visualized countdown

A chronograph can help its user visualize the passage of time. To do this, press the start button and stop the hand at the minute mark corresponding to the time of the upcoming. The gap between the halted hand and the continually moving hour or minute hand steadily closes. This shows that the interval between the present moment and the future event is narrowing with each passing second.

Log function

Nobody wants to be involved in a car accident. But if a crash does happen, there are plenty of more important things to worry about than writing down the exact time. A chronograph's wearer can start it immediately upon impact and leave it running. When the crisis is over and there's time to reconstruct what happened, the user halts the chronograph, subtracts the stopped interval from the current time and knows exactly when the accident occurred. In the same way, the tardiness of an employee or other person can be tallied and recorded with utmost discretion.

Mascot

Superstitious people can position the chronograph's elapsed-seconds hand so it points directly to their lucky number and hope that this little good luck charm will help them on difficult days.

A time-writer retrospective

No matter a chronograph is used or not used, the device will always look back on a long history of inventive concepts and clever godfathers. The tale begins in the early 18th century, when increasingly many watchmakers began augmenting the lone hour hand, which had been a soloist for centuries, with an additional longer hand to indicate the minutes. Second hands also increasingly came into the focus of attention starting around 1740. This quickly moving third hand underscored the quest for precision that inspired scientists, researchers and watchmakers in the Age of Enlightenment. The first steps towards capturing short intervals consisted of interrupting the running of a watch by temporarily halting its balance or escape wheel. But this meant that the user had to remember the position(s) of the hand(s) or record them in writing at the beginning and end of each measured timespan.

The master watchmaker Jean-Moïse Pouzait (1743–1793) presented his mechanism with an independent jumping or "dead" second hand (seconde morte) in 1776. His instrument had two second hands: a small, continuously advancing one at the "6" and the aforementioned jumping hand, which swept around the dial's periphery from the center of the face. This hand could be halted and set into motion again at the touch of a button, thus making it possible to measure intervals up to one minute in duration. Users who wanted to measure longer timespans had to reach for paper and pencil and perform some mental arithmetic. Furthermore, it was not possible to speedily return the central seconde morte to

Graf Chrono lässt bitten

Der Chronograph im Wandel der Zeiten

„Der Erfolg hat viele Väter. Der Misserfolg dagegen ist ein Waisenkind." Beim Blick in die Annalen der Uhrmacherei, genauer gesagt in das Kapitel Chronographen, trifft Ersteres uneingeschränkt zu. Chronographen sind ausgeklügelte Instrumente zum Erfassen der Dauer einer Begebenheit oder einer Beobachtung. Gegenüber gewöhnlichen Stoppuhren, die prinzipiell das Gleiche tun, besitzen sie einen entscheidenden Vorteil: Während sie im Dienste der Kurzzeitmessung tätig sind, drehen sich die Hände der Zeit unbeeindruckt weiter – Chronographen erledigen zwei Dinge simultan. Man bleibt also ständig informiert darüber, wie spät es gerade ist. Etymologisch entstammt der Begriff dem Altgriechischen. Er setzt sich zusammen aus „Chronos" und „Graphie". Die beiden Wörter „Zeit" und „Schrift" ergeben also jenen „Zeitschreiber", welcher heute zu den mit Abstand beliebtesten Zusatzfunktionen mechanischer und auch elektronischer Armbanduhren gehört. Und das aus zwei Gründen: Zum einen sind Chronographen außerordentlich vielseitig im Umgang mit jener Zeit, die Dr. Faust in Goethes Drama liebend gerne angehalten hätte: „Verweile doch, du bist so schön." Dass sich ihr kontinuierliches Verstreichen bedauerlicherweise nicht unterbrechen lässt, weiß jedes Kind. Aber dank eines separaten Räderwerks bieten Chronographen zumindest die Illusion, dem kostbarsten Gut der Menschheit hin und wieder ein Schnippchen schlagen zu können. Auf Knopfdruck setzt sich der zugehörige Zeiger in Bewegung, auf Knopfdruck bleibt er stehen und auf Knopfdruck springt er zurück auf null. Das Spiel beginnt aufs Neue.

Der Chronographen-Boom gründet sich aber auch auf den optisch starken Auftritt am Handgelenk. Zwei Drücker neben der Krone und ein strukturiertes Zifferblatt mit abgesetzten Feldern für die Zählfunktion lenken viele Blicke auf sich. Dass man damit auch stoppen kann, spielt heutzutage nur eine untergeordnete Rolle. Wenn es darum geht, Spaghetti al dente zu kochen, ist das Handy die bessere Wahl: Es gibt einen Ton von sich, wenn der Zeitpunkt gekommen ist. Regelmäßige Blicke auf Zifferblatt und Zeiger erübrigen sich, sodass man sich nebenbei anderen Dingen widmen kann.

Trotzdem lassen sich klassische Armbandchronographen auch heute noch sinnvoll nutzen. Hier sind einige Beispiele:

Terminzeiger
Wer sich diskret an einen Termin erinnern lassen möchte, startet seinen Chronographen und fixiert ihn vorübergehend bei der anstehenden Stunde oder Minute. Danach lässt jeder Blick aufs Zifferblatt wissen, dass da doch irgendetwas war.

Knoten im Taschentuch
Früher machten sich Menschen zur Erinnerung gerne einen Knoten ins Taschentuch. Einen solchen kann der Chronograph mühelos ersetzen. Wenn eine Idee, eine geniale nächtliche Eingebung oder sonst ein Ereignis nicht in Vergessenheit geraten soll, Aufschreiben aber gerade nicht möglich ist, lässt man den Chronographen einige Sekunden lang laufen. Danach erinnert der in schräger Position angehaltene Stoppzeiger zumindest daran, dass es an etwas zu denken galt.

Visualisierter Countdown
Chronographen können das Verstreichen der Zeit augenfällig visualisieren. Zu diesem Zweck betätigt man den Startdrücker und hält den Zeiger zum Beispiel dort am Zifferblatt an, wo ein Ereignis wartet. Kontinuierlich schließt sich danach die Zeitschere zwischen ihm und dem Stunden- oder Minutenzeiger. Sie führt vor Augen, dass es immer knapper wird.

Protokollfunktion
Niemand will in einen Autounfall verwickelt sein. Wenn es trotzdem geschieht, hat man andere Sorgen, als den exakten Zeitpunkt schriftlich festzuhalten. Besitzer eines Chronographen starten diesen unverzüglich, wenn es knallt. Nach dem Anhalten subtrahiert man die gestoppte Zeitspanne von der aktuellen Uhrzeit und ist

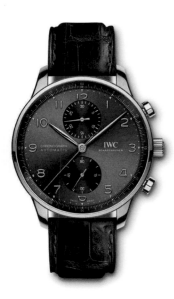

IWC Portugieser Chronograph, 2020

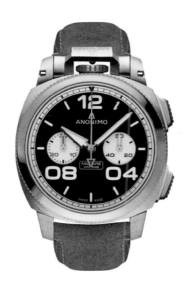

Anonimo Militare Chrono Vintage Newman

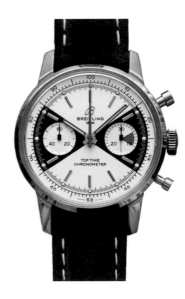

Breitling Top Time, limited edition, 2020

Chopard Alpine Eagle XL, 2020

its zero position. Pouzait's seminal thoughts fell on fertile soil. Numerous watchmakers, including legendary craftsmen such as Jules Jürgensen, adopted Pouzait's ideas for their own developments with two barrels.

Diverse constructions dedicated to the theme of measuring brief timespans appeared in the further course of the 18th and early 19th centuries. These devices are associated with more or less well-known names such as Ferdinand Berthoud, Abraham-Louis Breguet, Frederick-Louis Fatton, Nicolas Gourdain, Jean-Aimé Jacob, Jonas-Louis Lassieur, Louis Moinet, Louis-Frédéric Perrelet, Henri Robert or Hubert Sarton, to name but a few.

Ink writers

Genuine "time writers," which record a measured interval by placing a droplet of ink on the dial, first appeared as early as 1821. Athletic activities, especially races of various kinds, were en vogue. The accompanying phenomena that spilled over from England to the European mainland had sporting qualities of a different sort. While humans, horses or dogs raced toward the finish line, members of the high society placed bets on the outcome. Detailed background knowledge about the contestants and their racing performance could provide lucrative advantages, so an increasingly large number of competitive racing fans were eager to acquire helpful time-measuring instruments.

Precisely this is what Nicolas-Mathieu Rieussec (1781–1866) unveiled on September 1, 1821, when four horse races took place on the Champ de Mars in Paris. The French watchmaker had long been working towards this major sporting and social event. He hoped that his innovative equipment would be able to record the lap times on the Champ de Mars with to-the-second accuracy. He brought several chronographs to the racetrack and all of them fully lived up to expectations. Among the witnesses of their success were illustrious personages such as Antoine-Louis Breguet and Gaspard de Prony. The latter was an engineer, mathematician and respected member of the Bureau des Longitudes. After writing a glowing report about Rieussec's brainchildren, the French Academy of Sciences officially expressed respect for his "Chronograph with Seconds Indicator" on October 15, 1821. The commission hailed an invention that "indicates the duration of several successive events without the observer having to turn away from his observation to glance at a dial or concentrate on the sound of a time signal or view the oscillation of a balance wheel. A chronograph with such a property unquestionably offers precious resources to physicians, engineers and, in general, anyone who measures phenomena."

The five-year patent granted to Monsieur Rieussec on March 9, 1822 protected his rights to an innovative apparatus with a rotating dial and a 60-second scale. At the touch of a fingertip, a little nib marked the enameled ring with dots of colored ink. The enamel accordingly needed to be wiped clean after each elapsed-time measurement. A digital ten-minute totalizer was displayed in a small window. A wooden case protected the 112 x 85 x 58 millimeter pillar movement with cylinder escapement and a balance paced at a frequency of 2.5 hertz.

The granting of the first patent for a chronograph triggered a flurry of activity. In London, Frederick-Louis Fatton made a name for himself with a pocket-watch version of the "ink-pen time-writer." Rieussec likewise continued to develop his patented invention. His subsequent smaller model was again circular and intended to be worn in a pocket. A hand equipped with an ink reservoir rotated above its white enamel dial. Pressing a button triggered the little hand to mark the dial with a droplet of ink.

Lever movement instead of ink

Chronographs that relied on droplets of ink were popular in the early 19th century, but they would soon be rendered obsolete by inkless models. Many watchmakers were hard at work developing the device that is now known as a chronograph, but should correctly be called a chronoscope (from the Greek word skopeïn, which means "to observe"). This term denotes a watch with additional hands that can measure elapsed intervals and afterwards be reset to zero at the touch of a button. The seeds of a breakthrough were planted in 1844, when the watchmaker Adolphe Nicole premiered a heart-shaped, geometrically calculated disc. Nicole mounted it the same shaft that bears the chronograph's elapsed-seconds hand at its front end so that the heart-shaped cam collaborated with a suitably shaped lever to trigger an immediate zero reset. This intelligent component remained more theoretical than genuinely practical until 1862, when a version of the zero-reset chronograph similar to those still in use today debuted at the London International Exhibition. Credit for its fabrication is due to Henri-Ferréol Piguet, an employee of the Vallée de Joux-based manufactory Nicole & Capt. Adolphe Nicole was granted a patent the same year. A small but by no means negligible blemish remained. For technical reasons, the chronograph's ingenious auxiliary movement or "cadrature" was installed directly under the dial. This trick saved watchmakers the trouble of having to precisely drill through narrow-diameter steel shafts. It also made production easier because

Im weiteren Verlauf des 18. und frühen 19. Jahrhunderts begegnet man einer Vielfalt unterschiedlicher Konstruktionen, die sich dem Thema Kurzzeitmessung widmen. Sie sind verknüpft mit mehr oder minder bekannten Namen wie Ferdinand Berthoud, Abraham-Louis Breguet, Frederick-Louis Fatton, Nicolas Gourdain, Jean-Aimé Jacob, Jonas-Louis Lassieur, Louis Moinet, Louis-Frédéric Perrelet, Henri Robert oder Hubert Sarton, um an dieser Stelle nur einige zu nennen.

genau im Bilde. Auf die gleiche Weise lässt sich die Verspätung eines Mitarbeiters oder einer anderen Person mit größter Diskretion protokollieren.

Maskottchen

Abergläubische Zeitgenossen positionieren den Chronographenzeiger exakt gegenüber ihrer Glückszahl und hoffen inständig darauf, dass ihnen dies an schwierigen Tagen hilft.

Zeitschreibende Rückblende

Egal, wie immer man seinen Chronographen nutzt oder auch nicht: In jedem Fall blickt er zurück auf eine lange, von vielen gedanklichen Aspekten und schlauen Vätern geprägte Geschichte. Sie beginnt im frühen 18. Jahrhundert, als immer mehr Uhrmacher den schon lange gebräuchlichen Stundenzeiger um ein längeres Pendant zur Indikation der Minuten ergänzten. Ab etwa 1740 gelangten auch Sekundenzeiger zunehmend in den Fokus. Sie unterstrichen jenes Streben nach Präzision, welches Wissenschaftler, Forscher und Uhrmacher im Zeitalter der Aufklärung beseelte. Erste Schritte zum Erfassen kurzer Zeitintervalle bestanden darin, den Lauf einer Uhr durch das Blockieren von Unruh oder Ankerrad zu unterbrechen. Das jedoch verlangte nach dem schriftlichen Festhalten der Zeigerposition(en) zu Beginn und am Ende des jeweiligen Stoppvorgangs.

Als der Meisteruhrmacher Jean-Moïse Pouzait (1743–1793) seinen Mechanismus mit unabhängiger, springender („toter") Sekunde (*seconde morte*) vorstellte, zeigten die Kalender das Jahr 1776. Sein Instrument verfügte über zwei Sekundenzeiger: einen kleinen, kontinuierlich schleichenden bei „6" und besagten springenden in der Mitte des Zifferblatts. Letzterer ließ sich per Knopfdruck nach Belieben anhalten und wieder in Bewegung setzen. Dadurch waren Zeitnahmen bis zu einer Minute möglich. Wer länger stoppen wollte, musste zwangsläufig wieder zu Papier und Bleistift greifen und dazu im Kopf rechnen. Außerdem war das Nullstellen der zentralen *seconde morte* nicht möglich. Pouzaits Gedanken stießen auf fruchtbaren Boden. Viele Uhrmacher, darunter auch Legenden wie Jules Jürgensen, übernahmen sie für eigene Entwicklungen mit zwei Federhäusern.

Tintenschreiber

Echte Zeitschreiber, welche gestoppte Zeitintervalle mit Tinte aufs Zifferblatt bannen, lassen sich bis ins Jahr 1821 zurückverfolgen. Damals gewannen sportliche Aktivitäten wie Rennen aller Art zunehmend an Popularität. Die in diesem Zusammenhang aus England aufs europäische Festland herüberschwappenden Begleiterscheinungen besaßen freilich andersartige sportliche Qualitäten. Während Menschen, Pferde oder Hunde um den Sieg kämpften, wettete die bessere Gesellschaft auf das Resultat. Weil detailliertes Hintergrundwissen über die Kontrahenten und deren Leistungsfähigkeit einträgliche Vorteile bescheren konnte, verlangte die steigende Zahl wettsüchtiger Fanatiker nach hilfreichem Messgerät. Genau das präsentierte Nicolas-Mathieu Rieussec (1781–1866) am 1. September 1821. Auf dem Pariser Champ de Mars gingen gleich vier Pferderennen über die Bühne. Lange schon hatte der französische Uhrmacher auf dieses sportliche und gesellschaftliche Großereignis hingearbeitet. Mit neuartiger Gerätschaft wollte er die Rundenzeiten auf dem Marsfeld möglichst sekundengenau erfassen. Zu diesem Zweck führte er gleich mehrere Chronographen mit sich – und die leisteten exakt das Erwartete. Davon konnten sich renommierte Beobachter wie Antoine-Louis Breguet sowie der Ingenieur und Mathematiker Gaspard de Prony, ein angesehenes Mitglied des astronomischen Instituts Bureau des Longitudes, persönlich überzeugen. Nachdem ihr Bericht nicht an lobenden Worten gespart hatte, erkannte die Königliche Akademie der Wissenschaften den Sekunden-Chronographen am 15. Oktober 1821 mit einem Ausdruck des Respekts offiziell an. Auf diese Weise würdigte die zuständige Kommission eine Erfindung, welche „die Dauer mehrerer aufeinanderfolgender Ereignisse anzeigt, ohne dass der Beobachter sich von seiner Beobachtung abwenden muss, um den Blick auf ein Zifferblatt zu werfen oder sich auf den Ton eines Zeitsignals oder die Schwingung einer Unruh zu konzentrieren. Ein Chronograph mit solchen Eigenschaften ist ohne Zweifel eine große Hilfe für Physiker, Ingenieure und alle anderen, die sich mit der Messung zeitlich ablaufender Ereignisse beschäftigen." Die Erteilung des Fünfjahrespatents an Monsieur Rieussec ließ danach noch bis zum 9. März 1822 auf sich warten. Es bezog sich auf eine innovative Apparatur mit rotierendem Zifferblatt und

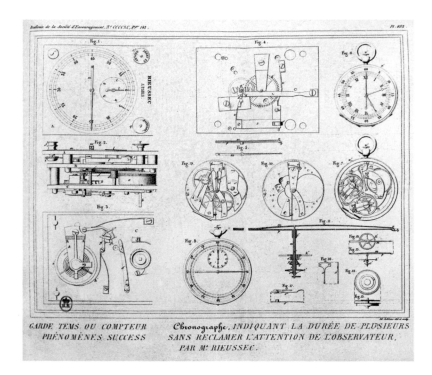

Technical drawing of a timepiece named Chronograph by Nicolas-Mathieu Rieussec, c. 1822 ∘ Zeichnung eines Chronograph genannten Zeitmessers von Nicolas-Mathieu Rieussec, ca. 1822

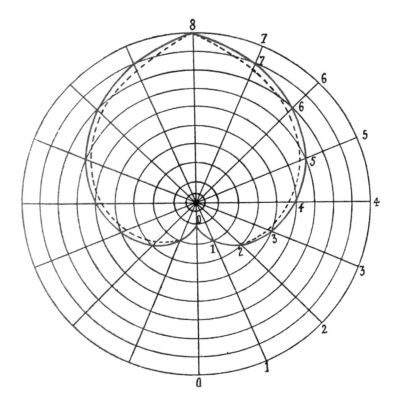

Heart-shaped zero-reset diagram ∘
Herzförmiges Nullstellenschema

the geometry of the movement that powered the cadrature played a subordinate role. The downside was that the hands and dial had to be disassembled before the cadrature could be repaired or adjusted. This shortcoming was duly rectified by the watchmaker Auguste Baud, who enriched the horological world with a rearward and thus more readily serviced chronograph mechanism. When Baud's innovation debuted in 1868, it seemed to write the final chapter in the history of the "time-writer"…but only seemingly.

Nonstop innovations

Much room for improvements still remained. The chronograph needed to undergo drastic miniaturization before it could be ensconced inside the small cases of ladies' pocket watches and, starting around 1910, also in wristwatches.

Until the early 1930s, a single button triggered the chronograph's three essential functions of start, stop and return to zero. Each of these three functions necessarily followed its predecessor in an unchangeable sequence. Shorter intervening intervals could not be measured while continuing to clock an ongoing event. This limitation was overcome by a mechanism with two buttons. Invented and patented by Breitling and a few other innovative companies, the twin-button chronograph could be triggered to momentarily interrupt an ongoing measurement. Experts refer to this as "additive stopping." The next challenge for technicians was to rectify another chronographic deficit: namely, its ability to tally only relatively brief intervals. The minute totalizer on most chronographs reached the end of its orbit after thirty minutes, whereupon it began its rotation anew. The first patents for an hour counter date to 1892. This solved the problem, but only solved in theory. Universal Genève SA debuted the first genuinely practical solution in 1937. One year later, Breitling launched a model with a 12-hour totalizer based on a Valjoux movement. Other watchmakers gradually followed in these pioneering footsteps.

Comely, but costly: the column wheel

The change that is inextricably linked to the nature of time was also reflected in the mechanism that controls the chronograph's three functions (start, stop and zero reset). The story began with the column wheel. Watchmakers regard this rotating component and the mechanisms around as a singularly challenging aspect of their profession. At the bottom, a column wheel consists of a ratchet wheel with triangular teeth; at the top, it comprises a ring of vertical pillars. These pillars or columns are why this component is known as a column wheel. Its function is like a computer chip. Each can always be in only one of two possible states, i.e. either on or off. If the end of a lever comes to rest atop one of the columns, the pillar keeps the lever raised; if the lever's end falls into the gap between two columns, pressure from a spring keeps the lever lowered. Pressing the start/stop button

60-Sekunden-Skala. Auf Fingerdruck markierte eine Schreibspitze den emaillierten Ring mit Farbpunkten. An gründlicher Reinigung nach jedem Stoppvorgang führte also kein Weg vorbei. In einem kleinen Fenster zeigte sich der digitale 10-Minuten-Totalisator. Eine hölzerne Schatulle schützte das 112 x 85 x 58 Millimeter große Pfeiler-Uhrwerk mit Zylinderhemmung und 2,5 Hertz Unruhfrequenz. Die Erteilung der ersten Schutzschrift für einen Chronographen löste verständlicherweise heftige Aktivitäten aus. In London machte Frederick-Louis Fatton mit einer Taschenuhrversion des Tintenschreibers von sich reden. Auch der Patentinhaber entwickelte seine Erfindung weiter. Das kleinere Nachfolgemodell war ebenfalls rund und für die Tasche bestimmt. Über einem weißen Emailzifferblatt drehte sich ein Zeiger mit Tintenreservoir, welcher auf Knopfdruck Markierungen setzte.

Hebelwerk statt Tinte

Das Hantieren mit Tinte war zu Beginn des 19. Jahrhunderts schön und gut, aber nicht der Weisheit letzter Schluss. Zahlreiche Uhrmacher beschäftigten sich in den Folgejahren intensiv mit dem, was heute als Chronograph in aller Munde ist, aber korrekterweise Chronoskop (von griechisch skopeïn: betrachten) heißen müsste. Gemeint sind Uhren mit zusätzlichen, per Knopfdruck nullstellbaren Zeigern zum Stoppen von Zeitintervallen. Den Stein der Weisen entdeckte dann der Uhrmacher Adolphe Nicole. 1844 präsentierte er eine herzförmige, geometrisch genau berechnete Scheibe. Befestigt auf jener Welle, die am vorderen Ende auch den Chronographenzeiger trägt, gestattet sie zusammen mit einem entsprechend geformten Hebel das direkte Rückstellen. Bis 1862 blieb das intelligente Bauteil mehr oder weniger graue Theorie. Dann brachte die Londoner Weltausstellung den bis heute gebräuchlichen Nullstell-Chronographen. Seine Herstellung ist Henri-Ferréol Piguet zu verdanken, einem Mitarbeiter der im Vallée de Joux beheimateten Manufaktur Nicole & Capt. Noch im gleichen Jahr konnte Adolphe Nicole das Patent entgegennehmen.

Was blieb, war ein kleiner, aber keineswegs zu vernachlässigender Schönheitsfehler. Aus technischen Gründen fand sich das ausgetüftelte Zusatzschaltwerk, fachsprachlich auch Kadratur genannt, direkt unter dem Zifferblatt. Dieser Kunstgriff ersparte dem Uhrmacher zum einen das präzise Durchbohren dünner Stahlwellen. Zum anderen erleichterte es die Produktion, weil die Geometrie des antreibenden Uhrwerks eine untergeordnete Rolle spielte. Im Gegenzug verlangten Reparaturen und Justierung zunächst nach der Demontage von Zeiger und Zifferblatt. Damit gelangt der Uhrmacher Auguste Baud als weiterer Vater zeitschreibender Uhren ins Boot. Ihm verdankt die Uhrenwelt den rückwärtig und damit servicefreundlich montierten Chronographenmechanismus. Man schrieb das Jahr 1868, als die Historie des Chronographen eigentlich enden könnte. Aber eben doch nur eigentlich.

Innovationen am laufenden Band

Es gab doch noch ungemein viel zu tun. Die Modifikation des Chronographen für kleine Damentaschenuhren und die Verwendung

Left ○ Links: *Louis Moinet Compteur de Tierces, thirds timer* ○ *Terzzähler, 1816*
Right: *pocket watch No. 495, with stopwatch function by Joseph Thaddäus Winnerl, c. 1840* ○ *Rechts: Taschenuhr mit Stoppfunktion Nr. 495 von Joseph Thaddäus Winnerl, ca. 1840*

ab etwa 1910 auch in Armbanduhren verlangte nach einer deutlichen Reduktion der Dimensionen.

Bis in die frühen 1930er-Jahre zeichnete für die essenziellen Funktionen Start, Stopp und Nullstellung ein einziger Drücker verantwortlich. Das heißt, alle drei Funktionen folgten zwangsläufig und in unveränderlicher Reihenfolge aufeinander. Zwischenstopps waren ausgeschlossen. Dann gestattete die Erfindung und Patentierung der Zwei-Drücker-Mechanismen – unter anderem durch Breitling – das beliebige Unterbrechen der Zeitnahme. Fachleute sprechen in diesem Zusammenhang von Additionsstoppungen. Anschließend machten sich die Techniker an die Beseitigung eines weiteren chronographischen Defizits, welches in der relativ kurzen Zählspanne bestand. Bei den meisten Chronographen reichte der Minuten-Totalisator bis Dreißig. Dann begann er seinen Rundlauf von Neuem. Die ersten Patente für einen Stundenzähler gehen zwar auf das Jahr 1892 zurück, allerdings blieb es damals bei der theoretischen Bewältigung des Problems. Seine erste praktische Realisierung erfolgte 1937 durch die Universal Genève SA. Breitling lancierte 1938 ein Modell mit 12-Stunden-Totalisator auf der Basis eines Valjoux-Rohwerks. Andere Uhrenhersteller folgten Zug um Zug.

Schön, aber teuer: das Schaltrad

Im Zeichen jenes Wandels, welcher untrennbar mit dem Wesen der Zeit verbunden ist, stand bei Chronographen auch der Mechanismus zur Steuerung der drei Funktionen Start, Stopp und Nullstellung. Am Anfang war das Schaltrad. Uhrmacher betrachten das Drehteil und die Mechanik drum herum als hohe Schule ihres

moves a command lever, which causes the column wheel to rotate through a precisely defined angle. Watch fans appreciate classically designed chronographs because the switching states of the column wheel are readily observable. Watchmakers like column wheels because they can be conveniently adjusted by turning specially marked eccentric screws. But manufacturers were not happy with the high cost of the column wheel. This handsome and dignified component first had to be milled in several steps from a solid block of metal and afterwards meticulously finished. The indispensable levers, pawls, pressure springs, retaining springs and locking springs were likewise cost-intensive.

The search for alternatives

Cost-benefit calculations were and are not alien to the watch industry. At the latest during the challenging 1930s that followed the global economic crisis, decision makers reappraised the costly column wheels in traditional chronograph movements. Several aspects of the column wheel stood in the way of its speedy and cost-effective production. Serial and highly accurate punching of flat components was intended to remedy this situation by reducing the costs of post-processing and assembly. Work began at the Hahn Frères ébauche factory in Le Landeron, which was founded by the brothers Aimé-Auguste and Charles-Alfred Hahn in 1873, and at Vénus SA, which was established at Moutier in the canton of Berne in 1924. Both belonged to Ebauches SA, i.e. the association of Swiss movement manufacturers, and were eager to develop low-cost alternatives to their chronograph calibers with classic column-wheel constructions. But before the punches could be set

into motion, technicians had to turn their inventive minds to the mechanics of "time-writing." This brainwork took quite some time. The chronograph finally entered the age of economic efficiency in the early 1940s. Hahn Frères had meanwhile become Landeron SA. Together with Vénus SA, Landeron SA eliminated the column wheel in new caliber families, taking into account the fact that single-button calibers did not necessarily harmonize with the new cam mechanism because triggering the cam-shift mechanism requires greater pressure than triggering a column wheel. Unlike the column wheel with its neatly defined positions and its clear separation of two possible switching states, the cam-shift mechanism functions via angular displacement. Consequently, precisely reaching the exact starting position is essential for the next step in measuring an elapsing or elapsed timespan.

Progress

The cam-shift mechanism patented for Landeron under number 209394 in 1940 required three pushers. The buttons to start and stop the chronograph were at the left and right of the crown. A third button to trigger the zero-reset function was located concentrically atop the crown. Vénus SA's design, which was likewise unveiled in the 1940s, embodied real progress. It is found in Caliber 188 and in the manually wound Valjoux 773x caliber family, which is derived from the 188. This construction introduced the pivoting switching cam, which is still used in numerous variations today. Its function is similar to that of a classic chronograph caliber with a column wheel and two push-pieces. Its clever innovation consists of a multipart lever assembly acting on two levels.

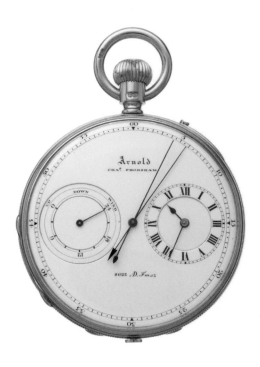

Left: drawing of the first chronograph by Joseph Thaddäus Winnerl, c. 1843 ◦ Links: Zeichnung des ersten Chronographen von Joseph Thaddäus Winnerl, ca. 1843 ◦ Right ◦ Rechts: Arnold & Frodsham London, pocket watch with split-seconds mechanism by Joseph Thaddäus Winnerl ◦ Taschenuhr mit Schleppzeigermechanik nach Joseph Thaddäus Winnerl, 1850

From left: column wheel, Valjoux VZ ○ Cam-shift mechanism, Landeron 148 ○ Rattrapante, Vénus 179 ○
Von links: Schaltrad, Valjoux VZ ○ Kulissenschaltung, Landeron 148 ○ Rattrapante, Vénus 179

Metiers. Unten besteht es aus einem Sperrrad mit dreieckigen Zähnen, oben aus einem Kranz senkrecht stehender Säulen. Daraus resultiert auch der alternative Begriff Säulen- oder Kolonnenrad. Die Funktion des Bauteils ähnelt einem Computerchip. Es kennt nämlich nur zwei Schaltzustände: ein oder aus. Kommt das Ende eines Hebels auf einer Säule zum Liegen, wird es durch diese angehoben. Fällt es dagegen zwischen zwei Säulen, sorgt leichter Federdruck für Absenkung. Per Kommandohebel bewirkt jede Betätigung des Start-Stopp-Drückers eine kleine Drehbewegung des Schaltrads in exakt definiertem Winkel. Bei klassischen Chronographenkonstruktionen lassen sich die verschiedenen Schaltzustände genau beobachten, was Uhrenliebhaber zu schätzen wissen. Uhrmachern hingegen kommt die relativ leichte Einstellbarkeit mithilfe eigens gekennzeichneter Exzenterschrauben sehr gelegen. Die Fabrikanten indessen störten sich an den Kosten des schönen, fast schon würdevollen Schaltrads. Das dreidimensionale Bauteil musste in mehreren Schritten aus dem Vollen gefräst und zudem auch noch mit Sorgfalt nachbearbeitet werden. Ins Geld gingen auch die unabdingbaren Hebel, Schaltklinken, Andruck-, Halte- und Sperrfedern.

Alternativen gefragt

Ausgeprägtes Kosten-Nutzen-Denken war und ist der Uhrenindustrie nicht fremd. Spätestens die schwierigen 1930er-Jahre nach der großen Weltwirtschaftskrise lenkten den Blick auf das kostspielige Schaltrad der bisherigen Chronographenwerke. Einer zügigen und damit kostengünstigen Serienfertigung stellten sich allerdings noch andere Aspekte in den Weg. Das serielle Stanzen von flächigen Komponenten mit hoher Passgenauigkeit sollte hier Abhilfe schaffen: Nachbearbeitungs- und Montagekosten könnten dadurch spürbar gedrückt werden. Also machten sich die 1873 von den Brüdern Aimé-Auguste und Charles-Alfred Hahn ins Leben gerufene Rohwerkefabrikation Hahn Frères in Le Landeron und die 1924 in Moutier, Kanton Bern, gegründete Vénus SA ans Werk. Beide Firmen waren Mitglieder des Zusammenschlusses von Schweizer Rohwerkeherstellern, Ebauches SA, und sie waren auf der Suche nach preiswerten Alternativen zu ihren Chronographenkalibern mit klassischer Schaltradbauweise. Bevor jedoch die Stanzen in Aktion treten konnten, mussten sich Techniker erst noch der

zeitschreibenden Mechanik widmen. Und das nahm etliche Zeit in Anspruch. Zu Beginn der 1940er-Jahre trat der Chronograph schließlich ins ökonomische Zeitalter. Aus Hahn Frères war inzwischen die Landeron SA geworden. Sie und die Vénus SA hatten das Schaltrad bei neuen Kaliberfamilien eliminiert und dabei auch berücksichtigt, dass Ein-Drücker-Kaliber nicht unbedingt mit der neuartigen Nockenmechanik harmonisierten, denn Schaltkulissen verlangen naturgemäß nach intensiverem Druck als Schalträder. Im Gegensatz zum Säulenrad mit seinen klar definierten Positionen und der klaren Trennung beider Schaltzustände funktioniert die Kulissen- oder Nockenschaltung per Winkelverschiebung. Folglich ist das Erreichen der exakten Ausgangsposition für den nächsten Stoppvorgang unverzichtbar.

Fortschritte

Um ganz auf Nummer sicher zu gehen, benötigte die 1940 unter der Nummer 209394 für Landeron patentierte Entwicklung einer Kulissenschaltung gleich drei Drücker. Links und rechts der Krone befanden sich die für Start und Stopp. Konzentrisch in der Krone hatten die Techniker einen weiteren Drücker fürs Nullstellen positioniert. Wirklichen Fortschritt zeigte die ebenfalls in den 1940er-Jahren vorgestellte Konstruktion der Vénus SA. Sie findet sich unter anderem im Kaliber 188 und der daraus abgeleiteten Kaliberfamilie Valjoux 773x mit Handaufzug. Diese Konstruktion brachte den schwenkbaren, bis heute in sehr verschiedenen Abwandlungen gebräuchlichen Schaltnocken. Ihre Funktionsweise ähnelt dem klassischen Chronographenkaliber mit Schaltrad und zwei Drückern. Der Kunstgriff besteht in einem mehrteiligen, auf zwei Ebenen agierenden Hebelwerk.

Gut gekuppelt

Bleibt ein letzter, nicht minder bedeutsamer Technikaspekt mechanischer Chronographen. Grundsätzlich handelt es sich ja um ein ganz normales Uhrwerk mit Zusatzmechanismus für die Stoppfunktion. Ähnlich dem Automobil setzt sich der Antriebsstrang aus Motor und Getriebe zusammen. Dazwischen befindet sich eine Kupplung. Auch hier haben Kreativität, ökonomische Zwänge und

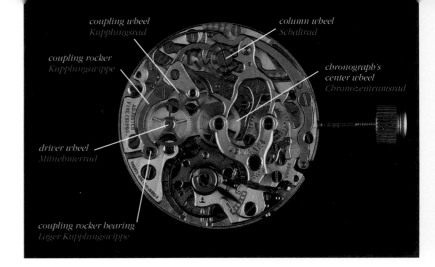

From left: patent application for Edouard Heuer's oscillating pinion, 1886 ◦ Lemania, Cal. 2310 ◦ Von links: Patentantrag für Edouard Heuers Schwingtrieb, 1886 ◦ Lemania, Kal. 2310

Well coupled

One last and equally important technical aspect of mechanical chronographs remains. Basically, a chronograph wristwatch encases an ordinary movement and an additional mechanism for the stopwatch function. As in a car, its power train consists of a motor and a transmission, coupled by a clutch between the two. Creativity, economic constraints and the desire to simplify and optimize the device gave rise to diverse systems.

Horizontal coupling with wheels

A classic chronograph coupling works by meshing gears. Watchmakers mount a driver wheel on the rearward-lengthened shaft of the fourth wheel. This gear accordingly rotates clockwise and at the same speed as the fourth wheel. The chronograph's elapsed-seconds hand usually sweeps clockwise from dial's center. Direct connection between the two is impossible because the laws of mechanics dictate that the last gear in a gear train rotates in the same direction as the first gear in the train only if the total number of gears is odd. Consequently, an intermediate wheel is needed. It is mounted on a coupling lever. Pressing the start/stop button, which is typically at the "2" when viewed from the movement side, causes the coupling lever to swivel slightly toward the right, thus connecting the driver wheel and chronograph's center wheel. This connection causes the chronograph's elapsed-seconds hand to start moving. Conversely, lifting the coupling lever causes the chronograph to stop instantaneously. The movement, along with the driver wheel and intermediate wheel, continue to run unaffected by the severed connection.

But the devil lurks in the details. Any transmission of power via gears always involves a certain amount of play, which is not conducive to the steady advance of the chronograph's elapsed-seconds hand. This is remedied by a tiny friction spring, which prevents the notorious "trembling" of the elapsed-seconds hand. The resulting loss of force causes the amplitude of the balance's oscillations to decline when the chronograph is switched on. The art of horological fine-tuning is to strike a well-balanced compromise between braking action and loss of torque. Further difficulties are caused by the intermeshing of the teeth of the intermediate wheel and the chronograph's center wheel when the coupling is engaging: if the tip of one tooth meets the tip of another, the chronograph's elapsed-seconds hand starts with a shudder. Technicians counteract this jump by giving triangular profiles to the teeth and by cutting especially fine teeth on the chronograph's center wheel.

Simply rocking

Edouard Heuer registered a much simpler coupling system for patent protection on Christmas Eve in 1886. His "oscillating pinion" is a movably mounted shaft with two pinions: the one on the dial side meshes directly with the fourth wheel of the movement; the other, which bears fine teeth and is positioned opposite its counterpart, meshes with the chronograph's center wheel after the start button is pressed and the oscillating pinion has swung through a short arc. Connection to the flow of force is established and the chronograph begins to run. A driver wheel and an intermediate wheel can be eliminated. Pressing the button a second time causes the oscillating pinion to swing away from the chronograph's center wheel, thus halting the chronograph's elapsed-seconds hand. This ingenious system was first used in wristwatches in 1946.

Valjoux economized by installing this relatively simple but extremely reliable oscillating mechanism in column-wheel Caliber 77 ECO. Current representatives of this coupling mechanism are ETA/Valjoux's Caliber 7750, which was launched in 1973, and Longines' Caliber L.688, which is a derivative of the 7750. Manufacture Caliber Heuer 01, which is based on a Seiko construction, likewise relies on this type of coupling, which is more than 130 years old yet still relevant today. IWC uses it in its 89xxx caliber family. The oscillating pinion proves that plain and simple needn't mean less suitable.

Vertically coupled

Modern chronograph designs usually rely on a vertical coupling mechanism without form-fit interlocking gears or pinions. They are replaced by a solution similar to the one used in cars: springs firmly press two coupling disks against each other to start the chronograph. Horizontally pivoting blades come into action when the chronograph is stopped. These blades separate the discs or rings that had been pressed against each other. This method of coupling the movement and the chronograph mechanism offers some remarkable advantages: at the push of a button, the chronograph's elapsed-seconds hand begins to move smoothly and thus with extreme precision; and a friction coupling makes much more economical use of the limited supply of energy available to keep

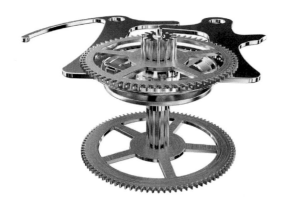

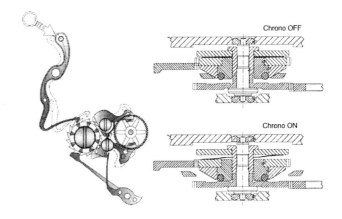

From left: rendering of a vertical clutch by Montblanc ◦ Vertical coupling of Chopard's Caliber L.U.C 10 CF ◦ Von links: Modell einer Vertikalkupplung von Montblanc ◦ Vertikalkupplung des Chopard-Kalibers L.U.C 10 CF

der Wunsch, die Dinge vereinfachen oder optimieren zu können, unterschiedliche Systeme hervorgebracht.

Horizontal mit Rädern

Die klassische Chronographenkupplung funktioniert ganz simpel durch das Ineinandergreifen mehrerer Zahnräder. Zu diesem Zweck montieren die Uhrmacher auf der nach hinten verlängerten Welle des Sekundenrads ein logischerweise gleich schnell im Uhrzeigersinn rotierendes Mitnehmer(zahn)rad. Weil der in aller Regel zentral positionierte Chronographenzeiger tunlichst auch rechtsherum drehen soll, verbietet sich eine unmittelbare Verbindung. Nach den Gesetzen der Mechanik bewegt sich das letzte Glied einer Getriebekette nur bei ungerader Zahl von Zahnrädern in die gleiche Richtung wie das erste. Folglich braucht es noch ein Zwischenrad, montiert an einem Kupplungshebel. Der schwenkt durch Betätigung des Start-Stopp-Drückers – (meist) bei „2" von der Werkseite betrachtet – ein wenig nach rechts, wodurch er Mitnehmer- und Chronozentrumsrad verbindet. Der Chronographenzeiger setzt sich in Bewegung. Im Umkehrschluss bewirkt das Anheben des Kupplungshebels augenblicklichen Stopp. Nur das Uhrwerk samt Mitnehmer- und Zwischenrad läuft unverdrossen weiter. Bekanntlich steckt der Teufel aber im Detail. Jede Kraftübertragung durch Zahnräder bringt zwangsläufig ein gewisses Spiel mit sich, was dem gleichförmigen Voranschreiten des Chronographenzeigers nicht dienlich ist. Abhilfe schafft eine kleine Friktionsfeder, welche das berüchtigte „Zittern" des Chronographenzeigers unterbindet. Der damit einhergehende Kraftverlust lässt die Amplitude der Unruhschwingungen bei eingeschaltetem Chronographen sinken. Die Kunst uhrmacherischen Feinstellens besteht also im ausgewogenen Kompromiss zwischen Bremswirkung und Drehmomentverlust. Schwierigkeiten bereitet auch das Ineinandergreifen der Zähne von Zwischen- und Chronozentrumsrad beim Einkuppeln. Denn: Trifft Zahnspitze auf Zahnspitze, springt der Chronographenzeiger beim Starten. Dem wirken die Techniker durch dreieckige Zahnprofile sowie durch ein besonders fein verzahntes Chronozentrumsrad entgegen.

Ganz einfach geschwungen

Wesentlich simpler ist ein Kupplungssystem, das Edouard Heuer am Heiligabend des Jahres 1886 zum Patent anmeldete. Hinter seinem „Schwingtrieb" verbirgt sich eine beweglich montierte Welle mit zwei Ritzeln. Das zifferblattseitig angebrachte greift unmittelbar ins Sekundenrad des Uhrwerks; das gegenüberliegende Ritzel mit feiner Verzahnung greift nach Betätigung des Start-Drückers und kurzem Schwenk ins Chronozentrumsrad. Die Verbindung steht, der Chronograph läuft. Mitnehmerrad und Zwischenrad sind entbehrlich. Ein weiterer Knopfdruck bewegt den Schwingtrieb wieder vom Chronozentrumsrad weg. Der Chronographenzeiger hält an. In Armbanduhren kam dieses geniale System erstmals 1946 zur Anwendung. Zum Zweck der Ökonomisierung konstruierte Valjoux das Schaltradkaliber 77 ECO mit dem relativ simplen, trotzdem jedoch ausgesprochen zuverlässigen Schwingtrieb. Aktuelle Vertreter dieser Kupplungsnische sind das 1973 lancierte ETA/Valjoux 7750 und das daraus abgeleitete L.688 von Longines. Das auf einer Seiko-Konstruktion basierende Manufakturkaliber Heuer 01 punktet ebenfalls mit dem mehr als 130 Jahre alten Kupplungstyp. IWC nutzt es in der hauseigenen Kaliberfamilie 89xxx. Schlicht und einfach bedeutet nämlich keineswegs weniger tauglich.

Vertikal gekuppelt

Moderne Chronographenkonstruktionen setzen meist auf eine vertikal agierende Kupplung. Formschlüssig ineinandergreifende Zahnräder oder -triebe sucht man hier vergebens. An ihre Stelle tritt das Automobilprinzip: Zum Starten des Chronographen drücken Federn zwei Kupplungsscheiben kraftschlüssig gegeneinander. Beim Anhalten treten horizontal schwenkende Klingen in Aktion. Sie trennen die zusammengepressten Scheiben oder Ringe. Es ist unbestritten, dass diese Form der Koppelung von Uhr- und Schaltwerk einige bemerkenswerte Vorteile mit sich bringt: Der Chronographenzeiger läuft auf Knopfdruck völlig ruckfrei und damit höchst präzise an; außerdem geht die Friktionskupplung wesentlich sparsamer mit der in einem mechanischen Mikrokosmos begrenzt verfügbaren Energie um. Die Unruh-Amplitude sinkt also weniger ab. Pionier der modernen Vertikalkupplung ist die japanische Manufaktur Seiko: 1969 stattete sie ihr Automatikkaliber 6139 damit aus. 1987 verwendete es der Rohwerkefabrikant Frédéric Piguet in seinem Automatikkaliber 1185.

Chronographische Vertikalkupplungen sind übrigens deutlich älter, als viele glauben. Schon 1876 hatte der in die USA ausgewanderte Uhrmacher Henry-Alfred Lugrin ein simples System mit fein verzahnten Kegelrädern vorgestellt. Sein geniales Schaltwerk ließ sich ohne größeren Umbau auf gängigen Uhrwerken mit ½-, ⅔- oder ¾-Platine montieren. Zu den Kunden gehörten damals Longines, die Genfer Timing and Repeating Watch Company sowie American

a timekeeping mechanical microcosm in motion, thus minimizing the inevitable decline in the balance's amplitude. The Japanese manufacturer Seiko pioneered modern vertical coupling when it equipped its automatic Caliber 6139 with this type of coupling in 1969. The ébauche manufacturer Frédéric Piguet used it in self-winding Caliber 1185 in 1987.

Vertical couplings for chronographs are much older than many people think. Henry-Alfred Lugrin, a watchmaker who had emigrated to the USA, debuted a simple system with finely toothed bevel gears in 1876. Without requiring any major conversions, his ingenious coupling mechanism could be mounted on standard movements with ½, ⅔ or ¾ plates. Lugrin's clientele included Longines, the Geneva Timing and Repeating Watch Company, and American Waltham. Some fifteen years later, the authorities granted a patent to Henri Jacot-Burmann for an axially docking coupling mechanism. In 1936, experts were startled by the unconventional vertical coupling in Pierce's 13-ligne manufacture Caliber 134. This device relied on a driver disc, studded with tiny pins, which it stuck into a small ring made of hard rubber. The mechanism was accordingly subject to rapid wear.

The obvious technical advantages of vertical coupling prompted Rolex to rely on finely dosed friction in Caliber 4130, which was introduced in 2000. Vertical coupling mechanisms are also installed in current chronograph calibers from companies such as Audemars Piguet, Breitling, Chopard, IWC, Jaeger-LeCoultre, Panerai, Patek Philippe, Piaget, Rolex and TAG Heuer. The only drawbacks: friction coupling mechanisms are usually a bit taller than other types and horological voyeurs are disappointed because these devices are positioned out of sight.

Self-winding chronograph

Looking back on the history of the chronograph, it is noteworthy that its combination with a self-winding mechanism took approximately a century to develop. The reason involves the complexity of the pairing. Many pitfalls make it difficult to install both complications in the same movement. Simply mounting a self-winding subassembly above or beside a chronograph mechanism doesn't do the trick. Kinetic energy must be transferred from the oscillating weight to the barrel, but wheels, levers, springs and other components obstruct the transmission chain required for this transfer. This dissuaded even experienced manufacturers. The situation began to change in the mid-1960s, when severely declining sales of manually wound chronographs impelled manufacturers in Switzerland and Japan to take action.

A collaborative movement

Breitling and Heuer-Leonidas ranked among the leading Swiss stopwatch manufacturers in the 1960s. Willy Breitling and Jack W. Heuer were therefore members of the so-called "Chronograph Committee," where the sorely afflicted entrepreneurs conceived the idea of collaborating to create a self-winding chronograph. Breitling and Heuer lacked the relevant manufacturing expertise, so they brought Gérald Dubois from Dubois Dépraz on board. Dubois estimated the development costs at around 500,000 Swiss francs. "Project 99" commenced at the beginning of 1966. The

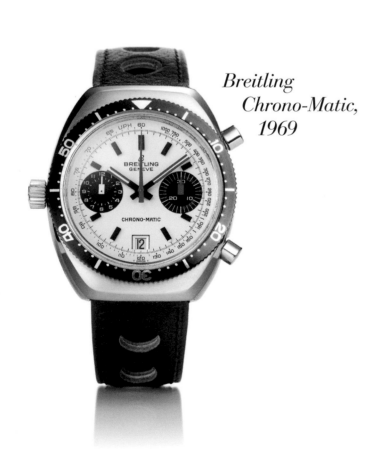

Breitling Chrono-Matic, 1969

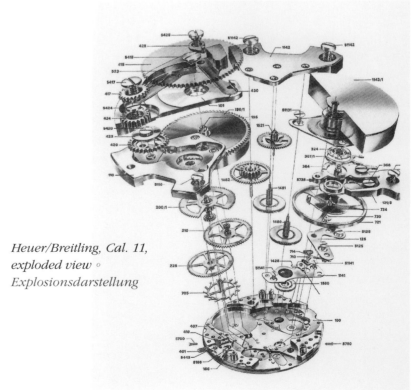

Heuer/Breitling, Cal. 11, exploded view ○ Explosionsdarstellung

Waltham. Etwa 15 Jahre später gestanden die Behörden Monsieur Henri Jacot-Burmann das Patent für einen axial andockenden Kupplungsmechanismus zu. Und 1936 staunten Fachleute beim 13-linigen Manufakturkaliber 134 von Pierce nicht schlecht über die mehr als unkonventionelle Vertikalkupplung. Bei ihm pikste eine dornenbestückte Mitnehmerscheibe in einen kleinen Hartgummiring. Entsprechend hoch war der Verschleiß.

Die nicht übersehbaren technischen Vorteile bewogen auch Rolex, beim 2000 vorgestellten Manufakturkaliber 4130 auf fein dosierte Reibung zu setzen. Gleiches gilt für aktuelle Kaliber beispielsweise von Audemars Piguet, Breitling, Chopard, IWC, Jaeger-LeCoultre, Panerai, Patek Philippe, Piaget, Rolex oder TAG Heuer. Der kleine Schönheitsfehler: Friktionskupplungen bauen in der Regel etwas höher. Außerdem kommen Augenmenschen wegen der versteckten Positionierung im Uhrwerk nicht zu ihrem Recht.

Stopper mit Selbstaufzug

Beim Rückblick auf die Geschichte des Chronographen fällt auf, dass die Kombination mit einem Selbstaufzug rund 100 Jahre auf sich warten ließ. Der Grund für diese lange Zeitspanne lässt sich mit der Komplexität dieser Paarung erklären. Zahlreiche Tücken erschwer(t)en die Synthese beider Zusatzfunktionen. Es ist nämlich keineswegs damit getan, irgendwo über oder neben dem Chronographenschaltwerk eine Automatikbaugruppe zu montieren. Schließlich muss die kinetische Energie auch von der Schwungmasse zum Federhaus gelangen. Der dazu nötigen Getriebekette stellen sich aber Räder, Hebel, Federn und andere Komponenten in den Weg – und das schreckte selbst einschlägig erfahrene Fabrikanten ab. Erst Mitte der 1960er-Jahre kam Bewegung in die Szene, als massiv rückläufige Verkäufe von Handaufzugschronographen Produzenten in der Schweiz und in Japan zum Handeln zwangen.

Gemeinschaftswerk

Zu den eidgenössischen Platzhirschen auf dem Gebiet der Uhren mit Stoppfunktion gehörten in den 1960er-Jahren Breitling und Heuer-Leonidas. Daher waren Willy Breitling und Jack W. Heuer Mitglieder im sogenannten Chronographen-Komitee, wo die leidgeplagten Unternehmer die Idee eines zeitschreibenden Gemeinschaftswerks mit Selbstaufzug gebaren. Weil es beiden an einschlägiger Manufakturerfahrung mangelte, holten sie Gérald Dubois vom Spezialisten Dubois Dépraz ins Boot. Der schätzte die Entwicklungskosten auf rund 500 000 Schweizer Franken. Anfang 1966 nahm das „Projekt 99" seinen Lauf. Vierter im Bunde waren die Buren SA und ihr Chefkonstrukteur Hans Kocher. Mit dem „intra-matic 1282" verfügte der Werkefabrikant über ein geeignetes Mikrororkaliber, das sich vorzüglich zur rückwärtigen und damit servicefreundlichen Montage eines Moduls mit Stoppfunktion eignete. Außerdem drehte der Datumsring direkt unter dem Zifferblatt. In ihrer Vereinbarung definierten die Beteiligten, zu denen später auch Hamilton gehörte, alle rechtlichen Belange angefangen bei den Kosten für Forschung, Entwicklung, Werkzeug- und Prototypenbau bis hin zur Anmeldung und Nutzung etwaiger Patente. Als Arbeitstitel für das neue Kaliber verständigte man sich auf „Chronomatic".

Im Frühjahr 1968 standen erste Prototypen zur Verfügung. Die anschließenden Trageversuche verliefen ausgesprochen positiv. Aufzug und Chronograph des 7,7 Millimeter hohen Kalibers 11 mit 31 Millimeter Durchmesser, Schwingtriebkupplung und Kulissenschaltung funktionierten selbst bei harter Beanspruchung einwandfrei. Die Unruhfrequenz von stündlich 19 800 Handschwingungen bewirkte Gangresultate nahe der amtlichen Chronometernorm. Nun stand die schnellstmögliche Herbeiführung der Serienreife an.

Am 3. März 1969 ging das Lancement gleichzeitig in Genf und New York über die Bühne. Ganz bewusst fand das bewegende Ereignis

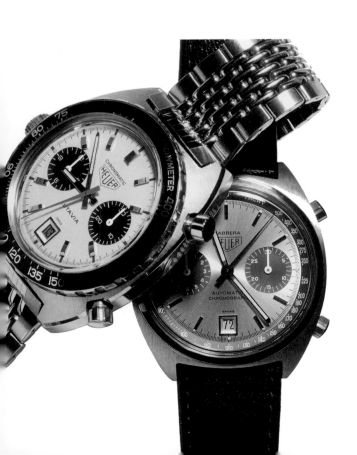

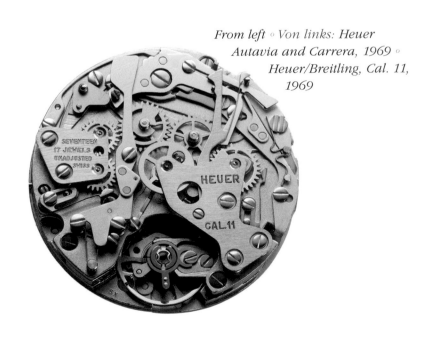

From left ◦ *Von links: Heuer Autavia and Carrera, 1969* ◦ *Heuer/Breitling, Cal. 11, 1969*

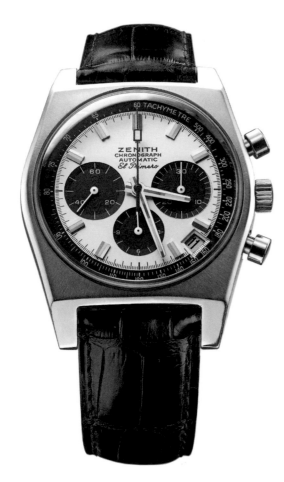

Zenith, first watch with El Primero movement ◦ *erste Uhr mit El-Primero-Werk*

fourth member of the group was the movement manufacturer Buren SA and its chief designer Hans Kocher. With the "intra-matic 1282," Buren SA had a suitable microrotor caliber that could be augmented with a rearward-installed chronograph module, which would accordingly be readily accessible whenever servicing was needed. Furthermore, its date ring rotated directly beneath the dial. The collaborating companies, which later also included Hamilton, drafted an agreement defining all legal issues—from the costs of research, development, tooling and prototyping to the registration and use of patents. They chose "Chronomatic" as the name for the intended caliber.

The first prototypes became available in the spring of 1968. Empirical tests on the wrist were very encouraging. The winding mechanism and chronograph of Caliber 11 functioned perfectly, even under severe stress and rough treatment. Equipped with oscillating pinion and so-called "Kulissenschaltung" (cam-shift mechanism), this caliber was 7.7 mm in height and 31 mm in diameter. The balance's hourly frequency of 19,800 vibrations enabled the rate to nearly uphold the official chronometer standard. The speediest possible development for serial production was the next step.

The launch occurred simultaneously in Geneva and New York on March 3, 1969. This important event was held under the patronage of the Fédération Horlogère (FH). Its president, Gérard F. Bauer, proudly declared, "At a time when foreign competition is growing increasingly fierce, this innovation proves the determination and ability of industrialists to remain competitive in the most active and assertive sense of the word. It also proves that three watchmaking companies, without sacrificing their individual personalities, can unite to achieve a technical feat that none of them would have been able to accomplish on its own."

Heuer installed the movement, which had undergone several modifications, inside the square and water-resistant case of its legendary "Monaco"; Breitling encased it in the "Chrono-Matic." The winding and hand-setting crown was rarely used so it was positioned on the left-hand side of the case. Ten years after it went into production, the history of Caliber 11 and subsequent Calibers numbers 12, 14 and 15 ended forever.

"El Primero," the first of its kind

The saga of Zenith's legendary "El Primero" began in 1965, i.e. five years after Zenith took over the Martel Watch Co. Its watchmakers were quite familiar with manually winding chronographs, so a departure from traditional construction principles with a column wheel and horizontal geared coupling was not even considered. Reasonably small dimensions called for a centrally positioned ball-borne rotor. When "El Primero" was unveiled for journalists on January 10, 1969, it had superlatively accomplished the desired miniaturization with a diameter of 29.33 mm and an overall height of only 6.5 mm. To achieve this small volume, a special bridge for the self-winding subassembly had to be installed above and beside the chronograph mechanism. Polarizing the rotor's motions enabled the system to quickly amass an approximately 50-hour power reserve. The balance oscillated at the rapid pace of five hertz or 36,000 vibrations per hour. This meant that the chronograph could measure elapsed intervals with the unprecedentedly high accuracy of one-tenth of a second. The El Primero series debuted in the autumn of 1969 with References AH 385 (stainless steel), GH 383 (yellow gold), and GH 381 (yellow gold) with 30-minute and 12-hour counters and a simple date display (280 components). The more complex "Espada" version with simple full calendar and moon-phase display (354 components) became available in stores soon afterwards.

But even this rapidly oscillating mechanical chronograph could not keep up with the ultrafast speed of a quartz crystal's vibrations. The American management accordingly ordered the destruction of Calibers 3019 PHC and 3019 PHF, including all tools, in the mid-1970s, but a stalwart watchmaker named Charly Vermot concealed components, movements and tools in the factory's capacious attic. In 1981, when Ebel's owner Pierre-Alain Blum sent an envoy to Le Locle to ask about "El Primero," resolute Charly Vermot was eager to assist. Thanks to Vermot, Ebel was able to build its "Beau" from leftover stock. Zenith, which had returned to Swiss ownership in 1978, did a brisk business and Charly Vermot became a hero, whom his employer thanked with a trip to New York. The decision to revive "The First" from 1986 onwards is ultimately also due to Rolex because Caliber 4030, which debuted in the "Cosmograph Daytona" in 1988, is based on "El Primero." In retrospect, it is the sole survivor from the field of erstwhile competitors. As the Bible says, "The last shall be first, and the first last."

Far Eastern "time-writers"

The old saying "all good things come in threes" also applies to the chronograph competition of the 1960s. Seiko, the third in the

unter dem Patronat der Fédération Horlogère (FH) statt. Deren Präsident Gérard F. Bauer erklärte stolz, dass „diese Neuheit [...] zum Zeitpunkt einer immer schärferen ausländischen Konkurrenz die Entschlossenheit und Fähigkeit der Industriellen belegt, konkurrenz- und wettbewerbsfähig zu bleiben – und zwar im aktivsten, offensivsten und aggressivsten Sinne dieser Begriffe. Außerdem ist der Beweis erbracht, dass drei Uhrenfirmen ohne Verzicht auf ihre Persönlichkeit gemeinsam eine technische Leistung erbringen können, zu der jede alleine nicht imstande gewesen wäre."

Heuer verbaute das mehrfach modifizierte Uhrwerk unter anderem in der legendären „Monaco" mit quadratischem, wasserdichtem Gehäuse. Breitling ging mit einem „Chrono-Matic" an den Start. Weil die Aufzugs- und Zeigerstellkrone nur noch selten gebraucht wurde, fand sie sich in der linken Gehäuseflanke. Zehn Jahre nach der Serienreife endete die Geschichte des Kalibers 11 sowie der nachfolgenden Nummern 12, 14 und 15 für immer.

„El Primero", der Erste seiner Art

1965 beginnt die Geschichte des legendären „El Primero" von Zenith. Fünf Jahre zuvor hatte Zenith die Martel Watch Co. übernommen. Deren Uhrmacher kannten das chronographische Metier mit manuellem Aufzug in- und auswendig. Eine Abkehr von überlieferten Konstruktionsprinzipien mit Schaltradsteuerung und horizontaler Räderkupplung stand also nie zur Debatte. Vernünftige Dimensionen verlangten nach einem zentral angeordneten Kugellagerrotor. Als sich „El Primero" am 10. Januar 1969 der Presse präsentierte, tat er das mit 29,33 Millimeter Durchmesser und nur 6,5 Millimeter Bauhöhe – ein Superlativ. Zur Realisation des geringen Volumens brauchte es eine spezielle, über und neben dem Chronographenmechanismus fixierte Automatikbrücke. Zusammen mit einem Wechselgetriebe zur Polarisierung der Rotordrehungen bauten sich zügig rund 50 Stunden Gangautonomie auf. Die Unruh oszillierte mit flotten 5 Hertz oder stündlich 36 000 Halbschwingungen. Daraus resultierte eine präzise und bei Armbanduhren einmalige Zehntelsekunden-Stoppgenauigkeit. Den El-Primero-Reigen eröffneten im Herbst des Jahres 1969 die Referenzen AH 385 (Edelstahl), GH 383 (Gelbgold) und GH 381 (Gelbgold) mit 30-Minuten- und 12-Stunden-Zähler sowie einfacher Datumsanzeige (280 Werkteile). Wenig später gelangte die komplexe Variante „Espada" mit einfachem Vollkalendarium und Mondphasenanzeige (354 Werkteile) in die Geschäfte.

Mit superschnell schwingenden Quarzen konnte freilich auch der Tempo-Chronograph nicht Schritt halten. Deshalb ordnete das amerikanische Management Mitte der Siebzigerjahre die Vernichtung der Kaliber 3019 PHC und 3019 PHF samt aller Werkzeuge an. Aber der widerspenstige Uhrmacher Charly Vermot versteckte Komponenten, Werke und Werkzeuge auf dem weitläufigen Dachboden des Fabrikgebäudes. Als Pierre-Alain Blum, Eigentümer von Ebel, 1981 einen Gesandten nach Le Locle schickte, um nach „El Primero" zu fragen, war der Unbeugsame eilfertig zur Stelle. Ebel konnte seinen „Beau" aus Restbeständen fertigen. Die Uhrenmanufaktur Zenith, seit 1978 wieder in Schweizer Eigentum, machte ein gutes Geschäft und Charly Vermot avancierte zum Helden, dem sein Arbeitgeber mit einer Reise nach New York dankte. Die Entscheidung, „den Ersten" ab 1986 wiederzubeleben, ist letztlich auch Rolex zu verdanken. Das 1988 vorgestellte Kaliber 4030 im „Cosmograph Daytona" basiert auf dem „El Primero". Retrospektiv ist er der einzige Überlebende aus dem einstigen Feld an Wettbewerbern. Der Erste wird der Letzte sein.

Fernöstlicher Zeitschreiber

„Aller guten Dinge sind drei" – das alte Sprichwort trifft auch auf den Chronographen-Wettstreit der 1960er-Jahre zu. Bei Seiko, dem Dritten im Bunde, fiel der Startschuss für das Projekt „Automatik" vermutlich 1967. Nach nur zwei Jahren Forschungs- und Entwicklungsarbeit startete die Fertigung des 27 Millimeter großen und 6,65 Millimeter hohen Kalibers 6139. Den Selbstaufzug in beiden Drehrichtungen bewerkstelligte ein Zentralrotor in Verbindung mit dem

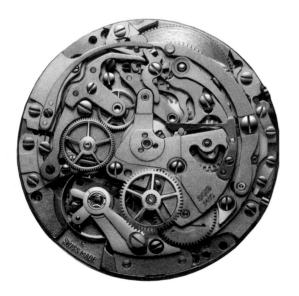

Zenith El Primero, Cal. 3019 PHC, without rotor ∘ ohne Rotor

Zenith El Primero, Cal. 400

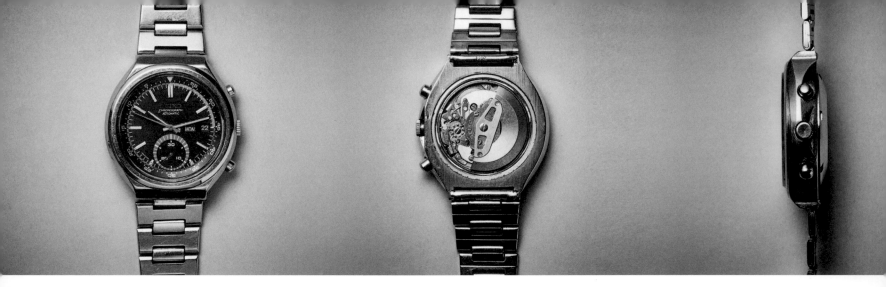

Seiko, automatic chronograph, Cal. 6139, c. 1970

group, probably fired the starting gun to start the "Automatic" project in 1967. Production of Caliber 6139 began after just two years of R&D work. Caliber 6139 is 27 mm in diameter, 6.65 mm in height, relies on a central rotor and the patented "Magic Lever" to bidirectionally wind its mainspring, and has both a column wheel and a counter for 30 elapsed minutes. Caliber 6139 also introduced the first vertical friction coupling. The balance is paced at three hertz. A date display and a bilingual weekday indicator with quickset mechanism are also on board. The first "Seiko 5 Speed-Timer" was delivered in May 1969. Version 6138 with an additional 12-hour counter followed in 1970. The manufactory in the Land of the Rising Sun can thus be regarded as the winner in the race for the first serially manufactured, market-launched, self-winding chronograph. Opinions differ as to the duration of its production. Seiko claims "production of Calibers 6138 and 6139 continued until the mid-1970s."

The Japanese deserve yet another honor: one of their watches accompanied astronaut William Reid Pogue as the world's first automatic chronograph on the Skylab 4 mission in 1973/1974.

Bestselling time stoppers

After the Quartz Revolution, the prospects for mechanical watchmaking were surely not rosy in 1973. But Valjoux SA, which was founded in the remote Vallée de Joux in 1901, swam against the current. After several years of development, this ébauche specialist introduced its new self-winding Caliber 7750. One of the first customers was Orfina, a small brand that encased the newcomer in its black Porsche Design Chronograph. Annual production quickly grew to circa 100,000 calibers, but bestseller status eluded it. The caliber was threatened with discontinuation in 1975. After protests against the destruction of his "baby" went unheard, the engineer Edmond Capt resorted to insubordination. Hoping for better times, the godfather of Caliber 7750 concealed its tools and components. Capt was right: in the course of the renaissance of mechanical watches, Valjoux's Caliber 7750, which combines some 250 components, soared to chronographic heights under the aegis of the ébauche giant ETA from 1983 onwards. It has kept and stopped time in simple and luxurious wristwatches in nearly all price classes ever since. It is available in its pure and not particularly refined form or perfectly finished and augmented with a calendar, a tourbillon and a repeater module. Often referred to as a "tank" because of its unbridled power and impressive size (30 mm in diameter,

7.9 mm in height and 29 grams in weight), this hardworking microcosm can withstand almost anything without complaint.

Its ball-borne rotor supplies the barrel with energy in only one direction of rotation, but this does not decrease the winding efficiency. The fully wound mainspring stores enough power for 44 or more hours of running. The balance is paced at four hertz. The integrated stopwatch mechanism is simple but reliable. A multilevel pivoting switching cam controls the chronograph's three functions. An oscillating pinion alternately creates and severs the connection between the gear train and the chronograph. Metal has replaced the plastic originally used for the blocking levers that keep the chronograph's halted hands in position. An unmistakable characteristic of the classic Valjoux 7750 is the positioning of its elapsed-time subdials on a vertical axis from the "12" to the "6." A counter tallies up to 30 elapsed minutes at the top; its counterpart counts maximally 12 elapsed hours at the bottom. A subdial at the "9" hosts the continually running seconds: this hand stops when the crown is pulled outward. Edmond Capt put digital weekday and date displays at the "3."

Chronographissimo

A chronograph with a split-seconds, twin or catch-up hand, ("rattrapante" in French) is a rare but immensely attractive subspecies. This far more complex variant performs extra functions. It can measure the durations of two events that began at the same moment. And it can also record split (or "lap") times. For this purpose, the rattrapante hand can be halted while its twin keeps running. After the user has read the time shown by the arrested hand, pressing a button sends it hurrying to rejoin its companion. Finally, both hands can be speedily returned to their mutual zero position. This extra function requires an additional switching mechanism, which increases costs by 50% compared to a conventional chronograph, so it's not surprising that split-seconds chronographs have always been expensive and rare. Incidentally, the term "double chronograph" is a misnomer for this variant: it denotes a timepiece encasing two independent chronographs.

The complex rattrapante dates to 1827, when Louis-Frédéric Perrelet and his son applied for a patent on invention that transformed their concept into horological reality by connecting two second hands at a single point of contact. The final design is credited to the Styrian watchmaker Joseph Thaddäus Winnerl, who relocated to Paris in 1829 and two years later developed the "mono rattrapante,"

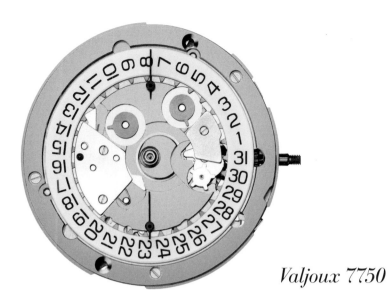

Valjoux 7750

patentierten „Magic Lever". Neben Schaltradsteuerung und 30-Minuten-Zähler verfügte der Chronograph erstmals in der Geschichte über eine vertikale Friktionskupplung. Mit 3 Hertz oszillierte die Unruh. Datums- und zweisprachige Wochentagsindikation mit Schnellschaltung gehörten ebenfalls zu den Ausstattungsmerkmalen. Bereits im Mai 1969 erfolgte die Lieferung der ersten „Seiko 5 Speed-Timer". 1970 folgte die Version 6138 mit zusätzlichem 12-Stunden-Zähler. Die Manufaktur im Land der aufgehenden Sonne kann also als Serienreife- und Markteinführungssieger im Wettrennen um den ersten Automatikchronographen gelten. Über die Produktionsdauer gehen die Meinungen auseinander. Seiko selbst lässt wissen: „Die Fertigung der Kaliber 6138 und 6139 währte bis zur Mitte der 1970er-Jahre."

Noch eine weitere Ehre gebührt den Japanern: Eine ihrer Armbanduhren begleitete den Astronauten William Reid Pogue 1973/1974 als weltweit erster Automatikchronograph bei der Skylab-4-Mission.

Stoppender Bestseller

In Sachen uhrmacherischer Mechanik standen die Dinge 1973 infolge der Quarz-Revolution nicht zum Besten. Dennoch stemmte sich die 1901 im abgeschiedenen Vallée de Joux gegründete Valjoux SA gegen den Trend. Nach mehrjähriger Entwicklungszeit stellte der Rohwerkespezialist das neue Automatikkaliber 7750 vor. Zu den ersten Kunden gehörte Orfina. Die kleine Marke nutzte den Newcomer für ihren schwarzen Porsche Design Chronograph. Obwohl die Jahresproduktion sehr schnell Dimensionen von circa 100 000 Exemplaren erreichte, konnte man nicht von einem Verkaufsschlager sprechen. Deshalb drohte schon 1975 das Aus. Nachdem Proteste gegen die Vernichtung seines „Babys" ungehört verhallten, mutierte der Ingenieur Edmond Capt zum widerspenstigen Befehlsverweigerer. In der Hoffnung auf bessere Zeiten verstaute der geistige Vater des 7750 Substanzielles an sicherem Ort. Und tatsächlich: Im Zuge der Renaissance mechanischer Uhren konnte sich das aus rund 250 Komponenten assemblierte Valjoux 7750 unter der Ägide des Rohwerkegiganten ETA ab 1983 in einsame chronographische Höhen aufschwingen. Seitdem bewahrt und stoppt es die Zeit in einfachen und luxuriösen Armbanduhren nahezu aller Preisklassen. Entweder pur und nicht sonderlich veredelt, oder bestens finissiert sowie mit Kalender, Tourbillon und Repetitionsmodul geadelt. Schließlich macht der wegen seiner beachtlichen 30 Millimeter Durchmesser, 7,9 Millimeter Höhe, 29 Gramm Gewicht und unbändiger Kraft gerne als

„Panzer" bezeichnete Mikrokosmos nahezu alles klaglos mit. Sein Kugellagerrotor versorgt das Federhaus nur in einer Drehrichtung mit Energie, was der Aufzugseffizienz aber keinen Abbruch tut: Voll aufgezogen reicht die gespeicherte Kraft für 44 Stunden und mehr. Die Unruh oszilliert mit 4 Hertz. Von schlichter, dafür aber zuverlässiger Natur ist die Mechanik des integrierten Stoppers. Die Steuerung der drei Funktionen besorgt ein mehrstöckiger, schwenkbarer Schaltnocken. Ein Schwingtrieb stellt die Verbindung zwischen Uhr- und Chronographenwerk her. Damit die Chronographenzeiger nach dem Anhalten an Ort und Stelle bleiben, braucht es Blockierhebel. Der ursprünglich dafür verwendete Kunststoff musste mittlerweile Metall weichen. Untrügliches Kennzeichen des klassischen 7750 ist die Positionierung der Zählzeiger auf senkrechter Achse von „12" zur „6". Oben dreht der 30-Minuten-Zähler, unten der bis zwölf Stunden reichende. Bei „9" findet sich die beim Ziehen der Krone anhaltende Permanentsekunde. Den Platz bei „3" nutzte Edmond Capt für die digitale Indikation von Wochentag und Datum.

Chronographissimo

Eher selten, aber ungemein reizvoll ist der Chronograph mit Schlepp-, Doppel- oder Einholzeiger, im Uhrmacher-Französisch Rattrapante genannt. Diese deutlich kompliziertere Spezies bietet zusätzliche Funktionen: Einmal lassen sich zwei parallel ablaufende Ereignisse mit gleicher Startzeit simultan stoppen; daneben eignet sich die aufwendige Mechanik zum Erfassen von Zwischenzeiten. Hierfür lässt sich der Einholzeiger unabhängig vom ersten anhalten. Nach dem Ablesen kann man ihn per Knopfdruck mit dem unterdessen weiterlaufenden Chronographenzeiger synchronisieren. Zum Schluss erfolgt das gemeinsame Nullstellen. Diese Funktion verlangt nach einem zusätzlichen Schaltwerk, welches die Kosten um 50 Prozent in die Höhe trieb. Kein Wunder also, dass Schleppzeigerchronographen von Anfang an verhältnismäßig teuer und deshalb auch rar waren. Falsch ist für diesen Uhrentyp übrigens der Terminus Doppelchronograph. Er meint eine Uhr mit zwei völlig unabhängig voneinander handhabbaren Chronographen.

Die Anfänge des chronographischen Komparativs reichen zurück bis ins Jahr 1827, als Louis-Frédéric Perrelet und sein Sohn das Patent für einen Schleppzeigermechanismus beantragten. Ihre Idee: Sie hatten zwei Sekundenzeiger durch einen Kontaktpunkt miteinander verbunden. Die endgültige Ausgestaltung ist dem

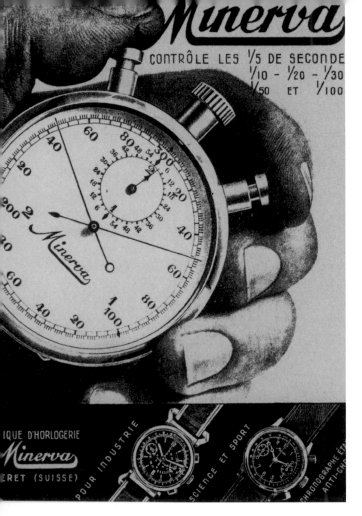

Top: ad for Minerva watch, 1946 ∘ Oben: Minerva-Anzeige, 1946 ∘ Bottom: Ralco, chronograph with rattrapante function by Movado, 1921 ∘ Unten: Ralco, Rattrapante-Chronograph von Movado, 1921

a catch-up mechanism with only one hand. A version with a pair of second hands followed in 1838, but a zero-reset mechanism was still lacking. Genuine split-seconds chronographs first became ticking reality in the form of pocket watches in 1883. The cadrature was directly under the dial because the manufacturers in the late 19th century were not yet able to drill a sufficiently precise hole through the long, thin shaft of the elapsed-seconds hand. Movado's subsidiary Ralco presented what was probably the first wristwatch of this genre in 1921. Luxury brands such as Patek Philippe followed suit several years later. Due to the labor involved and the commensurately high prices, ébauche manufacturers with chronographic expertise were not enthusiastic about rattrapante versions of common chronograph calibers. Valjoux, which led the industry, offered this capability only in movements with a diameter of 39.3 mm or more. Vénus offered smaller 14-ligne versions in the guise of Calibers 179 (minute counter, 7.2 mm tall), 185 (minute and hour counter, 8.55 mm tall), 189 (like 185 plus hand-type date display, 8.55 mm tall) and 190 (same as 189 plus moon-phase display, 8.55 mm tall). None of these achieved widespread distribution. The same rarity characterizes Bovet's "Mono Rattrapante," which debuted in 1936, and Dubey & Schaldenbrand's comparatively simple "Index-Mobile" construction, which debuted in 1946 with a slender hairspring that sent the momentarily halted rattrapante hand hurrying to rejoin its companion.

The renaissance of mechanical watchmaking precipitated a great leap forward starting in 1988. Pioneers were Frédéric Piguet and its Blancpain subsidiary with the duo of self-winding Caliber 1186 and hand-wound Caliber 1181. Chronoswiss, IWC and Ulysse Nardin added a rattrapante hand to the Valjoux 7750 in 1992. Breguet launched Caliber 533 NT, which was based on a Lemania caliber. A. Lange & Söhne's "Double Split" Caliber L001.1 debuted in 2004 as the world's first chronograph with two split hands—one doubled hand for the elapsed seconds and another pair for the minutes. The Saxons' "Triple Split," whose third catch-up hand measures elapsed hours, embodies the utmost complexity in this field to date. Costs are correspondingly high, but aficionados of the rarely used split hand can also find it other manufacturers' portfolios, where it sells in the four-digit price range. Horological voyeurs will be glad to know that the pincer mechanism, which combines more than 50 parts, can be seen above the chronograph mechanism per se either after opening the case or by peering through the case's glass back.

Fast-paced chronographs

How precisely a chronograph measures elapsed time depends solely on the frequency of the balance in the basic movement. Traditional rate regulators complete 18,000 vibrations per hour. Their frequency of 2.5 hertz causes the centrally axial elapsed-seconds hand to advance in fifth-of-a-second increments. The user can read the fractions of a second when this hand is paired with a corresponding scale marked with four slim lines between each pair of full-second indices. Slowly oscillating movements are difficult to regulate and have trouble maintaining a consistently accurate rate, so the industry leant wings to the balance's frequency. Its pace in wristwatches increased to 19,800, 21,600, 28,800 and—beginning in 1965—to 36,000 vibrations per hour. The latter two frequencies are the most common ones nowadays. Most contemporary chronograph movements vibrate at four hertz, which translates into eighth-of-a-second precision. Zenith's speedily oscillating "El Primero" can clock elapsed time to the nearest tenth of a second.

To increase the accuracy with which elapsed intervals can be timed, ingenious watchmakers invented the *seconde foudroyante* (lightning second) and installed it in timepieces with independently jumping second hands in the late 18th century. It could be started and stopped, but not yet reset to zero. Analogous to the balance's frequency, the lightning second hand speedily swept its circular orbit. When the

Touchon & Co., chronograph with rattrapante function, movement by Agassiz and new case, c. 1920 ∘ Touchon & Co., Rattrapante-Chronograph mit Agassiz-Kaliber und neuem Gehäuse, ca. 1920

steirischen Uhrmacher Joseph Thaddäus Winnerl zu verdanken, der 1829 nach Paris zog und dort zwei Jahre später zunächst den Mono-Rattrapante entwickelte, einen Einholmechanismus mit nur einem Zeiger. 1838 folgte die Version mit zwei Sekundenzeigern. Von einem Nullstell-Mechanismus war noch nicht die Rede. Echte Schleppzeigerchronographen in Gestalt von Taschenuhren wurden erst 1883 Realität. Aus technischen Gründen befand sich die Kadratur im späten 19. Jahrhundert noch direkt unter dem Zifferblatt. Den Fabrikanten war es nämlich nicht möglich, die gleichermaßen lange wie dünne Welle des Chronographenzeigers hinreichend präzise zu durchbohren. 1921 präsentierte die Movado-Tochter Ralco die vermutlich erste Armbanduhr dieses Genres. Mit einigem Abstand folgten Luxusmarken wie Patek Philippe. Angesichts des Aufwandes und der damit verbundenen Preise konnten sich chronographisch erfahrene Rohwerkefabrikanten nur schwer für Schleppzeigerversionen gängiger Kaliber erwärmen. Beim Branchenprimus Valjoux wird man erst ab einem Werkdurchmesser von 39,3 Millimetern fündig. Kleinere, sprich 14-linige Ausführungen offerierte Vénus in Gestalt der Kaliber 179 (Minutenzähler, Höhe 7,2 Millimeter), 185 (Minuten- und Stundenzähler, Höhe 8,55 Millimeter), 189 (wie 185 plus Zeigerdatum, 8,55 Millimeter hoch) und 190 (wie 189 plus Mondphasenanzeige, 8,55 Millimeter hoch). Eine größere Verbreitung war keinem der letztgenannten Kaliber vergönnt. Gleiches gilt für den 1936 vorgestellten „Mono-Rattrapante" von Bovet und die vergleichsweise simple Konstruktion „Index-Mobile" von Dubey & Schaldenbrand, bei der ab 1946 eine feine Spiralfeder das Nachspringen des Schleppzeigers bewirkte.

Erst die Mechanik-Renaissance brachte ab 1988 einen bemerkenswerten Sprung nach vorne. Vorreiter waren Frédéric Piguet und seine Tochtergesellschaft Blancpain mit dem Kaliber-Duo 1186 (Automatik) und 1181 (Handaufzug). 1992 werteten Chronoswiss, IWC und Ulysse Nardin das Kaliber Valjoux 7750 durch den Einholzeiger auf. Breguet wartete mit dem Lemania-basierten 533 NT auf. A. Lange & Söhne stellte 2004 mit seinem „Double Split", Kaliber L001.1, den weltweit ersten Chronographen mit zwei Schleppzeigern für Sekunden und Minuten vor. Inzwischen verkörpert der sächsische „Triple Split", dessen dritter Einholzeiger den Stunden gilt, die höchste uhrmacherische Schule auf diesem Gebiet. Entsprechend hoch sind die Kosten. Liebhaber des selten benötigten

Doppelzeigers werden – bei anderen Herstellern – inzwischen aber auch in vierstelligen Preislagen fündig. Augenmenschen sollten darauf achten, dass der komplexe, aus gut 50 Komponenten montierte Zangenmechanismus über dem eigentlichen Chronographenschaltwerk entweder nach Öffnen des Gehäuses oder durch einen Glasboden sichtbar ist.

Tempo-Chronographen

Wie genau man mit einem Chronographen stoppen kann, hängt einzig und allein von der Unruhfrequenz des Basisuhrwerks ab. Traditionell vollzieht der Gangregler stündlich 18 000 Halbschwingungen. Die Frequenz von 2,5 Hertz lässt den zentralen Stoppzeiger in Fünftelsekundenschritten voranschreiten. Gepaart mit einer entsprechenden Skala, welche zwischen zwei Sekundenindexen vier dünnere Striche vorweist, ist auch das Ablesen der entsprechenden Sekundenbruchteile möglich. Weil derart langsam oszillierende Uhrwerke das Regulieren und eine anhaltend gute Ganggenauigkeit erschweren, hat die Industrie der Unruhfrequenz sozusagen Flügel verliehen. Bei Armbanduhren erhöhte sie sich auf stündlich 19 800, 21 600, 28 800 und ab 1965 sogar auf 36 000 Halbschwingungen. Inzwischen liegt der Fokus auf den beiden letztgenannten Frequenzen. Die meisten der modernen Chronographenwerke agieren mit 4 Hertz, was Achtelsekunden-Stoppgenauigkeit bedeutet. Zenith hat sich beim „El Primero" für die Zehntelsekunden entschieden.

Zur Steigerung der Ablesegenauigkeit erfanden schlaue Uhrmacher schon im späten 18. Jahrhundert die *seconde foudroyante* (blitzende Sekunde), und zwar für Zeitmesser mit unabhängig springendem Sekundenzeiger. Der ließ sich zwar starten und stoppen, aber noch nicht nullstellen. Analog zur Unruhfrequenz trippelte die mit ihm verknüpfte „blitzende Sekunde" eilig im Kreis. Nach dem Anhalten zeigte die Zeigerspitze auf die nach der letzten vollen Sekunde verstrichenen Bruchteile. Freaks bekommen dieses Extra auch heute noch. La Joux-Perret zum Beispiel hat das Kaliber ETA/Valjoux 7750 durch Schleppzeiger und *seconde foudroyante* aufgewertet. Den bei „9" angeordneten Achtelsekunden-Blitzer verwendeten unter anderem Girard-Perregaux und Hublot. Fündig

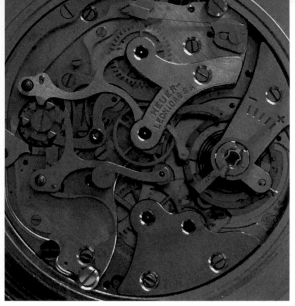

Heuer Mikrograph, pocket watch and
caliber ◦ Taschenuhr und Kaliber, 1916

chronograph is halted, the tip of the *foudroyante* hand points to the number of fractions of a second that have elapsed since the last full second. This rare complication is still available today. La Joux-Perret, for example, added a rattrapante hand and a *seconde foudroyante* to the ETA/Valjoux 7750. Girard-Perregaux, Hublot and a few others used this caliber, which has its eighth-of-a-second lightning second hand at the "9." Aficionados can also find a *seconde foudroyante* on watches made by Habring, Jaeger-LeCoultre and Zenith.

Already in the early 20th century, the degree of accuracy with which classic chronograph movements could measure elapsed timespans no longer sufficed for scientists, athletes, industry and the military. This prompted Charles-Auguste Heuer to begin developing the "Mikrograph" in 1914. The oscillating and escapement system of this stopwatch completed a breathtaking 360,000 vibrations every hour. The balance's 50-hertz frequency enabled this watch to measure elapsed intervals with unprecedented 100th-of-a-second precision. Longines and Minerva likewise offered stopwatches of this kind in the late 1920s. Such a high frequency necessarily consumes plenty of energy, so these stopwatches ran for only a few consecutive minutes, but this short interval sufficed for the intended purposes.

TAG Heuer heralded the era of genuinely fast-paced chronograph wristwatches with its premiere of the Carrera Calibre 360 Limited Edition in 2006. Two independent movements, each with its own balance frequency, tick inside this watch. ETA's automatic Caliber 2892-A2, which is responsible for the time display, is paced at four hertz, while La Joux-Perret's manually wound chronograph module is mounted on the front of Eta's movement and paced at a brisk 50 hertz, which enables it to time elapsing intervals to the nearest 100th of a second. Heuer presented the "Carrera Mikrograph 1/100th Second Chronograph" in 2011. Developed in-house at Heuer, it had an integrated automatic movement and two independent rate regulators. The "Carrera MikrotourbillonS 100," with one balance paced at four hertz and a second at 50 hertz, debuted in 2012. The automatic caliber inside this watch's gold case is equipped with two tourbillons. The smaller one, which is responsible for timing elapsed intervals, completes twelve rotations per minute.

The "Flying 1000 Concept Chronograph Microtimer" can measure timespans to the nearest 1,000th of a second. Classic balances cannot feasibly oscillate faster than 500 hertz, so a sturdy hairspring and a specially designed lever escapement regulate the rate. Chief developer Guy Sémon put his profound understanding of physics to the test for the "Mikrogirder," which followed in 2012. Its patented oscillator completes 7,200,000 vibrations per hour and consists of three metal blades arranged at right angles to one another. This frequency of 1,000 hertz enables the user to measure timespans to the nearest two-thousandth of a second. No mechanical movement had ever ticked at a speedier pace. As far as can be seen at this time, it appears that this record will remain unbeaten forever. Montblanc pursued a different path. Its "TimeWalker Chronograph 1000" likewise has two separate movements: one to display the time and another to measure elapsed intervals. The balance in the first movement is paced at five hertz; its counterpart in the second movement vibrates at a frequency of 50 hertz. A patented display mechanism enables the user to read the duration of an elapsed timespan to the nearest 1,000th of a second. Last but not least, Zenith equipped its "El Primero" with an additional speedier balance. Self-winding Caliber 9004 has two rate regulators: the one for ordinary timekeeping is paced at five hertz; its counterpart has a frequency of 50 hertz and can thus stop elapsed timespans to the nearest 100th of a second. A 1,000ths-of-a-second chronograph is under development but not yet available.

Practical scales

In addition to calibrations for the time display and the chronographic functions, some watches also include one or more logarithmic scales on their dial or bezel. These scales make it easier to perform various measurements with the chronograph.

Pulsometer

As its name suggests, a pulsometer helps its user to measure the pulse rate per minute. Depending on the design of the scale, the user starts the chronograph, counts either 20 or 30 pulse beats and then stops the mechanism. The tip of the halted hand now points directly to the extrapolated pulse rate per minute.

Tachymeter

A tachymeter scale measures average speeds and is easy to operate. The user starts the chronograph at the beginning of a measured stretch, e.g. when the vehicle passes a milepost beside the roadway. The chronograph is then halted after traveling one kilometer or one mile. The stopped hand points to the average speed at which this known distance was traversed.

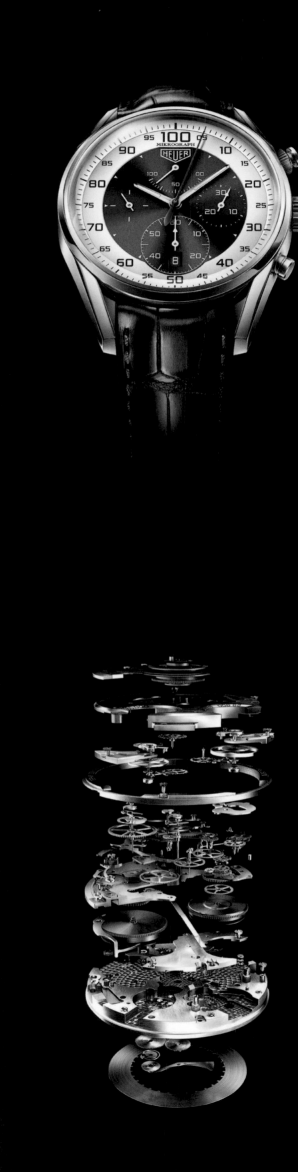

TAG Heuer Carrera Mikrograph,
100th-of-a-second chronograph and caliber
Hundertstelsekunden-Chronograph und Kaliber, 2011

werden Liebhaber dieser ausgefälligen Komplikation auch bei Habring, Jaeger-LeCoultre und Zenith.

Schon im frühen 20. Jahrhundert reichte Wissenschaftlern, Sportlern, Industrie und Militärs die mit klassischen Chronographenwerken erzielbare Stoppgenauigkeit nicht mehr aus.

Also ließ Charles-Auguste Heuer ab 1914 „Le Mikrographe" entwickeln. Rasante 360 000 Halbschwingungen vollzog das Schwing- und Hemmungssystem dieser Stoppuhr pro Stunde. 50 Hertz Unruhfrequenz gestatteten bei diesem uhrmacherischen Tempo-Weltrekord Stoppvorgänge auf die Hundertstelsekunde genau. In den späten 1920er-Jahren waren auch Longines und Minerva mit derartigen Stoppuhren zur Stelle. Weil Hochfrequenz viel Energie verschlingt, liefen diese Zeitmesser nur wenige Minuten am Stück. Für die intendierten Verwendungszwecke reichte das jedoch vollkommen aus.

Die Epoche echter Tempo-Chronographen fürs Handgelenk läutete TAG Heuer 2006 mit der „Carrera Calibre 360 Limited Edition" ein. In dieser Armbanduhr ticken zwei Uhrwerke mit unterschiedlicher Frequenz. Dem für die Zeitanzeige zuständigen Automatikkaliber ETA 2892-A2 sind 4 Hertz zu eigen, dem vorderseitig montierten Handaufzugsstoppmodul von La Joux-Perret flotte 50 Hertz. Damit erfasst es Zeitintervalle auf die Hundertstelsekunde genau. 2011 stellte Heuer den selbst entwickelten „Carrera Mikrograph 1/100th Second Chronograph" vor: mit integriert aufgebautem Automatikwerk und wiederum zwei Gangreglern. Die „Carrera MikrotourbillonS 100", auch mit 4 und 50 Hertz Unruhfrequenz, betrat 2012 die Bühne. Ihr im Goldgehäuse verbautes Automatikkaliber besitzt gleich zwei Tourbillons; das kleinere, fürs Stoppen zuständige, dreht jede Minute zwölfmal im Kreis.

Stoppungen auf die Tausendstelsekunde genau ermöglicht der „Mikrotimer Flying 1000 Concept Chronograph". Weil klassische Unruhschwinger bei 500 Hertz passen müssen, liefert hier ein Duo aus stämmiger Spirale und speziell konzipierter Ankerhemmung den Zeittakt. Für den 2012 folgenden „Mikrogirder" warf Chefentwickler Guy Sémon all sein physikalisches Können in die Waagschale. Stündlich 7 200 000 Halbschwingungen vollzieht ein patentierter, aus drei rechtwinklig angeordneten Metallklingen bestehender Oszillator. Diese 1000 Hertz ermöglichen Kurzzeitmessung auf die 1/2000stel Sekunde genau. Schneller tickte noch kein mechanisches Uhrwerk. Und so wie es aussieht, wird dieser Rekord auch für immer und ewig bestehen bleiben.

Einen anderen Weg beschritt Montblanc. Der „TimeWalker Chronograph 1000" besitzt ebenfalls zwei getrennte Werke zum Anzeigen und Stoppen der Zeit. Ersteres weist 5 Hertz Unruhfrequenz auf, das zweite den zehnfachen Wert. Das Ablesen der Tausendstelsekunden ermöglicht ein patentierter Anzeigemechanismus. Schließlich hat auch Zenith seinem „El Primero" Beine gemacht. Das Automatikkaliber 9004 mit zwei Gangreglern besitzt Frequenzen von 5 Hertz für die Zeit und 50 Hertz für die Hundertstelsekunden. In der Pipeline steckt derzeit noch ein Tausendstelsekunden-Chronograph.

Praktische Skalen

Neben der Indexierung für die Zeitanzeige und die zeitschreibenden Funktionen finden sich am Zifferblatt oder dem Glasrand eine oder mehrere zusätzliche Skalen. Sie sind logarithmischer Natur und gestatten unkomplizierte Messungen mithilfe des Chronographen.

*Frédérique Constant Flyback
Chronograph Manufacture,
with tachymeter scale ◦
mit Tachymeterskala, 2020*

*Alpina Alpiner 4 Manufacture
Flyback Chronograph,
with telemeter scale ◦
mit Telemeterskala, 2016*

*Longines Pulsometer
Chronograph,
Ref. L2.801.4.23.2,
2015*

Telemeter

A telemeter scale is based on the unequal speeds of light and sound. The distance between the user and a thunderstorm, for example, can be determined by starting the chronograph when a flash of lightning is seen and stopping it when the associated thunderclap is heard. Depending on the scale's calibration, the tip of the chronograph's elapsed-seconds hand will point to the distance in kilometers or miles. Soldiers in World War One determined the distance to enemy troops by measuring the interval between the muzzle flash of an adversary's cannon and the bang they heard soon afterwards.

How a column-wheel chronograph works

The following description applies to a chronograph mechanism with a column wheel and horizontal geared coupling.

Pressing the start/stop button, which is usually at the "2", starts the chronograph. The shift lever (1) moves the column wheel (2) one position forward. The intermediate wheel (3) creates a connection between the chronograph's center wheel (4) and the driver wheel (5).

The chronograph's central elapsed-seconds hand begins to move. As soon as it has completed one revolution, the star wheel (6) and thus the minute-counter wheel (7) are each rotated by one tooth. The hand on the minute counter jumps ahead to point to the first stroke. The zero-reset pusher, which is usually at the "4," remains inoperative as long as the chronograph hand is moving.

Pressing the start/stop button again rotates the column wheel one position further. This interrupts the flow of force between the chronograph's center wheel (4) and the driver wheel. At the same time, a blocking lever (8) is applied to the chronograph's center wheel (4). The elapsed-seconds hand stops and remains in its current position. Pressing the start/stop button a third time advances the column wheel (2) one position further and the chronograph's elapsed-seconds hand resumes its motion, e.g. for additive stopping.

If the chronograph has been stopped previously, then pressing the zero-reset button moves the zeroing lever (9). This lever returns the heart lever (10), the seconds heart (11), the minute heart and (if present) the hour heart to their starting positions. The chronograph's elapsed-seconds hand, elapsed-minutes hand and (if present) the hand on its hour counter return to their zero positions. The chronograph is now ready to begin measuring a new event.

Pulsometer

Wie der Name andeutet, hilft der Pulsometer beim Ermitteln der Pulsfrequenz pro Minute. Je nach Auslegung der Skala sind nach dem Starten des Chronographen 20 oder 30 Pulsschläge zu zählen. Dann zeigt die Spitze des wieder angehaltenen Stoppzeigers unmittelbar auf den hochgerechneten Wert pro Minute.

Tachymeter

Ausschließlich Durchschnittsgeschwindigkeiten lassen sich mithilfe der Tachymeterskala messen. Und das geht denkbar einfach: Am Anfangspunkt der Messstrecke, zum Beispiel bei einer Entfernungstafel am Rand der Autobahn, startet man den Chronographen. Nach genau einem Kilometer oder einer Meile wird er wieder angehalten. Der Stoppzeiger weist nun auf die Durchschnittsgeschwindigkeit, mit der die Strecke durchfahren wurde.

Telemeter

Auf der unterschiedlichen Ausbreitungsgeschwindigkeit von Licht und Schall basiert die Telemeterskala. Mit ihrer Hilfe lässt sich die Entfernung eines Gewitters bestimmen, indem der Chronograph beim Aufleuchten des Blitzes gestartet und beim Ertönen des Donners wieder gestoppt wird. Abhängig von der Eichung deutet der Chronographenzeiger auf die Distanz in Kilometern oder Meilen. Während des Ersten Weltkrieges ermittelten Soldaten den Abstand der gegnerischen Truppen anhand des Mündungsfeuers der Kanonen und des beim Abschuss ausgelösten Knalls.

Und so funktioniert ein Schaltradchronograph

Die folgende Beschreibung bezieht sich auf Chronographenwerke mit Schaltrad und horizontal wirkender Räderkupplung.

Das Starten des Chronographen erfolgt durch Betätigung des Start-Stopp-Drückers (meist) bei der „2". Mithilfe des Schalthebels (1) wird das Schaltrad (2) um eine Position weiterbewegt. Das Zwischenrad (3) bildet nun eine Verbindung zwischen Chronozentrumsrad (4) und Mitnehmerrad (5). Der zentrale Chronographenzeiger beginnt zu laufen. Sobald er eine Umdrehung vollführt hat, werden das Sternrad (6) und damit das Minutenzählrad (7) jeweils um einen Zahn gedreht. Der Minutenzählzeiger springt auf den ersten Teilstrich.

Solange der Chronographenzeiger in Bewegung ist, bleibt der Nullstelldrücker – (meist) bei der „4" – außer Funktion.

Durch abermalige Betätigung des Start-Stopp-Drückers dreht sich das Schaltrad erneut um eine Position. Auf diese Weise wird der Kraftfluss zwischen Chronozentrumsrad (4) und Mitnehmerrad (5) wieder unterbrochen. Gleichzeitig legt sich ein Blockierhebel (8) an das Chronozentrumsrad (4). Der Chronographenzeiger hält an und verharrt in seiner augenblicklichen Position. Durch eine weitere Auslösung des Start-Stopp-Drückers ließe sich das Schaltrad (2) um eine erneute Position weiterbewegen und der Chronographenzeiger wieder starten, beispielsweise um Additionsstoppungen vorzunehmen.

Über den Nullstelldrücker und den Nullstellhebel (9) bringt, wenn der Chronograph vorher gestoppt wurde, der Herzhebel (10) das Sekunden- (11), Minuten- und ggf. Stundenherz in die Ausgangslage. Chronographen-, Minuten- und ggf. Stundenzählzeiger springen in ihre Nullposition zurück.

Der Chronograph ist für einen neuen Stoppvorgang bereit.

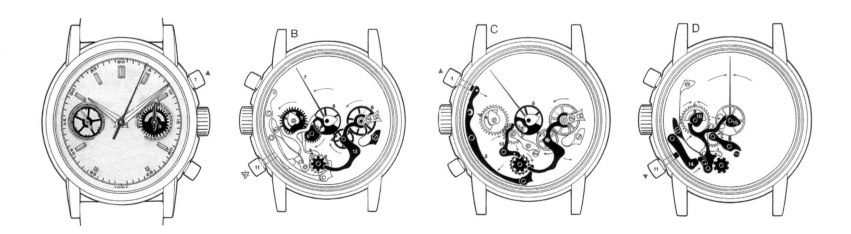

Functional principles of a Patek Philippe chronograph ◦ Funktionsweise eines Patek-Philippe-Chronographen

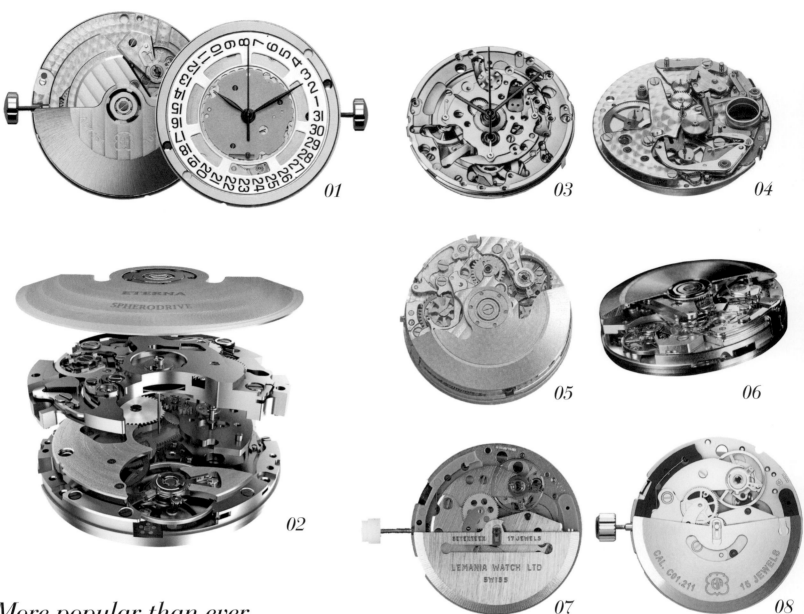

01

02

03

04

05

06

07

08

More popular than ever

Chronographs were formerly more popular among men, but nowadays increasingly many women are discovering its appeal. The popularity the "time-writing" function is undiminished by the fact that it is seldom really needed in our era of smartphones and electronic timers. Much more important is its attractive appearance with additional push-pieces on the side of the case and extra hands on the dial. The "time-writer's" long-lasting and undiminished popularity prompted the watchmaking industry to develop a wide variety of new chronograph movements. But developing an integrated chronograph is no mere child's play. It usually takes several years before a new one is ready for serial production. This lengthy timespan is necessarily reflected in the price. Modular designs with an under-the-dial cadrature atop an existing basic caliber are much less labor- and cost-intensive. Examples of this variant are ETA's widely used automatic Caliber 2894-A2 and the Frédérique Constant Group's Caliber 760. For visual reasons, Hublot likewise positions the chronograph mechanism on its in-house Caliber HUB 1240 atop the basic movement, where connoisseurs can see it in action. A modular chronograph can often be recognized by the more or less V-shaped arrangement of its push-piece and winding crown. Whether one chooses an integrated or modular chronograph is less a question of functionality and more a matter of taste and budget.

The ranks of manufacturers of exclusive chronograph movements have grown so large that it is difficult to maintain an overview. In Switzerland, they include Audemars Piguet, Blancpain, Breguet,

01. ETA A07.161
02. Eterna 3927A
03. ETA 2894-A2
04. Dubois Dépraz, chronograph module,
 for Audemars Piguet ∘ Chronographenmodul,
 für Audemars Piguet
05. Concepto 2000-RAC, with column wheel ∘
 mit Schaltrad
06. Sellita SW500
07. Lemania 5100
08. ETA C01.211
09. Blancpain 1185
10. Longines L688.2, based on ∘ basiert auf ETA A08.231
11. Breitling B01
12. Chopard L.U.C 03.03-L
13. Montblanc MB 25.10
14. Audemars Piguet 4401
15. Rolex 4130
16. Patek Philippe CH 28-520
17. Jaeger-LeCoultre 759
18. Omega 9300
19. Frédérique Constant FC-760

09

10

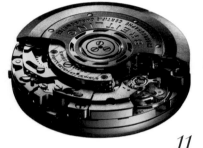

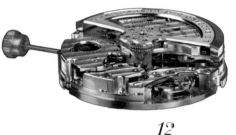

11

12

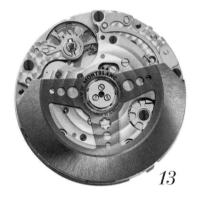

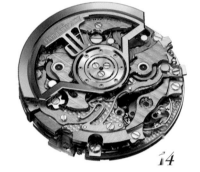

13

14

Beliebter als je zuvor

In der Vergangenheit standen Chronographen in erster Linie bei Männern hoch im Kurs, doch nach und nach schwören auch immer mehr Frauen auf diesen Typus Armbanduhr. Dabei spielt es keine Rolle, dass man die „zeitschreibende" Zusatzfunktion im Zeitalter von Smartphones oder elektronischen Timern nur noch selten braucht. Viel wichtiger ist der optische Auftritt mit zusätzlichen Drückern im Gehäuserand und weiteren Zeigern vor dem Zifferblatt. In der Industrie hat die seit Jahren währende Beliebtheit zur Entwicklung einer Fülle neuer Uhrwerke geführt. Die Entwicklung eines integriert aufgebauten Chronographen gestaltet sich aber auch heute keineswegs als Kinderspiel. Bis zur Serienreife vergehen in der Regel mehrere Jahre, was sich in den Kosten wiederspiegelt. Weniger Ansprüche stellen modulare Konstruktionen mit vorne, auf einem existenten Basiskaliber montierter Kadratur. Beispiele dafür sind das weit verbreitete Automatikkaliber ETA 2894-A2 oder das 760 der Frédérique Constant-Gruppe. Aus optischen Gründen ordnet auch Hublot das Schaltwerk beim hauseigenen HUB 1240 vorderseitig an. So kommen Augenmenschen beim Stoppen unmittelbar auf ihre Kosten. Oft geben sich Module durch eine mehr oder minder v-förmige Anordnung von Drücker und Aufzugskrone zu erkennen. Für welche Konstruktion man sich entscheidet, ist weniger eine Frage der Funktionalität, sondern eher eine Sache von Geschmack und verfügbarem Budget.

15

16

17

18

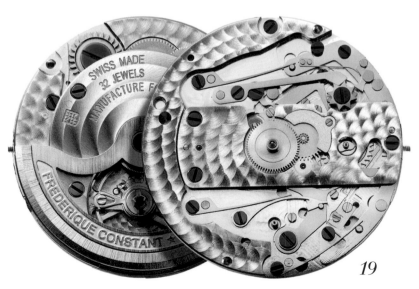

19

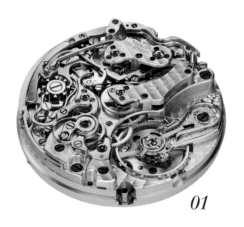

01

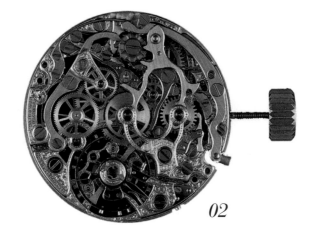

02

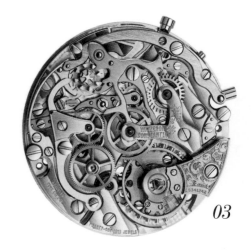

03

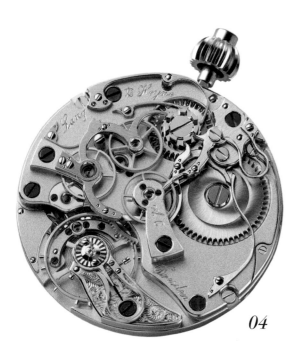

04

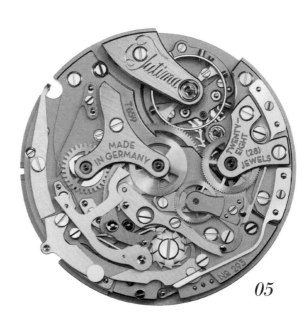

05

01. A. Lange & Söhne L951.1
02. Lemania 2310
03. Vacheron Constantin 1142,
 based on
 basiert auf Lemania
04. Lang & Heyne Caliber IV
05. Tutima T659
06. Girard-Perregaux GP3800
07. Chopard L.U.C 03.07-L
08. Maurice Lacroix MP7128
09. Cartier 9907 MC

Breitling, Bulgari, Cartier and Chopard, Eterna, Frédérique Constant, Girard-Perregaux, Hublot, IWC, Jaeger-LeCoultre, Maurice Lacroix, Montblanc, Omega, Panerai, Parmigiani, Patek Philippe, Piaget, Richard Mille, Rolex, TAG Heuer, Ulysse Nardin, Vacheron Constantin and Zenith. Agenhor, a Geneva-based family business, has broken wholly new and very complex ground with its "AgenGraphe," which is encased in wristwatches by Fabergé, H. Moser & Cie. and Singer Reimagined. German makers of chronograph movements include A. Lange & Söhne, Glashütte Original and Lang & Heyne. The Japanese giant Seiko offers the least costly manufacture chronograph movements. In Russia, Poljot makes several calibers from discontinued Swiss stock: e.g. Poljot's hand-wound Caliber 3133 is derived from the Valjoux 7734. Partly due to costs, most currently offered wristwatches with mechanical chronographs encase self-winding movements and their derivatives purchased from ETA or Sellita. With such a broad and diverse market at one's disposal, it is almost impossible not to find the right chronograph for every taste and budget.

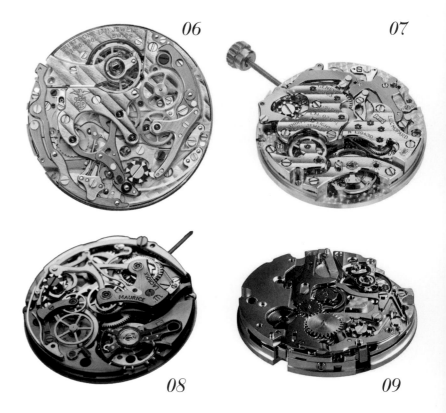

06

07

08

09

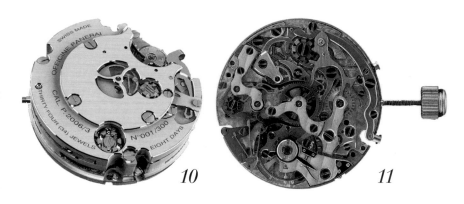

Die Palette an Herstellern exklusiver Chronographenwerke ist mittlerweile fast schon unüberschaubar. In der Schweiz reicht sie von Audemars Piguet über Blancpain, Breguet, Breitling, Bulgari, Cartier, Chopard, Eterna, Frédérique Constant, Girard-Perregaux, Hublot, IWC, Jaeger-LeCoultre, Maurice Lacroix, Montblanc, Omega, Panerai, Parmigiani, Patek Philippe, Piaget, Richard Mille, Rolex, TAG Heuer, Ulysse Nardin, Vacheron Constantin bis Zenith. Völlig neue und sehr komplexe Wege hat das Genfer Familienunternehmen Agenhor beschritten. Sein „AgenGraphe" findet sich in Armbanduhren von Fabergé, H. Moser & Cie. sowie Singer Reimagined. Aus Deutschland gibt es Chronographenwerke von A. Lange & Söhne, Glashütte Original sowie Lang & Heyne. Die preislich günstigsten Manufakturwerke bietet der japanische Gigant Seiko an. In Russland fertigt Poljot etliche aufgegebene Kaliber aus Schweizer Nachlass. Das Handaufzugskaliber 3133 stammt beispielsweise vom Valjoux 7734 ab. Im Großteil aller derzeit angebotenen Armbandstopper mit mechanischem Innenleben finden sich nicht zuletzt auch aus Kostengründen weiterhin von ETA oder Sellita zugekaufte Automatikwerke und ihre Derivate. Auf diesem breit gefächerten Chronographenmarkt nicht das Passende für sich zu finden, ist fast unmöglich.

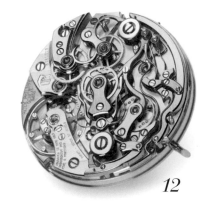
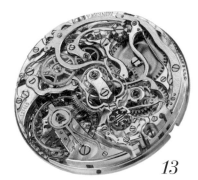

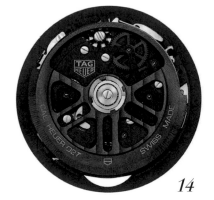
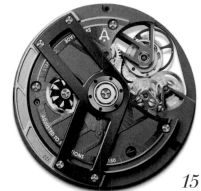

10. Panerai P.2006
11. Lemania 2310, rattrapante
12. Patek Philippe CHR 27-525 PS, rattrapante
13. Montblanc MB-M 16.31, rattrapante
Chronograph/tourbillon:
14. Heuer 02T
15. Angelus A-150
16. Hublot HUB 8100
17. Vacheron Constantin 3200

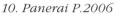

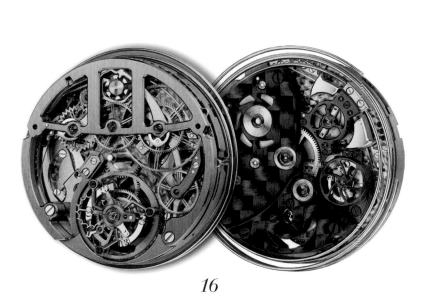

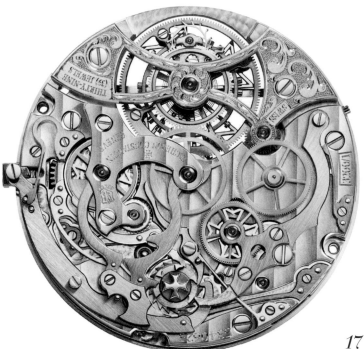

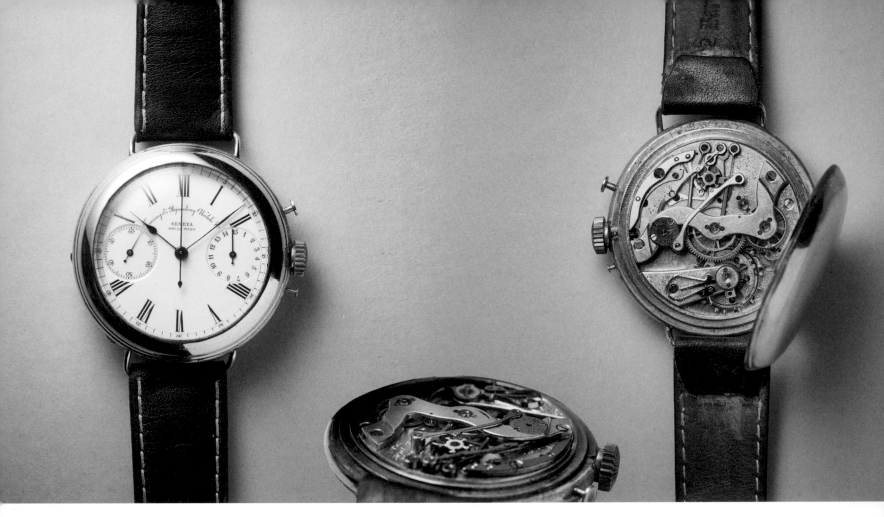

Timing and Repeating Watch Co., chronograph, 1895

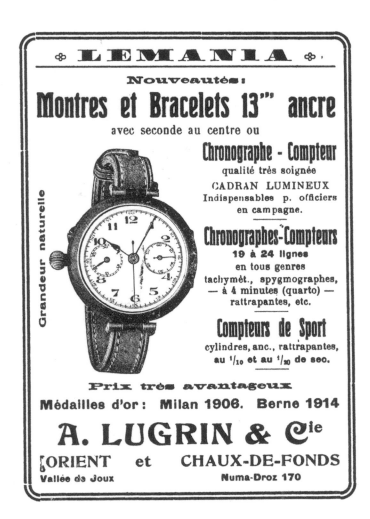

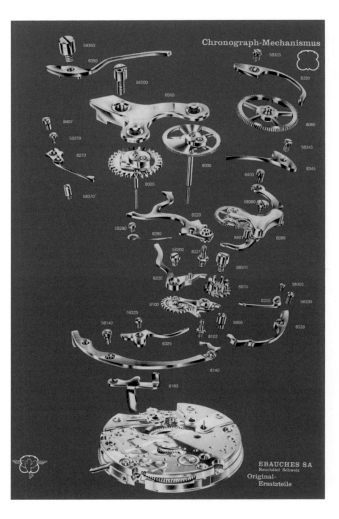

From left: ad for Lemania chronograph, 1916 ◦ Valjoux, chronograph mechanism, exploded view ◦ Von links: Anzeige für Lemania-Chronograph, 1916 ◦ Valjoux, Chronographmechanismus, Explosionsdarstellung

Breitling, Chronograph, 1915

Cartier Tortue, single-button chronograph ◦ Ein-Drücker-Chronograph, 1929

Mimo Mimolympic, zero-reset module, counter for 30 elapsed minutes ◦ Nullstellmodul, 30-Minuten-Zähler, 1936

Breguet Type XX Flyback Chronograph, c. 1954, Cal. Valjoux 22 with flyback module ◦ Kal. Valjoux 22 mit Flyback-Modul

Marvin, Chronograph, c. 1937

Lemania 105, c. 1950

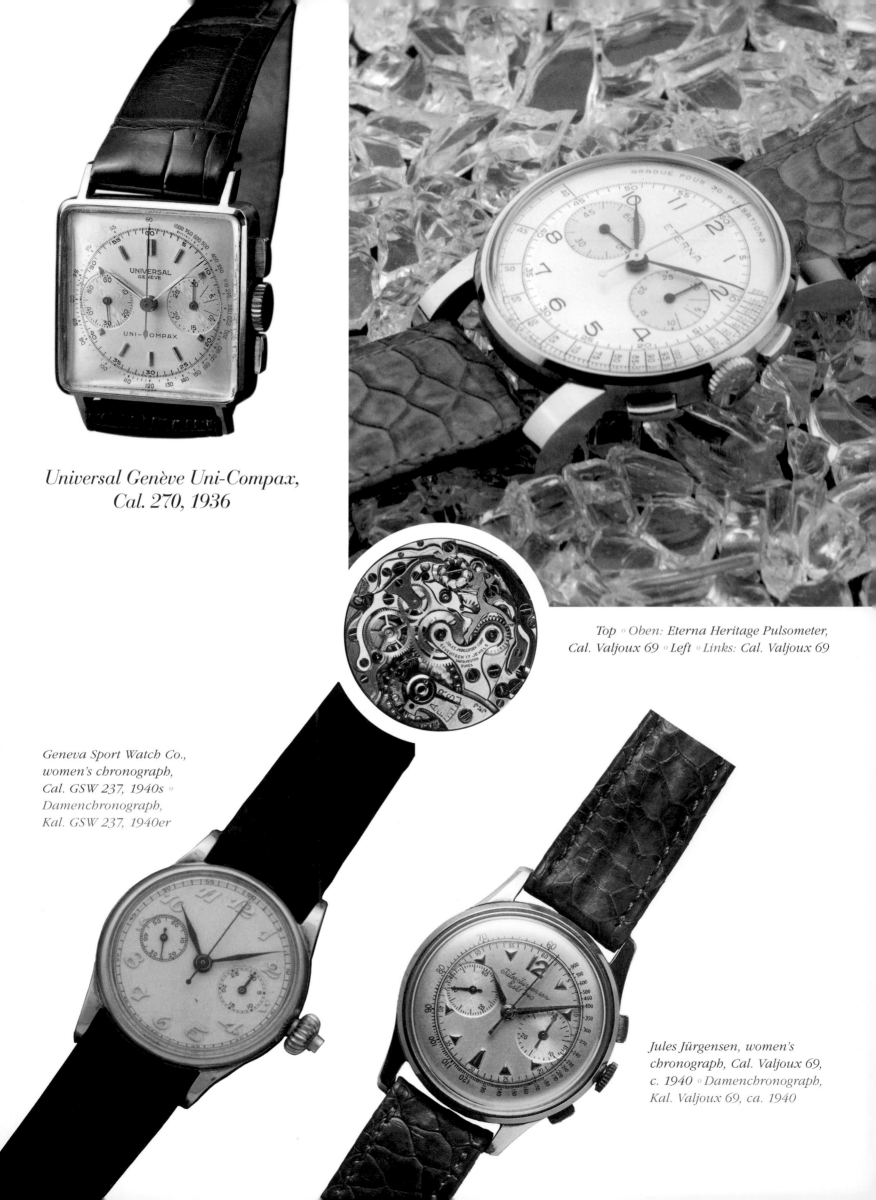

*Universal Genève Uni-Compax,
Cal. 270, 1936*

*Top ∘ Oben: Eterna Heritage Pulsometer,
Cal. Valjoux 69 ∘ Left ∘ Links: Cal. Valjoux 69*

*Geneva Sport Watch Co.,
women's chronograph,
Cal. GSW 237, 1940s ∘
Damenchronograph,
Kal. GSW 237, 1940er*

*Jules Jürgensen, women's
chronograph, Cal. Valjoux 69,
c. 1940 ∘ Damenchronograph,
Kal. Valjoux 69, ca. 1940*

Top left ◦ Oben links: Breitling Chronomat, with phases of the moon and hand-type date display, c. 1945 ◦ mit Mond-
phasen und Zeigerdatum, ca. 1945 ◦ Bottom left ◦ Unten links: Universal Genève Tri-Compax, Ref. 881.101-01 ◦
Right ◦ Rechts: Vénus, chronograph, Cal. Valjoux 88, c. 1950

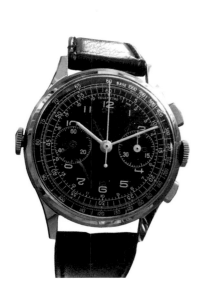

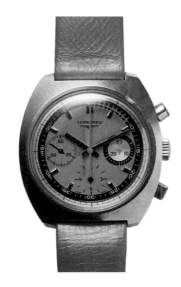

*Heuer
Abercrombie & Fitch
Mareographe Seafarer,
1950*

Left ◦ Links: Gallet MultiChron Navigator GMT, with north pointer ◦
mit Nordzeiger, 1943 ◦
Right ◦ Rechts: Longines Nonius Chronograph, Cal. Valjoux 72, c. 1975

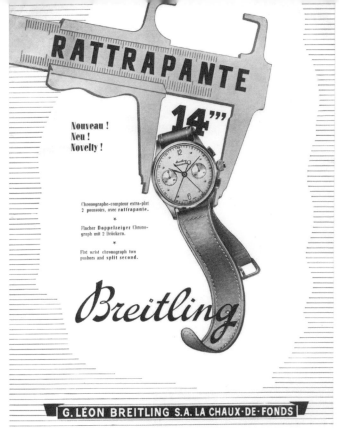

From left: Minerva split-seconds chronograph, used for timekeeping at the Olympic Winter Games 1936 ◦ ad for Breitling Duograph Rattrapante, 1943 ◦ Von links: Minerva Schleppzeigerchronograph, benutzt zur Zeitnahme bei den Olympischen Winterspielen 1936 ◦ Anzeige für Breitlings Duograph Rattrapante, 1943

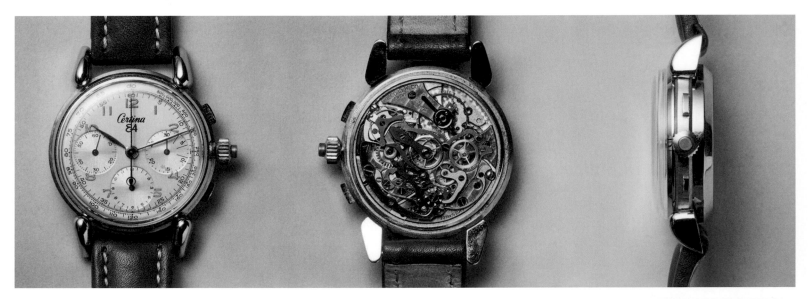

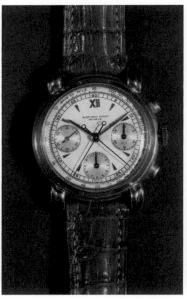

Above ◦ Oben: Certina EA Rattrapante Chrono, Cal. Vénus 185, c. 1955 ◦ Bottom, from left: split-seconds chronograph, open pincer—rattrapante hand moving ◦ closed pincer— rattrapante hand halted ◦ Audemars Piguet, split-seconds chronograph, 1943 ◦ Unten, von links: Rattrapante-Chronograph, Zange offen – Schleppzeiger läuft ◦ Zange geschlossen – Schleppzeiger angehalten ◦ Audemars Piguet, Rattrapante-Chronograph, 1943

Top, from left ○ *Oben, von links: chronographs with minute counter* ○ *Chronographen mit Minutenzähler: Panerai Luminor, Zenith El Primero Chronomaster Open, TAG Heuer Monaco Gulf, Tudor Black Bay* ○ *Bottom, from left* ○ *Unten, von links: chronographs with 30-minute and 12-hour counter* ○ *Chronographen mit 30-Minuten- und 12-Stunden-Zähler: Blancpain Leman Flyback, Longines Master L688, Seiko Presage, Jaeger-LeCoultre Deep Sea Cermet, TAG Heuer Autavia, Hanhart Pioneer TwinDicator*

Top ∘ Oben: Enicar Sherpa Super Graph, c. 1960 ∘ Bottom: Personalized made-to-order Blaken watch "Skulls", based on Rolex Daytona, Cal. 4130 ∘ Unten: Auf Kundenwunsch personalisierte Blaken-Uhr "Skulls", basierend auf Rolex Daytona, Kal. 4130

Bulgari Diagono Magnesium Chronograph, Cal. Zenith El Primero, 2016

Porsche Design by IWC, first chronograph made of titanium / erster Titan-Chronograph, 1981

Carl F. Bucherer Patravi TravelTec II, 2016

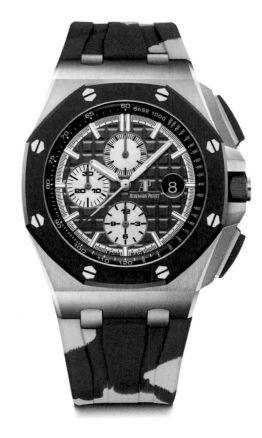

Audemars Piguet Royal Oak Offshore Chronograph Camo, 2019

Hublot Big Bang Unico Sapphire All Black, 2016

Graham Chronofighter Superlight Carbon, 2017

Girard-Perregaux Laureato Absolute Chronograph, 2019

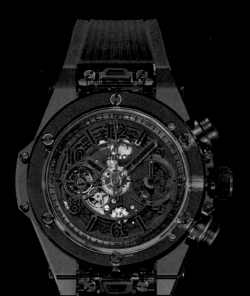

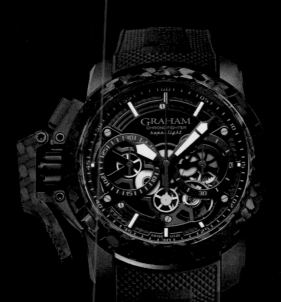

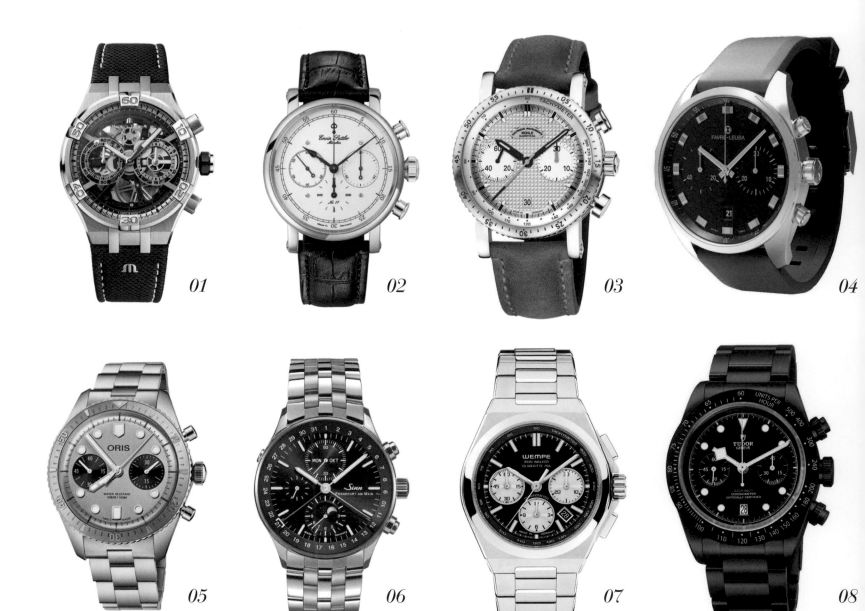

01. Maurice Lacroix Aikon
 Chronograph Skeleton, 2020
02. Erwin Sattler Chronograph II
 Classica Secunda, 2017
03. Mühle Glashütte Teutonia Sport I,
 Cal. MU 9419, based on ∘ basierend auf
 Sellita SW510-1, 2019
04. Favre-Leuba Sky Chief
 Chrono Steel, 2020
05. Oris Hölstein Edition Divers 65,
 bronze, 2020
06. Sinn Frankfurt Financial District
 Chronograph, Ref. 6012, Cal. ETA 7751 ∘
 Sinn Frankfurter Finanzplatzuhr mit
 Chronograph, Ref. 6012, Kal. ETA 7751
07. Wempe Iron Walker, 2020
08. Tudor Black Bay Chrono Dark, 2019
09. Rolex Daytona, Ref. 116500, Cal. 4130
10. Bulgari Octo Finissimo Chronograph
 Tourbillon Skeleton, slimmest watch of
 its kind ∘ weltweit flachstes Modell
 seiner Art, 2020

12 *13*

14 *15*

11

16

11. Porsche Design Indicator P6910,
 with digital minute counter ◦
 mit digitalem Minutenzähler, 2004
12. Hublot Big Bang Unico Chrono
 Soccer Bang, 2014
13. Glashütte Original
 PanoRetroGraph, 2000
14. Panerai Luminor Regatta,
 PAM00956, 2019
15. Louis Vuitton Tambour Spin
 Time Régate, 2014
16. Girard-Perregaux Foudroyante
 Scuderia Ferrari, 1999

Parmigiani Fleurier
Tonda Chronor Anniversaire,
2016

Montblanc 1858
Split Second Chronograph
LE 100, 2018

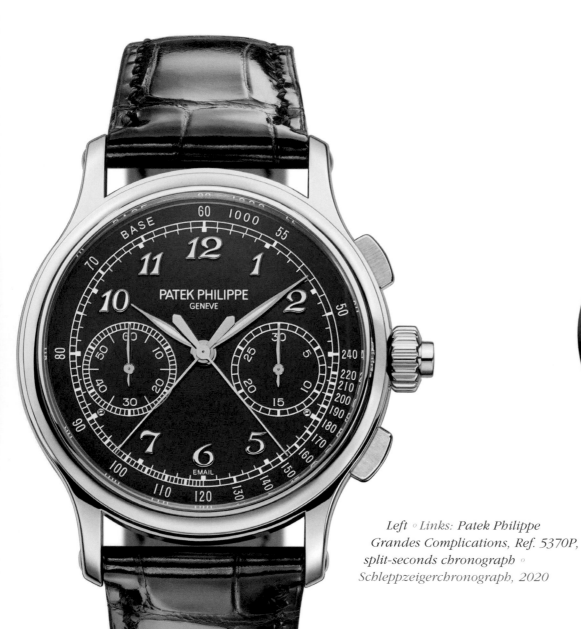

Angelus U30 Tourbillon
Rattrapante, 2016

Left ○ Links: Patek Philippe
Grandes Complications, Ref. 5370P,
split-seconds chronograph ○
Schleppzeigerchronograph, 2020

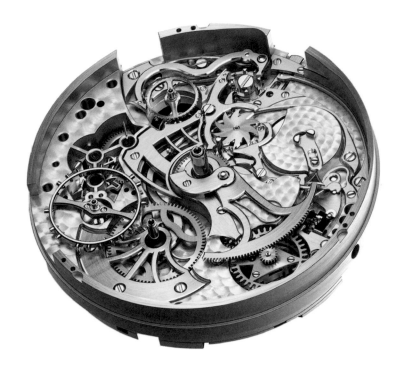

Montblanc TimeWalker Chronograph 1000 LE 18,
with 1,000ths-of-a-second stopper ◦ mit Tausendstel-
sekunden-Stopper, 2018

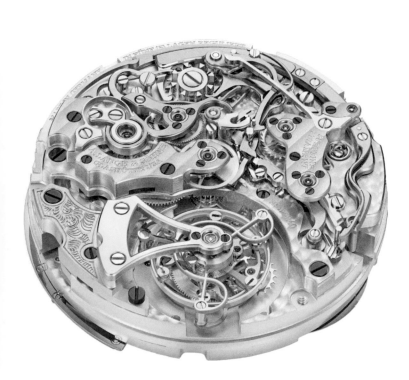

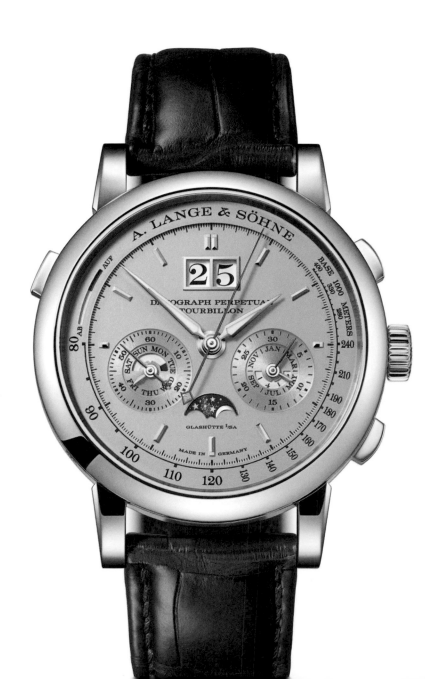

A. Lange & Söhne Datograph Perpetual Tourbillon,
manual-winding Caliber L952.2 ◦ Handaufzugskaliber L952.2, 2019

01

02

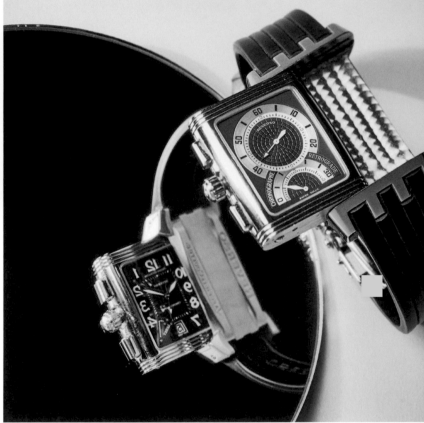

05

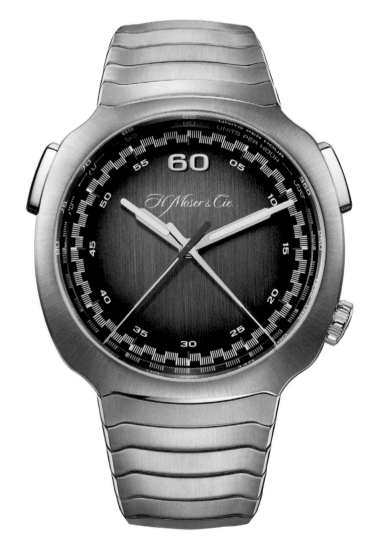

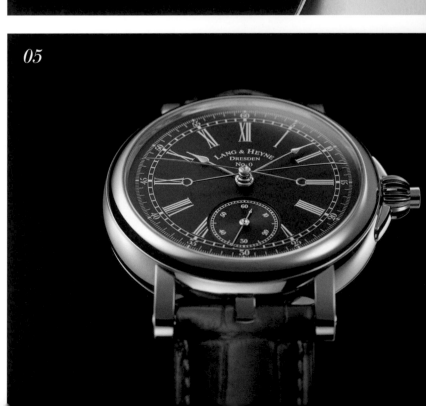

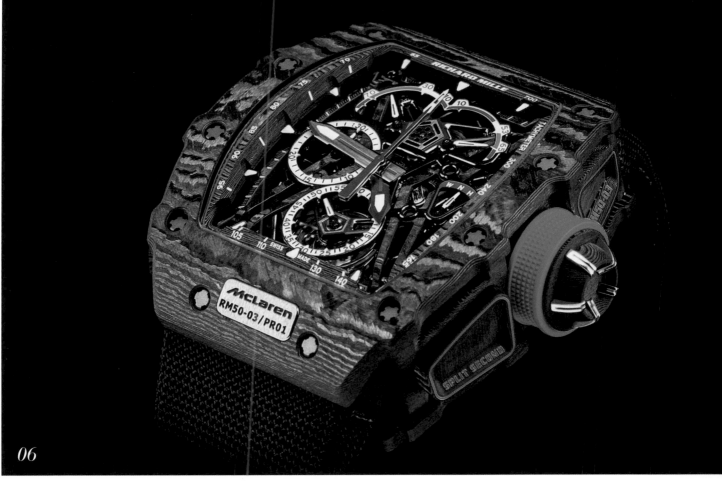

03

04

06

07

08

09

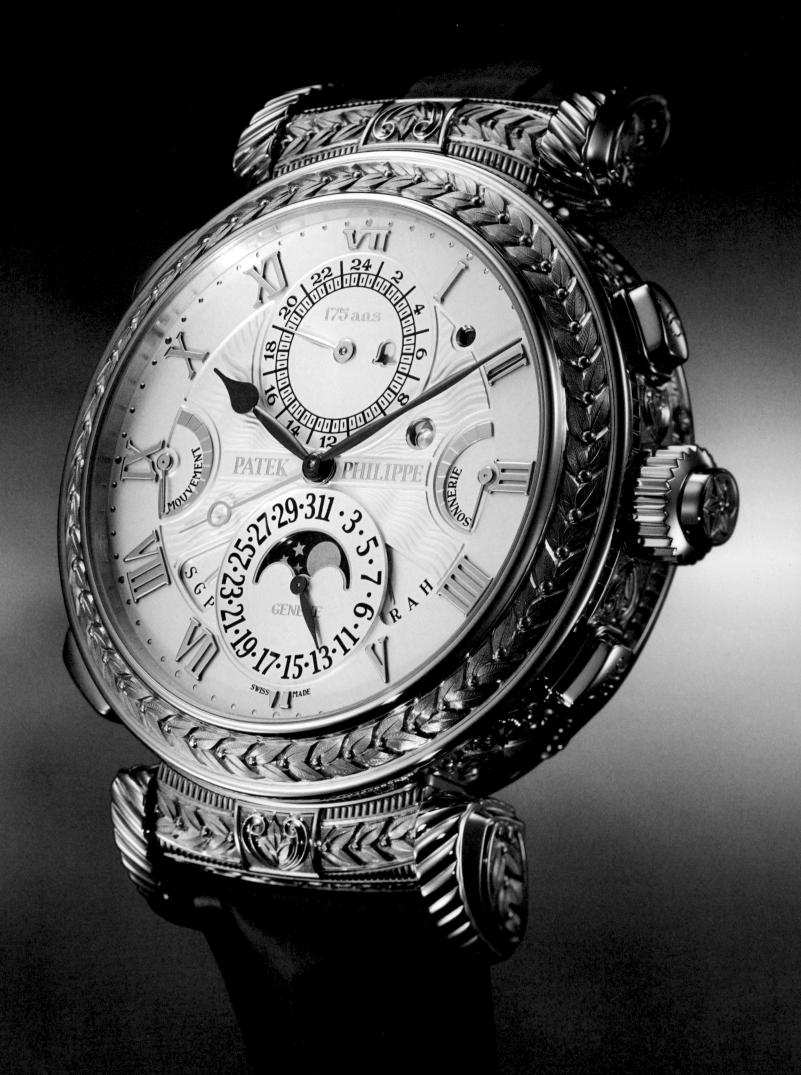

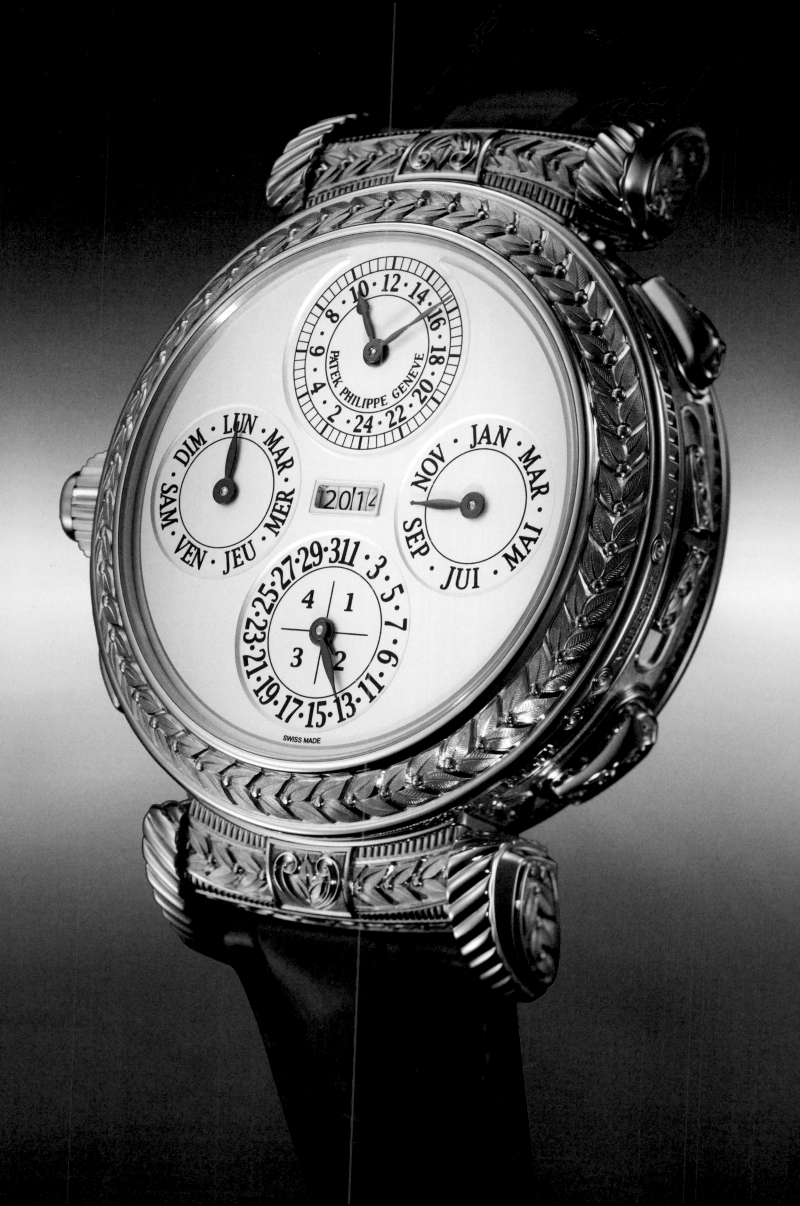

Complicated Epilogue

Thierry Stern's reply to the question "What is your favorite complication?" proved once again that brevity is indeed the soul of wit: "My wife," answered the president of the venerable Patek Philippe family business, who really ought to know, because since 1839, the manufacture currently under his management has fabricated every conceivable horological complication—including the crowning achievement of the watchmaker's métier in the form of so-called "grandes complications." The Janus-faced "Grandmaster Chime" wristwatch evokes the most intense emotions among many watch lovers, but is also unaffordable for all but the most affluent among them. It is equipped with two separate dials: the one usually worn facing upward is devoted primarily to the time and to the versatile striking mechanism; its counterpart focuses on the perpetual calendar with jumping indicators, the fully written out year and a moon-phase display. The hand-wound movement consists of 1,366 components. An additional 214 parts comprise the reversible case.

Affordable or not, everyone is free to dream of owning one of these mechanical works of art. Of course, Patek Philippe is not alone in this rarified atmosphere. Blancpain inaugurated the competition in 1990 with the "1735." This watch's eponymous self-winding caliber supports six additional functions and concatenates no fewer than 740 components.

A small eternity elapsed before the curtain rose on the final act in the genesis of a collaborative grand complication. In 1892, Louis-Elisée Piguet built a complicated three-handed movement with a grande and petite sonnerie as well as a minute repeater with two gongs. A century later, Franck Muller augmented it with a perpetual calendar and ensconced it inside a wristwatch's case. In 1995, this model's owner commissioned the Zurich-based watchmaker Paul Gerber to install a flying tourbillon. The crowning touches followed in 2003, when Paul Gerber again took this timepiece in hand and added a flyback chronograph with jumping minute counter and separate power-reserve indicators for the ordinary timekeeping movement and the striking mechanism.

After several years of development, Audemars Piguet completed its "Triple Complication" with automatic winding, chronograph, perpetual calendar and minute repeater in 1992. Although the movement performs several additional functions, its case is slightly less than twelve millimeters tall.

IWC celebrated its 125th anniversary in 1993 by giving itself and its loyal community of fans the "warhorse from Schaffhausen." In addition to the traditional ingredients of grand complications (i.e. minute-repeater striking mechanism, perpetual calendar and split-seconds chronograph), a flying tourbillon is also among the complications supported by the 750 components that comprise the hand-wound movement of "Il Destriero Scafusia."

A. Lange & Söhne's watchmakers accepted the challenge implicit in the assertion that "What can be done in large format can also be accomplished in a smaller size." On the basis of the "Grande Complication" pocket watch No. 42500, which was manufactured in 1902 and subsequently underwent 5,000 hours of painstaking restoration, a reincarnation equipped with the same functions but affixed to a wristband was built in 2013. Its watchmakers manufacture, decorate and assemble 876 components for each specimen of this watch's hand-wound Caliber L1902.

Chopard demonstrates its relatively recently acquired yet no less praiseworthy competence in horological complications with the "All in One," which debuted in 2010 as part of the manufacture's commemoration of its 150th anniversary. An exclusive orbital moon-phase indicator is visible on the back of hand-wound Caliber L.U.C 4TQE, which is assembled from 516 components. The highly accurate moon-phase display deviates from astronomical reality by an imperceptible 57.2 seconds per lunation.

Previous pages ○ Vorherige Seiten: Patek Philippe Grandmaster Chime, Ref. 5175R, 2014 ○ This page ○ Diese Seite: Patek Philippe Grandmaster Chime, Cal. 300, perpetual calendar (01) and under the dial (02) ○ ewiger Kalender (01) und unter dem Zifferblatt (02)

 01

 02

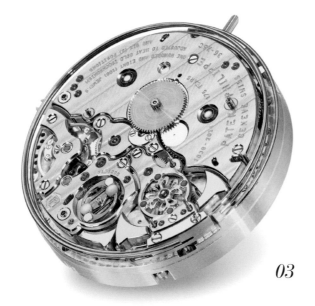 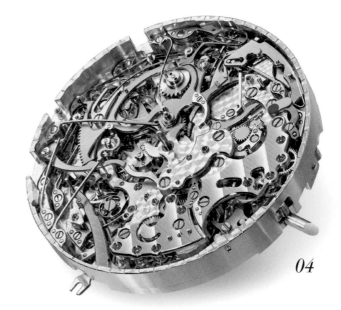

Patek Philippe Grandmaster Chime, Cal. 300, bearing bridge, side view (03) and Grande Sonnerie (04)
Brückenseite (03) und großes Schlagwerk (04)

Komplizierter Epilog

Auf die Frage, welches seine liebste Komplikation sei, antwortete Thierry Stern ebenso kurz wie scherzhaft: „Meine Frau." Der Präsident des altehrwürdigen Familienunternehmens Patek Philippe muss es wissen, denn seit 1839 hat die gegenwärtig von ihm geleitete Manufaktur alle erdenklichen uhrmacherischen Komplikationen hervorgebracht – einschließlich der Krönung dieses Metiers in Gestalt sogenannter großer Komplikationen. Am Handgelenk verkörpert die doppelseitige „Grandmaster Chime" für viele Uhrenliebhaber das Höchste der Gefühle, aber gleichzeitig auch absolut Unerschwingliche. Sie verfügt über zwei separate Zifferblätter: Das üblicherweise oben getragene widmet sich schwerpunktmäßig der Uhrzeit und dem vielfältigen Schlagwerk. Das andere richtet den Fokus auf das immerwährende Kalendarium mit springenden Indikationen, der voll ausgeschriebenen Jahreszahl sowie einer Mondphasenanzeige. Aus 1366 Komponenten besteht das Handaufzugswerk. 214 Teile braucht es für ein Wendegehäuse.

Es ist durchaus erlaubt, von derartigen mechanischen Kunstwerken zu träumen. Natürlich ist Patek Philippe nicht alleine auf weiter Flur. Blancpain hatte den Reigen 1990 mit der „1735" eröffnet. Ihr gleichnamiges Automatikkaliber mit Selbstaufzug und sechs Zusatzfunktionen verlangte nach 740 Teilen.

Eine kleine Ewigkeit dauerte es bis zum letzten Akt der Genese einer großen Gemeinschaftskomplikation. 1892 fertigte Louis-Elisée Piguet ein kompliziertes Drei-Zeiger-Uhrwerk mit großem und kleinem Schlagwerk sowie Minutenrepetition auf zwei Tonfedern. 100 Jahre später ergänzte es Franck Muller durch ein ewiges Kalendarium und ein Gehäuse zum Tragen am Handgelenk. Der ambitionierte Käufer des Modells beauftragte den Zürcher Uhrmacher Paul Gerber 1995 mit dem Einbau eines fliegenden Tourbillons. Die Krönung bestand 2003 in der Addition von Schleppzeigerchronograph mit Flyback-Funktion und springendem Minutenzähler sowie Gangreserveindikationen für Geh- und Schlagwerk – wiederum durchgeführt von Paul Gerber.

Audemars Piguet vollendete 1992 nach mehrjähriger Entwicklungsarbeit seine „Triple Complication" mit automatischem Aufzug, Chronograph, ewigem Kalender und Minutenrepetition. Ungeachtet der Ansammlung mehrerer Funktionen baute das Gehäuse nur knapp 12 Millimeter hoch.

Zum 125-jährigen Firmenjubiläum im Jahr 1993 schenkte die IWC sich und ihrer treuen Fangemeinde das „Streitross aus Schaffhausen": „Il Destriero Scafusia". Neben den traditionellen Zutaten großer Komplikationen, also Minutenrepetitionsschlagwerk, ewiger Kalender und Schleppzeigerchronograph, besitzt das aus 750 Einzelteilen komponierte Handaufzugswerk auch ein fliegendes Tourbillon.

Wie im Großen, so im Kleinen, sagte sich A. Lange & Söhne. Auf der Basis der 1902 hergestellten „Grande Complication"-Taschenuhr Nr. 42500, deren mühevolle Restaurierung 5000 Stunden in Anspruch nahm, entstand 2013 ein mit den gleichen Funktionen ausgestattetes Pendant mit Armband. Für ein Exemplar des Handaufzugskalibers L1902 fertigen, finissieren und assemblieren die Uhrmacher 876 Komponenten.

Chopard stellt seine relativ kurz während, aber deshalb nicht minder ausgeprägte Komplikationenkompetenz seit 2010, dem Jahr des 150. Jubiläums, mit der „All in One" unter Beweis. Auf der Rückseite des aus 516 Teilen assemblierten Handaufzugswerks L.U.C 4TQE findet sich eine exklusive orbitale Mondphasenindikation. Pro Lunation beträgt ihre Fehlweisung nicht wahrnehmbare 57,2 Sekunden.

Mit dem „Master Grande Tradition Gyrotourbillon Westminster Perpétuel" übertraf sich Jaeger-LeCoultre 2019 sozusagen selbst. Für eine *bella figura* am Handgelenk schrumpften die Dimensionen des sphärischen Drehgangs ganz beträchtlich. Zum Konstantkraftantrieb gesellen sich immerwährendes Kalendarium und Minutenrepetition. Dabei erfolgt die akustische Darstellung der Viertelstunden mit der Melodie des berühmten Londoner Big Ben.

Nicht fürs Handgelenk, sondern am besten für den Tresor ist schließlich die Taschenuhr 57260 von Vacheron Constantin gedacht. Komplizierter als bei diesem 2015 fertiggestellten Unikat geht es bislang nicht. Das belegen einige Zahlen: acht Jahre Entwicklungszeit, zehn Patente, 85 Prototypen und technische Detailstudien, 16 Kilogramm Zeichenpapier, 57 Funktionen, 2826 Komponenten, 957 Gramm Gewicht, Durchmesser 98 Millimeter, Bauhöhe 50,55 Millimeter. Den Preis möchte der anonyme amerikanische Sammler nicht nennen.

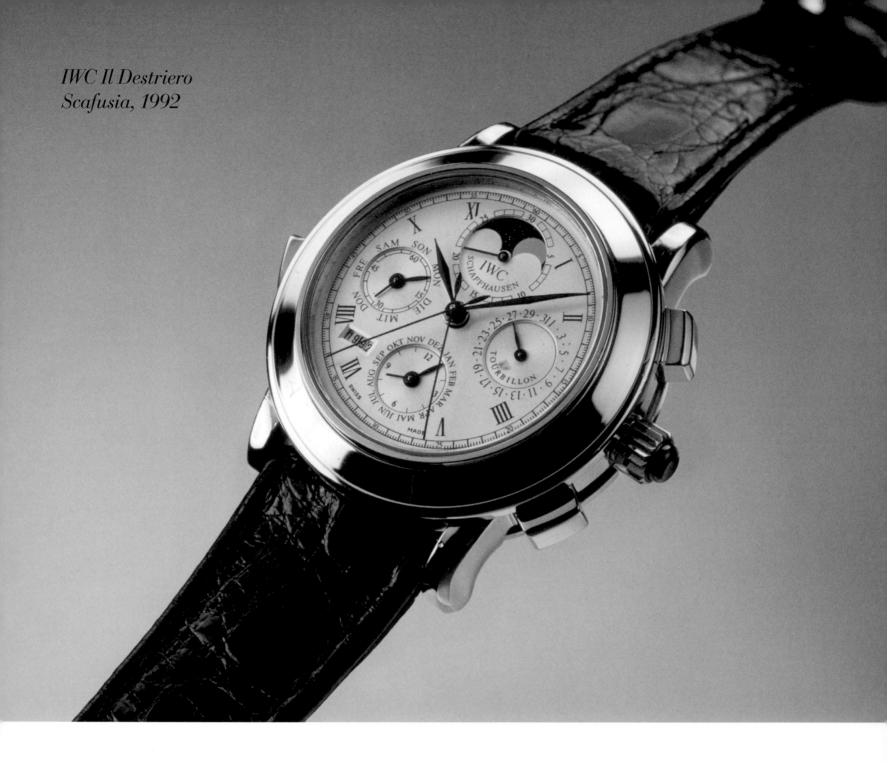

*IWC Il Destriero
Scafusia, 1992*

Jaeger-LeCoultre outdid itself, so to speak, with its premiere of the "Master Grande Tradition Gyrotourbillon Westminster Perpétuel" in 2019. The dimensions of the spherical "whirlwind" were radically miniaturized to ensure a *bella figura* on the wrist. A perpetual calendar and a minute repeater join the constant-force mechanism. The familiar melody of London's famous Big Ben tower clock chimes the quarter hours here.

Finally, Vacheron Constantin's 57260 pocket watch is not intended for wearing on a wrist, but for safekeeping inside a vault. Thus far, no other watch is as complicated as this unique timepiece, which was completed in 2015. A few statistics confirm this: eight years of development, ten patents, 85 prototypes and detailed technical studies, 16 kilograms of drawing paper, 57 functions, 2,826 components, 957 grams in weight, 98 millimeters in diameter and 50.55 millimeters in height. The anonymous American collector who purchased it prefers not to reveal its price.

Reading the foregoing paragraphs, people with a penchant for ticking microcosms cannot but succumb to raptures and paroxysms of delight. Precious few will ever ascend to this lonely summit of this Olympus of mechanical timekeeping. Nor need they venture the

attempt. Those who love the complicated aspects of traditional time-keeping can also be satisfied with much less. After all, the hope always remains that the ambitious aficionado will someday climb to the next higher rung on the ladder of horological complications.

In accord with the motto that those who give generously may receive with equal generosity, the elite watch brands strive to outdo one another by transforming more or less creative and functional ideas into ticking realities. In conclusion, a few words of apology would seem appropriate: The sheer overabundance of exceptional creations made it simply impossible to accommodate all types and all forms of horological complications in the limited space available here. Displays of the tides and phases of the moon, automata (animated figures), skeletonized movements, alarms, extremely long-lasting power reserves and the enormously diverse faces that watchmakers have given to precious time must accordingly remain subjects for a future book.

While enjoying these diverse treasures of mechanical watchmaking, one should never forget a worthwhile piece of advice from the Belgian author Phil Bosmans: "If you have time for a person, don't glance at your watch."

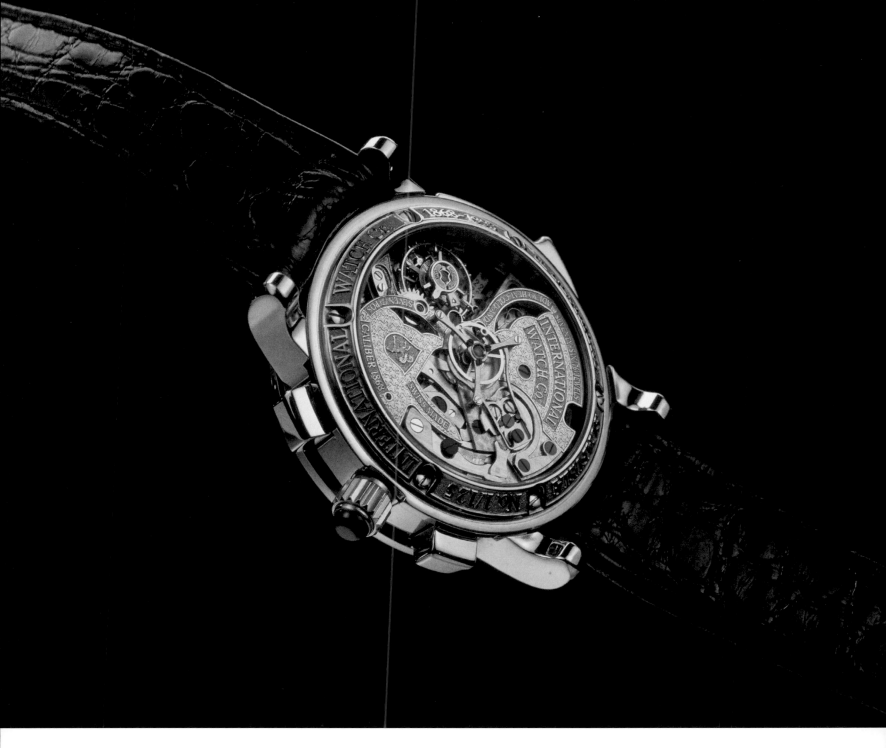

Bei all dem müssen Menschen mit einem Faible für tickende Mikrokosmen einfach ins Schwärmen kommen. Die wenigsten werden diesen einsamen Olymp mechanischer Zeitmessung jemals erreichen. Und das muss auch nicht sein. Wer das komplizierte Etwas der überlieferten Zeitmessung liebt, zeigt sich auch mit sehr viel weniger zufrieden. Immerhin bleibt ja die Hoffnung, eines Tages auf der Komplikationenleiter weiter nach oben zu steigen.

Nach dem Motto, dass manchem etwas bringt, wer vieles bringt, überbieten sich die Uhrenmarken mit mehr oder minder kreativen und funktionalen Ideen. Daher sind abschließend noch ein paar Worte der Entschuldigung nötig: Geballte Überfülle machte es schlichtweg unmöglich, alle Arten und Ausprägungen uhrmacherischer Zusatzfunktionen auf beschränktem Platz unterzubringen. Gezeiten- und Mondphasenindikationen, Figurenautomaten, Skelettwerke, Wecker, Langläufer und die ganze Vielfalt an Zeit-Gesichtern werden deshalb Gegenstände eines weiteren *Watch Book* sein.

Bei aller Freude an den wie auch immer gearteten Kleinodien mechanischer Uhrmacherkunst sollte man einen Ratschlag des Belgiers Phil Bosmans nie vergessen: „Wenn du Zeit hast für einen Menschen, dann sieh nicht auf die Uhr."

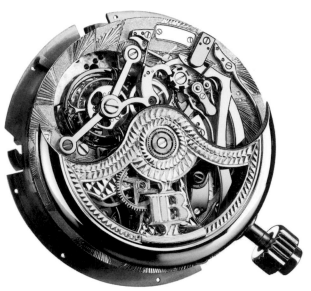

Blancpain 1735
Grande Complication, 1990

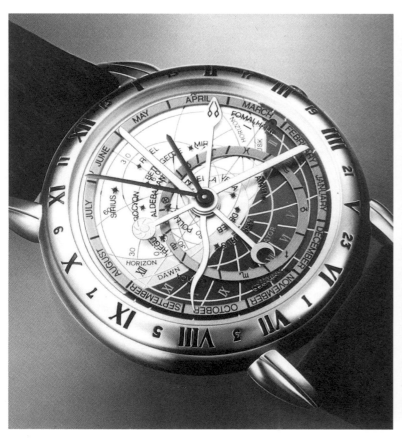

Ulysse Nardin Astrolabium, 1985

Audemars Piguet Jules Audemars
Grande Complication, Ref. 25866

Franck Muller Aeternitas Mega 2, 2008

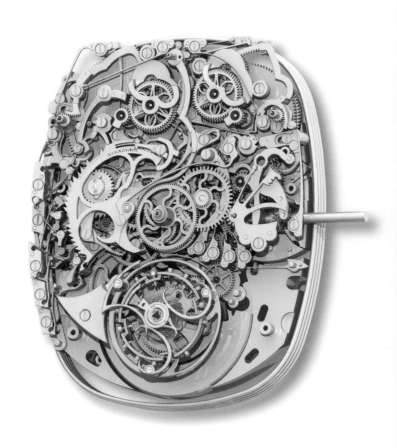

Franck Muller, Cal. 3470

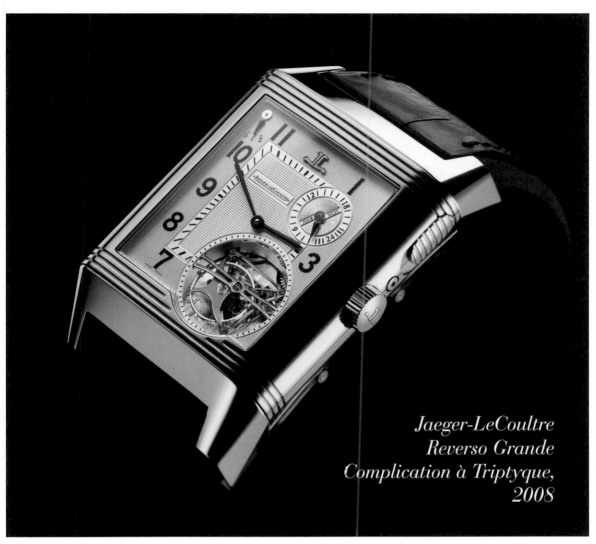

Jaeger-LeCoultre
Reverso Grande
Complication à Triptyque,
2008

*Below ◦ Unten:
Jaeger-LeCoultre Reverso
Grande Complication à
Tryptique, calendar and
isometer escapement ◦
Kalendarium und Isometer-
hemmung*

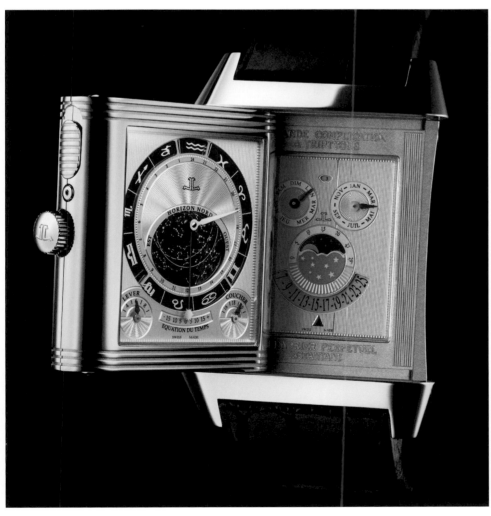

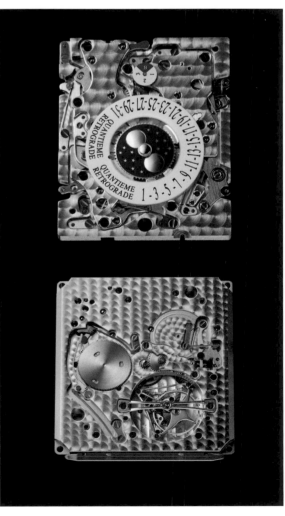

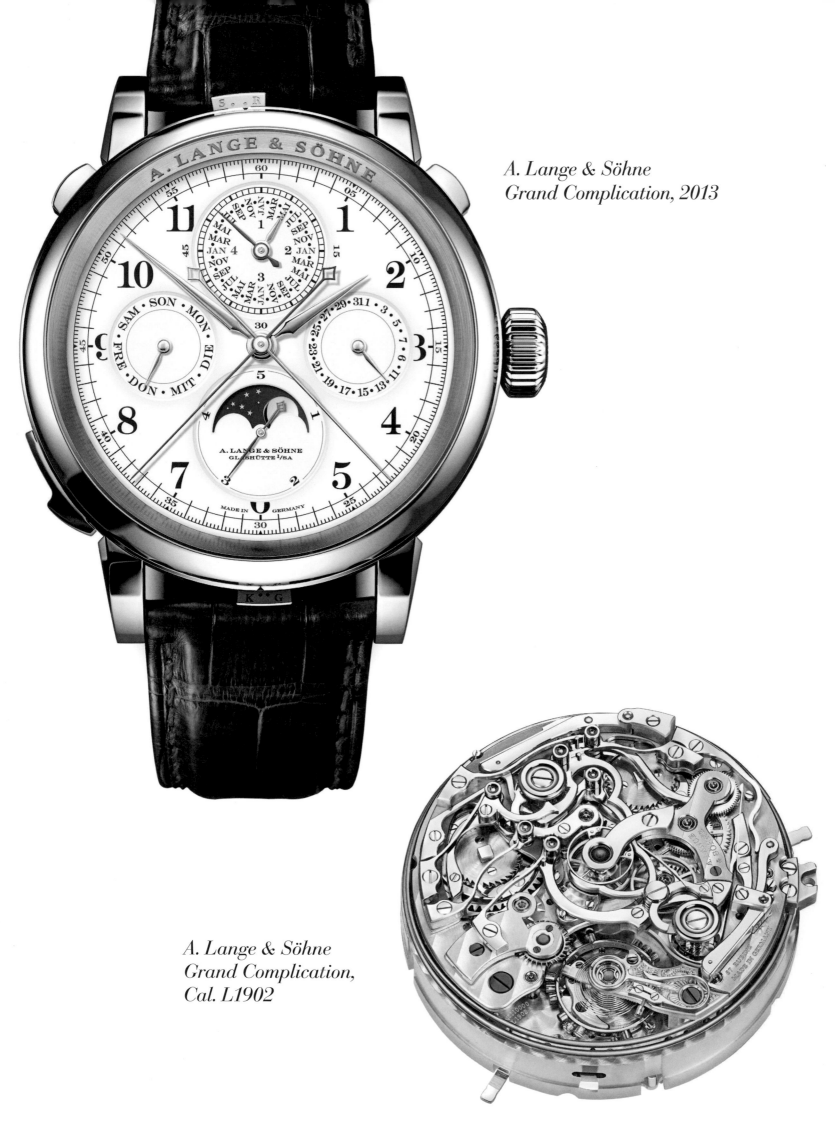

A. Lange & Söhne
Grand Complication, 2013

A. Lange & Söhne
Grand Complication,
Cal. L1902

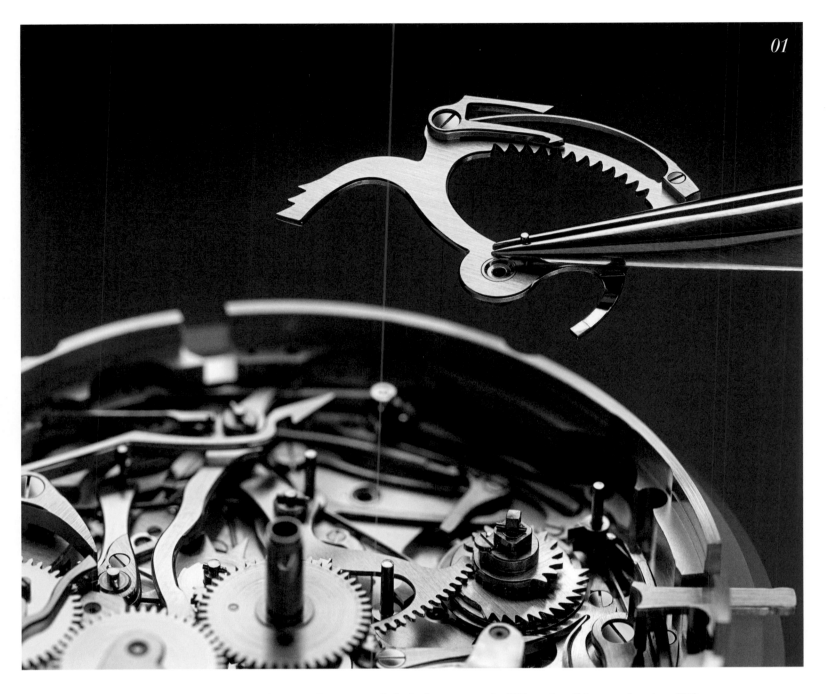

A. Lange & Söhne Grand Complication, striking mechanism: rack (01), flying seconds (02) and striking mechanism (03) ◦
Schlagwerksrechen (01), blitzende Sekunde (02) und Schlagwerk (03)

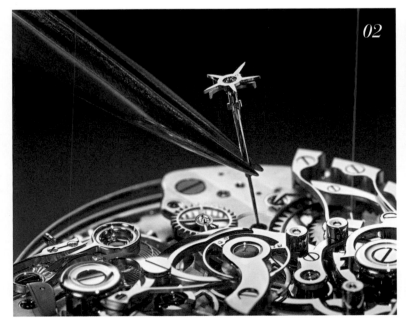

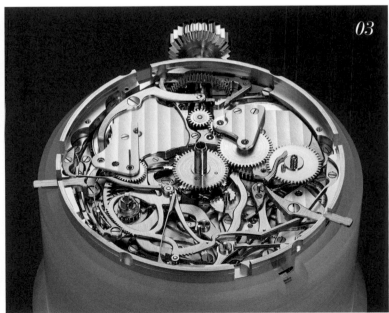

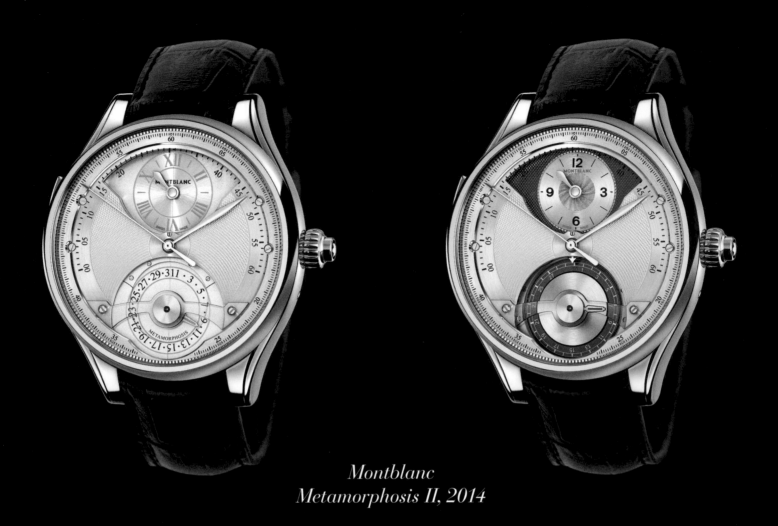

Montblanc
Metamorphosis II, 2014

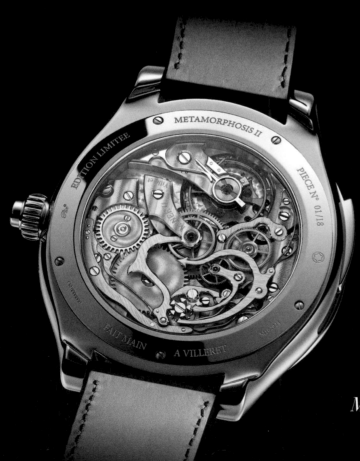

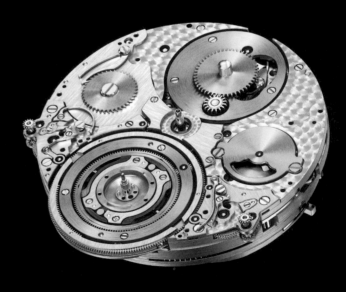

Montblanc Metamorphosis II,
Cal. MB M67.40

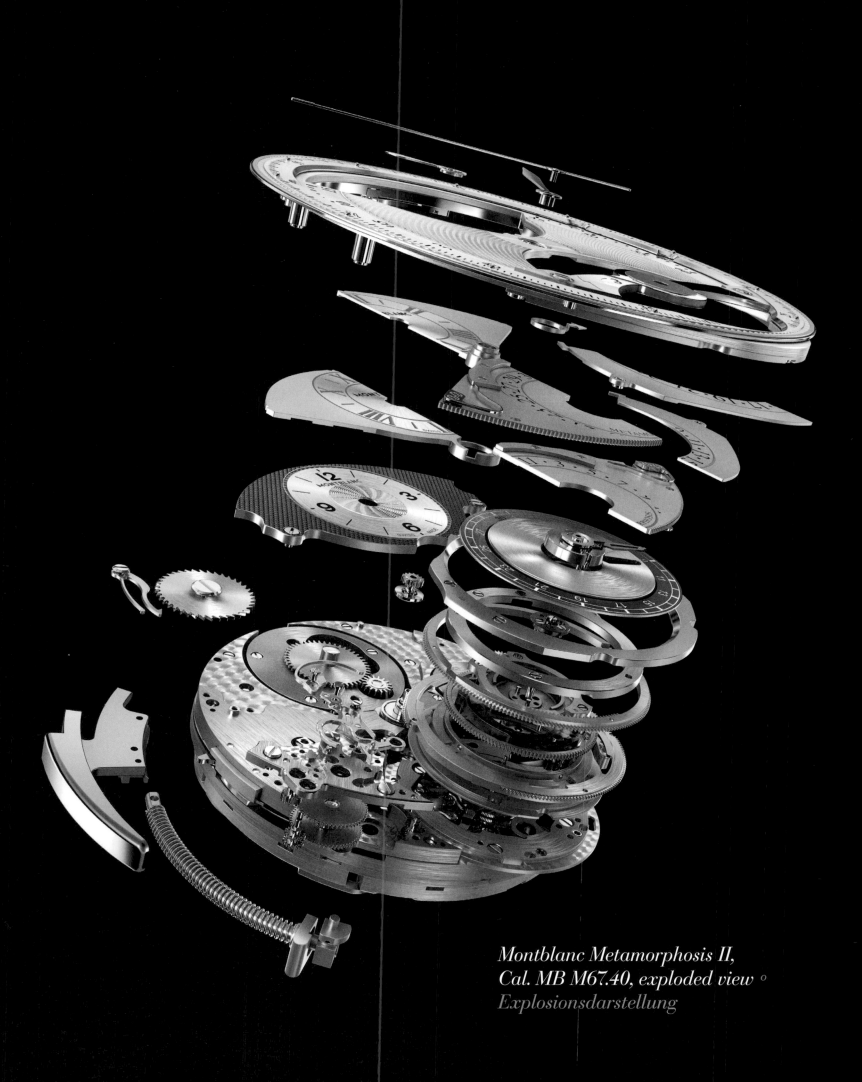

Montblanc Metamorphosis II,
Cal. MB M67.40, exploded view °
Explosionsdarstellung

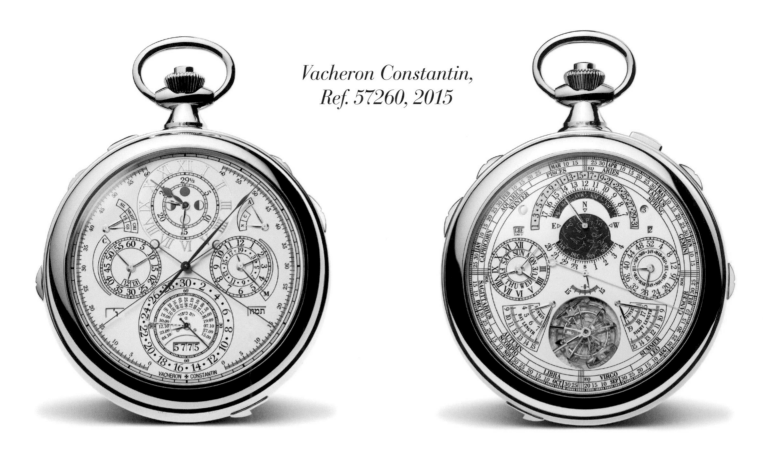

Vacheron Constantin,
Ref. 57260, 2015

The world's most complicated watch, featuring 57 complications ○ *Die komplizierteste Uhr der Welt mit 57 Komplikationen*

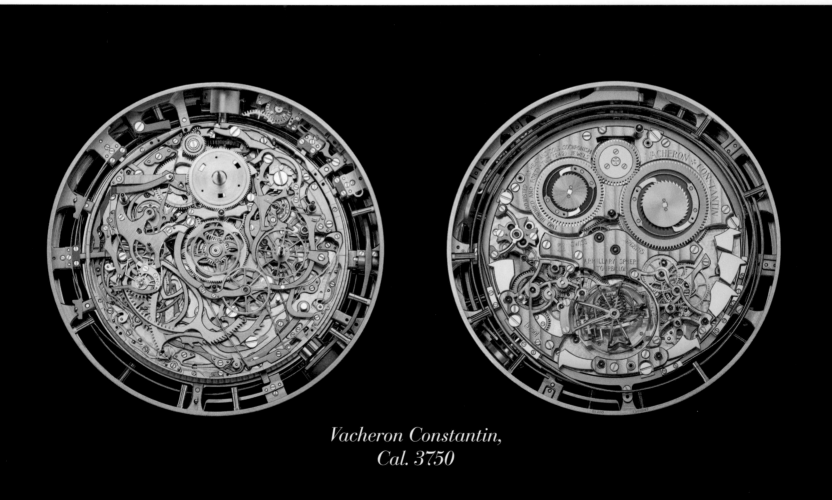

Vacheron Constantin,
Cal. 3750

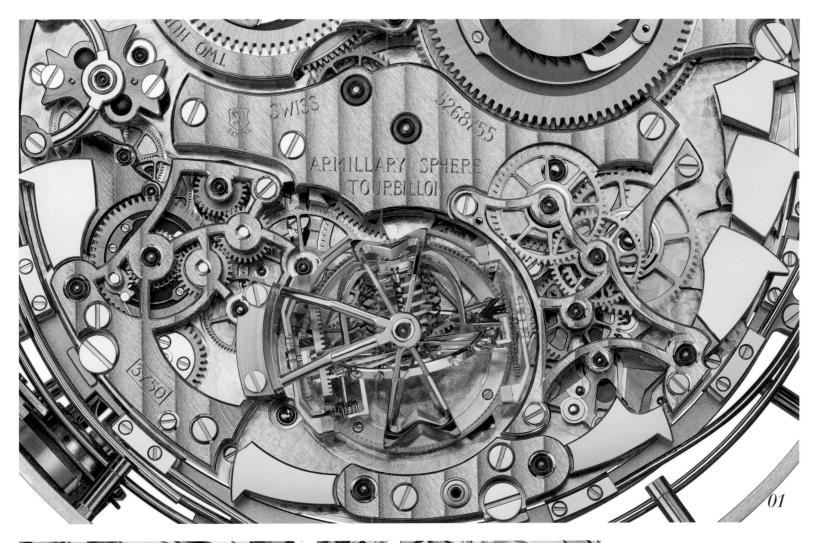

Vacheron Constantin, Cal. 3750, six hammers for striking mechanism and alarm (01), chronograph with column wheel (02) and striking mechanism (03) ◦ Sechs Hämmer für Schlagwerk und Wecker (01), Chronograph mit Schaltrad (02) und Schlagwerk (03)

Credits

The images related to the individual companies

Alpina	*Maurice Lacroix*
Andersen	*Landeron*
Angelus	*A. Lange & Söhne*
Anonimo	*Lang & Heyne*
Arnold & Son	*Lemania*
Ateliers deMonaco	*Leroy*
Audemars Piguet	*Lip*
Baume & Mercier	*Longines*
Ferdinand Berthoud	*Maîtres du Temps*
Blaken	*MB&F*
Blancpain	*MeisterSinger*
Bovet Dimier	*Eugène Meylan*
Breguet	*Richard Mille*
Breitling	*Minerva*
Carl F. Bucherer	*Louis Moinet*
Bulgari	*Montblanc*
Cartier	*H. Moser & Cie.*
Chanel	*Movado*
Chopard	*Mühle Glashütte*
Chronoswiss	*Franck Muller*
Concepto	*Nomos Glashütte*
Concord	*Omega*
Frédérique Constant	*Oris*
Corum	*Charles Oudin*
Cyrus	*Panerai*
Czapek & Cie.	*Parmigiani Fleurier*
Dubois Dépraz	*Patek Philippe*
Roger Dubuis	*Perrelet*
Philippe Dufour	*Piaget*
Dugena	*Porsche Design*
ETA	*Record*
Eterna	*Rolex*
Favre-Leuba	*Erwin Sattler*
Felsa	*Seiko*
Girard-Perregaux	*Sellita*
Glashütte Original	*Sinn*
Glycine	*Speake-Marin*
Graham	*Armin Strom*
Greubel Forsey	*TAG Heuer*
Moritz Grossmann	*Tissot*
Gübelin	*Tudor*
Harwood	*Tutima Glashütte*
Hermès	*Ulysse Nardin*
Hublot	*Universal*
Imexal	*Vacheron Constantin*
IWC Schaffhausen	*Vénus*
Jaeger-LeCoultre	*Louis Vuitton*
Jean Lassale	*Wempe*
Junghans	*Zenith*

come from each company's own museum or collection.

Cover: Personalized made-to-order Blaken watch "Casino", based on Audemars Piguet, photo by Johannes Bauer
Back Cover: © Montblanc

The images related to the modern wristwatches were made available by the companies' press offices.

Pictures from other sources are listed below:

Photos by Antiquorum
pp 69 (top left), 104 (middle), 113 (right), 147 (left)

Photos by Alexander Bauer
pp 89 (right), 91 (bottom), 139 (top middle), 187 (bottom middle), 188 (top right & bottom left), 189 (top left)

© The Trustees of the British Museum. All rights reserved.
pp 53 (top), 105 (left), 133 (middle & right)

Photos by Gisbert L. Brunner
pp 7, 178 (right), 189 (middle & bottom left), 190 (top left & bottom left & middle), 194 (bottom left)

Photo by Christie's
p 60 (right)

Photo by LUCeum
p 166 (right)

Photo by Phillips
p 61 (right)

Photo by Sotheby's
p 83 (right)

Photos by Uhrenkosmos
pp 28–29, 44–45, 50–51, 57, 68, 70 (top left), 90 (right), 93, 94–95, 137, 158–159, 174, 177, 186 (top), 187 (bottom left), 188 (bottom right), 189 (top right & bottom middle), 190 (middle), 191, 192 (top), 198 (middle)

Map by US Central Intelligence Agency
via Wikimedia Commons
p 80

Glossary

Glossary

Age of the moon

An → indication showing the number of days that have elapsed since the last new moon. In a synodic month, the interval from one new moon to the next lasts exactly 29 days, 12 hours, 44 minutes, and 3 seconds.

Analog time display

The time is indicated by a pair of hands. The current time can be told by comparing the relative positions of the hour and minute hand.

Antimagnetic (correctly: nonmagnetic)

A watch is described as antimagnetic if it's protected against the negative influences of magnetic fields. It can be termed "nonmagnetic" if it continues to run in a magnetic field of 4,800 A/m (amperes per meter) and afterwards deviates from correct timekeeping by no more than 30 seconds per day.

Automatic winding

An additional mechanism that uses energy derived from the motions of the wearer's forearm to tighten the → mainspring of a mechanical watch.

Balance

A circular metal hoop that oscillates together with the → balance-spring in portable timepieces. Their oscillations subdivide the steady passage of time into brief segments, which are ideally of identical duration.

Balance-spring

The balance-spring can be described as the "soul" of a mechanical watch. The inner end of this spring is attached to the balance-staff and the outer end is affixed to the balance-cock. The balance-spring's elasticity assures that the → balance oscillates regularly. The duration of each swing is determined by the active length of the balance-spring and by the moment of inertia of the balance's rim.

Beveling

Beveled edges on steel parts are a distinguishing feature of fine watches. The edges can be beveled mechanically with the aid of a pantograph or, in the finest luxury watches, the beveling is performed manually with a file. Ideally, each angle on the edge should be precisely 45 degrees. Beveling has no effect on the movement's function.

Bezel

This term can have various meanings in watchmaking. Strictly speaking, a bezel is an annulus surrounding the crystal of a watch's → case. The crystal is pressed into the bezel, which is then mounted on the middle part of the case. The term is often used, however, to denote rotatable rings on the fronts of watch cases.

Breguet balance-spring

A balance-spring with a high upward curvature at its outer end to assure uniform "breathing." This type of spring is costly to manufacture, so nowadays it is installed only in very high-quality → calibers.

Cadrature

An additional switching mechanism in complicated watches, e.g., a mechanism for a → chronograph, → repeater, or calendar. The term is derived from the French word *cadran* (dial). Cadratures accordingly denote traditional switching mechanisms installed on the dial side of the movement and thus under the dial. Depending on its construction, a cadrature may be integrated into a movement or mounted on a separate → plate and connected to the movement as an additional module.

Caliber

The dimensions and shape of a watch movement and its parts. The caliber designation facilitates precise identification, e.g., when ordering spare parts. Manufactory calibers should be distinguished from movement-blanks furnished by suppliers of → ébauches. The former are movements that → manufactories produce for their own use. Aficionados sometimes talk about exclusive or reserved calibers: these are movement-blanks that ébauche suppliers develop and/or produce solely for individual customers. These calibers are not available for other → établisseurs.

Case

The protective exterior housing of a watch. Cases are made in diverse versions and materials. Two common varieties of cases for pocket watches are the open (Lépine) and closed (Savonnette) case. Water-resistant or → watertight cases are commonly used for wristwatches. Watch cases are made in many different shapes (round, square, oval, rectangular, tonneau) and materials (platinum, gold, silver, steel, titanium, carbon, aluminum, plastic).

Chaton (setting)

A circular metal disc with a hole to accept a bearing jewel. Chatons are either pressed or screwed into place in watch movements. Because of their attractive appearance, screwed chatons are again used today, especially by manufactories in Glashütte.

Chronograph

A chronograph—or more correctly "chronoscope"—is a watch with an hour hand, a minute hand, and a special additional mechanism which, at the push of a button, alternately starts a (usually) centrally positioned elapsed-seconds hand, stops it, and returns it to its zero position. The ordinary time display remains unaffected. Depending on the particular version, a chronograph may also have counters to tally the minutes and hours that have elapsed since the chronograph was switched on. When the zero-return button is pressed, the counters' hands likewise return to their starting positions. Two-button chronographs have predominated since the 1930s: one button starts and stops the stopwatch; the other returns the elapsed-time hands to zero. Such chronographs facilitate additive stopping, i.e., the elapsed-second hand can be halted and restarted from its last position as often as desired. Depending on its balance's frequency, a mechanical wristwatch chronograph can measure elapsed intervals to the nearest tenth of a second.

Chronograph rattrapante

This type of chronograph can simultaneously time two or more events that began at the same moment. The split-seconds mechanism is useful for measuring intermediate times at races.

Chronometer

A chronometer is a precise timepiece which has proven the accuracy of its rate during a 15-day test at one of the official watch-testing authorities, e.g., the COSC (Contrôle Officiel Suisse des Chronomètres) in Switzerland. In the five → positions "crown left," "crown up," "crown down," "dial up," and "dial down," the average daily rate must remain within −4 and +6 seconds; the average daily deviation may not exceed two seconds; and the greatest deviation of rate must not be greater than five seconds. All watches are tested at 23°, 8°, and 38° Celsius. Only after a watch has passed the chronometer test does it earn the right to bear the word "chronometer" on its dial and to be marketed together with a corresponding certificate.

Column-wheel chronograph

A rotatable component which can have five, six, seven, eight, or nine columns controls the start, stop, and zero-return functions in a classical chronograph. With each switching process, the column-wheel rotates clockwise through an exactly defined angle. If the end of the switch yoke comes to rest atop a column, the latter keeps the former lifted; if the switch yoke's end falls between two columns, gentle pressure from the spring holds it down.

Complication

An additional mechanism in a mechanical watch, e.g., → chronograph, → perpetual calendar, or → tourbillon.

Coulisse switching

A switching mechanism to control a → chronograph. A moveable cam, differently shaped depending on the particular → caliber, embodies the "program" to start the chronograph, stop it, and return its elapsed-time hands to zero. Chronographs with coulisse or cam switching are technically less complex, but no less reliable than their counterparts with column-wheels.

Counterfeit

A plagiarized imitation of a popular and usually high-quality watch. Certificates, invoices, and etuis no longer adequately protect purchasers against counterfeiters because these supplementary items can likewise be counterfeited.

Crown

A button or knob to wind a watch, to set its hands and/or to adjust its date display. The crown was formerly also sometimes used to control the → chronograph.

Crown winding

Until the late 19th century, many pocket watches were wound, and their hands were often set with the aid of a little key. With modern crown winding, both tasks are performed via a small → crown equipped with a mechanism to switch between the winding and setting functions.

Crystals

Four kinds of crystals are used on wristwatches. Glass crystals are found primarily on early wristwatches: they resist scratches, but are very fragile and prone to breakage. Plexiglas progressively replaced glass for watch crystals beginning in the early 1940s: Plexiglas crystals are unbreakable, but become scratched relatively easily. Crystals made of mineral glass have a hardness of 5 on the Mohs scale and are therefore much more robust than plastic crystals. Nowadays, high-quality watches usually use → sapphire for their crystals: with a hardness of 9 on the Mohs scale, sapphire is extremely resistant to scratches and breakage, but can only be processed with special diamond-tipped tools.

Date display

→ Indicator of the date, either in analog form via a hand (hand-type date display) or digitally via a printed ring (window date). The watch industry uses two separate digits (one in the "tens" and another in the "ones" column) for the outsize date display. Date displays can be divided into three types: creeping, half-creeping, and jumping. The first two types are gradually advanced by the movement. Jumping indicators successively amass power from the movement throughout the day, store the energy in a → spring, and suddenly release the stored → energy exactly at midnight to power the switching mechanism.

Digital time display

The time of day or night is shown by numerals.

Diver's watches

Wristwatches manufactured in compliance with clearly defined standards and intended for underwater use. Professional diver's watches must be watertight to a minimum depth of 200 meters (660 feet). For the diver's safety, a jeweler should annually test the watch's watertightness and functionality.

Ébauche

French term for "sketch." In specialized French watchmaking vocabulary, the movement-blank for a watch is also known as an ébauche or blanc.

Enamel

A colored vitreous coating applied to a metal substrate. The enameling technique has been used on watches (e.g., the dial and the → case) for more than 350 years. An enamel dial was almost a standard feature on fine watches in the early 20th century. Enamel dials have become extremely rare nowadays, partly because of the high cost of manufacturing them.

Energy

The ability to do work. Potential energy is needed to power watches. In mechanical timepieces, this potential energy can be stored in a tightened → mainspring (spring power) or in a manually raised weight (gravity power).

Escapement

A mechanism that conveys the power of the → mainspring in small impulses to the watch's oscillating system (→ balance and → balance-spring) and also prevents the movement from racing ahead and exhausting its stored energy. In a watch with a balance paced at 28,800 semi-oscillations per hour, the escapement allows the gear-train to advance 691,200 times each day. This adds up to more than a billion impulses in the course of four years—approximately six times the performance of a human heart.

Établisseur

A watchmaker who purchases components (e.g., movement, dial, hands, and → case) from specialized manufacturers and then assembles these parts to make complete watches.

Fabrication number

Many watch manufacturers use fabrication numbers to identify their products. The makers number the movement, the → case, or both. An officially tested → chronometer must always bear a movement number. This number is also printed on the accompanying test certificate.

Faceted

Steel and brass components in very fine watches have faceted edges (→ beveling). The bevel should ideally have an angle of 45 degrees.

Finishing

The final decorations and processing given to a watch.

Frequency

Oscillations per unit of time, measured in hertz (Hz). Pendulums are most commonly used to regulate the rate of stationary clocks, while mobile timepieces rely on → balances. Both components move to and fro at a particular frequency. The pendulum of a one-second pendulum clock requires exactly one second to swing from one extreme point of its arc to the other, so it has a frequency of 0.5 Hz or 1,800 semi-oscillations per hour (A/h). Early balances were paced at 7,200 or 9,000 A/h. The frequency of balances in pocket watches was increased first to 12,600 and later to the now common standard of 18,000 A/h (2.5 Hz). This frequency originally developed into the most common standard for wristwatches. To increase precision, watch manufacturers later raised the frequency to 21,600 A/h (3 Hz), 28,800 A/h (4 Hz), 36,000 A/h (5 Hz), 57,600 (8 Hz), and even 72,000 (10 Hz). A speedier balance frequency is associated with greater energy consumption. Higher rotational speeds must also be taken into account when lubricating the → escapement.

Full calendar

A complete calendar showing the current day, date, and month.

Geneva waves

An undulating pattern commonly used to decorate the bridges and cocks in fine → calibers. Generally found only on high-quality movements, Geneva waves are applied prior to galvanic ennoblement but remain visible afterwards.

GMT

Greenwich Mean Time, also known as World or Universal Time Coordinate (UTC), is the time at zero degrees longitude, i.e., the meridian that passes through Greenwich, England. GMT is currently used as the standard time for navigation and international radio communication.

Gregorian calendar

After lengthy preparations and the abrupt elimination of ten full days, the calendar reform instituted by Pope Gregory XIII took effect in Rome on October 15, 1582. This new calendar rectified the tiny residual error that had been accumulating since the introduction of the → Julian calendar in 45 BC, which had erroneously added 0.0078th of a day to each year.

The special feature of the Gregorian calendar, which corrects this in-accuracy, is that it eliminates three leap days from the leap-year cycle every 400 years. Leap days are not included in secular years (i.e., years that begin a new century) unless the year is evenly divisible by 400. There will accordingly not be a 29th day in February in the years 2100, 2200, and 2300.

Guilloche
The engraving of fine and sometimes artistically interwoven patterns on the → cases or dials of watches. Traditional guilloche is performed manually with the aid of antique machines.

Hallmarks
Stamps punched into → cases specifying the type and fineness of the → precious metal, the country and sometimes also the city of origin, the year of manufacture, and the case-maker. Other punched hallmarks may represent the trademark of the manufacturing or delivering watch company, a → reference or a serial number.

Hand-wound movement
Depending on its construction, a hand-wound movement may contain 80 or more components, which can be divided into eight main functional groups:
1. the power system as the energy-providing organ;
2. the transfer system to convey → energy to
3. the subdividing system, also known as the → escapement;
4. the regulating system;
5. the motion-work (dial-train);
6. the organs for indicating the time;
7. the hand-setting system; and
8. the winding system.

Hand-wound watch
A timepiece in which the → mainspring must be wound by hand.

Hour counter
A constructive feature of some → chronographs to tally the number of hours that have elapsed since the stopwatch function was triggered. Most hour counters can tally up to twelve hours. Pressing the zero-return button triggers the hand on the hour counter to return to its zero position.

Indication
A display, e.g., of the time, date, day of the week, month, equation of time, → power reserve, or second time zone.

Jewels
An internationally used term denoting the → stones in a watch movement.

Julian calendar
The cycle of three 365-day years and one 366-day leap year can be traced back to Gaius Julius Caesar. But the Julian year is 0.00078th of a day longer than the actual astronomical year. This error accumulated over the centuries, prompting Pope Gregory XIII to correct the Julian calendar in 1582.

Lever
The lever is one of the most complicated parts of a mechanical watch. Its twofold task is to transfer power from the gear-train to the → balance, thus keeping the latter in oscillation, and to prevent the gear-train from racing ahead and quickly exhausting the energy stored in the mainspring.

Lever escapement
Currently the most commonly used type of → escapement in mechanical watches. The Swiss lever escapement predominates among today's high-quality wristwatches.

Ligne
A unit of length traditionally used to express the dimensions of watch. The ligne is derived from the *pied du roi*, i.e., the French foot. For example: a circular movement can have a diameter of 11 lignes and a rectangular movement may measure 8¾ by 12 lignes. One ligne is equivalent to 2.2558 millimeters.

Luminous dial
A dial from which the time can also be read in the dark.

Mainspring
An elastic and spirally-coiled strip of steel which stores the energy needed to power a portable mechanical watch.

Manufactory (French: manufacture)
According to the unwritten laws of watchmaking, a watch manufacturer may only describe itself as a manufactory if it makes at least one → ébauche or movement-blank of its own. The industry uses the term → établisseur to denote a manufacturer who assembles watches from pre-made movement-blanks.

Mechanical geared clocks
Timepieces powered by a → mainspring. The rate is regulated either by a → balance with a balance-spring or by a pendulum. The development of the geared clock probably resulted from the mechanism used to propel planetariums, which have been known since the late 13th century. The oldest mechanical geared clock in German-speaking Europe is probably the clock in Strasbourg's cathedral. This clock was completed in 1352. Functional geared clocks probably first appeared in England toward the end of the 13th century.

Moon's phases
Depending on the relative positions of the sun, the earth, and the moon, the moon waxes through various phases from new moon through waxing half moon to full moon, then wanes through waning half moon to new moon. One lunation is equal to circa 29.5 days.

Perpetual calendar
A complex calendar mechanism, consisting of approximately 100 parts, that automatically takes into account the different lengths of the months. Most perpetual calendars won't require manual correction until February 28, 2100.

Plate
Also known as movement plate. A metal plate bearing the bridges, cocks, and other parts of a watch movement.

Position
Unlike pocket watches, wristwatches are worn in many different orientations, which can be divided into the following positions: "crown up," "crown down," "crown right," "dial up," and "dial down." A precise wristwatch accordingly undergoes fine adjustment in each of these five positions.

Power reserve
Energy potential beyond the normal winding interval of a wristwatch (24 hours). The power reserve usually ranges between 10 and 16 hours. However, the propulsive force of the → mainspring declines during this remaining interval, which causes a reduction in the watch's rate performance.

Power-reserve display
Indication of the currently remaining → power reserve in a mechanical movement.

Precious metals
The precious metals gold, platinum, and silver are usually used for the → cases of wristwatches. Gold alloys are available in various finenesses: 333/1,000 (8 karat), 375/1,000 (9 karat), 575/1,000 (14 karat), or 750/1,000 (18 karat). Admixture of other metals (e.g., copper) determines the hue. Winding rotors are often made of 21-, 23-, or 24-karat gold. The fineness of platinum is usually 950/1,000.

Pulsometer
A time- and work-saving scale on the dial (usually on a → chronograph) to help the wearer measure pulse rates. Depending on the calibrations, the user starts the chronograph, counts either 20 or 30 pulse beats and then stops the chronograph: the tip of the halted elapsed-seconds hand will point to the calculated pulse rate per minute.

Rate autonomy

The entire running interval of a mechanical movement, i.e., the time that elapses from complete winding of the → mainspring to motionlessness due to its slackening.

Reference

A manufacturer-specific combination of letters and numbers to classify various watch models. The reference number often also includes information about the type, case material, movement, dial, hands, wristband, and embellishment with gemstones.

Regulator dial

Off-center → indication of the hours and seconds.

Repeater striking-train

An elaborate additional function which enables a movement to audibly chime the current time with greater or lesser accuracy. Depending on the specific repeater, the timepiece may be triggered to chime every quarter hour, every eighth of an hour (i.e., every 7½ minutes), every five minutes, or every minute.

Retrograde display

A retrograde hand advances stepwise along an arc of a circle to indicate the time, date, or day of the week and then suddenly jumps back to its starting position when it reaches the end of the arc.

Rotor:

An unlimitedly rotatable oscillating weight in watches with → automatic winding. Depending on the construction of the self-winding mechanism, the rotor acts to tighten the → mainspring in either one or both of the rotor's directions of rotation. Central rotors rotate above the entire movement; microrotors are inset into the plane of the movement.

Sapphire crystal

A scratch-resistant crystal with a hardness of 9 on the Mohs scale. Only diamond is harder.

Satin finish

A fine, silky, matt finish on metal surfaces.

Shock absorption

A system to prevent breakage of the slender and thus very delicate pivots of the balance-staff. For this purpose, the ring jewel and cap jewel of the balance-staff's bearing are elastically affixed in the → plate and balance-cock. If the watch suffers a strong impact, the jewels can shift laterally and/or axially. A wristwatch with a shock-absorption system should be able to survive a plunge from a height of one meter (3.3 feet) onto an oak floor without suffering damage and without showing significant rate deviations afterwards.

Silicon

Brass, steel, and synthetic rubies predominated for centuries in the fabrication of mechanical movements. But silicon, the basic material of electronic microchips, became acceptable in the world of haute horlogerie in 2001. In its monocrystalline form, silicon has the same crystalline structure as diamond. Silicon is 60 percent harder and 70 percent lighter than steel, → nonmagnetic, and resistant to corrosion. Even without post-processing, silicon has an extremely smooth surface which makes lubricant oil unnecessary. Silicon is elastic, but not plastically formable. Specially treated "Silinvar" expands only very minimally when warmed, so it's well suited as a material for → balance-springs. A neologism derived from the words "invariable silicon," Silinvar was co-developed by Patek Philippe, Rolex, and the Swatch Group in collaboration with the Centre Suisse d'Electronique et de Microtechnique (CSEM) and the Institut de Microtechnique of the University of Neuchâtel.

Skeletonized movement

A watch movement in which the → plate, bridges, cocks, barrel, and sometimes also the → rotor are pierced and filed away to leave only the material that is indispensable for each component's proper function. The openwork enables connoisseurs to peer into the depths of the movement. Wristwatches with skeletonized movements first appeared in the 1930s.

Spring

Many different types of springs are used in watch movements. Alongside the → balance-spring and → mainspring, locking springs and retainer springs are also commonly used.

Stainless steel

A popular alloy containing the metals steel, nickel, and chrome with admixed molybdenum or tungsten. Stainless steel does not rust and is extremely resistant and → antimagnetic, but is comparatively difficult to process.

Stones

To reduce friction in precise watches, jewels are inserted into the most important bearings, as pallet stones on the lever and on the impulse-pin.

Stop-seconds function

A mechanism to momentarily halt the movement and/or the second-hand so the hands can be set with to-the-second accuracy.

Stopwatches

Unlike → chronographs, stopwatches do not display the ordinary time of day. In simply constructed stopwatches, the movement is halted to stop the second-hand.

Tourbillon

Invented by Abraham-Louis Breguet in 1795 and patented by him in 1801, the tourbillon compensates for the center-of-gravity error in the oscillating system (→ balance and → balance-spring) of a mechanical watch. The French word *tourbillon* means "whirlwind." In horological contexts, it refers to a construction in which the entire oscillating and escapement system is mounted inside a cage of the lightest possible weight. The cage continually and uniformly rotates around its own axis, usually completing one rotation per minute. These constant rotations compensate for the negative influences exerted by the earth's gravity on the accuracy of a watch's rate when the timepiece is in a vertical → position. The tourbillon's rotations also improve the watch's rate performance. A tourbillon has no effect on the accuracy of the rate when the timepiece is in a horizontal position.

Tourbillon cage

Made of steel or (in modern wristwatches) also of titanium or aluminum, this delicate cage contains the oscillating and escapement system (→ balance, balance-staff, → balance-spring, → lever, escape-wheel) in a watch with a → tourbillon. The tourbillon cage usually completes one rotation around its own axis every minute. A tourbillon cage should be rigid, filigreed and as lightweight as possible. Fabricating it is one of the most challenging horological tasks.

Watertight wristwatches

Watches can be labeled with the word "watertight" if they are resistant against perspiration, sprayed water, and rain. Furthermore, they must not allow any moisture to penetrate their → cases while submerged to a depth of one meter (3.3 feet) for 30 minutes. The additional phrase "50 meters" or "5 bar" means that these watches have been tested at the corresponding pressure by their manufacturers. Nevertheless, it is not recommended to swim—and it is even less recommendable to dive—while wearing such watches.

World-time indication

Watches with world-time indication normally show 24 time zones on their dials. Exceptional world-time watches indicate the time in as many as 37 different time zones.

Glossar

Analoge Zeitanzeige
Zeitanzeige per Zeigerpaar. Die aktuelle Uhrzeit ergibt sich aus der Stellung von Stunden- und Minutenzeiger zueinander.

Anglierung
Merkmal feiner Uhren sind u. a. die gebrochenen Kanten der Stahlteile. Die Anglierung wird entweder maschinell mit Pantographen (Storchenschnabel) angebracht oder bei Luxusuhren auf höchstem Niveau in überlieferter Form per Feile von Hand ausgeführt. Idealerweise beträgt der Kantenwinkel exakt 45 Grad. Die Anglierung besitzt keine Auswirkungen auf die Funktion des Uhrwerks.

Anker
Eines der kompliziertesten Teile mechanischer Uhren. Seine Aufgabe besteht zum einen darin, die Kraft vom Räderwerk auf die → Unruh zu übertragen, um deren Schwingungen aufrechtzuerhalten. Andererseits verhindert er das ungebremste Ablaufen des aufgezogenen Räderwerks.

Ankerhemmung
Heute die am meisten verbreitete → Hemmung bei mechanischen Uhren. Bei hochwertigen Armbanduhren beherrscht mittlerweile die Schweizer Ankerhemmung das Feld.

Antimagnetisch, korrekt amagnetisch
Eine Uhr ist amagnetisch, wenn sie gegen die negativen Einflüsse magnetischer Felder geschützt ist. Sie darf dann als amagnetisch bezeichnet werden, wenn sie in einem Magnetfeld von 4800 A/m (Ampere pro Meter) weiterläuft und anschließend eine Gangabweichung von höchstens 30 Sekunden/Tag aufweist.

Automatischer Aufzug
Zusatzmechanismus, welcher die (Arm-)Bewegungen zum Spannen der → Zugfeder einer mechanischen Uhr nutzt.

Breguet-Spirale
→ Unruhspirale mit hochgebogener Endkurve für gleichförmigeres „Atmen". Aufgrund beträchtlicher Herstellungskosten ist sie heute nur noch in sehr hochwertigen → Kalibern zu finden.

Chaton
Kreisrundes, gebohrtes Metallstück zur Aufnahme eines Lagersteins, durch Einpressen oder Verschrauben im Uhrwerk befestigt. Vor allem Glashütter Uhrenmanufakturen verwenden heute aus optischen Gründen wieder verschraubte Chatons.

Chronograph
Unter Chronograph oder – sprachlich korrekter – Chronoskop versteht man eine Uhr mit Stunden- und Minutenzeiger, deren spezieller Zusatzmechanismus das Starten, Stoppen und Nullstellen eines (meist) zentral positionierten Sekundenzeigers per Knopfdruck ermöglicht. Die Zeitanzeige bleibt davon unberührt. Je nach Ausführung besitzen Chronographen zudem Zählzeiger für die seit Beginn der Stoppung verstrichenen Minuten und Stunden. Nach Betätigung des Nullstelldrückers springen auch die Zählzeiger in ihre Ausgangsposition zurück. Seit den 1930er Jahren dominierte der Zwei-Drücker-Chronograph. Ein Drücker dient dem Starten und Anhalten, der andere dem Nullstellen. Diese Chronographen ermöglichen Additionsstoppungen, d. h. der Chronographenzeiger kann beliebig oft angehalten und aus der zuletzt eingenommenen Position heraus erneut gestartet werden. Abhängig von der Unruhfrequenz können mechanische Armbandchronographen bis auf die Zehntelsekunde genau stoppen.

Chronograph-Rattrapante
Mit seiner Hilfe lassen sich zwei oder mehr Vorgänge simultan stoppen, sofern sie gleichzeitig beginnen. Der Schleppzeiger-Mechanismus eignet sich bei Wettrennen auch zum Erfassen von Zwischenzeiten.

Chronometer
Präzisionsuhr, welche ihre Ganggenauigkeit im Rahmen einer 15-tägigen Kontrolle bei einer offiziellen Uhrenprüfstelle (z. B. der COSC Contrôle Officiel Suisse des Chronomètres in der Schweiz) unter Beweis gestellt hat. In den fünf → Lagen „Krone links", „Krone oben", „Krone unten", „Zifferblatt oben" und „Zifferblatt unten" muss der mittlere tägliche Gang zwischen –4 und +6 Sekunden liegen; die mittlere tägliche Gangabweichung darf 2 Sekunden, die größte Gangabweichung 5 Sekunden nicht überschreiten. Alle Uhren werden bei Temperaturen von 23,8 und 38 °C geprüft. Erst nach dem Bestehen der Chronometerprüfung darf eine Uhr auf dem Zifferblatt die Bezeichnung Chronometer tragen und mit einem entsprechenden Zertifikat vermarktet werden.

Datumsanzeige
→ Indikation des Datums entweder analog durch einen Zeiger (Zeigerdatum) oder digital durch einen bedruckten Ring (Fensterdatum). Beim sogenannten Großdatum verwendet die Uhrenindustrie zwei separate Ziffern für die Zehner und Einer. Grundsätzlich zu unterscheiden sind schleichende, halbspringende und springende Datumsanzeigen. Erstere werden vom Werk allmählich fortgeschaltet. Springende Indikationen entziehen dem Uhrwerk im Laufe des Tages sukzessive Kraft und speichern sie in einer → Feder. Die → Energie wird exakt um Mitternacht für den Schaltvorgang freigesetzt.

Digitale Zeitanzeige
Darstellung der Uhrzeit in Ziffern.

Drehgang
Andere Bezeichnung für → Tourbillon.

Drehgestell
Feiner Käfig aus Stahl oder – bei modernen Armbanduhren – auch aus Titan oder Aluminium, welcher bei Uhren mit → Tourbillon zur Aufnahme des Schwing- und Hemmungssystems (→ Unruh, Unruhwelle, → Unruhspirale, → Anker, Ankerrad) dient. Das Drehgestell rotiert in der Regel einmal pro Minute um seine Achse. Es soll fest, filigran und möglichst leicht sein. Seine Herstellung gehört zu den uhrmacherischen Herausforderungen.

Ebauche
Französischer Begriff für Entwurf. In der französischen Uhrmachersprache wird das Rohwerk einer Uhr als blanc oder ébauche bezeichnet.

Edelmetalle
Für die → Gehäuse von Armbanduhren werden in aller Regel die Edelmetalle Gold, Platin und Silber verwendet. Gold gibt es mit einem Feingehalt von 333/1000 (8 Karat), 375/1000 (9 Karat), 575/1000 (14 Karat) oder 750/1000 (18 Karat). Die Legierung mit anderen Metallen (z. B. Kupfer) bestimmt den Farbton. 21-, 23- oder 24-karätiges Gold findet man z. B. bei Aufzugsrotoren. Bei Platin beträgt der Feingehalt 950/1000.

Edelstahl
Populäre Legierung aus den Metallen Stahl, Nickel und Chrom unter Beifügung von Molybdän oder Wolfram. Sie ist rostfrei, extrem widerstandsfähig und → amagnetisch, jedoch vergleichsweise schwer zu bearbeiten.

Email
Französisches Wort für farbigen Glasfluss auf Metall. Bei Uhren (Zifferblätter und → Gehäuse) findet die Emailtechnik seit mehr als 350 Jahren Anwendung. Nach der Wende vom 19. zum 20. Jahrhundert gehörte das Emailzifferblatt beinahe zum Standard für feine Uhren. Inzwischen ist es – nicht zuletzt auch aus Kostengründen – extrem rar geworden.

Energie

Gespeicherte Arbeitsfähigkeit. Zum Antrieb von Uhren ist ein Energiepotenzial erforderlich. Dies kann bei mechanischen Uhren eine gespannte → Zugfeder (Federkraftantrieb) oder ein hochgezogenes Gewicht (Schwerkraftantrieb) sein.

Etablisseur

Uhrenhersteller, welcher Komponenten (Werk, Zifferblatt, Zeiger, → Gehäuse) bei spezialisierten Fabrikanten einkauft und zu fertigen Zeitmessern verarbeitet.

Ewiger Kalender

Komplexes Kalenderwerk, bestehend aus etwa 100 Teilen, welches die unterschiedlichen Monatslängen in aller Regel bis zum 28. Februar 2100 ohne manuelle Korrektur berücksichtigt.

Fabrikationsnummer

Zur Identifikation ihrer Produkte greifen viele Uhrenhersteller auf Fabrikationsnummern zurück. Dabei nummerieren sie Werk oder → Gehäuse oder beides. Offiziell geprüfte → Chronometer müssen in jedem Fall eine Werksnummer tragen. Diese findet sich auf dem Prüfzertifikat wieder.

Facette

Bei sehr feinen Uhren besitzen die Stahl- und Messingteile facettierte Kanten (→ Anglierung). Diese Kantenflächen sollten idealerweise im Winkel von 45 Grad angebracht sein.

Fälschungen

Plagiate beliebter, in der Regel sehr hochwertiger Uhren. Zertifikate, Rechnungen und Etuis schützen vor Fehlkäufen schon lange nicht mehr. Sie werden ebenfalls massenhaft gefälscht.

Feder

In Uhrwerken kommen Federn unterschiedlichster Natur zum Einsatz. Neben → Unruhspirale und → Zugfeder sind dies vor allem Sperr- und Haltefedern.

Finissage

Fein- oder Fertigbearbeitung einer Uhr.

Frequenz

Schwingungen pro Zeiteinheit, gemessen in Hertz (Hz). Bei ortsfesten Uhren findet man als gangregelndes Organ primär das Pendel, während mobile Uhren eine → Unruh besitzen. Beide bewegen sich mit einer bestimmten Frequenz hin und her. Das Pendel einer Sekundenpendeluhr benötigt von Umkehrpunkt zu Umkehrpunkt exakt eine Sekunde. Es verfügt also über eine Frequenz von 0,5 Hz oder 1800 Halbschwingungen/Stunde (A/h). Frühe Unruhschwinger brachten es auf 7200 bis 9000 A/h. Bei Taschenuhren wurde die Frequenz zunächst auf 12600 und später auf den allgemein üblichen Standard von 18000 A/h (2,5 Hz) gesteigert. Auch bei den Armbanduhren entwickelte sich diese Unruhfrequenz anfänglich zur gängigen Norm. Zur Steigerung der Präzision erhöhten die Uhrenfabrikanten die Schlagzahl auf 21600 A/h (3 Hz), 28800 A/h (4 Hz), 36000 A/h (5 Hz), 57600 (8 Hz) und sogar 72000 (10 Hz). Mit höherer Unruhfrequenz verknüpft sich steigender Energiebedarf. Außerdem verlangen zunehmende Rotationsgeschwindigkeiten Berücksichtigung beim Schmieren der → Hemmung.

Gangautonomie

Gesamte Laufzeit eines mechanischen Uhrwerks, also der Zeitraum zwischen dem vollständigen Aufzug und dem Stehenbleiben wegen Entspannung der → Zugfeder.

Gangreserve

Über das normale Aufzugsintervall einer Armbanduhr (24 Stunden) hinausreichendes Energiepotenzial. Üblicherweise bewegt sich die Gangreserve in einer Größenordnung zwischen 10 und 16 Stunden. Allerdings lässt die Antriebskraft der → Zugfeder in dieser verbleibenden Zeitspanne nach, was zu einer Reduzierung der Gangleistungen führt.

Gangreserveanzeige

→ Indikation der aktuell verbleibenden → Gangreserve bei mechanischen Uhrwerken.

Gehäuse

Schützende Hülle einer Uhr. Gehäuse gibt es in den unterschiedlichsten Ausführungen und Materialien. So unterscheidet man bei Taschenuhren u. a. zwischen offenen (Lépine) und geschlossenen Gehäusen (Savonnette). Für Armbanduhren werden z. B. wassergeschützte oder → wasserdichte Gehäuse verwendet. Außerdem gibt es eine Vielzahl unterschiedlicher Gehäuseformen (rund, quadratisch, oval, rechteckig, tonneauförmig) und -materialien (Platin, Gold, Silber, Stahl, Titan, Carbon, Aluminium, Kunststoff).

Genfer Streifen

Häufig verwendete rippenförmige Dekoration auf den Brücken und Kloben feiner → Kaliber. Sie wird vor der galvanischen Veredelung aufgebracht, bleibt aber dennoch erkennbar. Genfer Streifen finden sich im Allgemeinen nur bei hochwertigen Werken.

Gläser

Für Armbanduhren gibt es vier verschiedene Sorten von Gläsern: Kristallgläser kommen hauptsächlich bei frühen Armbanduhren vor. Sie sind zwar kratzfest, dafür jedoch sehr bruchempfindlich. Zu Beginn der 1940er-Jahre wurden die Kristallgläser mehr und mehr von Kunststoffgläsern (Plexiglas) abgelöst. Die sind zwar unzerbrechlich, verkratzen aber relativ leicht. Mineralgläser besitzen eine Härte von 5 Mohs und sind daher wesentlich robuster als Kunststoffgläser. Heute wird in hochwertigen Uhren zumeist → Saphirglas verwendet. Bei einer Härte von 9 Mohs ist es extrem kratz- und bruchfest, jedoch nur mit speziellen Diamantwerkzeugen zu bearbeiten.

GMT

Greenwich Mean Time; Welt- oder Universalzeit (UTC) am Greenwich-Nullmeridian. Die mittlere Zeit von Greenwich gilt heute als Standard im Navigationswesen und im internationalen Funkverkehr.

Gregorianischer Kalender

Am 15. Oktober 1582 trat in Rom nach langen Vorarbeiten und der Eliminierung von zehn ganzen Tagen eine von Papst Gregor XIII. verfügte Kalenderreform in Kraft. Sie beseitigte den winzigen Restfehler des 45 v. Chr. eingeführten → Julianischen Kalenders. Nach diesem war das Jahr um 0,0078 Tage zu lang. Das Spezifikum des Gregorianischen Kalenders, das diesen Fehler beseitigt, besteht darin, innerhalb von 400 Jahren drei Schalttage ausfallen zu lassen – und zwar in allen nicht durch 400 teilbaren Säkularjahren (Jahre des vollen Jahrhunderts). Demnach werden die Jahre 2100, 2200 und 2300 ohne den 29. Februar auskommen müssen.

Guillochieren

Gravieren feiner, teilweise kunstvoll verschlungener Muster in Uhrengehäuse oder Zifferblätter. Traditionelles Guillochieren geschieht von Hand mit Hilfe überlieferter Maschinen.

Handaufzugsuhr

Zeitmesser, bei dem die → Zugfeder von Hand gespannt werden muss.

Handaufzugswerk

Ein Handaufzugswerk besteht, je nach Konstruktion, aus 80 und mehr Teilen. Es lässt sich in acht wichtige Funktionsgruppen einteilen:
1. das Antriebssystem als energiespendendes Organ
2. das Übertragungssystem zur Weiterleitung der → Energie an
3. das Verteilungssystem, auch → Hemmung genannt
4. das Reguliersystem
5. das Zeigerwerk
6. die Organe zur Zeitanzeige
7. das Zeigerstellsystem
8. das Aufzugssystem

Hemmung

Mechanismus, der die Kraft der → Zugfeder in kleinen Stößen an das Schwingsystem (→ Unruh und → Unruhspirale) einer Uhr weiterleitet und das ungebremste Ablaufen des Uhrwerks verhindert. Bei einer Unruh-

frequenz von 28 800 Halbschwingungen/Stunde lässt sie das Räderwerk täglich 691 200 Mal vorrücken. Im Laufe von vier Jahren ergibt dies mehr als eine Milliarde Kraftstöße. Das entspricht etwa der sechsfachen Leistung eines menschlichen Herzens.

Indikation
Anzeige z.B. von Zeit, Datum, Wochentag, Monat, Äquation, → Gangreserve, zweiter Zonenzeit.

Jewels
Internationale Bezeichnung für die → Steine eines Uhrwerks.

Julianischer Kalender
Auf Gaius Julius Cäsar geht der Rhythmus von jeweils drei Normaljahren mit 365 Tagen und einem 366-tägigen Schaltjahr zurück. Allerdings ist das Julianische Jahr gegenüber den wahren astronomischen Gegebenheiten um 0,0078 Tage zu lang. Deshalb musste Papst Gregor XIII. den Julianischen Kalender im Jahr 1582 korrigieren.

Kadratur
Begriff für ein zusätzliches Schaltwerk komplizierter Uhren, z.B. der Mechanismus für einen → Chronographen, ein → Repetitionsschlagwerk oder ein Kalendarium. Der Name leitet sich ab vom französischen Wort cadran (Zifferblatt). Deshalb meinen Kadraturen traditionsgemäß Schaltwerke auf der Vorderseite des Uhrwerks und damit unter dem Zifferblatt. Je nach Konstruktion kann die Kadratur ins Uhrwerk integriert oder auf einer separaten → Platine montiert und als Modul additiv mit dem Uhrwerk verbunden sein.

Kaliber
Dimension und Gestalt eines Uhrwerks und seiner Teile. Die Kaliberbezeichnung ermöglicht eine exakte Identifikation u.a. zum Zweck der Ersatzteilbestellung. Von den konfektionierten Rohwerken der → Ebauches-Lieferanten sind Manufakturkaliber zu unterscheiden. Letztere sind Uhrwerke, die → Manufakturen für ihren eigenen Bedarf produzieren. Gelegentlich ist auch von exklusiven oder reservierten Kalibern die Rede. Dahinter verbergen sich Rohwerke, welche Ebauches-Fabrikanten ausschließlich für einzelne Kunden entwickeln und/oder produzieren. Auf diese Kaliber haben andere → Etablisseure keinen Zugriff.

Komplikation
Zusatzmechanismus bei mechanischen Uhren wie → Chronograph, → ewiger Kalender oder → Tourbillon.

Krone
Knopf zum Aufziehen einer Uhr, zum Zeigerstellen und/oder Korrigieren von → Datumsanzeigen sowie früher auch zum Steuern von → Chronographen.

Kronenaufzug
Bis ins späte 19. Jahrhundert erfolgten Aufzug und/oder Zeigerstellung vieler Taschenuhren mit Hilfe eines kleinen Schlüssels. Beim modernen Kronenaufzug geschieht beides über eine kleine → Krone mit Umschaltvorrichtung.

Kulissenschaltung
Schaltwerk zur Steuerung eines → Chronographen. Ein beweglicher, je nach → Kaliber unterschiedlich ausgeformter Schaltnocken liefert das „Programm" für die Funktionen Start, Stopp und Nullstellung. Chronographen mit Kulissen- oder Nockenschaltung sind technisch weniger aufwendig, aber nicht minder zuverlässig als die Pendants mit Schalt- oder Säulenrad.

Lagen
Armbanduhren werden im Gegensatz zu Taschenuhren in vielen verschiedenen Lagen getragen. Es sind dies die Positionen „Krone oben", „Krone unten", „Krone rechts", „Zifferblatt oben" und „Zifferblatt unten". Bei Präzisionsuhren erfolgt daher eine Regulierung in diesen fünf Lagen.

Leuchtzifferblatt
Zifferblatt, von dem sich auch bei Dunkelheit die Zeit ablesen lässt.

Linie
Überlieferte Maßeinheit für Uhrwerksdimensionen, abgeleitet vom „Pied du Roi", dem französischen Fuß. Beispielsweise 11‴ bei runden Werken oder 8¾ x 12‴ bei Formwerken. Eine Linie entspricht 2,2558 Millimetern.

Lünette
In der Uhrmacherei ein vielschichtiger Begriff. Streng genommen versteht man darunter den Glasreif eines → Gehäuses. Dieser wird mit dem eingepressten Glas auf dem Mittelteil des Gehäuses montiert. Oft werden heute auch auf der Vorderseite von Uhrengehäusen befestigte Drehringe als Lünetten bezeichnet.

Manufaktur
Nach den ungeschriebenen Gesetzen der Uhrmacherei darf sich ein Uhrenhersteller nur dann Manufaktur nennen, wenn er mindestens ein → Ebauche oder Rohwerk selbst fertigt. Die Fertigsteller von Uhren unter Verwendung konfektionierter Rohwerke heißen branchenintern → Etablisseure.

Mechanische Räderuhren
Uhren, die über eine → Zugfeder angetrieben werden. Die Regulierung des Gangs erfolgt durch eine → Unruh mit Spiralfeder oder ein Pendel. Die Entwicklung der Räderuhr resultiert vermutlich aus dem Antriebsmechanismus von Planetarien, die seit dem späten 13. Jahrhundert bekannt sind. Als älteste mechanische Räderuhr des deutschsprachigen Raums kann wohl die Uhr des Straßburger Münsters gelten. Sie wurde 1352 fertiggestellt. In England gab es aber vermutlich schon gegen Ende des 13. Jahrhunderts funktionsfähige Räderuhren.

Mondalteranzeige
→ Indikation zum Ablesen der Anzahl von Tagen, die seit dem letzten Neumond vergangen sind. Im synodischen Monat beträgt das Zeitintervall von Neumond zu Neumond exakt 29 Tage, 12 Stunden, 44 Minuten und 3 Sekunden.

Mondphasen
Der Mond durchläuft seine von der Stellung Sonne, Mond, Erde abhängigen Licht- bzw. Mondphasen (Neumond – erstes Viertel – Vollmond – letztes Viertel – Neumond) innerhalb einer Lunation von etwa 29,5 Tagen.

Platine
Auch Werkplatte. Eine Metallplatte, welche die Brücken, Kloben und sonstigen Bestandteile eines Uhrwerks trägt.

Pulsometer
Arbeitserleichternde Zifferblattskalierung (meist bei → Chronographen) zum Messen der Pulsfrequenz. Abhängig von der Graduierung sind nach dem Starten des Chronographen 20 oder 30 Pulsschläge zu zählen. Die Spitze des gestoppten Chronographenzeigers zeigt dann auf die hochgerechnete Pulsfrequenz pro Minute.

Punzen
Stempel in → Gehäusen, die Auskunft geben über die Art und den Feingehalt des verwendeten → Edelmetalls, über Herkunftsland und teilweise Herkunftsort, über das Herstellungsjahr sowie über den Gehäusemacher. Hinzu kommen häufig das Markenzeichen der herstellenden oder liefernden Uhrenfirma, eine → Referenz- und eine Seriennummer.

Referenz
Herstellerspezifische Kombination von Buchstaben und Ziffern zur Klassifizierung seiner verschiedenen Uhrenmodelle. Die Referenznummer beinhaltet oft auch Informationen über Typ, Gehäusematerial, Werk, Zifferblatt, Zeiger, Armband und Ausstattung mit Edelsteinen.

Regulatorzifferblatt
Außermittige → Indikation von Stunden und Sekunden.

Repetitionsschlagwerk
Aufwendige Zusatzfunktion eines Uhrwerks, die es gestattet, die aktuelle Zeit mehr oder minder genau akustisch wiederzugeben. Je nach Ausführung des Schlagwerkes unterscheidet man zwischen Uhren mit

Energie

Gespeicherte Arbeitsfähigkeit. Zum Antrieb von Uhren ist ein Energiepotenzial erforderlich. Dies kann bei mechanischen Uhren eine gespannte → Zugfeder (Federkraftantrieb) oder ein hochgezogenes Gewicht (Schwerkraftantrieb) sein.

Etablisseur

Uhrenhersteller, welcher Komponenten (Werk, Zifferblatt, Zeiger, → Gehäuse) bei spezialisierten Fabrikanten einkauft und zu fertigen Zeitmessern verarbeitet.

Ewiger Kalender

Komplexes Kalenderwerk, bestehend aus etwa 100 Teilen, welches die unterschiedlichen Monatslängen in aller Regel bis zum 28. Februar 2100 ohne manuelle Korrektur berücksichtigt.

Fabrikationsnummer

Zur Identifikation ihrer Produkte greifen viele Uhrenhersteller auf Fabrikationsnummern zurück. Dabei nummerieren sie Werk oder → Gehäuse oder beides. Offiziell geprüfte → Chronometer müssen in jedem Fall eine Werksnummer tragen. Diese findet sich auf dem Prüfzertifikat wieder.

Facette

Bei sehr feinen Uhren besitzen die Stahl- und Messingteile facettierte Kanten (→ Anglierung). Diese Kantenflächen sollten idealerweise im Winkel von 45 Grad angebracht sein.

Fälschungen

Plagiate beliebter, in der Regel sehr hochwertiger Uhren. Zertifikate, Rechnungen und Etuis schützen vor Fehlkäufen schon lange nicht mehr. Sie werden ebenfalls massenhaft gefälscht.

Feder

In Uhrwerken kommen Federn unterschiedlichster Natur zum Einsatz. Neben → Unruhspirale und → Zugfeder sind dies vor allem Sperr- und Haltefedern.

Finissage

Fein- oder Fertigbearbeitung einer Uhr.

Frequenz

Schwingungen pro Zeiteinheit, gemessen in Hertz (Hz). Bei ortsfesten Uhren findet man als gangregelndes Organ primär das Pendel, während mobile Uhren eine → Unruh besitzen. Beide bewegen sich mit einer bestimmten Frequenz hin und her. Das Pendel einer Sekundenpendeluhr benötigt von Umkehrpunkt zu Umkehrpunkt exakt eine Sekunde. Es verfügt also über eine Frequenz von 0,5 Hz oder 1800 Halbschwingungen/Stunde (A/h). Frühe Unruhschwinger brachten es auf 7200 bis 9000 A/h. Bei Taschenuhren wurde die Frequenz zunächst auf 12600 und später auf den allgemein üblichen Standard von 18000 A/h (2,5 Hz) gesteigert. Auch bei den Armbanduhren entwickelte sich diese Unruhfrequenz anfänglich zur gängigen Norm. Zur Steigerung der Präzision erhöhten die Uhrenfabrikanten die Schlagzahl auf 21600 A/h (3 Hz), 28800 A/h (4 Hz), 36000 A/h (5 Hz), 57600 (8 Hz) und sogar 72000 (10 Hz). Mit höherer Unruhfrequenz verknüpft sich steigender Energiebedarf. Außerdem verlangen zunehmende Rotationsgeschwindigkeiten Berücksichtigung beim Schmieren der → Hemmung.

Gangautonomie

Gesamte Laufzeit eines mechanischen Uhrwerks, also der Zeitraum zwischen dem vollständigen Aufzug und dem Stehenbleiben wegen Entspannung der → Zugfeder.

Gangreserve

Über das normale Aufzugsintervall einer Armbanduhr (24 Stunden) hinausreichendes Energiepotenzial. Üblicherweise bewegt sich die Gangreserve in einer Größenordnung zwischen 10 und 16 Stunden. Allerdings lässt die Antriebskraft der → Zugfeder in dieser verbleibenden Zeitspanne nach, was zu einer Reduzierung der Gangleistungen führt.

Gangreserveanzeige

→ Indikation der aktuell verbleibenden → Gangreserve bei mechanischen Uhrwerken.

Gehäuse

Schützende Hülle einer Uhr. Gehäuse gibt es in den unterschiedlichsten Ausführungen und Materialien. So unterscheidet man bei Taschenuhren u. a. zwischen offenen (Lépine) und geschlossenen Gehäusen (Savonnette). Für Armbanduhren werden z. B. wassergeschützte oder → wasserdichte Gehäuse verwendet. Außerdem gibt es eine Vielzahl unterschiedlicher Gehäuseformen (rund, quadratisch, oval, rechteckig, tonneauförmig) und -materialien (Platin, Gold, Silber, Stahl, Titan, Carbon, Aluminium, Kunststoff).

Genfer Streifen

Häufig verwendete rippenförmige Dekoration auf den Brücken und Kloben feiner → Kaliber. Sie wird vor der galvanischen Veredelung aufgebracht, bleibt aber dennoch erkennbar. Genfer Streifen finden sich im Allgemeinen nur bei hochwertigen Werken.

Gläser

Für Armbanduhren gibt es vier verschiedene Sorten von Gläsern: Kristallgläser kommen hauptsächlich bei frühen Armbanduhren vor. Sie sind zwar kratzfest, dafür jedoch sehr bruchempfindlich. Zu Beginn der 1940er-Jahre wurden die Kristallgläser mehr und mehr von Kunststoffgläsern (Plexiglas) abgelöst. Die sind zwar unzerbrechlich, verkratzen aber relativ leicht. Mineralgläser besitzen eine Härte von 5 Mohs und sind daher wesentlich robuster als Kunststoffgläser. Heute wird in hochwertigen Uhren zumeist → Saphirglas verwendet. Bei einer Härte von 9 Mohs ist es extrem kratz- und bruchfest, jedoch nur mit speziellen Diamantwerkzeugen zu bearbeiten.

GMT

Greenwich Mean Time; Welt- oder Universalzeit (UTC) am Greenwich-Nullmeridian. Die mittlere Zeit von Greenwich gilt heute als Standard im Navigationswesen und im internationalen Funkverkehr.

Gregorianischer Kalender

Am 15. Oktober 1582 trat in Rom nach langen Vorarbeiten und der Eliminierung von zehn ganzen Tagen eine von Papst Gregor XIII. verfügte Kalenderreform in Kraft. Sie beseitigte den winzigen Restfehler des 45 v. Chr. eingeführten → Julianischen Kalenders. Nach diesem war das Jahr um 0,0078 Tage zu lang. Das Spezifikum des Gregorianischen Kalenders, das diesen Fehler beseitigt, besteht darin, innerhalb von 400 Jahren drei Schalttage ausfallen zu lassen – und zwar in allen nicht durch 400 teilbaren Säkularjahren (Jahre des vollen Jahrhunderts). Demnach werden die Jahre 2100, 2200 und 2300 ohne den 29. Februar auskommen müssen.

Guillochieren

Gravieren feiner, teilweise kunstvoll verschlungener Muster in Uhrengehäuse oder Zifferblätter. Traditionelles Guillochieren geschieht von Hand mit Hilfe überlieferter Maschinen.

Handaufzugsuhr

Zeitmesser, bei dem die → Zugfeder von Hand gespannt werden muss.

Handaufzugswerk

Ein Handaufzugswerk besteht, je nach Konstruktion, aus 80 und mehr Teilen. Es lässt sich in acht wichtige Funktionsgruppen einteilen:
1. das Antriebssystem als energiespendendes Organ
2. das Übertragungssystem zur Weiterleitung der → Energie an
3. das Verteilungssystem, auch → Hemmung genannt
4. das Reguliersystem
5. das Zeigerwerk
6. die Organe zur Zeitanzeige
7. das Zeigerstellsystem
8. das Aufzugssystem

Hemmung

Mechanismus, der die Kraft der → Zugfeder in kleinen Stößen an das Schwingsystem (→ Unruh und → Unruhspirale) einer Uhr weiterleitet und das ungebremste Ablaufen des Uhrwerks verhindert. Bei einer Unruh-

frequenz von 28800 Halbschwingungen/Stunde lässt sie das Räderwerk täglich 691 200 Mal vorrücken. Im Laufe von vier Jahren ergibt dies mehr als eine Milliarde Kraftstöße. Das entspricht etwa der sechsfachen Leistung eines menschlichen Herzens.

Indikation
Anzeige z.B. von Zeit, Datum, Wochentag, Monat, Äquation, → Gangreserve, zweiter Zonenzeit.

Jewels
Internationale Bezeichnung für die → Steine eines Uhrwerks.

Julianischer Kalender
Auf Gaius Julius Cäsar geht der Rhythmus von jeweils drei Normaljahren mit 365 Tagen und einem 366-tägigen Schaltjahr zurück. Allerdings ist das Julianische Jahr gegenüber den wahren astronomischen Gegebenheiten um 0,0078 Tage zu lang. Deshalb musste Papst Gregor XIII. den Julianischen Kalender im Jahr 1582 korrigieren.

Kadratur
Begriff für ein zusätzliches Schaltwerk komplizierter Uhren, z.B. der Mechanismus für einen → Chronographen, ein → Repetitionsschlagwerk oder ein Kalendarium. Der Name leitet sich ab vom französischen Wort cadran (Zifferblatt). Deshalb meinen Kadraturen traditionsgemäß Schaltwerke auf der Vorderseite des Uhrwerks und damit unter dem Zifferblatt. Je nach Konstruktion kann die Kadratur ins Uhrwerk integriert oder auf einer separaten → Platine montiert und als Modul additiv mit dem Uhrwerk verbunden sein.

Kaliber
Dimension und Gestalt eines Uhrwerks und seiner Teile. Die Kaliberbezeichnung ermöglicht eine exakte Identifikation u.a. zum Zweck der Ersatzteilbestellung. Von den konfektionierten Rohwerken der → Ebauches-Lieferanten sind Manufakturkaliber zu unterscheiden. Letztere sind Uhrwerke, die → Manufakturen für ihren eigenen Bedarf produzieren. Gelegentlich ist auch von exklusiven oder reservierten Kalibern die Rede. Dahinter verbergen sich Rohwerke, welche Ebauches-Fabrikanten ausschließlich für einzelne Kunden entwickeln und/oder produzieren. Auf diese Kaliber haben andere → Etablisseure keinen Zugriff.

Komplikation
Zusatzmechanismus bei mechanischen Uhren wie → Chronograph, → ewiger Kalender oder → Tourbillon.

Krone
Knopf zum Aufziehen einer Uhr, zum Zeigerstellen und/oder Korrigieren von → Datumsanzeigen sowie früher auch zum Steuern von → Chronographen.

Kronenaufzug
Bis ins späte 19. Jahrhundert erfolgten Aufzug und/oder Zeigerstellung vieler Taschenuhren mit Hilfe eines kleinen Schlüssels. Beim modernen Kronenaufzug geschieht beides über eine kleine → Krone mit Umschaltvorrichtung.

Kulissenschaltung
Schaltwerk zur Steuerung eines → Chronographen. Ein beweglicher, je nach → Kaliber unterschiedlich ausgeformter Schaltnocken liefert das „Programm" für die Funktionen Start, Stopp und Nullstellung. Chronographen mit Kulissen- oder Nockenschaltung sind technisch weniger aufwendig, aber nicht minder zuverlässig als die Pendants mit Schalt- oder Säulenrad.

Lagen
Armbanduhren werden im Gegensatz zu Taschenuhren in vielen verschiedenen Lagen getragen. Es sind dies die Positionen „Krone oben", „Krone unten", „Krone rechts", „Zifferblatt oben" und „Zifferblatt unten". Bei Präzisionsuhren erfolgt daher eine Regulierung in diesen fünf Lagen.

Leuchtzifferblatt
Zifferblatt, von dem sich auch bei Dunkelheit die Zeit ablesen lässt.

Linie
Überlieferte Maßeinheit für Uhrwerksdimensionen, abgeleitet vom „Pied du Roi", dem französischen Fuß. Beispielsweise 11''' bei runden Werken oder 8¾ x 12''' bei Formwerken. Eine Linie entspricht 2,2558 Millimetern.

Lünette
In der Uhrmacherei ein vielschichtiger Begriff. Streng genommen versteht man darunter den Glasreif eines → Gehäuses. Dieser wird mit dem eingepressten Glas auf dem Mittelteil des Gehäuses montiert. Oft werden heute auch auf der Vorderseite von Uhrengehäusen befestigte Drehringe als Lünetten bezeichnet.

Manufaktur
Nach den ungeschriebenen Gesetzen der Uhrmacherei darf sich ein Uhrenhersteller nur dann Manufaktur nennen, wenn er mindestens ein → Ebauche oder Rohwerk selbst fertigt. Die Fertigsteller von Uhren unter Verwendung konfektionierter Rohwerke heißen branchenintern → Etablisseure.

Mechanische Räderuhren
Uhren, die über eine → Zugfeder angetrieben werden. Die Regulierung des Gangs erfolgt durch eine → Unruh mit Spiralfeder oder ein Pendel. Die Entwicklung der Räderuhr resultiert vermutlich aus dem Antriebsmechanismus von Planetarien, die seit dem späten 13. Jahrhundert bekannt sind. Als älteste mechanische Räderuhr des deutschsprachigen Raums kann wohl die Uhr des Straßburger Münsters gelten. Sie wurde 1352 fertiggestellt. In England gab es aber vermutlich schon gegen Ende des 13. Jahrhunderts funktionsfähige Räderuhren.

Mondalteranzeige
→ Indikation zum Ablesen der Anzahl von Tagen, die seit dem letzten Neumond vergangen sind. Im synodischen Monat beträgt das Zeitintervall von Neumond zu Neumond exakt 29 Tage, 12 Stunden, 44 Minuten und 3 Sekunden.

Mondphasen
Der Mond durchläuft seine von der Stellung Sonne, Mond, Erde abhängigen Licht- bzw. Mondphasen (Neumond – erstes Viertel – Vollmond – letztes Viertel – Neumond) innerhalb einer Lunation von etwa 29,5 Tagen.

Platine
Auch Werkplatte. Eine Metallplatte, welche die Brücken, Kloben und sonstigen Bestandteile eines Uhrwerks trägt.

Pulsometer
Arbeitserleichternde Zifferblattskalierung (meist bei → Chronographen) zum Messen der Pulsfrequenz. Abhängig von der Graduierung sind nach dem Starten des Chronographen 20 oder 30 Pulsschläge zu zählen. Die Spitze des gestoppten Chronographenzeigers zeigt dann auf die hochgerechnete Pulsfrequenz pro Minute.

Punzen
Stempel in → Gehäusen, die Auskunft geben über die Art und den Feingehalt des verwendeten → Edelmetalls, über Herkunftsland und teilweise Herkunftsort, über das Herstellungsjahr sowie über den Gehäusemacher. Hinzu kommen häufig das Markenzeichen der herstellenden oder liefernden Uhrenfirma, eine → Referenz- und eine Seriennummer.

Referenz
Herstellerspezifische Kombination von Buchstaben und Ziffern zur Klassifizierung seiner verschiedenen Uhrenmodelle. Die Referenznummer beinhaltet oft auch Informationen über Typ, Gehäusematerial, Werk, Zifferblatt, Zeiger, Armband und Ausstattung mit Edelsteinen.

Regulatorzifferblatt
Außermittige → Indikation von Stunden und Sekunden.

Repetitionsschlagwerk
Aufwendige Zusatzfunktion eines Uhrwerks, die es gestattet, die aktuelle Zeit mehr oder minder genau akustisch wiederzugeben. Je nach Ausführung des Schlagwerkes unterscheidet man zwischen Uhren mit

Viertelstunden-, Achtelstunden- (bzw. 7½-Minuten-), 5-Minuten- oder Minutenrepetition.

Retrograde Anzeige
Zeiger, der sich zur → Indikation von Zeit, Datum oder auch Wochentag schrittweise über ein Kreissegment bewegt und, am Ende der Skala angekommen, ruckartig in seine Ausgangsposition zurückspringt.

Rotor
Unbegrenzt drehende Schwungmasse bei Uhren mit → automatischem Aufzug. Je nach Konstruktion des Selbstaufzugs wird die → Zugfeder in eine oder beide Drehrichtungen gespannt. Zu unterscheiden sind Zentral- und Mikrorotoren. Erstere drehen sich über dem ganzen Werk, letztere sind in die Werksebene integriert.

Saphirglas
Kratzfestes Uhrenglas der Härte 9 Mohs. Eine noch größere Härte weist nur der Diamant auf.

Satinierung
Feiner, seidiger und matter Schliff auf Metalloberflächen.

Schaltradchronograph
Bei klassischen Chronographenkalibern erfolgt die Steuerung der Funktionen Start, Stopp und Nullstellung über ein drehbar gelagertes Bauteil mit – je nach Konstruktion – fünf, sechs, sieben, acht oder neun Säulen. Bei jedem Schaltvorgang bewegt es sich um einen exakt definierten Winkel im Uhrzeigersinn weiter. Kommt das Ende einer Schaltwippe auf einer Säule zu liegen, wird es durch diese angehoben. Fällt es hingegen zwischen zwei Säulen, sorgt leichter Federdruck für eine Absenkung.

Silizium
Jahrhundertelang beherrschten Messing, Stahl und synthetischer Rubin die Fertigung mechanischer Uhrwerke. Seit 2001 ist auch Silizium, das Basismaterial elektronischer Mikrochips, salonfähig. In monokristalliner Form besitzt es die gleiche Kristallstruktur wie Diamant. Es ist 60 Prozent härter und 70 Prozent leichter als Stahl, → amagnetisch und korrosionsfest. Auch ohne Nachbearbeitung verfügt es über eine extrem glatte Oberfläche, die Öl entbehrlich macht. Silizium ist elastisch, aber nicht plastisch verformbar. Speziell behandeltes „Silinvar" dehnt sich bei Erwärmung so gut wie nicht aus. Somit eignet es sich auch zur Herstellung von → Unruhspiralen. Invariables Silizium „Silinvar" ist eine Gemeinschaftsentwicklung von Patek Philippe, Rolex und der Swatch Group mit dem Zentrum für Elektronik und Mikrotechnik (CSEM) und dem Institut für Mikrotechnik der Universität Neuchâtel.

Skelettwerk
Uhrwerk, bei dem → Platine, Brücken, Kloben, Federhaus und ggf. → Rotor so weit durchbrochen werden, dass nur noch das für die Funktion unabdingbar notwendige Material übrigbleibt. Auf diese Weise kann man durch das Uhrwerk schauen. Armbanduhren mit skelettiertem Uhrwerk gibt es seit Mitte der 1930er-Jahre.

Steine
Bei Präzisionsuhren werden zur Verminderung der Reibung in den wichtigsten Lagern, an den Ankerpaletten und der Ellipse Steine eingesetzt.

Stoppsekunde
Vorrichtung zum Anhalten von Uhrwerk und/oder Sekundenzeiger, um die Uhrzeit sekundengenau einstellen zu können.

Stoppuhren
Im Gegensatz zu → Chronographen besitzen Stoppuhren keine Zeitanzeige. Bei einfachen Konstruktionen wird das Werk angehalten, wenn der Sekundenzeiger stoppen soll.

Stoßsicherung
System zum Schutz der feinen und deshalb sehr empfindlichen Zapfen der Unruhwelle vor Bruch. Zu diesem Zweck sind die Loch- und Decksteine der Unruhwellenlager federnd in → Platine und Unruhkloben befestigt. Bei harten Stößen geben sie entweder lateral und/oder axial nach.

Eine stoßgesicherte Armbanduhr soll einen Sturz aus einem Meter Höhe auf einen Eichenholzboden unbeschadet überstehen. Außerdem darf sie danach keine wesentlichen Gangabweichungen aufweisen.

Stundenzähler
Konstruktionsmerkmal mancher → Chronographen zur Erfassung der seit Beginn des Stoppvorgangs verstrichenen Stunden. Meist werden bis zu zwölf Stunden gezählt. Die Betätigung des Nullstelldrückers bewirkt auch eine Rückstellung des Stundenzählers.

Taucheruhren
Nach klar definierten Normen hergestellte Armbanduhren für Einsätze unter Wasser. Professionelle Taucheruhren müssen dem nassen Element bis mindestens 200 Meter Tiefe widerstehen. Zur eigenen Sicherheit sollte jede Taucheruhr einmal jährlich vom Juwelier auf ihre Dichtigkeit hin überprüft werden.

Tourbillon
Von Abraham-Louis Breguet 1795 erfundene und im Jahr 1801 patentierte Konstruktion zur Kompensation von Schwerpunktfehlern im Schwingsystem (→ Unruh und → Unruhspirale) mechanischer Uhren. Beim Tourbillon (dt.: Wirbelwind) ist das komplette Schwing- und Hemmungssystem in einem möglichst leichten Käfig untergebracht. Dieser dreht sich innerhalb einer bestimmten Zeitspanne (meist eine Minute) einmal um seine Achse. Auf diese Weise können die negativen Einflüsse der Erdanziehung in den senkrechten → Lagen einer Uhr ausgeglichen und die Gangleistungen gesteigert werden. In waagrechter Lage hat das Tourbillon dagegen keinen Einfluss auf die Ganggenauigkeit.

Unruh
Kreisrunder Metallreif, welcher in tragbaren Uhren durch seine Oszillationen gemeinsam mit der → Unruhspirale für das Unterteilen der kontinuierlich verstreichenden Zeit in möglichst gleichlange Abschnitte sorgt.

Unruhspirale
Die Unruhspirale kann als Seele einer mechanischen Uhr bezeichnet werden. Mit ihrem inneren Ende ist sie an der Unruhwelle, mit dem äußeren am Unruhkloben befestigt. Durch ihre Elastizität sorgt sie dafür, dass die → Unruh gleichmäßig hin und her schwingt. Ihre aktive Länge bestimmt neben dem Trägheitsmoment des Unruhreifens dessen Schwingungsdauer.

Vollkalendarium
Komplettes Kalendarium mit Anzeige von Tag, Datum und Monat.

Wasserdichte Armbanduhren
Uhren dürfen die Bezeichnung „wasserdicht" tragen, wenn sie gegen Schweiß, Spritzwasser und Regen resistent sind. Zudem darf in einem Meter Tiefe mindestens 30 Minuten lang keine Feuchtigkeit eindringen. Der Zusatz „50 Meter" oder „5 Bar" besagt, dass diese Uhren vom Fabrikanten einem entsprechenden Prüfdruck ausgesetzt wurden. Dennoch empfiehlt es sich nicht, mit solchen Uhren zu schwimmen oder gar zu tauchen.

Weltzeitindikation
Uhren mit Weltzeitindikation zeigen normalerweise 24, in Ausnahmefällen bis zu 37 Zonenzeiten auf einem Zifferblatt an.

Zugfeder
Elastisches und spiralförmig aufgewickeltes Stahlband zur Speicherung der Antriebsenergie für tragbare mechanische Uhren.

Imprint

First published in 2020 at
teNeues Media GmbH & Co. KG, Kempen

© 2022 teNeues Verlag GmbH
Second printing

Introduction & texts by Gisbert L. Brunner

Photo editing by Gisbert L. Brunner
Editorial management by Nadine Weinhold
Design & layout by Anne-Marie Gundelwein
Translation by Howard Fine (English)
Copy editing by Dr. Simone Bischoff & Hanna Lemke (German)
Proofreading by Nadine Weinhold
Production by Alwine Krebber
Color separation by Robert Kuhlendahl

ISBN 978-3-96171-277-9

Library of Congress Control Number: 2020935924
Printed in Slovakia by Neografia a.s.

Bibliographic information published by the
Deutsche Nationalbibliothek:
The Deutsche Nationalbibliothek lists this publication in the
Deutsche Nationalbibliografie; detailed bibliographic data are
available on the Internet at dnb.dnb.de.

Published by teNeues Publishing Group

teNeues Verlag GmbH
Ohmstraße 8a
86199 Augsburg, Germany

Düsseldorf Office
Waldenburger Straße 13
41564 Kaarst, Germany
e-mail: books@teneues.com

Augsburg/München Office
Ohmstraße 8a
86199 Augsburg, Germany
e-mail: books@teneues.com

Berlin Office
Lietzenburger Straße 53
10719 Berlin, Germany
e-mail: books@teneues.com

Press Department Stefan Becht
Phone: +49-152-2874-9508 / +49-6321-97067-97
e-mail: sbecht@teneues.com

teNeues Publishing Company
350 Seventh Avenue, Suite 301
New York, NY 10001, USA
Phone: +1-212-627-9090
Fax: +1-212-627-9511

www.teneues.com

FSC
MIX
Paper | Supporting
responsible forestry
www.fsc.org FSC® C020353

teNeues Publishing Group
Augsburg / München
Berlin
Düsseldorf
London
New York

teNeues